Art, Medicine, and Femininity

Intoxicating Histories
SERIES EDITORS: VIRGINIA BERRIDGE AND ERIKA DYCK

Whether on the street, off the shelf, or over the pharmacy counter, interactions with drugs and alcohol are shaped by contested ideas about addiction, healing, pleasure, and vice and their social dimensions. Books in this series explore how people around the world have consumed, created, traded, and regulated psychoactive substances throughout history. The series connects research on legal and illegal drugs and alcohol with diverse areas of historical inquiry, including the histories of medicine, pharmacy, consumption, trade, law, social policy, and popular culture. Its reach is global and includes scholarship on all periods. Intoxicating Histories aims to link these different pasts as well as to inform the present by providing a firmer grasp on contemporary debates and policy issues. We welcome books, whether scholarly monographs or shorter texts for a broad audience focusing on a particular phenomenon or substance, that alter the state of knowledge.

Hannah Halliwell

Art, Medicine, and Femininity

Visualising the Morphine Addict in Paris, 1870–1914

McGill-Queen's University Press

Montreal & Kingston • London • Chicago

© McGill-Queen's University Press 2024

ISBN 978-0-2280-1990-9 (cloth)
ISBN 978-0-2280-1991-6 (ePDF)

Legal deposit first quarter 2024
Bibliothèque nationale du Québec

Printed in Canada on acid-free paper

McGill-Queen's University Press in Montreal is on land which long served as
a site of meeting and exchange amongst Indigenous Peoples, including the
Haudenosaunee and Anishinabeg nations. In Kingston it is situated on the
territory of the Haudenosaunee and Anishinaabek. We acknowledge and thank
the diverse Indigenous Peoples whose footsteps have marked these territories on
which peoples of the world now gather.

Library and Archives Canada Cataloguing in Publication

Title: Art, medicine, and femininity : visualising the morphine addict in Paris,
 1870–1914 / Hannah Halliwell.
Names: Halliwell, Hannah, author.
Series: Intoxicating histories ; 8.
Description: Series statement: Intoxicating histories ; 8 | Includes bibliographical
 references and index.
Identifiers: Canadiana (print) 20230472567 | Canadiana (ebook) 20230472621 |
 ISBN 9780228019909 (cloth) | ISBN 9780228019916 (ePDF)
Subjects: LCSH: Drug abuse—France—Paris—History—19th century. |
 LCSH: Morphine abuse—France—Paris—History—19th century. | LCSH: Drug
 addicts—France—Paris—History—19th century. | LCSH: Medicine and art—
 France—Paris—History—19th century. | LCSH: Drug abuse in art—History—19th
 century. | LCSH: Art, French—France—Paris—19th century. | LCSH: Feminism—
 France—Paris—History—19th century.
Classification: LCC HV5840.F8 H35 2024 | DDC 362.29/3094409034—dc23

Set in 10.5/13 Sina Nova with Philosopher
Book design & typesetting by Garet Markvoort, zijn digital

Contents

Preface

As an art historian, I have always been especially interested in French art of the late nineteenth century, a time that saw new modes of art making and display practice emerge, alongside technological and medical advances, a rising feminist movement, and an increased presence of women in public spaces. Whilst working on my master's degree in art history, I came across a handful of blog posts about a recent exhibition titled *Tea and Morphine: Women in Paris, 1880–1914* at the Hammer Museum in Los Angeles (25 January–18 May 2014). Although I was already specialising in this period, this was the first time I had come across morphine use as a subject matter in art. Mounting an exhibition about women's morphine use implied that it was a significant facet of French art and society. The curators emphasised this with a quotation from *Felix*, Robert Hichen's novel of 1902, printed on one of the exhibition walls: 'You have no idea what a rage for morphia there is in Paris ... Paris is the centre of the cult.' Intrigued, I requested a list of exhibited objects. But out of the 101 objects displayed at the exhibition, only two artworks actually depicted morphine use.

I was soon to learn that the small number of artworks depicting morphine use at the *Tea and Morphine* exhibition was indicative of the lack of widely known artworks dedicated to the subject matter, despite the prominence of morphine addiction in France at the time. That was the starting point for my research, which began as a PhD proposal and has culminated in this book. Artists are part of the society in which they live; considering the nineteenth-century trend for painting modern life, I was certain there would be more images of morphine use out there. Research involved investigating exhibition catalogues, art magazines, and newspapers to find artworks by artists anonymous and well known. During this research process, I uncovered a multitude of images of morphine use(rs) that were yet to be discussed in scholarship, in addition to references to many more artworks whose locations and appearances still remain unknown.

Could uncovering a large number of previously forgotten artworks allow for a fresh understanding of the history of addiction and substance use? By investigating these images in the context of their historical moment and the gendering of drug use they portray, I realised that only through an analysis of these artworks would it be possible to gain that deeper understanding of morphine use and the nineteenth-century perception of addiction. Over the last several years, I have shared some of these images and the seeds of this research at medical and drugs history conferences around the world. These are important spaces of knowledge sharing within and across disciplines. I have learnt a tremendous amount from drugs history scholars about how to approach topics of substance use and addiction, but art history can also offer new ways of approaching and theorising the history of drugs.

One comment that I received after a paper I gave at the 2019 Alcohol and Drugs History Society conference in Shanghai has stuck with me: 'I didn't realise you could analyse paintings like that.' You can.

Acknowledgements

I started my bachelor's degree in art history at the University of Birmingham in 2012, having applied because I thought I might like writing about art. Well, it turns out I do. The department would become my home for nine years, as I completed a BA, a master's degree, a PhD, and a teaching fellowship. I am immensely grateful to the university's Department of Art History, Curating and Visual Studies. Its members taught me with a knowledge and passion that I can only hope to emulate in my own teaching.

My sincere thanks go in particular to Francesca Berry, my primary PhD supervisor. Fran's enthusiasm for French art and feminism continue to inspire me. Now that I am working in academia, I appreciate more fully the vast amount of time Fran gave to me. And to Camilla Smith and Ting Chang, my secondary supervisors, thank you for guiding me through the doctoral process with your invaluable comments and advice.

I could not have pursued a doctorate without the generous funding I received from Midlands4Cities (AHRC) and the University of Birmingham. The University of Birmingham's Haywood Fellowship meant I could take a fourth year to work on the thesis. Midlands4Cities funding, along with its stipend, allowed me to conduct necessary primary research in Paris and to present my developing ideas at conferences. Attending the Alcohol and Drugs History Society conference in 2019 opened my eyes to the discipline of drugs history and the impressive researchers who are part of it. A special thanks goes to Jamie Banks for first alerting me to McGill-Queen's University Press's new series, Intoxicating Histories.

Along with a doctorate comes, of course, its viva. Thank you to my internal and external examiners, Kate Nichols and Fae Brauer, for their time, expertise, and kind comments. Their observations gave me the confidence I needed to pursue publication of my thesis in the form it now takes. I am grateful also to Richard Baggaley from McGill-Queen's University Press, whose enthusiasm and kindness have been unfaltering from our first phone call. The suggestions and insights of the anonymous peer reviewers and

copy editor Jane McWhinney certainly helped me improve the manuscript, so I thank them as well. My thanks extend to Richard Thomson, specifically for his advice on chapter 7, but also for his passion for French art, which was much needed during tiring writing days. A huge thank you goes to my other colleagues and friends at the University of Edinburgh who have been so welcoming and supportive as I navigated teaching and book writing.

As an art historian, it was important for me to include colour images in this book. I am grateful to the Association for Art History and the University of Edinburgh History of Art department for funding the associated publication costs. I also thank the Society for French Studies and the University of Edinburgh for funding costs associated with image reproductions, and the Association for Art History for funding all artist estate fees.

My final thanks go to the important people who have been in the background the whole time. I thank my parents, for their ongoing support and for suggesting that art history might be a subject I'd like to study. I also thank my wonderful friends, who continued to provide much-needed laughs throughout this process, as they have done for the last two decades. And finally, thank you to my partner, my greatest champion, for always being there. We first met in Chelwood Hall at the University of Birmingham in September 2012, on the day my art history journey began, so it only feels right that this book is dedicated to him.

Art, Medicine, and Femininity

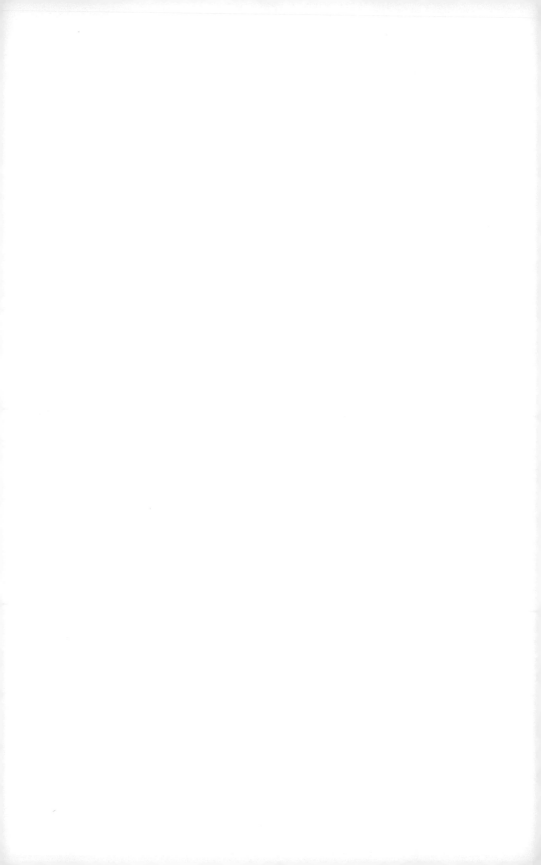

Introduction

At the La Scala cabaret in Paris in the winter of 1894, the celebrated French singer Yvette Guilbert performed a song about morphine addiction titled 'La Morphinée'. Theatre critic Michel Zévaco's review in *Le Courrier Français* described Guilbert's performance in sensationalist terms: 'Here she comes, *la morphinée*, in her morbid allure of sensual perversion, with her ravaged features, hollowed out perhaps by the invisible and slow corrosion of the kiss of a Ghoul, and her strangely red lips ... gestures symptomatic of madness ... the lily-like paleness of her face ... an unexpected spark of tenderness that flashed from her Sphinx-like eyes ... she wanted to be the incarnation of Disease, the one that slowly sinks back into the previous night ... more than Disease: Evil.'[1] Guilbert was renowned for her physical appearance, particularly her pale skin, red lips, and long arms.[2] Letters between Guilbert and the French poet and songwriter Jean Lorrain reveal that Lorrain had pleaded with Guilbert to perform his new song about morphine; not only did the singer owe Lorrain a favour but her physical appearance corresponded to an already established visualisation of the so-called morphine addict, as formulated by artists.[3] In fact, Zévaco's review corresponds in its entirety to artistic visualisations of the morphine addict that came before and after Guilbert's performance.

'La Morphinée' was part of a far broader fixation on morphine addiction in the late nineteenth-century French cultural imagination. The morphine addict was portrayed at the cabaret and the theatre, and in caricatures, illustrations for novels, institutionally approved and nationally exhibited paintings, avant-garde prints, and so on. Almost all representations of the morphine addict in art parallel Zévaco's description of Guilbert's La Scala performance: eroticised, decadent, pale, heavily made-up, Sphinx-like, dangerous, otherworldly, unscrupulous. Such descriptors have historically been associated with wayward women and reflect the representation of the morphine addict in fin-de-siècle literature, theatre, and art as overwhelmingly female. No cultural sector feminised the morphine addict more than artists.

Yet the reality was that men made up the highest proportion of morphine addicts and, of that percentage, medical professionals were the largest sector of users.[4]

One review of Guilbert's performance, by journalist and theatre critic Francisque Sarcey, suggested that 'La Morphinée' would be more suitable 'in a studio with artists'.[5] But Sarcey's review was uncharacteristic of the general reception of Guilbert's act. Whereas Sarcey compared 'La Morphinée' to artistic visual culture, most critics praised the performance for its believable correspondence to the supposed real morphine addict, regardless of contemporary statistics. As this book does as well, Sarcey's review highlights the important role that art played in visualisations of the morphine addict. His review gestures towards the unreality of both Guilbert's performance and of artworks depicting morphine addiction. Aligning art with cabaret performance is an important reminder that art is not a reflection of reality. 'Art is an *interpretation* of nature' is the way art critic Charles Blanc expressed it in 1867.[6] In other words, artworks represent deliberate choices on the part of the artist who wants to show or imply something to the viewer. It may initially be construed that artworks portraying the morphine addict gave accurate representations of French society, created in response to a rise in social drug use. But this book demonstrates that artists' depictions of morphine addiction did not represent the truth about morphine use. One cannot assume that artists' capacity to mimic reality means their art provides an accurate reflection of history. Their representations must be challenged in relation to the wider society in which they exist, as a means to consider how and why artists disregarded the truth about addiction, whether deliberately or subconsciously.

Zévaco's overdramatic description of Guilbert as *la morphinée* attests to many of the artistic devices that artists of different nationalities working in Paris, and France more broadly, used over an approximately thirty-year period beginning in the 1880s in order to depict the morphine addict. These tropes shaped and perpetuated a false representation of those who were or could become addicted to morphine. Artists thus misrepresented the reality of morphine addiction in France, which was rooted in medical treatment rather than in the decadence and pleasure-seeking antics that they portrayed. Through an examination of different visualisations of the morphine addict, this book traces how late nineteenth-century artists in France depicted the morphine addict in their artworks – and asks why. In the process it offers insights into broader themes of art and medicine, the gendering of drug use, and art's potential to influence and take influence from socio-political commentary. Why was the habitual morphine user prominent across such a

variety of cultural forms in this period? What can consistencies and differences in representations of morphine use tell us about wider perceptions of drug use at the turn of the twentieth century?

En/Visioning Addiction[7]

Art, Medicine, and Femininity presents the first comprehensive analysis of the visual culture of the 'drug addict' as created in France at the end of the nineteenth century. These artworks signal the first historical moment that any form of habitual substance use was cohesively visualised in Western society; existing substances such as alcohol and opium lacked the unified representation seen in imagery related to morphine use. In other words, French visual culture of the morphine addict at the end of the nineteenth century set a historical precedent for the visualisation of addiction. It may also be suggested that this visual culture initiated a paradigm for the gendering of addiction. The representation of the morphine addict is a gendered issue, and the role of femininity is crucial to this corpus of images.

By considering art's potential for influence, this book focuses on the artist's role in constructing the appearance of the habitual morphine user through visual culture created primarily in France. The book does not posit art as a mirror-image response to society; it positions art as having the power to create, change, and perpetuate opinion. These long-lasting effects mean that artworks depicting morphine use are still used as illustrations of undisputed historical accounts. An understanding of this visual culture also enables greater insight into turn-of-the-century French society – the complex interrelationships between femininity, medicine, and art, and the way these categories amalgamated in the visualisation of the morphine addict. Through its analysis of morphine addiction in French visual culture, this book demonstrates the validity of art-historical methodologies and their importance to the historical study of drug use.

Art, Medicine, and Femininity is structured primarily around the analysis of these artworks – through a consideration of their appearance, critical reception, intended audience, and function. Historical studies of opiates and the gendering of drug use have been plentiful in the last two decades, and their numbers are increasing. Far rarer is the analysis of the visual culture of substance use, which has until now been dominated by an assessment of the wider economic, social, and medical developments of drugs and has thus used images illustratively. Art historians have rarely contributed to this discourse. Julia Skelly, in one of the few existing art-historical books engaging with drug use, concludes *Addiction and British Visual Culture* by noting

that existing art-historical scholarship lacks a feminist approach to depictions of women as addicts.[8] Progressing from Skelly's 2014 study, this book on images of morphine use(rs) puts forward a long-overdue transferable framework for analysing visualisations of female substance users.

Morphine use in nineteenth-century France has been explored recently from a variety of perspectives, each adding a new layer to our understanding of the drug. Sara Black's book *Drugging France* centres on mind-altering drugs, with specific consideration of the roles played by doctors and pharmacists. In particular, the chapter titled 'Sex and Drugs' sets up important narratives relating to gender dynamics and drug use.[9] Femininity is also an underlying theme in Susannah Wilson's chapter on morphine and prohibition in the French cultural imagination.[10] Existing scholarship has already shown that the nineteenth-century gendering of drug use, morphine use in particular, is a key line of enquiry.[11] Evolving from there, *Art, Medicine, and Femininity* demonstrates that art played an immeasurable, and thus far unconsidered, role in this gendering. Visual culture holds the key to understanding how the gendering of morphine addiction relates to wider social issues.

The body of research in this book is of relevance not only to art historians investigating late nineteenth-century French art but also to those with interests in drug history, medical history, gender studies, and related areas such as historical marketing strategies, medical visual and material culture, and the history of journalism. The book shows the validity and necessity of visual analysis to each of these fields. It presents a new way of approaching drugs history that I hope will be applied beyond the nineteenth-century morphine addict to future analyses of substance use throughout history and across geographical location.

By approaching the creation of art as what T.J. Clark terms 'a series of actions in but also on history', the book considers art's potential to influence the construction, perpetuation, and ultimate control of the public's perception of morphine addiction.[12] What if, as I argue in chapter 1, the morphine addict – as a social and artistic phenomenon – evolved specifically in response to French artist Georges Moreau de Tours's life-size canvas *La Morphine*? After all, even before that painting was recirculated in books and newspapers in the 1890s, it had been seen by up to half a million people when it was first exhibited in 1886. *Art, Medicine, and Femininity* draws attention to how art was pivotal to the influx and spread of (mis)information in French society and beyond. Whilst artists may not have deliberately misinformed viewers – and we cannot know their true intentions or

subconscious biases – their visualisations undoubtedly influenced public perception of the morphine addict. By considering the powers of the medical sector and the social and political changes women were undergoing in France, the book thus demonstrates how the morphine addict image-type both influenced and directly manifested the social anxieties of the time.

Just as artists choose what they want to depict, they also choose what they want to exclude. Acknowledging and suggesting reasons for such exclusions can often tell us more about society than what is depicted within an artwork. In a way comparable to Clark's analysis of art through the social art history model, but with a greater consideration for gender, this book is concerned with 'what prevents representation as much as what allows it'.[13] My approach to understanding absences in art stems from John Barrell's analysis of the eighteenth-century English painter George Morland. According to Barrell, Morland revealed the limits of public tolerance by including just enough aspects of the ideal rural life in his paintings to counteract suggestions of workers' unhappiness.[14] In fact, the absence of expression in Morland's paintings was a sign of discontent; if the workers had been happy, the artist would have depicted them that way. Morland gave his viewers enough information to identify the figures as representational of the rural poor, but he could not accurately depict their toil and unhappiness by direct means. The present book approaches absences in morphine use imagery in a comparable way. Chapter 4, for example, demonstrates how, through the inclusion of the hypodermic syringe, artists made indirect reference to the medical world despite the figural absence of physicians.

Opium and alcohol have a much more extensive history than morphine, which only became a drug of public concern in the latter half of the nineteenth century. Artists did not use specific, recurring tropes to represent opium and alcohol users, and neither substance was gendered to the same extent as morphine. The longer history of alcohol and opium meant that images depicting the explicit use of these substances in the late nineteenth century were recognisable to a contemporary audience. But addiction to morphine, as a social and medical phenomenon, was new to nineteenth-century society. It required defining, both medically and pictorially. This was a key reason that artists established and came to rely on repeated tropes to characterise a representation – albeit false – of the addict. As Michel Foucault argues in *The Order of Things*, the repetition of (visual) discourse results in its acceptance as fact.[15] In the case of the morphine addict, the set of tropes that artists working in different media and styles established became associated through repetition with morphine use and addiction in general,

as chapter 2 shows. My research underlines the art-historical significance of this moment as the first time the so-called addict was pictured consistently and cohesively with repeated characteristics.

Timothy Hickman highlights the end of the nineteenth century as a point where habitual narcotic use became 'an object of popular concern'.[16] According to Hickman, a century of trying to represent narcotic use set the precedent for 'heroin chic', a popularised visualisation of drug addiction whereby fashion photographers, artists, and filmmakers of the mid-1990s drew on stereotypes of what society expected the 'heroin addict' to look like. Hickman demonstrates the significance of the end of the nineteenth century as a historical moment when that (pseudo-)medical visualisation began to take root. He writes: 'Everyone knows what a junkie is supposed to look like ... and yet, narcotic addiction, as a physiological or psychological condition, is invisible ... [But] we should bear in mind that the difficulty of *seeing* addiction has never stopped either the professional or lay public from trying to make this inherently invisible condition visible – from en/visioning addiction.'[17] Significantly, however, the appearance of the nineteenth-century addict relies not only on such social descriptors but also on artistic representation. I contend that artists who portrayed morphine use(rs) demonstrated the first 'en/visioning' of addiction, and that it occurred primarily through artistic visual media rather than through descriptive medical factors. My approach aligns with Hickman's argument: heroin chic was not a 'symptom of moral lapse' or a 'liberation of desire that was specific to the mid-1990s Anglo-American culture', but part of a much longer history that began with opiate use at the end of the nineteenth century.[18] Added to this, however, this book documents the extensive reach of artistic depictions of the morphine addict and the potential of the Paris art world for influence on an international scale. As explored in chapter 7, French visual culture of the morphine addict not only had an impact on its French audience; it set a precedent for the West.

As with visual constructions of the morphine addict in French visual culture over a century earlier, there exists today a continuing presupposition that a distinct set of recurring tropes can be used to identify and stigmatise the 'addict'. In nineteenth-century French visual culture, female morphine users were presented as pleasure-seekers and hence as not requiring or deserving help or support. Whilst our understanding of addiction has changed vastly since that time, as Nancy D. Campbell and Elizabeth Ettorre report, 'most women who need drug treatment in the US and UK still do not get it'.[19] In their *Gendering Addiction*, they pose important questions about twenty-first-century treatment implications for drug-using women: 'Why

have women drug users been marginalized so consistently in treatment and policy circles?' and 'Why, knowing that so many women still cannot get what they need in terms of healthcare and economic and social support, do we persist in criminalizing them – as if prosecuting women will make the situations for which they are held responsible anything but worse?'[20] These questions speak not only to the present, but also to the past, and to the historical moment when artists created an influential corpus of addiction visual culture in France during the early Third Republic.

Art, Medicine, and Femininity attributes a significance to the gendering of addiction, which lies historically in the visual. This approach demonstrates how our understanding of morphine addiction, and perhaps perceptions of substance use in general, have hinged on social constructions that demonise the women represented, whilst simultaneously denying actual women the help they need.[21] Through an investigation into the visual culture of the morphine addict, we can achieve greater insight into feminism, the medical world, and the ways in which artists interacted within the competitive environment of Paris, the art capital of the Western world. These interconnected categories – medicine, art, and femininity – are the key components of the visual culture of morphine addiction – and, in turn, of this introduction. A chapter outline will follow.

Medicine

Morphine, a strong and highly addictive opiate, was first isolated from opium around 1805 by the German pharmacist's assistant Friedrich Sertürner, who named the drug Morphium after Morpheus, the Greek god of dreams, because of its tendency to cause deep sleep.[22] Sertürner quickly realised that morphine, at around ten times the potency of opium, was much more effective for pain relief. With the invention of the hypodermic syringe by Alexander Wood in the early 1850s, morphine use became widespread. Injections gave faster and more direct relief than the previous method of oral ingestion and dramatically increased the drug's ease of use. China's defeat by Britain and France in the Second Opium War (1856–60) forced the legalisation of opium and stimulated production on an enormous scale. As the trade opened up globally, opium and its derivatives – morphine, opium tonics such as laudanum, heroin (first made in 1874 by C.R. Alder Wright), and others – became internationally accessible.[23] Although morphine is a derivative of opium, morphine visual culture rarely includes the overt references to Turkey, the Middle East, and South-East Asia that can be seen in nineteenth-century opium artworks. Morphine, labelled 'the opium of the

West [*l'Occident*]' by Henri Fouquier in 1891, was medicalised at the same time that it was Westernised – a likely reason that artists refrain from orientalising narratives in their depictions of morphine use.[24] A recent book by David Guba analyses nineteenth-century orientalising attitudes towards cannabis and hashish in colonial France.[25] It is hoped that the research put forward in this book, when considered alongside Guba's important contribution to the field, will encourage new lines of enquiry into the underexplored imperial framing of opium visual culture, which is beyond the scope of this book.

Several large-scale conflicts in the latter half of the nineteenth century, including the American Civil War (1861–65) and the Franco-Prussian War (1870–71), popularised the injection of morphine for diarrhoea and pain relief, and initiated its widespread use in Western Europe and America. In particular, and perhaps because of morphine's use in the Franco-Prussian War, the administration of morphine in Parisian hospitals increased considerably in the final quarter of the nineteenth century, as Sara Black has demonstrated.[26] This surge in morphine use extended beyond hospital walls and into the homes of middle- and upper-class French citizens.

In addition to its use in hospitals, the primary route to habitual morphine use was via medical prescriptions. For those who could afford doctors' visits, morphine was prescribed for anything from headaches and menstrual pain to chronic conditions such as cancer and neuralgia. Morphine began to be considered a panacea. That attitude, coupled with a lack of understanding about the dangers of substance dependence, provides one explanation as to why so many people became habitual users. Tolerance build-up and morphine's highly addictive nature in turn made prescriptions increasingly costly. In principle, the doctor or patient would acquire morphine from a local pharmacy and the doctor would administer the drug to the patient. Having the means to buy morphine – a relatively expensive drug, particularly if it came via doctors' appointments – was crucial. In France morphine addiction offers a stark contrast to alcoholism, which was an illness associated with the poor. Contemporary writers with a direct awareness of alcoholism amongst the poorer classes called morphine addiction the 'alcoholism of the rich'.[27] Newspaper reports and scientific studies acknowledged that any use of morphine found among poorer members of society resulted almost exclusively from their 'contact with the rich classes'.[28]

Although drug dependence has no boundaries, it was unlikely that those with little income could have afforded the doctors' visits that would introduce them to morphine. Not until the turn of the twentieth century do we find press reports of the drug's democratisation. The journalist Albéric

Darthèze noted in a 1901 article of *L'Aurore* that, although morphine still commanded a high price, the growing numbers of traffickers selling morphine illegally had begun to make the drug more accessible.[29] One could question the reliability of these journalistic reports, but articles on the democratisation of morphine did coincide with the emergence around 1900 of an unregulated clandestine market through which morphine could be bought from alternative sources. Morphine was legal to purchase and use, so for those unable to access the drug via prescription, these sources would have offered a somewhat cheaper route still behind the façade of legitimacy. It should nevertheless be noted that purchases of morphine via illegitimate means would likely only occur as a result of an existing dependence that had originated with legitimate medical prescriptions. In 1916 the French government criminalised the social consumption of drugs.[30]

Georges Pichon, in his 1889 medical book *Le Morphinisme*, blamed the medical profession for France's growing number of morphine addictions, calling doctors 'the prime culprit' behind prescribing the drug too liberally.[31] Overall, however, the power of morphine and its medical uses functioned mainly to enhance the doctor's role as an alleviator of pain. This role coincided with the invention of important medical instruments such as the stethoscope, thermometer, and hypodermic syringe. French doctors in the latter half of the nineteenth century were responsible for individual and family health, and as such were deemed to play a key role in rebuilding the strength of France after its defeat by Prussia in 1871 and the emergence of the Third Republic (1870–1940). During the 1880s physicians struggled to obtain what Claudine Herzlich terms the 'recognition of their monopoly', and a new law guaranteeing the practice of medicine and solidifying the professional status of medical practitioners came into effect in 1892.[32]

Science, stability, and social progress were prime objectives of the Third Republic. Dedication to science and medicine gave the republic a needed distance from its 'ideological rival', the Catholic Church.[33] Concurrently, degeneration (or 'reverse Darwinism', as sociologist Alfred Fouillée referred to it in 1896) became a major concern amongst European social commentators, particularly following France's defeat and its ensuing decline in population growth.[34] In 1892 the German writer Max Nordau published *Entartung* (Degeneration), which was translated into French just two years later. Along with atheism, mysticism, hysteria, and many other social phenomena, Nordau identified the significant increase in the consumption of 'narcotics and stimulants' as a cause of degeneration.[35] Degeneration (the 'ultimate signifier of pathology' according to historian Daniel Pick) was inextricably connected with public health and medical models of sexual deviance, which

are recurring themes throughout the present book.[36] Degeneration was intertwined with decadence, and both represented forms of societal, moral, biological, and economic decline. France – Paris in particular – embodied the artifice and excess that underpinned these fin-de-siècle concerns.[37] The morphine addict, who became a prominent figure in the French cultural imagination, encapsulated these anxieties about degeneration and decadence, specifically in relation to public health, neuroses, contagions, sexuality, hedonism, and medical classifications.

As Robert Nye shows in *Crime, Madness and Politics in Modern France*, a symptom of these fears relating to degeneration was the proliferation of medical categories and social models of crime and deviance.[38] In the 1880s and 1890s medical professionals and journalists simultaneously debated what this new morphine 'epidemic' should be called, and tried to distinguish between the different routes that led to habitual morphine use; but little consistency was to be found. Some used *morphinisme* to describe addiction that resulted from use for physical disorders or illness, whilst *morphinomanie* became the term for addictions that occurred psycho-sensorially or as a result of moral weakness and the pursuit of pleasure.[39] Still other doctors used *morphinisme* for all forms of morphine dependence; Ernest Chambard, for instance, argued in *Les Morphinomanes* that distinctions were meaningless because the result was always the same.[40] Pichon created an 'intermediate class' of habitual users labelled the *morphinisés*, whose addictions had occurred 'accidentally' or 'as a result of ennui'.[41] Paul Rodet, by contrast, used this same term to categorise those who became addicted following a doctor's administration for illness.[42] Despite these debates, artists and writers for popular audiences – journalists, authors, novelists – gave preference to the word *morphinomane* (morphine-maniac) to describe a habitual morphine user and *morphinomanie* (morphine-mania) to refer to the 'epidemic' of increased usage.[43] Considering the socio-historic context and the overwhelming use of these terms at the time, I have chosen for this book to use *morphinomanie* to describe the phenomenon of morphine addiction and *morphinomane* to denote the morphine addict. In the nineteenth and early twentieth century these terms disregarded any medical distinctions and placed habitual morphine users in the wider categorisations of neuroses (for example, kleptomania, monomania, neurasthenia), as explored in chapter 3. The professionalisation of psychology and the shaping of neurology as a medical specialism meant that the latter half of the nineteenth century was rife with the classification of various neurotic illnesses, many of which were feminised. As this book demonstrates, women's supposed vulnerability to

these socially constructed psychological disorders undoubtedly contributed to the feminisation of morphine use in medicine and art.

Femininity

Morphine's function as an effective pain reliever implied that it responded to moral and physical weakness, both of which were deemed inherently feminine; the 'inability to exercise willpower' was seen as a primary symptom of degeneration.[44] This judgement was reinforced by women's supposed susceptibility to addiction as the nineteenth century understood it – 'an ominous twilight between immorality and disease,' in the words of Susan Zieger.[45] Visual representations of the habitual morphine user, which perpetuated certain ideas about who was or could become addicted to morphine, showed an overwhelming bias towards middle- and upper-class women. In reality, as the statistics showed, more men than women were habitually using morphine.[46] Whilst it is not my intention to deny that some women were indeed addicted to morphine, there is an evident imbalance between reality and its visual representations. This book shows the extent to which the visual culture of the *morphinomane* is a gendered issue, and asks, 'How did the representation of the *morphinomane* influence or perpetuate anxieties about actual women?'

The visual culture of the morphine addict can tell us a lot about the gendering of addiction and its origins, but it can also tell us about perceptions of women at the time, beyond the so-called morphine epidemic. *Morphinomanie* and its visualisations coincided with changes in women's social experiences in France, and I argue that this was no accident. This study explores how artists used visual references to deviant women in their depictions of the *morphinomane* and illuminates how this practice relates to the shifting experiences and increasing liberation of middle- and upper-class women. One pivotal change was the reintroduction of divorce in 1884, which meant that women could now legally separate from their husbands.[47] Women's educational and professional possibilities also improved at the end of the nineteenth century. The year 1880 brought the implementation of the Camille Sée law, which established state-sponsored secondary education for women, and in the 1890s women gained access to higher education. Together, these measures gave women career options previously accessible only to men.[48] Such changes paved the way for a more liberated lifestyle for some women and reinforced feminism in France. The first International Congress on Women's Rights was held in Paris in 1878, timed to coincide with the city's

third Exposition Universelle. For France's small but rising feminist movement, the congress marked 'a new wave of its organisational efforts' and was followed by a notable increase in the use of the term *féminisme*.[49]

Although feminism was an incipient movement in France at the time, contemporaries saw it as a force 'assailing governments like a mounting tide'.[50] French feminism of the 1890s was mostly about accepting differences between the sexes and promoting and valuing women's role as mothers. Different groups of feminists campaigned for different changes, but their ideas were amalgamated into the symbolic figure of the *femme nouvelle*, or 'New Woman'. The *femme nouvelle* was perceived as a threat to French masculinity for several reasons: the misperception that women's fashion choices indicated increasing masculinisation, the growing liberation of bourgeois women, and the intensity of debates on women's reproductive capacities, to mention a few.

As Elizabeth Menon has argued, the *femme nouvelle* was a social construct.[51] In a manner comparable to artists' depictions of the morphine addict, the figure was based on women who had lives considered unconventional or socially inappropriate. In this book I demonstrate how concurrent developments towards women's liberation were related to artists' visualisations of the *morphinomane* and played into the hyper-feminisation of the figure. As such, the corpus of imagery presented here should be understood as part of a much longer and broader history of the social constructs of femininity. Less than two decades before the *femme nouvelle* and the feminised visualisation of the *morphinomane* in France came the *pétroleuse*. The *pétroleuses* were characterised as women who supported the 1871 Paris Commune and reportedly set fire to Paris buildings. Gay Gullickson has challenged the reality of these 'dangerous' figures in *Unruly Women of Paris*, suggesting that the representation of female bodies in light of the Commune showed that it was not possible 'to ignore the female barricade fighter', and led to a multitude of responses to the problematic female/fighter dichotomy.[52] This book approaches the *morphinomane* in an analogous way. Like the *pétroleuse*, the *morphinomane*, both as social phenomenon and as artistic depiction, should be interpreted as an artistic construction that is symptomatic of wider anxieties about women.

Anxieties about women also manifest in art, particularly in depictions of the female body and art-critical responses to representations of femininity. This is not a new argument in art history, but its application to the gendering of drug use through the female body signals an important cultural and societal context that has largely been ignored. Jennifer Shaw's analysis of paintings submitted to the prestigious, state-sponsored Paris Salon of 1863

provides a useful approach for considering how artists' depictions of the female body are representative of anxieties about women beyond the walls of art institutions. The 1863 Salon saw an unusual number of celebrated (male) artists exhibit paintings of Venus. Each artist created their own version: some Venuses were sexualised, some had pubic hair, some resembled the classical Venus, and others looked more like contemporary Parisians. 'To speak of Venus was, of course, to speak of Woman', Shaw notes.[53] She demonstrates how these differing representations of Venus, and thus critics' responses to these artworks, can be understood as responses to mid-century gender politics and new ideas about female reproductive systems, which were based on the nineteenth-century discovery that the ovulation of mammals occurs independently from intercourse. The different artistic depictions of Venus served mostly to illustrate 'conflicting discourses about the status of woman' in society at that time rather than 'contradictions in codes of [artistic] representation'.[54] The female body as Venus at the 1863 Paris Salon can thus be understood to carry meaning and to signify 'man's relation to and control of the feminine' in art and hence in contemporary society.[55] Shaw contends that the figure of Venus – and by extension the portrayal of the female body in art – should be seen as a construction by artists: 'a palimpsest upon which anxieties about male creativity and control could be projected'.[56]

Whereas Gullickson has analysed the wider contexts for *why* a deviant female figure-type (the *pétroleuse*) came into existence, Shaw considers *how* the artistically constructed bodies of Venus signified contemporaneous attitudes towards women. Through a combination of the approaches of Gullickson and Shaw, *Art, Medicine, and Femininity* is informed by a methodological framework that considers the *morphinomane* at once as a social construction and as a comment on femininity via its intrinsic artistic representation and its extrinsic existence as a recurring image-type.

Art

As of the mid-nineteenth century, Paris had become a central hub for the innovation, progression, and establishment of the arts. By the turn of the twentieth century, the French capital had secured its position as a tourist hotspot for decadence and the arts, and as a forerunner of the avant-garde and international art market. Although artists preferred to exhibit all over Europe, Paris 'came first very often'.[57] The city attracted artists from all over the globe who attempted to initiate or advance their careers with the help of art dealers, critics, agents, and independent galleries. These artists often

brought new perspectives and different influences to the Paris art world, but the subjects of their artworks were typically French by nature and demonstrated an assimilation with French culture, French decadence, and French art.[58] Whilst morphine use was prevalent in many Western countries – America, England, Germany, and Denmark, for example – no other centre fostered such a large output of the visual representation of morphine use as France did. This book focuses predominantly on images created or exhibited in France – Paris, more specifically – but the nature of Paris as a global art community meant that it was not French artists alone who created the artworks considered in this study. Hence, a geographical significance can be attributed to the combination of Paris, the habitual morphine user, and this field of visual culture. What was the potential significance of the role played by Paris and its dominating art market in the creation of these images?

Artworks depicting morphine users were created in Paris during a short and relatively well-defined period in the first half of the Third Republic. The first known appearance of the subject matter was in 1884, coinciding with the distinct increase in morphine use in France during the 1880s; and, with the start of the First World War and criminalisation of morphine in 1916, the subject was rarely engaged with in the same way again. The extensive use of morphine as a painkiller in the war perhaps had some impact on this timing, but it was the specific art conditions of the early Third Republic that allowed for the proliferation and perpetuation of the *morphinomane* in all art forms. With the early twentieth century came the decentralising of Paris within a globalising art market that saw changes to modes of art making and display. Perhaps most significantly, morphine was by then no longer the new, sensationalised drug it had been, and social concern had turned to cocaine and heroin. However, as the epilogue explores, visualisations of the homogenised addict make overt reference to earlier depictions of the *morphinomane* even in the 1930s.

The image that initiates the scope of this book is *La Comtesse Morphine* (Countess Morphine), which the unknown artist Paul-Rave Duthoit created and exhibited at the Exposition des Arts Incohérents in Paris in 1884. The painting's appearance and location are currently unknown, but its title makes its subject matter unmistakable. I end the scope of this book with the outbreak of the First World War and the creation of an etching by Alméry Lobel-Riche, *Morphinomane*, which was displayed at the 1914 Salon des Artistes Français. This is another unseen and lost artwork. Beginning and ending with lost artworks draws attention to the fact that, although this book analyses an abundance of previously unexplored images, there are likely many more examples whose whereabouts remain unknown. Many of

the images discussed here are explicit in their representations of drug administration whilst others, at least to a modern-day viewer, appear initially to offer no explicit indications of morphine use except for their title. Some of the artists remain anonymous and worked under pseudonyms; others, well known at the time, have since been disregarded, such as Moreau de Tours and the Spanish artist Hermenegildo Anglada-Camarasa, who made his home in Paris. Some of the works discussed here are by artists with a lasting legacy, such as Pablo Picasso, who moved to Paris as a young adult and exhibited *Morphinomane* at his first major exhibition, or the celebrated Swiss-French printmaker Théophile Steinlen, who had a successful career working in Montmartre.

Morphinomanie was exaggerated and sensationalised in all artistic forms. These images exist in different styles and media – caricature, naturalist painting, lithography, modernist impasto, medical visual culture – and were shown in a range of locations, from large-scale salon exhibitions and avant-garde galleries to newspaper front pages and novels, as well as in hospital museums and medical books. This visual culture was displayed in diverse contexts and functioned in different ways. I give preference to the term 'visual culture' in order to encompass the types of objects analysed here, because *morphinomanie* traversed artistic categories – not only the supposedly disparate categories of traditional and modernist art, but also the medical and the artistic. I turn to Vanessa Schwartz's understanding of visual culture as the examination of any objects 'not for their aesthetic value per se but for their meaning as modes of making images and defining visual experience in particular historical contexts'.[59] With this definition in mind, we may treat the *morphinomane* images considered throughout this book as objects created with the intention of being looked at, whether inside or outside institutionalised art spaces.

I have chosen and organised the artists and artworks here in such a way that they present a cross-section of *morphinomane* visual culture.[60] My intention is to develop an increasingly broad and complex picture of the way these images operated in society. Containing representations of the *morphinomane* within specific geographic and temporal boundaries allows for an in-depth synthesis of the artistic working conditions and the socio-political climate of the time. By understanding the conditions behind these artworks, and thus their function and reception, we can rethink the perception of *morphinomanie* in terms of its gender bias and the far-reaching impact of art during this period. Aside from formal and material differences, interpretation and meaning may be transferred across *morphinomane* visual culture. As such, this exploration of that culture is less concerned with *who* created

these works or *how* they were created (although, at times, these are necessary aspects to consider) than with *why*: why did the *morphinomane* need to be visualised? How does its visualisation function and what more can it tell us about historical perceptions of drug use(rs)?

The visual culture of *morphinomanie* is central to this book. But we must also consider the objects' functions and wider contexts in artistic, medical, and popular spheres. The visual and the textual are often discussed as separate entities, but in this book I show how they interlock and overlap. *Morphinomane* artworks are a key facet in the kaleidoscopic crossing of textual (mis)information on *morphinomanie*. By employing Roland Barthes's concept of intertextuality, I consider the important interrelationship between images of *morphinomanie* and its portrayal in writing (novels, newspaper articles from across the political spectrum, art criticism, medical theses).[61] The research for this book is based predominantly on published primary sources – from medical books, theses, scientific case studies, and newspapers to exhibition catalogues, art magazines, and novels – in order to better understand what information was relayed to the public and by what means. At some points, the artworks are informed by primary textual information; at other times, textual information is influenced by the visual. The ready availability of these texts to a significant proportion of the French population was crucial. The book is underpinned by the recognisability of the *morphinomane* and its extensive representation in texts read and images seen by large numbers of people.

Chapter Overview

This book is constructed so as to demonstrate how the visualisation of the *morphinomane* can be understood through the categories of medicine, art, and femininity. Each of the seven chapters looks at this question through a different but allied lens. The first chapter approaches the interrelationship between art and medicine by examining one key painting. As the chapters progress, still linked by the interlocking themes of medicine, femininity, and art, additional artworks are introduced when and where necessary to illustrate key arguments regarding femininity and the medicalisation of society. The final three chapters discuss the visualisation of morphine use(rs) as a whole and its broader impact on the medical world, the art world, and women's experiences. Hence, as the chapters advance and the focus broadens, the book shows how the visual culture of the *morphinomane* evolved from art into the wider society. This development is symptomatic of the way artworks

operate within their wider socio-cultural and political context, in general, as well as the way the visualisation of addiction through the body of the morphine addict had an impact beyond its direct artistic output.

The first chapter focuses on Moreau de Tours's *La Morphine*, an image that is often used without context in scholarship discussing nineteenth-century morphine use. The chapter reframes the painting as an intertextual conglomerate of information on *morphinomanie*; a fusion of sensationalist journalism, artistic licence, and medical knowledge – the latter of which enhanced the painting's credibility. The unrivalled attention accorded this painting in its critical reception demonstrates why *La Morphine* should be understood as a particularly impactful work. As such, I argue, this painting set a precedent for the visual construction and perception of *morphinomanie* and its representation in visual culture beyond the medical.

The primary way in which morphine addiction could be 'diagnosed' was through evidence of hypodermic injection. The skin of the morphine user as portrayed in medical visual culture is scarred and damaged by repeated needle use.[62] Just as physicians looked for corporeal signifiers of habitual morphine use in their patients, viewers of *morphinomane* artworks looked for repeated tropes that, in the absence of explicit signs, could aid in identifying – or diagnosing – figures as *morphinomanes*. The second chapter explores the recurring tropes used by artists, as described in Zévaco's review of Guilbert's performance of 'La Morphinée' that opened this introduction. Through these tropes, artists addressed contemporary anxieties about the transformation of women's identities. An art-historical analysis reveals the origins of these tropes in medical sources on *morphinomanie* and artistic images of deviant women, hence demonstrating a crucial interaction between art, medicine, and femininity.

One of the most obvious tropes across *morphinomane* imagery is the hyper-representation of femininity. Chapter 3 explores how artists feminised morphine, its users, and its paraphernalia. The chapter shows that two key concepts contributed to the feminisation of morphine: the association between morphine addiction and fashion, and the representation of *morphinomanie* as a neurotic and contagious disease. Following on from the *morphinomane*'s feminisation, chapter 4 notes the lack of male figures in these artworks, investigating the impact of their absence and how it may be considered a rare criticism of the fin-de-siècle physician. Whilst these two chapters analyse how the *morphinomane* was feminised and de-masculinised, chapter 5 considers the reasons that morphine use was gendered through analysis of the specific socio-historical context of these

images. How did contemporary constructions of wayward femininity, such as the *femme nouvelle*, influence and take influence from artists' portrayals of the *morphinomane*?

The final two chapters analyse how journalists, authors, medical writers, and artists used the figure of the *morphinomane* strategically to garner attention and increase sales. Chapter 6 investigates how sensationalised images of morphine users were printed in newspapers to increase sales, drawing comparisons between journalistic methods and techniques employed by artists. The final chapter shows why the *morphinomane* functioned as a convenient figure to use in art: it was shocking, modern, dangerous, pleasure-seeking, and feminine, and it could be easily sexualised. Foreign artists who moved to Paris used the *morphinomane* to boost their emerging careers, drawing attention to new artistic styles via the attention-grabbing subject matter of the morphine addict.

These final two chapters specifically – but indeed, the contents of the entire book – focus primarily on the way these images were used, perceived, and manipulated, rather than on the truth about habitual morphine use in fin-de-siècle France. *Art, Medicine, and Femininity* offers the first substantial and comprehensive analysis of *morphinomane* artworks, bringing together a wide range of representations that have for the most part been previously unknown. The breadth of the *morphinomane* image-type – its familiarity, its international recognisability, its appearance in all media and locations – encapsulates the importance and usefulness of analysing this visual culture and its impact on issues beyond *morphinomanie*. The visual culture of the morphine addict was instrumental to the construction of *morphinomanie* as a social phenomenon, underpinned by the three interrelated spheres of art, medicine, and femininity.

1

Setting the Precedent

Of the thousands of artworks exhibited each year in Paris at the Salon des Artistes Français, only a fraction garnered significant attention in newspaper and journal reviews; the 'majority of them pass unnoticed', one writer stated in 1883.[1] The artworks displayed at the Salon were chosen by jury, but it was often the subsequent critical reviews that shaped their public reception. Art writers could incite an artist's celebrity or notoriety by writing about new artistic techniques or subject matter. The 5,416 artworks on display at the 1886 Paris Salon would have been viewed by the hundreds of thousands of visitors who walked through the doors of the Palais des Champs-Élysées over a four-week period.[2] The majority of those visitors probably attended after midday on Sundays when no entrance fee was charged.[3] One painting that received noteworthy attention that year was *La Morphine* (Plate 1), an almost life-size oil on canvas by French artist Georges Moreau de Tours. Reviewers wrote about *La Morphine* in abundance because of its unique subject matter; on the international stage of the Paris Salon, an artist had for the first time painted the hypodermic administration of morphine.

Two female figures play out the narrative of *La Morphine*. Fashionably striped curtains fill the background of the painting, but a gap in the drapery reveals the recognisable apartment architecture of Georges-Eugène Haussmann's reconstructed Paris. A stone balustrade cuts across the composition, intercepting the curtains and leaving the two figures in a liminal space that is neither outside nor inside. The inclusion of a small table and chaise longue on this indistinct balcony adds to the ambiguity of the setting. The reclining figure, whose body follows the shape of the chaise longue, has closed eyes and holds an empty syringe case, implying the recent administration of morphine. The standing figure, in contrast, holds to its arm a syringe, presumably taken from the empty box. This figure looks directly out at the viewer, ready to inject morphine into the upper arm. In accordance with their

surroundings, both figures are dressed in fashionable French clothing of the 1880s. Several books can be seen under the small table on the right-hand side, including Charles Baudelaire's infamous book about the effects of opiates, *Les Paradis artificiels*, first published in 1860. On top of the table is another syringe case, with a syringe and a large bottle of morphine. The bottle's depleted state suggests this is not the first time it has been used. The table also holds a paper bag overflowing with what appears to be *rahat-loukoum* (Turkish delight).[4] Its inclusion in *La Morphine* is undoubtedly a comment on decadent consumption and indulgence, but it is also a rare indication of the orientalised narratives that framed the nineteenth-century opium trade.

Although Moreau de Tours has since been largely forgotten in art history, *La Morphine* became an impactful painting following its exhibition in 1886. The work's recognisability stemmed from the sheer number of critical reviews that discussed the painting specifically in French newspapers and journals that year, as well as from the numerous mechanical reprints of the oil on canvas that appeared in various formats in the following three decades. *La Morphine* also earned international and long-lasting renown through discussions of it in American, British, and Irish newspapers during the 1886 Salon and in the several months after the event. Reference to Moreau de Tours's 1886 canvas was made the following year in reviews of the 1887 Paris Salon, and it was reproduced in the 1887 illustrated edition of *La France juive*, the influential anti-Semitic two-volume book by Édouard Drumont, a prominent anti-Semite.[5] Drumont constructed a connection between morphine use and Judaism; in a critique analogous to contemporary narratives of morphine-addicted wives introducing morphine to their husbands, he contended that wealthy Parisian Jews were corrupting French Christians.[6] On 21 February 1891, *Le Petit Journal supplément illustré*, the weekly illustrated supplement of France's predominant daily newspaper, reproduced an almost full-page lithograph of Moreau de Tours's *La Morphine* to accompany a short column on concerns about *morphinomanie*. Continuing its exposure further afield, the canvas of *La Morphine* was transported from Paris to Chicago to be shown at the huge and influential World's Fair of 1893 and was reprinted in follow-up publications. And over three decades after the painting's Salon debut, a photograph of *La Morphine* was included in *Album Gonnon: Iconographie médicale*, an illustrated medical text aimed at the general public. Even though the book discussed how different diseases and ailments had been illustrated over the previous thirteen years, the chapter on morphine disregarded the large number of artworks depicting morphine use that had been created during that time and used Moreau de Tours's earlier canvas to illustrate the text.

La Morphine was the earliest significant representation of morphine use in artistic visual culture. Benefited by the display at the Paris Salon, Moreau de Tours's work set a precedent for subsequent visualisations of morphine use(rs). *La Morphine* remained the most impactful visual portrayal of morphine users created during the period of *morphinomanie*'s greatest visibility in France, between 1886 and the start of the First World War. A perusal of the reviews that discussed *La Morphine* when it was first exhibited makes clear how and why this painting influenced society's perception of addiction and set a precedent for the visualisation of addiction.

This chapter explores the painting's far-reaching impact through three significant and related factors. First, Moreau de Tours used strategic techniques to encourage the conspicuous display of the painting. Second, the artist employed visual and textual references to the medical sector which were exaggerated in critical reviews and ultimately attributed a medical authority to *La Morphine*. Third, the ambiguity of the painting's narrative left room for critics to attribute their own interpretations to the painting, echoing the flurry of mixed messages about morphine addiction that circulated in contemporary discourse.

Strategic Impact

Some newspapers had been publishing short news reports on morphine use since the 1860s, but the mid-1880s marked a turning point for public awareness. Validation from medical professionals, whose opinions were now being repeated in the popular press, increased the exposure of *morphinomanie* beyond the medical sector. Moreau de Tours responded to that heightened visibility of the theme with a painting that would be readily available in the public sphere. As part of the growing discourse on *morphinomanie* that was emanating from the scholarly confines of medical journals, *La Morphine*'s impact extended well beyond the image-laden walls of the Salon.

The opening up of the art world at the end of the 1870s led to its expansion and diversification. It became more difficult in many ways for artists to attract critical attention in the crowded market. In addition, during the 1870s, there had been a huge increase in the number of works shown at the Salon: the number of submissions rose from around two thousand in 1872 to almost six thousand in 1879. After being under official state sponsorship for more than two centuries, the event was handed over in 1880 to the Société des Artistes Français, which exhibited annually from 1881 onwards.[7] Coinciding with the emergence of new and modernised salons, the prestige of the official Salon gradually decreased, and by the turn of the century it

was deemed by many to have lost relevance. But this chapter is concerned with the 1880s, a period when the Salon was still a dominant art exhibition in Paris and for the most part respected in the international art world.

The huge number of artworks displayed, crammed floor to ceiling, was one of the factors that contributed to the decline of the Paris Salon. During the 1880s, around five thousand artworks were exhibited each year. For artists to have a chance of success, whether economic or reputational, they needed to stand out among the thousands of other entries. Submitting something unpredicted or original for exhibition may have been a tactical choice. Novelty could risk infamy, but it could also call significant attention in critical reviews. The latter was certainly the case with *La Morphine*, and writers focused their reviews predominantly on the painting's unexpected subject matter.

The strategic techniques that Moreau de Tours implemented in the creation and display of *La Morphine* generated an enduring attention around the painting and, for a time, around the artist too. Many reviews of *La Morphine* also mentioned the artist's other painting displayed at the same Salon: the well-received *La Mort de Pichegru*, a history painting depicting the death in 1804 of the French revolutionary general Jean-Charles Pichegru. By 1886 Moreau de Tours was known as a successful professional artist. He first trained under Gustave Louis Marquerie, and from 1870 studied at the École des Beaux-Arts under the celebrated Alexandre Cabanel, a favourite of Napoleon III. Moreau de Tours had success at the Salon of 1873 and would go on to show at least one painting per Salon until 1897. In 1879, he received a prestigious second-class medal for two history paintings. With thousands of works on display, however, even established artists could not be sure that critics would mention their Salon entries by name, let alone praise them. How many would have reviewed Moreau de Tours's *La Mort de Pichegru* had it not been for the attention created by *La Morphine*?

A little-known artwork referencing morphine had been exhibited in Paris two years prior to *La Morphine*. The 1884 work, *La Comtesse Morphine*, was created by an artist known as Paul-Rave Duthoit. It was displayed at an early exhibition of Les Arts Incohérents, a nonsensical and satirical art movement active in the 1880s and early 1890s. Despite the considerable crowds at the 1884 Salon des Arts Incohérents (the exhibition of 1883 had attracted over twenty thousand visitors), *La Comtesse Morphine* attracted no attention in critical reviews [8] In fact, specific artists and artworks were rarely ever mentioned in any Les Arts Incohérents exhibition reviews, in part because many of the artists involved were not professionals. Besides, morphine-related

subject matter would perhaps not have stood out in an exhibition full of unintelligible, unpredictable, and controversial art.

Moreau de Tours's image of drug use, on the other hand, was not only unexpected within its display setting but it was also unexpected within the artist's oeuvre. His earlier paintings, which had been positively received, had until 1886 only featured traditional Salon subjects: portraits, modern life genre scenes, and mythological or historical narratives such as *La Mort de Pichegru*. *La Morphine* represented a new line of enquiry for the artist. In addition, the shape and size of the canvas Moreau de Tours used for *La Morphine* (160 by 220 centimetres) were usually reserved for prestigious history paintings showing complex or numerous mini-narratives in compositions of multiple figures. Whilst the size of Moreau de Tours's painting was by no means unique, its comparatively simple composition and the almost life-size stature of the figures would have added to the painting's visibility on the crowded walls.

Beyond subject matter, canvas size, and scale, artists also sought artwork visibility through listings in the Salon exhibition catalogue, the *Salon livret*.[9] The *Salon livret* provided each artist's name, address, and tutor, alongside the title of their displayed work(s). From the mid-nineteenth century, a minority of artists, including Moreau de Tours, submitted captions for the *Salon livret* along with their artworks. Captions gave artists additional space on the catalogue page. The rapid surge in Salon submissions in the late 1870s thus coincided with an increase in artists using captions. Including captions for *La Mort de Pichegru* and *La Morphine* in the 1886 *Salon livret* made Moreau de Tours's catalogue entry substantially longer than those of most of the other artworks without captions, thereby drawing attention to the painting by means other than its physical properties.

Captions in the *Salon livret* were often excerpts from literature or mythology that served as educational explanations of the artwork's subject matter. By providing such additional information, artists attributed a superiority to their works by acknowledging their historical or literary context as well as their wider potential impact. In the case of *La Morphine*, the accompanying *Salon livret* caption was taken from a medical text and stated some of the effects of morphine use. Moralising artworks that warned against vices have existed throughout Western art history but, as some commentators at the time noted, Moreau de Tours's approach to this moralising tendency in *La Morphine* was surprisingly ambiguous. Francis Enne, regular art critic for the republican daily newspaper *Le Radical*, for instance, argued that since the painting 'must have aroused curiosity [and] tempted the senses',

it was decidedly pro-morphine.[10] Moreau de Tours did not present a picture of suffering addicts; nor did he provide a caption that functioned as a warning against habitual morphine use. Although he painted against the backdrop of increasing anxiety about *morphinomanie*, decadence, and degeneration, the artist did not act out of concern for public welfare.

Salon art of the 1880s was often didactic, anecdotal, and moralistic, perhaps signalling a shift in the audience's expectation of how the role of art should be defined within its wider societal context. The caption for *La Morphine*, in combination with its outward-looking figure, involves the viewer in the painting's scenario and opens up a debate about *morphinomanie*. The figure who is about to inject looks out at the audience. The viewer, having acquired knowledge about morphine from the caption in the *Salon livret*, can be included in the decision-making process: should the figure inject itself with morphine? By involving the audience in this dialogue, the painting commands attention; it evokes a response to a contemporary societal issue within a painting of modern life.

The dominant artistic style at the Salon in the early Third Republic, as seen in *La Morphine*, was naturalism.[11] Salon painting was still generally rooted in the compositional and stylistic conventions of the traditional École des Beaux-Arts. But for artists working both within and outside of academic painting conventions, a trend towards depicting scenes of modern life was gaining popularity. Artworks showing scenes of modern life are most often associated with art circles such as Impressionism, which, primarily because of the Impressionists' opposition to academic art conventions, had limited success at the Paris Salon. Although paintings of modern life could be found at the Salon from the mid-nineteenth century, only in the 1880s did a considerable number of Salon artists begin to prefer depicting scenes of modern life over religious or historical narratives, which had traditionally been the most significant categories. The eighth and final Impressionist exhibition, held in May 1886, was timed to coincide with the competing Paris Salon, thereby further emphasising the diminishing relevance of the Salon in France's diversified and changing art market. For artists like Moreau de Tours who were still exhibiting at the Salon in the 1880s, depicting modern life in that venue was perhaps an attempt to reinforce the Salon's relevance by aligning their subject matter with so-called avant-garde art groups.

La Morphine depicts not only a scene of modernity but one of newsworthy significance. Enne remarked on Moreau de Tours's choice of a modern scene, as did the critic Albert Wolff in his review for *Figaro-Salon*.[12] Guy de Maupassant's four-part review in *Le XIXe siècle* where he categorised

some of the noteworthy 1886 Salon entries placed *La Morphine* in the '*fait divers* paintings' group.[13] The *faits divers* was a popular section in French nineteenth-century newspapers – columns comprising very short reports on sensational, dramatic, or tragic events involving ordinary people. Other paintings included as *faits divers* by Maupassant were Louis Henri Deschamps's artwork of a woman holding a rabbit (*Folle*, 1886), Luigi Loir's painting of a train going through Paris (*Cherchez le train*, 1886) and Jean-Léon Gérôme's *Œdipe* of 1886, better known as *Napoleon before the Sphinx*. Maupassant's link between *La Morphine* and newspapers underscores the topicality of the artist's subject matter, whilst placing *La Morphine* firmly within the supposedly factual discourse of news reporting.

Maupassant was likely aware of the sensationalist tendencies of the *faits divers* in his use of the term for the Salon review. Nineteenth-century newspaper editors acknowledged the profitability of these reports and used melodramatic vocabulary and illustrations to describe events.[14] Parisian newspapers in particular frequently told morphine-related stories and relied on sensationalised headlines about addiction and deaths to boost sales. The British magazine *The Athenaeum*, in its Salon review, criticised specifically the comparable tactics used by Moreau de Tours in 1886: 'It is sad ... to find a man of his standing out-Heroding Herod in a sensational subject. He need not condescend to the tricks of younger artists who are bound to make themselves known at any cost ... [*La Morphine*] is one of the most outrageous examples of error by an excellent artist whose reputation is secure.'[15] The writer then devotes a substantial portion of the review to describing *La Morphine*, successfully giving the artist the attention he likely sought.

The fact that the subject matter of *La Morphine* – women self-injecting with morphine – could be found in contemporary newspapers, situated the painting precisely within this discourse. Salon reviews of *La Morphine* appeared in the same papers that published extensively on *morphinomanie*, whether in the form of serialised novels, *faits divers*, obituaries, medical articles, or front-page columns. The strategic impact of *La Morphine*, and the subsequent attention paid to Moreau de Tours's painting, typifies the interrelationship between diverse types of texts on *morphinomanie*; their origin – what Roland Barthes refers to as the 'anonymous formulae' – can 'scarcely ever be located'.[16] The abundance of reviews that discussed *La Morphine* contributed to the continual recirculation of the representation of morphine use, propagating the intertextuality of *morphinomanie* through the painting's reviews and continuing to blur the constructed boundaries between fact and fiction, art and medicine.

A 'Medical Painting'?

Alexandre Georget, art critic for the daily conservative newspaper *L'Écho de Paris*, labelled Moreau de Tours's *La Morphine* a 'medical painting', as did Wolff in his review for *Le Figaro*.[17] In *Le Radical*, Enne called it a 'scientific explanation'.[18] Maupassant declared that the work was intended as an illustration 'for the scholarly work of doctors'.[19] Armand d'Epirey, writing for *Officiel-Artiste*, stated that Moreau de Tours had 'studied the causes and effects' of morphine, implying that the artist had sketched from life two women injecting themselves with morphine – a highly improbable conclusion for an artist who likely worked with paid models.[20] In addition to the painting's naturalism, the perceived medicalisation of *La Morphine* lent authority to Moreau de Tours's depiction of habitual morphine use; if the painting was perceived as medical, it was therefore also deemed to be credible.

Moreau de Tours's father, Jacques-Joseph Moreau (de Tours), and his brother, Paul Moreau (de Tours), were both medical professionals specialising in psychiatry. Of particular relevance to the medicalisation of *La Morphine* is the celebrated career of the artist's father. One of Jacques-Joseph's former students was Benjamin Ball, who researched and wrote one of the first comprehensive medical books on morphine dependency, *La Morphinomanie*, published in 1885. Jacques-Joseph investigated the effects of drugs on the central nervous system and focused mainly on hashish and its potential use in psychiatry. In 1845 Jacques-Joseph published *Du Hachisch et de l'aliénation mentale*, probably the first Western medical text on the consumption of drugs and their effects.[21] Jacques-Joseph had also been a member of the infamous Club des Hachichins, a Parisian group that partook in drug taking and experimentations. The group existed from around 1844 to 1849 and included well-known literati such as Alexandre Dumas *père* and Victor Hugo.

Upon Jacques-Joseph's death in 1884, less than two years prior to the exhibition of *La Morphine*, the French public were reminded of the artist's familial medical connections. Detailed obituaries emphasised Jacques-Joseph's achievements in the understanding of drugs and profiled his two sons' careers. It was convention to include artists' addresses in the *Salon livret* and, from the year following his father's death, Moreau de Tours's address was 51 rue Claude Bernard (named after the celebrated physician Claude Bernard, who had died in 1878). This address was in an area of Paris renowned for its medical facilities and hospitals, including Salpêtrière hospital, where Jacques-Joseph had worked. It is likely that by early 1885 Moreau de Tours had moved into what had been his father's house.

FIGURE 1.1 | Lucien Laurent-Gsell, *La Vaccine de la rage*, 1887, oil on canvas, 250 × 290 cm, University of Strasbourg, Strasbourg. Lithograph by F. Pirodon after Laurent-Gsell, c.1887–89.

In the Paris Salon of 1875 Moreau de Tours had exhibited his *Portrait du docteur Moreau de Tours*. This portrait of his father was more than just a celebration of the doctor's career; it was part of a growing trend that saw artists create images relating to science and medicine. This seemingly new genre was indicative of a wider medicalisation in society, which included the publication of detailed scientific and medical articles in non-specialist journals. Scientific artworks mostly showed medical innovations and demonstrations or portraits of medical professionals from recent history and the contemporary medical world.[22] Whilst some artists focused on breakthroughs and discoveries, others depicted more generic medical themes. The contemporaneity of *morphinomanie* and its connection to the medical sector, in addition to its representation of the relatively new invention (around 1853) of the hypodermic syringe, place it almost by default in this medical genre of the 1880s, despite there being no overt reference to the medical sector in the painting.

FIGURE 1.2 | Georges Moreau de Tours, *Les Fascinés de la Charité*, 1890, oil on canvas, 125.8 × 158.7 cm, Musée des Beaux-Arts de Reims, Reims.

Although medical paintings of the 1880s are by no means accurate representations of medical events, their scientific themes alone granted them credibility. The composition of Lucien Laurent-Gsell's *Le Vaccin de la rage* of 1887 (Fig. 1.1), for instance, presents the viewer with an open scene in which all the figures can be clearly seen. Overseen by Louis Pasteur, standing, a doctor holds a rabies vaccination ready to innoculate the child, who is the focus of the canvas. The child is held out towards the viewer rather than towards the doctor, who is seated slightly behind. The composition is demonstrative in that it shows the viewer how the vaccination process may look, rather than presenting a specific narrative; there is a lack of connection between the figures and the medical action. In a manner reminiscent of this painting by Laurent-Gsell, the standing figure in *La Morphine* also looks out towards the viewer, instead of at the hypodermic syringe held to its arm. The scenario might otherwise have been shrouded in secrecy and could have been depicted voyeuristically, but the figures in *La Morphine* face the viewer in an open, demonstrative composition. Four years later, Moreau de Tours returned to a similar composition for *Les Fascinés de la Charité* (Fig. 1.2), in which psychiatric patients are positioned in an arc, including the viewer,

with hypnotist Jules Bernard Luys (the grey-haired figure wearing black) positioned behind the patients. This was Moreau de Tours's only other attempt at a painting with a modern, medical narrative, and it was for the most part disregarded in Salon commentary when it was exhibited in 1890.

La Morphine verges on the diagrammatic. The outstretched arm of the figure that holds a syringe to its upper arm extends diagonally across the composition, leading the viewer's eye to the reclining figure, who is evidently in a state of post-morphine administration. The syringe on the small table is positioned carefully in its case despite the implied recent use by the reclining figure. The painting's medicalisation is emphasised further by Moreau de Tours's use of contrasts and the compositional bisection created by the gap in the curtains. The figures' contrasting poses – standing up and reclining – form part of a wider set of oppositions in the painting: awake and asleep, dressed for public and dressed for private, alert and unaware, neat and messy, pre-morphine and post-morphine. Medical case studies and medical visual culture have a long history of before-and-after images. Such images usually function to show a patient's deteriorating state (as suggested in *La Morphine*) or a recovery from illness. In the case of ailments and diseases for which colour and depth had diagnostic significance, nineteenth-century medical professionals opted to capture dermatological details of deterioration or healing in wax, watercolour, or oil on canvas.[23]

For medical professionals who were most concerned with indicating general shapes, taxonomy, and improvement or deterioration in a patient's demeanour, photography was the preferred medium. The 1890s saw photography being used for the first time to capture before-and-after narratives of drug users, as seen in an 1897 pamphlet by the American doctor Leslie E. Keeley, who showed photographs of a young boy 'cured' from an opium addiction.[24] Where Keeley used photography to capture a narrative centring on a patient's improved demeanour, before-and-after photographs representing the deterioration of drug users also became popular in the twentieth century and in the 1940s were used by institutions such as the Federal Bureau of Narcotics. Timothy Hickman argues that this narrative of 'wasting away' was seen in photography throughout the twentieth century and functioned to 'make narcotic addiction visible'.[25] But six decades earlier in *La Morphine*, Moreau de Tours recounts the same narrative through the medium of oil paint.

For his *Salon livret* caption, Moreau de Tours used an excerpt from Désiré-Magloire Bourneville and Paul Bricon's *Manuel des injections sous-cutanées,* a medical text from 1883.[26] Bourneville was a neurologist who worked both at the Salpêtrière and at the Saint-Louis hospital, among other

well-known institutions, and carried out a variety of studies on morphine use which appeared in books on *morphinomanie*.[27] Bricon worked under Bourneville and wrote mostly on autopsies for the journal *Progrès médical*. The excerpt used by Moreau de Tours for *La Morphine* names the two doctors and reads: 'In small doses and even in fairly high doses, the period of prostration is preceded by a period of excitement, very short; if the dosage is high: insomnia, agitation, hallucinations.'[28] Enne stated in his review that the painting's caption resembled the warning labels that pharmacists would insert into jars of pills or bottles of morphine, thereby implying that the caption contributed to a perception of *La Morphine* as a medical painting and enhanced its legitimacy.[29] Although the quotation lists several effects of morphine use, Moreau de Tours only demonstrates prostration in the painting. The fact that the chosen quotation does little to explain the painting's narrative indicates that Moreau de Tours sought a caption for the painting after its creation.

Bourneville and Bricon's *Manuel des injections sous-cutanées* is not specifically about morphine use. It is perhaps an unusual source text, considering that the mid-1880s saw the publication of several influential studies on that drug. Most of these books included the history of morphine and its uses, as well as debates around addiction, such as *La Morphinomanie* by Ball, Jacques-Joseph's student. *Manuel des injections sous-cutanées* was a specialist medical text. It likely existed in Jacques-Joseph's collection and would have been inherited by Moreau de Tours, along with the apartment on rue Claude Bernard, after his father's death. Given the simple alphabetical navigation of topics in *Manuel des injections sous-cutanées*, it would have been easy to find a quotation under 'Morphine' to accompany the already completed painting. The fact that the quotation is taken from a seemingly insignificant footnote in a section on morphine suggests that the artist was searching for something specific to complement his painting.

In *La Morphine*, the figure who lies back in a drug-enhanced sleep scarcely acts as a deterrent for morphine use. Whilst prostration may be an effect of morphine use, and was the only side effect suggested in the painting, it is disguised by the commonly used trope of reclining female figures in Western art history, first popularised in the Renaissance. Although the accompanying caption mentions a couple of unpleasant side effects of morphine, comparison with the original text reveals that Moreau de Tours includes only the first half of the sentence from the footnote in *Manuel*. The latter half of the sentence speaks of the serious implications of morphine use: raised blood pressure, heightened temperature, and an accelerated heart rate.[30] There was no practical reason for this part of the quotation to be omitted from the

BRAS D'UNE MORPHINOMANE.
D'après nature.

FIGURE 1.3 | 'Bras d'une morphinomane', interior illustration, Paul Regnard, *Les Maladies épidémiques de l'esprit: Sorcellerie, magnétisme, morphinisme, délire des grandeurs* (Paris: E. Plon, Nourrit et Cie, 1887), 323.

Salon livret; some artists had longer captions for their works. As such, the artist's manipulation of the original text emphasises his unwillingness to depict, or at least to imply, the more dangerous side effects of morphine use. Moreau de Tours's avoidance of explicit representation of the psychological and physical effects of morphine on the body meant that he felt it was necessary to exclude them from the accompanying caption in order to enhance the painting's contrived authenticity.

The physical effects of habitual morphine use are in reality often non-existent, but the scarred skin from the repeated injection of hypodermic syringes became a recognisable identifying trope of the morphine addict. There is 'no *morphinomane* who does not have at least half a dozen broken needles under their skin', wrote the pseudonymous Tout-Paris in 1892.[31] This can be seen in a sketch in an 1887 text, *Les Maladies épidémiques de l'esprit*, by Paul Regnard (Fig. 1.3).[32] The book's status as a medical text allows a supposedly accurate portrayal of skin, albeit exaggerated through the image's monochromatism. In addition, it permits a disregard for the academic art conventions that governed the portrayal of the body in contemporary Salon art. For Moreau de Tours's painting to be acceptable to the Salon jury, it was crucial that the female body be transformed from life, yet the artist evidently sought a balance between authenticity and acceptability. Moreau de Tours here uses a strategic composition to overcome potential issues of credibility. The figure that shows bare skin – thus revealing the arm that

would potentially be scarred – is implied to be a new user of morphine who would therefore have no scars.[33] In contrast, the body of the reclining post-morphine figure, with the large bottle of the drug suggesting habitual use, is covered by clothing. By sanitising any serious or unpleasant side effects, Moreau de Tours was able to create a composition palatable to the Salon jury and to the public.

Especially because this was the first painting of this potentially controversial subject matter submitted to the Paris Salon, the combination of the caption quoted from *Manuel des injections sous-cutanées* and the sanitisation of the physical side effects of morphine addiction worked to ensure the painting's acceptance by the Salon jury for display in 1886. Despite the orchestrated aspects of the painting's presentation – its demonstrative composition, the manipulation of the catalogue caption, the absence of physiological signs of habitual use – the painting's naturalism and medicalisation validated Moreau de Tours's depiction of *morphinomanie*.

The medical sector itself, however, provided no validation for Moreau de Tours's *La Morphine*. Each year *L'Union médicale*, a medical journal founded in 1847 with one of the largest readerships in France, published reviews of the Paris Salon. In the last quarter of the nineteenth century, *L'Union médicale*'s reviews were increasingly dominated by discussions of the growing number of medical paintings in the Salon. The journal's art critic, Claude Suty, had commented previously on Moreau de Tours's portrait of his father in 1875, noting that he had 'nothing but praise' for the painting.[34] In 1886 Suty wrote a lengthy five-part review of the Salon, detailing certain rooms. He gave attention to paintings in Room 17 where *La Morphine* was hung, but disregarded Moreau de Tours's large, unmissable canvas. From Room 17, the critic chose to briefly discuss a painting of the recently deceased physician and politician Étienne Rufz de Lavison. Suty's comment that the painting was 'placed a bit high', 'without a number or visible [artist] name', suggested it was worthy of little critical acclaim.[35] Yet the anonymous portrait of Lavison appears to have been more deserving of Suty's attention than Moreau de Tours's *La Morphine*, despite the large number of reviews on *La Morphine* in generic newspapers that made claims about its medical authenticity.

Why was *La Morphine* deliberately snubbed by *L'Union médicale*? The absence of medical figures from the painting perhaps offers a rudimentary reason for its exclusion from *L'Union médicale*. Nevertheless it should be emphasised that morphine use was inextricably connected to the medical sector by the 1880s, and the hypodermic syringe was a requisite medical instrument. Those with connections to the medical sector were aware of physicians' role in administering morphine as a panacea, and thus of their role in

perpetuating morphine addictions. And by the 1880s there was an increased awareness that morphine use was highest amongst medical professionals.[36] Moreover, in 1883, dermatologist Démétrius Zambaco-Pacha had stated in his newly published book *De la Morphéomanie* that habitual morphine users were 'indoctrinated by the doctor'.[37] Nevertheless, information that definitively implicated doctors in *morphinomanie* – either as prescribers or as users – was not commonly stated in newspapers until the 1890s. The absence of *La Morphine* from *L'Union médicale*'s Salon review freed Suty from having to address the role of the medical sector in *morphinomanie*. The medical sector was distancing itself from responsibility for the so-called morphine epidemic. By disregarding the medical sector's role in creating and sustaining addictions to morphine, *L'Union médicale* implicitly placed the onus on the patient; once morphine had been prescribed by a doctor, it was no longer a medical responsibility.

Although newspapers avoided associating doctors with the rise in morphine use during the 1880s, journalists did attribute a significant role to pharmacists. 'Only pharmacists welcome the introduction of *morphinomanie*', claimed an anonymous writer for *Le Gaulois*.[38] It was often reported that pharmacists would sell substantial amounts of morphine without prescriptions. Large bottles of morphine, which could allegedly only be obtained from corrupt pharmacists, were frequently mentioned in newspaper articles about the deaths of habitual morphine users. In *La Morphine*, the presence of a large bottle of morphine, in conjunction with the absence of medical personnel, perhaps serves to absolve physicians from any culpability in *morphinomanie* and contributes to a much broader debate that often situated the doctor as the saviour of the national body and the pharmacist as a corrupt and mercenary accomplice. It perpetuates an alternative narrative of the painting's depiction of morphine use that focuses on deviant women obtaining morphine via illegitimate routes, even though the vast majority of patients in the 1880s were prescribed morphine legitimately.

Interpreting the Interpretations

Moreau de Tours and the reviewers of *La Morphine* were undoubtedly influenced by several types of discourse on morphine addiction, from erotic novels with morphine-addicted fictional protagonists to medical studies that weighed the pros and cons of prescribing and administering morphine. Moreau de Tours's 1886 painting epitomises the conglomeration of information on *morphinomanie*. As a consequence, reviewers gave elements of the painting varying importance and attributed potentially new meanings

to ambiguous aspects of its composition. Reviewers' focus on different aspects of *La Morphine* in turn echoed the ambiguity and complexity of *morphinomanie* during the mid-1880s. A number of details of Moreau de Tours's painting had independent relevance to discussions on *morphinomanie*: the figures' gender, their clothing, references to contagions, the figures' unblemished skin, lesbianism, class, books and reading, notions of artificiality and decadence, and references to the medical sector. These details were variously made pertinent by the painting's reviewers and were re-purposed by other artists in subsequent depictions of morphine addiction.

Moreau de Tours includes images of several books in *La Morphine*; one lies open on the chaise longue and a small pile can be seen in the lower right-hand corner. Several reviewers attributed a significance to these books and indicated their role in the narrative of addiction. Writer and poet Rodolphe Darzens, for example, stated that the painting shows not only the effects of morphine but also the effects of reading Baudelaire, whilst the pseudonymous caricaturist Sahib satirically labelled the depicted books 'honest novels', implying their detrimental impact on the painting's morphine users.[39] These reviews reference contemporary debates on women's reading and associate the pastime with drug addiction. It was believed that reading could have a powerful (negative) influence on women by creating a distance from actuality, which could result in women identifying with fictional characters and imitating their behaviour. Anxieties about novels influencing women were discussed in newspapers throughout the latter half of the nineteenth century. Simultaneously, there emerged an increasing amount of Decadent fiction on morphine addiction, beginning in 1884 with Marcel-Jacques Mallat de Bassilan's *La Comtesse Morphine*. It cannot be a coincidence that the first known exhibited artwork on morphine use, Duthoit's artwork for Les Arts Incohérents, was exhibited the same year as Bassilan's book and shared its title. This novel initiated a growing trend whereby the female addict became what Laura Spagnoli describes as a stock character.[40] It was believed that the (woman) reader would identify with the *morphinomane* protagonists, consequently resorting to morphine addiction and other supposedly associated activities such as extramarital affairs, the abandonment of family obligations, and lesbianism.

Further connections can be drawn between the *morphinomane* and the female reader through their artistic visualisations. Kathryn Brown points out that artworks of female readers show them in a 'passive state', abstracted from reality, with a 'combination of downcast eyes and physical abandon'.[41] Moreau de Tours borrows this established iconography to depict the post-morphine figure in his 1886 canvas. Subsequent artworks of the

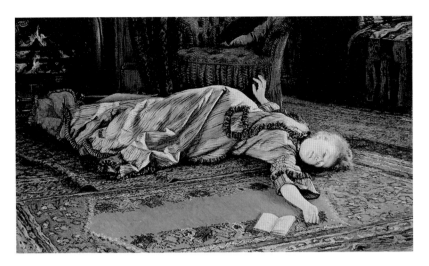

FIGURE 1.4 | James (Jacques) Tissot, *Abandoned*, c.1881–82, oil on panel, 31.7 × 52.1 cm, private collection.

morphinomane similarly reused poses seen in visualisations of the female reader. James (Jacques) Tissot's *Abandoned* (Fig. 1.4), for example, exploits nineteenth-century concerns that novels had the potential to unleash inappropriate desires that could result in a loss of moral consciousness. The body language seen in Tissot's *Abandoned* is reused in an illustration by the Italian Art Nouveau artist Manuel Orazi (Fig. 1.5), who was active in France at the turn of the twentieth century. Orazi was commissioned to create several illustrations for the French writer Victorien du Saussay's 1906 novel *La Morphine*. This particular illustration shows Blanche, the morphine-addicted female protagonist, abandoned, naked, helpless, and unconscious on the floor. Aligning illicit drug use with women's reading has a two-fold impact. First, the *morphinomane*, like the female reader, becomes indicative of what Brown calls 'physical abandon'. Second, through the recycling of this visual iconography, the association created between drug use and reading reinforces the potential dangers of women engaging with books.

Late nineteenth-century social commentators repeatedly alerted their audiences to the dangers of reading. It is no accident that the increase in factual and fictional literature on drug use in the latter half of the nineteenth century coincided with its growing prevalence in visual culture. Even thirty years after the publication of Baudelaire's *Les Paradis artificiels*, an article in an 1890 issue of *Le Gaulois* newspaper claimed the book was still so influential that it could lead men to try morphine.[42] Four years prior to this

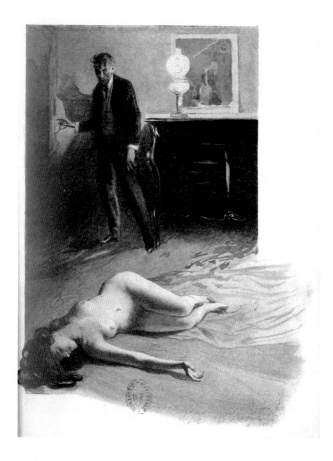

FIGURE 1.5 |
Manuel Orazi,
interior illustration,
Victorien du Saussay,
La Morphine (Paris:
A. Méricant, 1906), 53.

article, Moreau de Tours visualised similar concerns in *La Morphine* by titling the book under the small table *Les Paradis artificiel*[s], with the name of the book's famous author almost legible below the title. *Les Paradis artificiels* was about the effects of opium and hashish on the body and their wider potential implications. The book's influential nature was due to its account of the isolating qualities and benefits of hallucinatory substances. These accounts were no doubt inflated by the fact that *Les Paradis artificiels*, a precursor to the Decadent movement, centred on Baudelaire's own opium use and included lengthy sections of description that were adapted from Thomas de Quincey's autobiographical *Confessions of an Opium Eater* of 1821.

Moreau de Tours's reference to Baudelaire in *La Morphine* also functions to reinforce the artist's familial connections. Baudelaire, like the physician Jacques-Joseph Moreau, was a member of the Club des Hachichins. Jacques-Joseph's membership in that club, a group very much embedded in

the drug culture of the literary and artistic elite, conflated the seemingly separate spheres of bohemian Paris and the expanding world of medicine. By extension, Moreau de Tours's so-called 'medical painting' references Baudelaire's exploration of the influences and effects of drugs, as recounted in *Les Paradis artificiels*. Specifically, the term 'artificial paradise' was found in newspaper columns on morphine use describing the experience of drug consumption, and echoed wider ideas about the artificiality and excess relating to fin-de-siècle decadence.[43]

Only on close inspection of the painting is it possible to read the book's title; a contemporary reviewer would have needed to see the painting up-close in order to obtain this information. Mechanical reproductions were detailed enough to make out the presence of books, but not their titles, so readers who did not visit the Salon had to rely on critics' commentaries. In his review, Darzens stated that the reclining figure in *La Morphine* had been reading Baudelaire, but he did not specify the title.[44] Baudelaire's *Les Fleurs du mal*, published in 1857, was also about drug use and was far more controversial than *Les Paradis artificiels*. Darzens's vague reference to Baudelaire allows for alternative narratives on the part of readers who had not seen the painting, particularly since *fleurs du mal* ('flowers of evil') was a term sometimes signifying poppies in nineteenth-century discussions of opiates.

Baudelaire's *Les Fleurs du mal* was a collection of poems that had acquired immediate notoriety. The first edition of *Les Fleurs du mal* (originally planned to be titled *Les Lesbiennes*) included three texts focused on themes of lesbianism. Baudelaire, whom Max Nordau specifically described as a 'true degenerate', constructs an interrelationship between opiates (*fleurs du mal*) and sexual deviance – a narrative that recurs frequently in art and text at the turn of the twentieth century.[45] In 1903 Spanish artist Hermenegildo Anglada-Camarasa exhibited *Fleurs de Paris* (Flowers of Paris) at the Salon de la Société Nationale des Beaux-Arts, during a lengthy stay in Paris.[46] The painting shows two female figures dressed in white; their extravagant clothing and the painting's night-time setting make evident their status as prostitutes or *demi-mondaines*. Art critic Armand Dayot, in reviewing the painting in *Gil Blas*, gave its title as '*Fleurs de Paris* (read *Fleurs du mal*)'.[47] Dayot's retitling indicates the disreputable figures' drug-induced states, likely caused by the habitual use of an opium derivative such as morphine.

A comparable rendering can be found in René de Schwaeblé's pseudo-factual book *Les Détraquées de Paris* (c.1905), which describes various women's alleged subcultures in Paris, first published between 1903 and 1905 as a series of semi-regular instalments in the literary and illustrated periodical *Le Fin de siècle*. A section of the book is dedicated to 'les morphinomanes',

a group of women who congregate to inject morphine in a *hôtel particu-lier* – a private mansion or townhouse built for the *haute-bourgeoisie*. The women's rejection of men, their practice of injecting morphine in each oth-er's company, and Schwaeblé's insistence that morphine must be injected on body parts not revealed by low-cut dresses or bathing suits imply homosex-uality.[48] This implication echoes late nineteenth-century literary trends to sexualise lesbianism, which was commonly utilised in fictional plots involv-ing morphine use and extramarital affairs. In Jean-Louis Dubut de Laforest's novel *Morphine* (1891), for example, the syringe is repeatedly feminised and becomes the female character's new lover, whilst the protagonist in Catulle Mendès's *Méphistophéla* (1890) is both *morphinomane* and lesbian.[49]

These orchestrated connections between morphine use and lesbianism perhaps explain why, in a review of the 1886 Salon for the literary periodical *Gil Blas*, journalist Henry Fouquier suggested that the reclining figure in *La Morphine* had been reading '*Été à la campagne* or something similar', de-spite there being no evidence of this in the painting.[50] *Un Été à la campagne*, written anonymously but often attributed to Auguste Poulet-Malassis, was first printed in 1868 and is presented as a factual collection of letters be-tween two women who had been having a lesbian affair before they were separated over the summer. The book's preface notes how the letters 'were not intended for publication' and were 'collected by a man of the world', al-though these claims are dubious and the book is likely entirely fictional.[51] Fouquier's reference to *Un Été à la campagne*, described as 'that famous little erotic classic' when it was translated into English in 1901, solidifies his inter-pretation of Moreau de Tours's *La Morphine* as a lesbian affair induced by hedonistic morphine use.[52]

Fouquier's orchestrated review parallels contemporary discussions on the effects of morphine and reaffirms the misperception that the type of people who take drugs are salacious women associated with lesbianism, debauch-ery, and decadence. Moreau de Tours encourages this false association. The post-morphine figure in *La Morphine* is clothed in a *robe d'intérieur*, an un-usual garment to see in a Salon artwork because of its connotations of in-timacy and its association with underclothing. The *robe d'intérieur* was an indoor dress, often worn in wealthier homes, comfortably fitted, and gen-erally worn without a corset. The loose fit of the dress reflects the figure's relaxed morphine-induced state and, by extension, suggests relaxed morals. The combination of a figure in a reclining pose and the wearing of intimate apparel was rarely seen in artworks of the time because of its association with promiscuity and sexual deviance, but its inclusion in a 'medicalised' image of women's morphine use perhaps validates these associations within the public display of the Paris Salon.

Valerie Steele notes that the *robe d'intérieur* was also known as *le tea-gown*.[53] As suggested by its alternative name, this article of clothing was sometimes worn by the host of an at-home tea party, a fashionable social activity for bourgeois and *haut-bourgeois* women. Perhaps the viewer of *La Morphine* is intended to interpret the reclining figure as the fashionable host. But, instead of providing the guest with tea, it is morphine that is on offer. The casually drawn curtains and *le tea-gown* are ambiguous, but their inclusion contributes to a wider concern about women's sociability by suggesting that *morphinomanie* replaced acceptable fashionable activities, such as tea drinking.

The *robe d'intérieur* was consistently popular throughout the last years of the nineteenth century and appeared in books and journals on fashion as style variations became more available.[54] Similarly, the standing figure in Moreau de Tours's canvas is clothed in a dress of the latest fashion, with a large bustle. The bustle had enjoyed a brief reintroduction in 1883, taking an even more exaggerated contour than in its earlier popularity at the beginning of the 1870s.[55] The dark, checked pattern of the skirt could be seen in many contemporary fashion plates in French magazines such as *La Mode illustrée* and *Revue de la mode*. By portraying the figures in *La Morphine* in clothing styles of the day, Moreau de Tours dates the creation of the canvas to the mid-1880s, emphasising the contemporaneity of the painting and, as a result, of *morphinomanie*. The clothing portrayed in *La Morphine* echoes the alleged fashionability of morphine. When Moreau de Tours's *La Morphine* was still on display at the 1886 Salon, Labruyère (pseudonym of Albert Millaud) wrote a front-page article for *Le Figaro* on habitual morphine use, stating that 'morphine [had] become a fashion'.[56] Three years earlier, Zambaco-Pacha noted how he had 'often seen fashionable people with an arsenal of little injecting instruments', and others similarly described the syringes as 'objets d'art', suggesting that morphine paraphernalia had become fashionable accessories.[57]

Through the last two decades of the nineteenth century, it was widely reported in newspapers and journals across the political spectrum that the opera and theatre were popular places for fashionable women to inject morphine (although there is little evidence behind these claims).[58] *La Morphine* is not set at the theatre or the opera, but elements of the composition correspond to a setting of theatricality and artifice, aligning the painting with narratives on *morphinomanie*. The location of *La Morphine*, on a balcony with large dramatic curtains, is reminiscent of the loges at the Palais Garnier, the opulent Paris opera house completed in 1875. This comparison was no doubt enhanced by the interchangeability of the French word 'balcon', which can mean either a platform on the outside of a building or a dress circle at the

theatre.[59] Moreau de Tours's composition emphasises the notion of a theatrical stage performance and thus a degree of artificiality, a concept particularly enhanced by the figures' orchestrated poses, the shallow foreground, and the painting's didactic arrangement.

Balconies such as the one in *La Morphine* were indicative of *haut-bourgeois* status. The balcony setting was also a common feature in fashion plates throughout the 1860s, 1870s, and 1880s and was used to heighten the elite nature of the images. Similarly, sections of stone balustrade, representative of balconies, were used as props in *carte-de-visite* photographs to convey the sitter's wealth and class. Large stone balconies are typically found on first-floor apartments, which were inhabited by the *haute-bourgeoisie* in accordance with apartment hierarchies, or on *hôtels particuliers*. *Hôtels particuliers* could be found in wealthy and fashionable areas of Paris such as rue Saint Philippe du Roule, rue de Miromesnil, or the Champs-Élysées. Unlike the ornate cast-iron railings that were designed during Haussmannisation for smaller balconies and window-guards on Parisian apartment buildings, stone balustrades were not a modern architectural feature.[60]

Large stone balconies such as the one seen in *La Morphine* were restricted after regulations on building projections were introduced in 1823. Despite the change in the law, there were notable exceptions. The *hôtel particulier* of the extremely wealthy courtesan Esther Lachmann, better known as La Païva, was built between 1856 and 1866 and it has large stone balconies similar to those seen in Moreau de Tours's painting. In *La Morphine*, the balcony undoubtedly indicates the figures' wealth, but it also reinforces the idea that this wealth was long-standing or influential; either reminiscent of the *ancien régime* or signalling a dangerous (new) wealth that was seemingly exempt from the new law of 1823, as seen in the construction of Hôtel de la Païva.

In the latter half of the nineteenth century Paris was building an international reputation for its status as an artificial paradise for pleasure-seekers, as advocated by the fresh abundance of guide books aimed at British, American, and French tourists.[61] Benefiting from Haussmann's reconstruction of the French capital, the enjoyment of Paris as a spectacle had become a popular pastime for those living in and visiting the city.[62] For *bourgeois* and *haut-bourgeois* women in particular, viewing the city from the balcony offered an acceptable way to admire it without interacting with the dirt of the streets or encountering any unsuitable experiences and inhabitants. The contradictory concepts of 'the gaze/the touch: desire/contamination' underpin the significance of the balcony, particularly in literature and art: 'from the balcony, one could gaze and not be touched', as Peter Stallybrass and Allon White point out.[63] Yet Moreau de Tours's balcony setting is closed

off from the outside world. The figures are uninterested in experiencing the city from the balcony. The curtains are drawn to give them privacy before they inject morphine. In *La Morphine* Moreau de Tours's pleasure-seekers replace the experience of one decadent, artificial paradise (Paris) with a very different one: morphine.

A Precedent Is Set

La Morphine remained in Moreau de Tours's family until 2018, when it was sold at auction for more than twenty-six times the estimated price.[64] It was never sold during the artist's life, but perhaps sale was never his intention. A photograph taken between 1887 and 1892 shows Moreau de Tours in his studio (Fig. 1.6). The image formed part of a collection of photographs likely taken by Édouard Fiorillo (active in Paris from 1879 to the 1920s) of over seventy artists at their places of work, which probably functioned as souvenirs for visitors to artists' studios.[65] Significantly, the only artwork that can be seen in the photograph of Moreau de Tours's studio is *La Morphine*. Whether that is where the painting had always hung after the Salon or it was placed there specifically for the photograph is not known, but *La Morphine* is seen here prominently like a talisman above the artist at his desk. It is a testament to the work's impact on art and society following its showing at the Paris Salon in 1886.

Although *La Morphine* was probably Moreau de Tours's most uncharacteristic work, it was, paradoxically, one of his most influential. Not only did *La Morphine* create impact in terms of its unexpected subject matter but it also influenced wider debates on *morphinomanie* – whether directly through the profusion of discussions in the press and popular discourse or indirectly through the conspicuous disregard for the painting in *L'Union médicale*. *La Morphine* commanded a unique attention from Salon visitors and reviewers via various strategic techniques employed by the artist. Moreau de Tours's painting influenced discourses on *morphinomanie* in several ways: first, via its status as a Salon painting depicting morphine use for the first time; second, via the painting's medicalisation; and third, via the multitude of interpretations that proliferated in reviews.

Some reviewers used *La Morphine* as a springboard for expressing concerns over the rising number of habitual morphine users in France. Such reviews accorded the painting a newsworthy authority that was no doubt influenced by its medicalisation. The *Salon livret* caption, the increasing number of medical genre paintings, the demonstrative composition, and the artist's familial connections all aided in authenticating this orchestrated

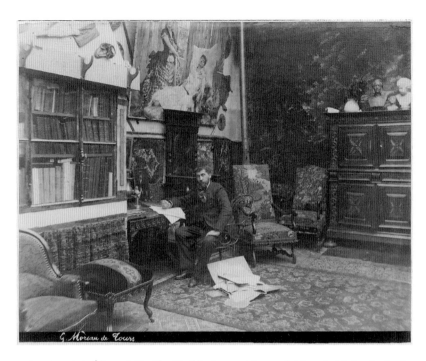

FIGURE 1.6 | Édouard Fiorillo (likely), *Georges Moreau de Tours in his Studio*, Paris, c.1887–92, albumen print, 25.4 × 30.5 cm, Frick Art Reference Library Archives, New York.

depiction of the *morphinomane*. This chapter's approach to repetition and omission in Salon reviews has echoed contemporaneous debates on *morphinomanie*, which often exaggerated some aspects, such as women's morphine use, and disregarded other areas, namely the role of the medical sector.

Whilst the long-standing prestige of the Paris Salon diminished during the 1880s, the medical sector in France gained a new institutional power with the medicalisation of society, a trend that became evident in art, novels, plays, and newspaper articles. Late nineteenth-century newspapers continuously blurred the lines between populist and specialist, fact and hyperbole, in the same way that Moreau de Tours brought together the purportedly divergent worlds of fashion and science, public and private, and medical and artistic. Reviews of Moreau de Tours's 1886 Salon painting are indicative of these blurred boundaries; there was rarely a unified interpretation of the artwork, except that it was deemed to be a credible portrayal. Aided by the painting's critical and artistic impact, *La Morphine* set a precedent for the visualisation of habitual morphine use.

2

Identifying Morphine Users

'Nocturne Élyséen' (Elysian Night), a short story by Paul-Jean Toulet that appeared in Paris's *Revue illustrée* in 1905, tells of two characters strolling around Paris after dusk. The story ends with a description of a woman they pass on the Champs-Élysées who wears a 'bright and flowing dress', and has a 'white face' and 'bright eyes with bruised outlines'.[1] Everard, one of the characters, says she reminds him of the '*morphinomane* that the painter Hermenegilde Anglada depicted'.[2] Everard describes the woman in the painting: 'She's all alone, pale, in a large armchair – and so tired, ah! So tired of smiling. Near her there are red roses, as if heavily made up [*fardées*] by the electric light, and, in the background ... tables, bars, all shining with a harmonious and variegated light.'[3]

Through Everard, Toulet describes a painting created by Catalan artist Hermenegildo Anglada-Camarasa during his time in Paris at the turn of the twentieth century: *Le Jardin-concert* (Plate 2). In 1904 *Le Jardin-concert* was exhibited at the Eduard Schulte Kunstsalon in Berlin and the Salon de la Société Nationale des Beaux-Arts (also known as Salon de Champs-de-Mars), which took place in Paris just a few weeks before the publication of 'Nocturne Élyséen'. In 1905, for its showing at the VI Venice Biennale, *Le Jardin-concert* was renamed *Le Paon blanc* (The White Peacock), which is how it is known today. *Le Paon blanc* is representative of Anglada-Camarasa's flourishing career in France. Having moved to Paris from Barcelona in 1894 to study at the Académie Julian, the Catalan artist was soon using his French base to launch a successful international career leading to exhibitions in numerous countries across Europe, as well as in Russia, Argentina, and America. When Anglada-Camarasa moved to Majorca in 1914, his oeuvre shifted primarily to scenes of Spanish culture, but his success began in the previous decade with depictions of Parisian night-life.

The focus of *Le Paon blanc* is a centrally positioned, illuminated female figure who is staring at something beyond the confines of the canvas. Bars and artificial lighting in the background of the painting denote a *café-concert*

setting, as implied by the painting's original title. Anglada-Camarasa paints the figure with pale skin and heavy makeup: a white face, outlined eyes, black eyebrows, and red lips. The figure wears a fashionable gown with an elaborate headpiece. Surrounded by flowers, the figure is slumped yet tense in a large chair and its arms are bare and outstretched. The artist does not show any morphine paraphernalia and neither of the painting's titles makes any reference to the figure's condition; yet Toulet refers to the figure in *Le Paon blanc* as a *morphinomane*.

The key features in Anglada-Camarasa's painting, as listed by Toulet's protagonist, are the same visual tropes that are used repeatedly in *morphinomane* visual culture. First seen in Georges Moreau de Tours's *La Morphine* of 1886 (Plate 1), the earliest and arguably most impactful depiction of morphine users, these tropes were employed by artists through to the second decade of the twentieth century. While medical professionals relied on the skin 'as a canvas for physical stigmata signifying addiction', artists adhered to artistic conventions.[4] Evidence of needle-scarring on the skin, caused by repeated hypodermic administration of morphine, was the primary way for medical professionals to 'diagnose' *morphinomanie*.[5] Medical visual culture of the *morphinomane*, such as the pedagogical wax models created for the Saint-Louis hospital in Paris, show the skin's surface as scarred and broken.[6] Artists working in traditional art media, however, continued to portray the skin of their *morphinomane* figures as unscarred, unblemished, and smooth, as it has ordinarily been represented throughout art history. Artists were therefore limited in the ways in which they could indicate that these figures should be understood as morphine addicts. They required a new visual language. In answer to that need, the morphine user in art was constructed through a set of recurring characteristics: emphasis on the arm, large eyes staring out towards the viewer, references to insomnia and boredom, animalistic influences, *femme fatale* narratives, heavy makeup, and fashionable clothing. These tropes aid the viewer in identifying the figures in these artworks as morphine addicts, particularly when drug paraphernalia is absent. The prevalence of these tropes and their reiteration in various cultural forms – from newspapers, prints, and paintings to *cafés-concerts*, poetry, and novels – meant this new visual language would be understood beyond the circles of artists and their critics.

This chapter presents these key tropes identifying the *morphinomane* in an order that shows how these characteristics are increasingly distanced from the physical symptoms discussed in medical texts. Although each section opens with where and how the trope in question was written of in medical and popular texts, we should note that the relationship between art

and text is synergistic. Some of the recurring tropes used in artistic depictions of the *morphinomane* have their roots in the medical understanding of morphine addiction. Other tropes are borrowed from artistic visualisations of problematic women and are found in more familiar constructions of femininity, namely the *femme fatale* and the *demi-mondaine* (a wealthy woman, or female figure, of dubious morals). It is the visual combination of these tropes that creates a confected figure indicative of the *morphinomane*.

'The truly heart-breaking appearance of the arm'[7]

In written descriptions of the *morphinomane*, novelists and medical professionals alike focused on the parts of the body that were sites of injection for the habitual user. Medical writers provided the most detail. Ernest Chambard, who wrote one of the first medical books on habitual morphine use in 1890, explains: '*morphinomanes* usually choose the most accessible parts of their body as the site of injection; ... arms, thighs, legs, chest and belly are covered in characteristic lesions'.[8] A medical thesis by Lubin-Émile Delorme similarly noted that sites of injection are usually 'the abdomen, sometimes going up to the breasts, the upper thighs ... the legs, the arms'.[9] Writers for a non-specialist audience tended to simplify the list of bodily locations. 'She thinks only of being pricked [*piquer*] somewhere: on the arm or the leg', stated the French writer Émile Bergerat, writing under the name Caliban.[10] In *Le Gaulois*, Guy de Maupassant described a comparable situation: 'thousands of men and women prick [*piquent*] their arms every day'.[11]

The simplification of morphine administration to just one or two body parts in non-specialist texts parallels artists' reduction of habitual morphine users to a set of repeated characteristics. In visual culture, the arm was most associated with the site of injection. Although the depiction of the *morphinomane*'s skin in artistic visual culture is continuously idealised, artists emphasise the arm across the majority of images. Some artists explicitly show the arm being injected. But, even when morphine paraphernalia is not depicted, artists still emphasise the arm as the site of injection. The arm is often limp, always elongated and inappropriately bare, and the stark paleness of the skin stands out as a plane of emptiness within these compositions.

Artists' use of bare skin in their representations of the arm has broader cultural significance. Bare arms had become associated with the widespread campaign for smallpox vaccination in the mid-nineteenth century, as Tamar Garb demonstrates through her analysis of the critical responses to Édouard Manet's 1870 portrait of the artist Eva Gonzalès.[12] Critics were fixated on the skin of Gonzalès, whose bare, outstretched arms were reminiscent of

illustrations from newspapers of the same year showing women waiting to be vaccinated.[13] The bare, outstretched arm that was synonymous with vaccinations would seamlessly become synonymous with injecting morphine. Repeated depictions of the bare arm in *morphinomane* artworks symbolise morphine use without the need to depict the act of administration. Despite artists' paradoxical sanitisation of the skin, the recurring portrayal of the arm must be understood as a repeated trope in representations of habitual morphine users.

The thigh was also a site of injection, but presenting visual depictions of the thigh was slightly more complex. It is relatively straightforward in text to mention a woman injecting her thigh: as a journalist wrote in the non-political *Le Petit Parisien*, 'she injected under her skin, – to the legs or arms'.[14] In order to inject into the leg, the skirt must be lifted or trousers must be taken down. But such details are not needed in written descriptions; the scenario can be imagined. As a result, written descriptions are often less provocative than visual portrayals. In an image of a figure injecting its thigh, the dress is usually raised, revealing the naked skin beneath. Artists' rare depictions of the thigh as a site of injection for the (female) *morphinomane* have sexual overtones and thus appear very rarely and only in illustrations for erotic texts – such as an image by Lubin de Beauvais for René de Schwaeblé's pseudo-documentary erotic book *Les Détraquées de Paris* (c.1905), which shows a male figure, likely intended to be a doctor, injecting the thigh of a female figure above the stocking – or as caricatures, where freedom from naturalistic representation can extend the boundaries of acceptability (Fig. 4.2).[15]

Although habitual morphine users did inject into the upper leg, artists depict the thigh only for purposes of titillation. Such intentions were echoed by medical professionals. Henri Guimbail, in *Les Morphinomanes*, wrote: 'Through a feeling of justified coquetry, women often inject themselves in regions hidden to the eyes: thighs, pubic area, lateral gluteal regions are usually their place of choice. Men are more likely to choose their arms'.[16] The generalised nature of Guimbail's claim is questionable, but his reference to women's morphine use as associated with the most private of body parts eroticises the act of self-injection and underpins the placement of these images in erotic texts. Claims that women tended to inject morphine into the thigh also support contemporary concerns about women being more likely to hide corporeal signs of morphine addiction. Showing a female figure injecting into its bare thigh was likely too erotic for the majority of artists who planned to display their work publicly. Eugène Grasset's *morphinomane* figure (Plate 3), who is about to inject into its bare thigh, may be

deemed an exception, but the artist's uglification of other aspects of the figure's body – the pained facial expression, furrowed brow, and bared teeth – prevent the female figure becoming too erotic or too problematic for art that was viewed publicly.

In artworks that focus on the arm, the bare outstretched arm symbolises the act of injecting morphine without the need to depict any paraphernalia. Emphasis on the arm makes it a visual identifying factor, but it is a simplification of the reality of habitual morphine users' injection practices. The arm in *morphinomane* artworks becomes simultaneously representational of truth and deception: the arm signifies morphine addiction, yet the sanitisation of needle scars and abscesses presents an artificial image of habitual use in comparison to medical visual culture. Artists' focus on the addict's arm, but with unscarred and unbroken skin, draws attention to the limits of artistic conventions. The sanitisation of any corporeal signs of addiction paradoxically emphasises contemporary anxieties about women's ability to hide their addiction. In the same way that the viewer cannot trust the artist's depiction of habitual morphine use, many people believed they could not trust appearances to determine who was or was not addicted to morphine. In fact, the bare yet idealised arm of the *morphinomane* in these artworks emphasises the public paranoia surrounding the identification of morphine users. If even the figure's arms, one of the most frequently reported sites of injection, are not corporeally affected, how can *morphinomanes* be identified?

'Night owls'

Morphine, named after Morpheus, the Greek god of dreams and sleep, was associated with sleep and insomnia in often-conflicting ways. In a medical text titled *La Cure de la morphinomanie*, Georges Magoulas noted that morphine was used to 'cure' insomnia because it could induce sleep.[17] A writer of a scientific column from an 1878 issue of *Le XIXe siècle* similarly noted that morphine was 'the most convenient and prompt means of putting an end to intolerable pain or persistent insomnia'.[18] As a result of this employment of the drug, insomnia is a common withdrawal symptom of habitual morphine use and was suffered by many of those who relied on the drug's sedative properties. Benjamin Ball surmised that morphine addiction in one of his patients caused insomnia and Guimbail described *morphinomanes* as 'night owls' in his medical text.[19] An advertisement that was repeatedly printed on the back pages of newspapers throughout the early years of the twentieth century offered 'Radical healing of insomnia / 8 hours of normal sleep ensured each night / Unique way to cure *Morphinomanes*'.[20] The ambiguity

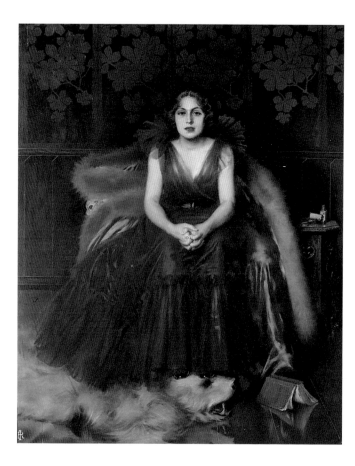

FIGURE 2.1 |
Vittorio Corcos,
La Morfinomane,
c.1890–99, oil on
canvas, unknown
dimensions,
unknown location.
Glass plate
photograph by
Brogi Giacomo,
c.1890–99, Pitti
Palace, Florence.

of this advertisement conflates habitual morphine use with disturbed sleep patterns, insinuating that a cure was on offer for *morphinomanes* suffering with insomnia, whilst also suggesting that habitual morphine users relied on morphine to get to sleep.

A case study published in 1885 deduced that an actress began using morphine to help her sleep at night because a 'life too sedentary causes insomnia'.[21] This writer creates a link between women, dubious lifestyles, insomnia, and habitual morphine use. These connections are perpetuated in artistic representations of the *morphinomane*. Artists who depict the *morphinomane* in night-time settings insinuate the figures' insomniac state and imply a profession or lifestyle that aligns with night-time activities. There are numerous examples of artistic depictions of *morphinomanes* in urban, night-time settings, but shadowy interiors also indicate dusk. Amongst others, the Italian artist Vittorio Corcos, who trained in Paris in the 1880s

under Léon Bonnat, painted two known images of the *morphinomane* in dark interior settings (Plate 4 and Fig. 2.1) during the final decade of the nineteenth century.[22]

In other *morphinomane* artworks, figures are shown asleep or in bed during the day – perhaps a reference to morphine's sedative properties or the aftermath of a night spent awake with insomnia caused by withdrawal. Paintings by Moreau de Tours and Santiago Rusiñol (Plate 5), for example, show a female figure lying in bed with sunlight coming into the room. Caricaturists also engaged with this insomniac narrative. One particular example is a vignette from a centre-page spread in *La Vie Parisienne* by Louis Vallet (Fig. 7.3), showing a semi-naked figure sleeping in bed. The accompanying caption reads: 'Four o'clock in the afternoon ... It is as painful for her to get out of bed at four in the evening as at four in the morning. To pick herself up, – she makes excessive use of ether and morphine.'[23] Artists' depictions of female figures awake at night and asleep during the day also indicate the unconventional lifestyle of the subject. There is little suggestion of activities considered appropriate for women, such as motherhood or domesticity. This lack of conventionality not only parallels contemporaneous narratives on the role of insomnia in *morphinomanie* but also emphasises an additional narrative that associates morphine use with certain types of women.

Eyes that 'resemble open wounds'

The poet, novelist, and art critic Octave Mirbeau described the *morphinomane*'s eyes as 'enlarged', 'with a strange glow'.[24] Comparably, in *Les Détraquées de Paris*, Schwaeblé stated that the pupil 'shines with a piercing brilliance, rendering the eye singularly lustful'.[25] More specific descriptions of the appearance of the eyes suggest they are animated immediately post-morphine but extinguished, dull, and vacant at any other time.[26] In *Une Femme par jour*, a written collection of 300 characterisations of French women, Jean Lorrain proclaimed that the eyes of morphine-addicted courtesans 'resemble open wounds'.[27] Here, 'open' gives implications of something gaping, whilst 'wounds' insinuates something visceral or corporeal. Lorrain attributes importance to the eyes as indicators of the body's condition. If artists could not depict the *morphinomane*'s skin as damaged and scarred, an emphasis on the figures' eyes could, in keeping with artistic conventions, reveal the sickliness of the body and mind.

Caricatures rely on exaggeration and simplification. It is therefore perhaps unsurprising that the eyes of the caricatured *morphinomane* are often enlarged. In Albert Robida's caricature from 'Les Victimes de la science'

FIGURE 2.2 | Albert Lammour, 'Des femmes aux yeux rendus immenses par la morphine,' Jacques Rhéas, 'À quoi bon?,' *Revue illustrée*, 10 April 1911.

(Fig. 4.2), the *morphinomane* has a miniscule nose and mouth in comparison to its exaggerated, heavily outlined eyes.[28] Albert Lammour's drawing of two *morphinomane* figures for a short story in *Revue illustrée* also shows a figure with enormous eyes (Fig. 2.2).[29] The figure's eyelids are drooping and the eye area is shadowed by the figure's hat, but the white of the eyes and their thick outlines draw attention to the size. Lammour ensures that the reader is aware of these details by captioning the illustration: 'Women with eyes made huge by morphine'.[30]

In caricature, the exaggeration of specific features of a figure's outward appearance highlights the dominant traits that are important to understanding the perception of the character, but exaggerated eyes can also be found in representations of the *morphinomane* in other art media. Lammour's *morphinomane* is comparable to Albert Besnard's 1887 etching *Morphinomanes, ou Le Plumet* (Fig. 2.3): the eye of the figure that looks out at the viewer in Besnard's etching is slightly enlarged, accentuated by the thick eyebrow and darkened under-eye area. Similarly, in *La Morfinómana* (Plate 6), Anglada-Camarasa exaggerates the eyes, making them disproportionately large and outlined with dark rings. Another Catalan artist living in Paris, Evelio (Eveli) Torent, friend of Pablo Picasso and relative of Anglada-Camarasa, exhibited a now lost charcoal sketch titled *La Morphinomane* at his Paris exhibition in 1907. Although little was said about the work, the very few words used by critic Louis Vauxcelles to describe Torent's *La Morphi-*

FIGURE 2.3 | Paul-Albert Besnard, *Morphinomanes, ou Le Plumet*, 1887, etching on woven paper, 23.5 × 36.9 cm, National Gallery of Art, Washington.

nomane centred on the figure's 'enlarged' pupils.[31] Artists' use of exaggerated eyes in many visual depictions of the *morphinomane* draw attention to the significance of the eye's condition, referencing alleged corporeal changes to the addict's body without compromising the skin's surface.

The direction in which the figures' eyes are looking – the figure's gaze – is of significance in *morphinomane* imagery. In art history, the way a (female) figure looks, and where, can indicate what type of woman the artist intends to portray. The eyes in *morphinomane* visual culture draw attention to the gaze, which, in turn, is indicative of certain social conventions and artistic iconography. Nineteenth-century etiquette advice for women in France advocated an averted gaze. Restricting when and where women should look was a way of controlling their sexuality, and staring was considered to be a form of 'incivility and impudence'.[32] 'I insist above all ... on not turning around to look at passers-by', wrote Louise d'Alq in an 1884 issue of *La Science du monde*.[33] Yet, *morphinomane* figures often look out of the composition and towards the viewer.

As Ruth Iskin notes, women with 'bold gazes' were presumed to be of dubious moral standing.[34] Hence, in art, a confrontational gaze became associated with problematic women, and formed the basis of artists' depictions of courtesans or prostitutes. As seen in Manet's notorious *Olympia* of 1863, a confrontational gaze could be seen as seductive or accusatory.

A confrontational gaze assigns an active role to the figure, overriding the assumption that femininity equates passivity. It is possible, therefore, that artists positioned the *morphinomane* facing the viewer in order to attribute to them an uncomfortable control via active looking. It is more likely, however, that artists show *morphinomane* figures looking out at the viewer because of their association with other depictions in visual culture of problematic women such as prostitutes or courtesans, with an aim of placing the *morphinomane* in the same category as these deviant figures.

Although figures looking out towards the viewer may infer a claim of power, the *morphinomane* gaze is more nuanced than this and cannot be considered as active looking. In many *morphinomane* artworks, the figures look beyond the canvas frame and do not confront the viewer. The use of heavy eyelids in visualisations of the addict is indicative of vacancy rather than of active looking or the accusatory gaze found in works such as *Olympia*. This vacant gaze, which may be deemed the '*morphinomane* gaze', parallels aforementioned medical descriptions of 'extinguished' eyes.

Both the accusatory gaze and the *morphinomane* gaze signal a loss of what may be deemed 'proper' femininity and a lack of self-consciousness. Etiquette for women's looking was centred on self-consciousness, awareness of physical appearance, and bourgeois respectability, in contrast to the practice of the (male) *flâneur* who 'observed others'.[35] The majority of *morphinomanes* who appear to face the viewer do not have agency but, rather, suggest a loss of social self-consciousness. The vacant gaze as a conveyor of lost self-consciousness references contemporary narratives about bourgeois women becoming addicted to morphine and losing respectability. As Lorrain described, the *morphinomane*'s eyes are 'open wounds'; they reveal the woman's condition not only as a habitual morphine user but also as a problem to society.

'She is bored!'

The majority of morphine addictions had their origins in legitimate medical treatments, but many writers provided an alternative narrative, positing boredom – ennui – as the root cause of women's habitual use. A newspaper article of 1890 noted that 'to combat this boredom' women went to the pharmacy for morphine: 'this life so full, she finds it empty, hollow! She is bored!'[36] Similarly, a front-page column in the socialist newspaper *L'Aurore* stated that 'morphine is a remedy for pain and boredom'.[37] The pseudonymous journalist Tout-Paris profiled different *morphinomane* types and the reasons for their addictions. One of these characters is a bored and melan-

FIGURE 2.4 |
Georges de Feure,
La Voix du mal,
1895, oil on canvas,
65 × 59 cm, private
collection.

cholic bourgeois woman who has 'tried everything to relieve boredom', but
resorts to morphine when there is 'no Opera, no dinner in town, no ball'.[38]

Women's boredom was indeed problematic. Society prescribed that
women should keep themselves occupied by being wives and mothers. Being
bored meant not being sufficiently busy. Tout-Paris not only underscores
this by suggesting that the female character resorts to morphine when bored,
but also clearly states that the character's life is not dedicated as it should
be to the so-called natural duties of motherhood. Boredom was deemed a
danger to women that could lead to unconventional lifestyles. Georges de
Feure's *La Voix du mal* (The Voice of Evil) of 1895 (Fig. 2.4) demonstrates the
potential dangers of boredom in women. De Feure relies on artistic iconog-
raphy to convey the figure's boredom, visually referencing the well-known
pose used in Albrecht Dürer's *Melencolia* of 1514. The vignette in the top half

of de Feure's canvas shows the viewer a glimpse of *la voix du mal* that overcomes the figure's thoughts: two entwined naked female figures. One of the figures appears as a horned creature, literally demonising lesbianism and indicating the potential outcome of boredom amongst women.

As seen in *Melencolia* and *La Voix du mal*, artistic iconography to indicate boredom consists of a vacant gaze, the head resting on a fist, and a slumped posture. Artists' use of this familiar iconography in their depictions of the *morphinomane* perpetuates an association between habitual morphine use and the types of women who were bored: bad mothers or wives, or those with lives that allowed time for boredom. Of particular interest with respect to the bored morphine user is Picasso's *Morphinomane* (Plate 7), which was likely created specifically for the artist's first Paris exhibition, held at Galerie Vollard in 1901. At some point between 1901 and 1932, when *Morphinomane* was in the collection of Lluís Plandiura, it was retitled *L'Attente* (The Wait) *(Margot)*.[39] The title *L'Attente* is based only on the figure's pose; waiting is assimilated with the artistic conventions associated with boredom. When the painting was sold to the Catalunya government in 1932, Christian Zervos retitled it *Pierreuse, la main sur l'épaule* (Prostitute [Streetwalker], with Her Hand on Her Shoulder). It is likely that Zervos used this title because of the figure's heavy makeup and outward gaze, both of which have been associated historically with dubious female figures, as well as the notions of boredom related to prostitutes waiting for clients. The range of titles applied to Picasso's *Morphinomane* exploits the conflation of habitual morphine use with boredom and prostitution, or suspicious morals at least. It is unclear what Picasso's *morphinomane* is bored of waiting for – is it entertainment, a client, or the next dose of morphine?

Many images of the bored *morphinomane* show women alone at night. The public nature of the settings in these artworks alludes to prostitution or a *demi-mondaine* lifestyle. The figures in these paintings by Picasso and Anglada-Camarasa appear to be at *cafés-concerts*, a form of entertainment that offered new and alternative experiences to those bored with the mundane and conventional lifestyle of the bourgeoisie, in a way comparable to narratives on the causes of morphine use. References to boredom in *morphinomane* imagery insinuate a narrative of transformation, a movement from traditional mother and wife to a deviant woman who has abandoned society's expectations of womanhood. According to dominant ideology, bourgeois women should not experience boredom; their lives should revolve around being respectable mothers and wives. But artists offer a counternarrative. Iconography that symbolises boredom makes references to fin-de-siècle writers' assumptions about the potential causes of *morphinomanie*

in women. Artists' depictions of specifically problematic female figures, in conjunction with this iconography of boredom, create and perpetuate the idea that (women) *morphinomanes* did not live, or no longer lived, conventional lives.

'What is this beast that comes here ... ?'

Medical professionals, journalists, and fiction writers alike employed animalistic terms to describe the *morphinomane*'s skin and temperament. The pseudonymous Caliban presented a *morphinomane* figure in a lengthy news column for an 1885 issue of *Le Figaro*: 'What is this beast that comes here, in an elegant woman's dress? It is the beast that does not sleep'.[40] The novelist Victorien du Saussay repeatedly referenced animals to describe his characters in *La Morphine*, remarking that the morphine-addicted protagonist Blanche 'resembled a tigress defending her prey'.[41] Paul Regnard gave a detailed description of the skin of a *morphinomane* in his medical book on mental illnesses: 'the needle marks are so close together that they merge ... the skin resembles more that of a reptile than the skin of a human being'.[42] The text is accompanied by a rudimentary sketch (Fig. 1.3); in its simplicity it gives the same depth and tone to each scar, imitating the regularity of scales and enhancing Regnard's description of the user's skin as reptilian. Analogously, Schwaeblé describes the *morphinomane*'s skin changing from 'pink satin' to 'disgusting scaly cuirass' in *Les Détraquées de Paris*.[43] The skin signifies the body's physical and mental state. Pink satin, symbolic of softness, sensuality, and femininity, is contrasted with textured and repulsive reptilian skin. In the process of addiction, or the metamorphosis to the *morphinomane*, a transformation occurs in which femininity and humanity are lost. A similar portrayal recurs in Manuel Orazi's illustration for the cover of Saussay's *La Morphine* (Plate 8). The figure's hands are animalistic and clawlike, monstrous compared to the rest of the body, and the skin on the hands is textured to resemble fur. The fur blends into the idealised skin seen on the rest of the figure's body, symbolising a transformation from human to beast.

Orazi's front cover image notwithstanding, most artists were relatively subtle in their representations of the animalistic *morphinomane*, possibly in order to maintain a visible connection to reality. Anglada-Camarasa's female figures in *Le Paon blanc* and *La Morfinómana* are depicted with unscarred skin, yet the sinuous and supple shape of the arms and the figures' green-tinged skin make the arms snake-like in form and colour. It was most often art reviewers who orchestrated the *morphinomane*'s bestial transformation by exaggerating animalistic tropes that may seem visually tenuous.

Influenced by discourse portraying the morphine user as bestial, critics pursued an agenda about who could be a habitual morphine user by constructing the *morphinomane* as animalistic. The art critic known as Solrac, for one, discussed Anglada-Camarasa's turn-of-the-century paintings in *L'Occident*, describing the figures as 'coming out at night like moths'.[44] The same figures were labelled as 'the vicious night owls of Paris' by a writer in the Barcelona journal *La Publicidad*.[45] In his section on Anglada-Camarasa in *Gazette des beaux-arts*, the previous director of the École des Beaux-Arts (1903–05), Henry Marcel, described the female figure in *Le Paon blanc* as serpentine and as being portrayed with 'such animalisation' because its 'trade has its requirements, it is necessary to move, to hunt'.[46] Marcel alludes here to prostitution, associating both the *morphinomane* and women deemed socially problematic with bestial transformations.

A response to an oil painting by Moreau de Tours at the 1887 Salon des Artistes Français, a year after his prominent *La Morphine* was exhibited, embodies further the amalgamation of the *morphinomane* with animalistic characteristics. The Salon review, featured in *L'Univers illustré*, takes the form of a thirteen-page script spoken by various characters as they walk around the Salon and discuss Moreau de Tours's *Portrait de Mme et Mlle ****, a lost painting showing a woman breastfeeding.[47] As the group approaches the portrait, one of the characters states that Moreau de Tours 'exhibits another *morphinomane*' despite there being no obvious reference to morphine use or paraphernalia in the painting.[48] However, the caricature accompanying the portrait shows a figure looking out towards the viewer – seemingly with the same vacant gaze as seen in the plethora of *morphinomane* artworks – and the figure's facial features are exaggerated and outlined, suggesting the depiction of heavy makeup. The characters do not discuss the portrait in detail but the figure's expression is described only as 'bestial'.[49] As early as 1887, art viewers were practised at interpreting the *morphinomane* as bestial and subhuman.

By attributing animalistic features to the *morphinomane* in art, via artistic tropes and art criticism, the reptilian appearance of skin that was so often described in medical texts is insinuated without actually disrupting the skin's smooth surface. Moreover, and most significantly, these animalistic qualities underscore a transformative process – a transformation from socially conventional roles of bourgeois wife and mother (the epitome of femininity) to the *morphinomane* (a dangerous and subhuman creature). Subtle artistic references to animalistic traits form connections between women living unconventional lives and the othered or dehumanised addict. By alluding to the *morphinomane* as animalistic, artists and art reviewers

categorised the actual habitual morphine user as a threat to humans and to humanity. Henceforth, by analogy, the suppposedly predatory nature of the *morphinomane* was deemed to exemplify the dangerous effect of women's unconventional lives on society.

The 'seductive Siren'

In 1892, in an article for the radical newspaper *La Justice*, a journalist known as Joleaud-Barral described morphine as an 'enchantress'.[50] Similarly, in 1896 the drug was referred to as 'the powerful seducer' in a front-page column on morphine for the politically independent newspaper *Gil Blas*.[51] Writing under the collective pseudonym Jean Frollo, a writer for the widely circulated *Le Petit Parisien* called for legal sanctions to prevent the 'perfidies of the attractive siren [morphine]'.[52] And in an article from 1886, a doctor writing in *Gil Blas* similarly characteristed morphine as a 'seductive Siren', and the drug was described in the fashionable daily newspaper *Le Gaulois* as having the 'allure of the forbidden fruit'.[53] These descriptions of enchantment, beauty, danger, and deception, in addition to references to mythical creatures and the Original Sin, placed morphine within the familiar narrative of the irresistible *femme fatale*.

As Rebecca Stott points out, the 'seductive Siren', or *femme fatale*, 'appears time and again in art, poetry and fiction either in her mythical forms or in contemporary guise'.[54] The *morphinomane* is a clear example of the *femme fatale*'s contemporary appearance. Whilst fin-de-siècle writers personified the drug itself as a dangerous woman, it was artists who specifically merged the *femme fatale* with the drug's users. Traits associated with drug use and addiction likely contributed to the *femme fatale*'s specific fin-de-siècle visualisation, or 'contemporary guise'. Like the *femme fatale*, the *demi-mondaine*, and the *femme nouvelle*, the *morphinomane* was just another construction of problematic femininity.

The pseudonymous Fernand Nozière, in his 1909 article for the influential daily newspaper *Le Temps*, wrote of Eve as a *femme fatale* – holding her responsible for 'the destiny of her companion [Adam] and the universe'.[55] The fact that the serpent plays a significant role in the story of the Original Sin meant that reptilian skin, snakes, and green-tinged skin often appear in artworks referencing the *femme fatale* at the turn of the twentieth century.[56] Snakes also appear in several images of *morphinomanes*: subtly as the gold bracelet in Orazi's front-cover illustration and, more overtly, as creatures encircling a *morphinomane* figure in a centre-page spread of *La Vie Parisienne* (Fig. 2.5).[57] The caption accompanying this centrefold states that the figure

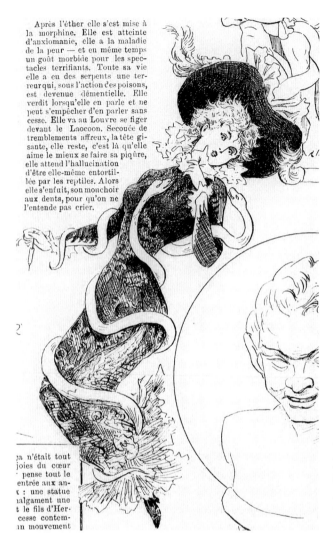

Après l'éther elle s'est mise à la morphine. Elle est atteinte d'anxiomanie, elle a la maladie de la peur — et en même temps un goût morbide pour les spectacles terrifiants. Toute sa vie elle a eu des serpents une terreur qui, sous l'action des poisons, est devenue démentielle. Elle verdit lorsqu'elle en parle et ne peut s'empêcher d'en parler sans cesse. Elle va au Louvre se figer devant le Laocoon. Secouée de tremblements affreux, la tête gisante, elle reste, c'est là qu'elle aime le mieux se faire sa piqûre, elle attend l'hallucination d'être elle-même entortillée par les reptiles. Alors elle s'enfuit, son mouchoir aux dents, pour qu'on ne l'entende pas crier.

2'

;a n'était tout
joies du cœur
· pense tout le
entrée aux an-
ς : une statue
ialgament une
t le fils d'Her-
cesse contem-
in mouvement

FIGURE 2.5 |
Hyp, vignette from 'Les Statues qu'elles aiment,' *La Vie Parisienne,* 7 January 1899.

visits the *Laocoön* at the Louvre with the intention of injecting herself with morphine. She then waits to be 'entangled by reptiles' in her hallucination, as the snakes from the sculpture wind around her body.[58] The text describes the figure's fear of snakes – a simultaneous desire to terrify herself – recounting that she 'turns green when she talks about it'.[59] This is indicative of the animalistic transformations often seen in contemporary paintings of the *femme fatale*, as well as the corporeal, animalistic transformations of the *morphinomane*. Artists' alignment of Eve and the *morphinomane* insinuates ideas about temptation and the transformation from wife and mother to

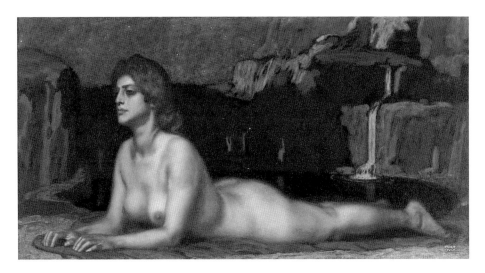

FIGURE 2.6 | Franz von Stuck, *Sphinx*, 1904, oil on canvas, 83 × 157 cm, Hessisches Landesmuseum Darmstadt, Darmstadt.

morphinomane, or from purity (Eve) to temptation (serpent) and degeneration (Original Sin).

The Sphinx, an alluring yet deadly human-creature hybrid who devoured those who could not solve her riddle, is another *femme fatale* type that was popular in Decadent literature and fin-de-siècle art more broadly.[60] Many visual examples of the Sphinx, particularly those created at the turn of the twentieth century, portrayed the mythical beast as a sexualised female figure. As seen in *Sphinx* of 1904 by German symbolist Franz von Stuck (Fig. 2.6), the supposed dangers of women's sexuality are combined with the powerful attraction of this mythical creature. Oscar Wilde's *The Sphinx Without a Secret* (1887) also conflates the Sphinx with the nineteenth-century *femme fatale*, but Wilde's description of the female protagonist (the Sphinx) has similarities not only with the typical *femme fatale* figure but also with *morphinomane* artistic tropes.[61] The female character is described as having 'large vague eyes', as being 'wrapped in rich furs', and as having 'the face of someone who had a secret'.[62] Furs and dead animals appear repeatedly in *femme fatale* and *morphinomane* visual culture. A stole with an animal's head in Anglada-Camarasa's *La Morfinómana*, a polar bear rug in Corcos's *La Morfinomane*, and a bearskin stole in another of Orazi's illustrations for *La Morphine* all summon censured notions of decadence, degeneration, and danger. Wilde's references to secrecy echo anxieties about deception and hidden identities, a common narrative in discussions about the *morphinomane* and the *femme*

fatale. However, the woman's eyes as he describes them are usually found in representations of the *morphinomane* rather than the *femme fatale*.

The *morphinomane* and the Sphinx are amalgamated in Orazi's front cover for Saussay's novel. The figure's human face is heavily made up, referencing iconography used by artists to indicate dubious women, and the figure's pose is sexualised. Fur on the figure's hands blends into its human skin, insinuating the transformatory process. The figure is turning into the animalistic Sphinx with morphine as the catalyst. The snake bracelet worn by the Sphinx-hybrid not only alludes to the temptation of Eve, but it also references jewellery from Classical and Hellenistic antiquity and the origins of the Sphinx.

Alex Murray notes that the fin-de-siècle Sphinx in particular merged the 'ancient riddler with the "New Woman"'.[63] The Sphinx epitomised the independent *femme nouvelle* of the late nineteenth century and created an association between actual women and this mythical *femme fatale* type. Nozière's article on the *femme fatale* in *Le Temps* alludes to modern women via references to their playing tennis and golf or driving cars; mobility and sports encroached on conventionally masculine freedoms.[64] Stemming from male fears about women's freedom and its potential outcomes, the *femme fatale* achieved a new relevance at the end of the nineteenth century when the status of modern women aroused anxiety. Simultaneously, and not coincidentally, the *morphinomane* emerged as another type of femininity that was thought to be a product of modernity and of modern women. The *femme nouvelle* was inextricably linked to morphine via the destructive potential of her alleged unconventional lifestyle and her abandonment of traditional feminine roles.[65] Like the *femme nouvelle*, the *morphinomane* – signalling the growing number of habitual morphine users in France – was deemed a real and dangerous threat to society.

It must be reiterated that the *femme nouvelle*, the *femme fatale*, and the *morphinomane* are all social and artistic constructions. But their relevance to contemporaneous events (namely the growing feminist movement in Western Europe and an increase in habitual morphine use) heightened the assumed authenticity of these social types, emphasising the anxieties that manifested in each of these constructions of femininity. The *morphinomane* intersected all modern and problematic aspects of society at that time: decadence, feminism, social problems, ill health or degeneration, addictiveness (allure). Artists' visual references to manifestations of the *femme fatale* in *morphinomane* artworks represent the monstrous feminine, encapsulating a visualisation of man's fear of femininity. Like the *femme fatale*, the

morphinomane is a mythical character imbued with contemporary anxiety about real women and social change.

As depicted in art and as described in literature, the *morphinomane* was portrayed in ways that are most often associated with the *femme fatale*. However, the references to temptation, sin, and bestial transformations that occur in *morphinomane* visual culture suggest that the *morphinomane* likely informed the revived *femme fatale* that emerged at the turn of the twentieth century. These two manifestations of problematic femininity did not occur autonomously. Whilst the *morphinomane* is perhaps one of many *femme fatale* types, like Eve, the Sphinx, and the *femme nouvelle*, the fin-de-siècle *femme fatale* appears also to be a manifestation of the *morphinomane*.

'You cannot distinguish honest women!'

In newspaper reports and numerous criminal cases that involved tricks or false identities, the habitual morphine user was portrayed as duplicitous, echoing the penchant for deception that characterised not only the *femme fatale* and the *morphinomane*, but also female criminals.[66] In the 'Nouvelles Judiciaires' (Judicial News) column of *Le XIXe siècle*, a woman described as a 'passionate *morphinomane*' was convicted for committing 'a whole series of scams' to support her daily morphine habit.[67] Nineteenth-century criminologists reinforced such concerns about women's mendacity, with one stating that 'deceitful habits' are 'innate in woman'.[68] Artists visualised similar ideas in their portrayal of the (female) morphine user. In a series of captioned drawings from a 1903 edition of the satirical, anarchist journal *L'Assiette au beurre*, a figure labelled the Prefect of Police states, 'you cannot distinguish honest women!' (Fig. 2.7).[69] Then, as illustrated by the Greek cartoonist and landscape painter Demetrios Galanis, who lived and worked in Paris from 1900, in a night-time setting the policeman approaches a female figure. To her claim that she is a typist, he responds, 'Liar! Show me your needle marks!'[70] The demand to see the woman's skin conveys concerns about the deceptive façade of women's clothing. Through this image, Galanis reinforces associations between habitual morphine use, night-time activities, and women with questionable morals. The Prefect of Police's words suggest that the presence of hypodermic needle scarring is inseparable from problematic women; that only corporeal differences can distinguish the honest from the dishonest.

Journalist and literary scholar Octave Uzanne, in his discussion of fashion in 1911, called women 'actresses' who are 'in love with the effect they

FIGURE 2.7 | Demetrios Galanis, 'Dessins de Galanis,' *L'Assiette au beurre* (*La Police II*), 30 May 1903, © ADAGP, Paris and DACS, London 2023.

produce, anxious to attract attention and to dominate their rivals'.[71] Uzanne draws on contemporary anxieties about women's clothes and their capacity to alter the perception of one's so-called true identity. In a manner comparable to narratives of the animalistic qualities of the *femme fatale* and the *morphinomane*, Uzanne insinuates that any identity could be hidden behind the fashionable Parisienne. The Parisienne, he said, was able to use clothing to enhance attractiveness for her own benefit with the potential to ensnare men and lead them to self-destruction. These issues likely originated from anxieties surrounding the shopping habits of wealthy and independent women (often labelled *demi-mondaines*), who patronised the same fashion houses as women of the *haute bourgeoisie*. 'Courtesans and society women share designers ... Not only do they wear the same clothing, but they use the same language', observed Alexandre Dumas *fils* in 1890.[72] Significantly, artists almost always depict the *morphinomane* wearing clothing styles that could be purchased in *haute-couture* fashion houses. One such example is the dress in Corcos's *La Morfinomane*, which is reminiscent of the *haute-couture* gown seen in Giovanni Boldini's 1894 *Portrait of Gertrude Elizabeth* (Fig. 2.8), an art critic and socialite who had scandalously divorced her husband eight years earlier. Corcos's depiction of the *morphinomane* as wealthy and fashionable is in keeping with his own upper-class upbringing. It also does not stray far from his oeuvre, which often featured provocative or sensualised upper-class

FIGURE 2.8 |
Giovanni Boldini,
*Portrait of Gertrude
Elizabeth (née
Blood), Lady Colin
Campbell*, 1894, oil
on canvas, 184.3 ×
120.2 cm, National
Portrait Gallery,
London.

Parisiennes, a genre influenced by his art dealer, Adolphe Goupil, and by Boldini, both of whom Corcos met in Paris in the 1880s. Crucially, artists' depictions of the *morphinomane* wearing clothing of the latest design echo concerns about women's ability to disguise their 'true' identities.

Long sleeves and skirts could easily hide hypodermic needle scars. Indeed, it may be argued that Moreau de Tours paints such clothing on the reclining figure in *La Morphine* specifically to avoid having to depict the figure's potentially scarred body. Newspapers and medical texts frequently repeated

these ideas about deception. Although Regnard stated in an interview with Pierre Aubry for the 13 May 1885 issue of *La Petite République Française* that 'more men than women are taking morphine' ('only twenty-five women per hundred men'), he immediately added, 'the truth ... is that these ladies know better how to hide their little sin'.[73] These statements were reiterated in various forms, as in the daily paper *La Justice* the following day, where a journalist claimed that 'women are better at hiding their vice'.[74] In the same way that clothing could hide the wearer's 'true' self or class, clothing could also allegedly conceal the wearer's identity as a habitual morphine user.

'All the artifices of makeup'

'The fear of losing their teeth and their hair is likely to stop women' from pursuing morphine use, stated *Le Figaro* in 1885, on reporting the findings of a Dr Combe.[75] The following year, Ernest Monin outlined a multitude of beauty treatments in *L'Hygiène de la beauté*, informing readers: 'Dr Jackson has shown that the use of morphine is an active cause of rosacea. Take note, *morphinomanes!*'[76] And almost three decades later, a writer known as Mme Bouët-Henry claimed that women were resorting to morphine use in order to 'acquire a greater beauty', but warned that 'after a very short time' their efforts would result in 'wrinkles and ruins'.[77] Fin-de-siècle writers exacerbated a connection between habitual morphine use and women's beauty, vanity, and egotism. Monin and Combe endeavoured to dissuade women from using morphine because of its alleged effects on the body's outward appearance. Bouët-Henry's warning describes habitual morphine use as a physical transformatory process, paralleling the symbolic and animalistic transformations in artworks of the *morphinomane*.

By the end of the nineteenth century, many women wore makeup. Light facial powders functioned to smooth and whiten the surface of the skin, hiding natural changes in textures and tones. For nineteenth-century women, fine powder was intended to 'give their skin the effect of marble', veiling their flesh with an artificial skin.[78] Thickly applied makeup was problematic for several reasons. At a time when it was believed cosmetics could 'damage and prematurely age skin', *fard* (heavy makeup) invoked ideas about aging. Heavy makeup was more prone to cracking on the skin's surface, thus having the potential to reveal the wearer's 'true' identity. Additionally, no doubt enhanced by the endorsement of commercial cosmetics by well-known actresses such as Sarah Bernhardt, *fard* was associated with performers and performance.[79] Actresses and the like, often deemed unscrupulous members of society, relied on the exaggerated effects of makeup for

stage performances. These negative implications perpetuated the association between makeup and false identities, as well as broader concerns about artifice, excess, and societal decadence.

Heavy makeup is implied in monochromatic drawings and caricatures of the *morphinomane*, but it can best be seen in polychromatic paintings. In Corcos's *La Morfinomane*, the black eyebrows, outlined eyes, and tinted lips contrast with the whiteness of the figure's skin, which in itself implies the use of thick facial powders. Similarly, the red lips of the upright figure in Albert Matignon's *Les Morphinomanes* (Plate 9) stand out against the mostly muted colour palette. The critic Solrac commented on Anglada-Camarasa's figures, stating that they know 'all the artifices of makeup' and 'use them to the extreme'.[80] In Anglada-Camarasa's *La Morfinómana* (Plate 6), for instance, the whiteness of the figure's face contrasts with its dark hair, black hat, and outlined facial features. The female figure's face in *Le Paon blanc* (Plate 2) also has heavily outlined eyes, thickly lined eyebrows, red lips, and a white face. The change in that painting's title in 1905, from *Le Jardin-concert* to *Le Paon blanc*, shifted the focus from the painting's location to the female figure itself. 'White peacock' suggests notions of vanity and ostentation that were associated with the appearance of *demi-mondaines*, whilst reinforcing the nineteenth-century obsession with both cosmetic and class-based whiteness of skin.[81]

In *Morphinomane* (Plate 7) Picasso emphasises the figure's makeup. Once again, the figure's eyebrows are thick lines of black paint, the eyes are outlined and the figure's lips are painted a bright red. The red paint used to create the figure's clothing also makes up the base of the face, which is left uncovered around the eyes, and strokes of blue give the impression of dark circles. Picasso applies white paint over the red, layering the former over the skin as if it were a thick facial powder. The impasto painterly style parallels the thick layering of white powders that was problematic to many critics. The figure's face is not the same colour as its hands, perpetuating further ideas about artifice and the use of makeup to hide identities. The red paint marks on the figure's face insinuate the breaking of the skin's surface, revealing an impure, uneven skin texture beneath the thick white layers.

The use of heavy makeup was a popular trope amongst artists in images of *demi-mondaine* or prostitute-type figures in nineteenth-century artworks. A prime example of this can be seen in *Splendeur* (Fig. 2.9), a painting by Ernest-Ange Duez. *Splendeur*, an oil on canvas of a wealthy yet disreputable female figure, is one half of a diptych. The other half, now lost, is titled *Misère* and shows an impoverished prostitute.[82] The figure in *Splendeur* wears heavy makeup, presenting the façade of a youthful appearance, and

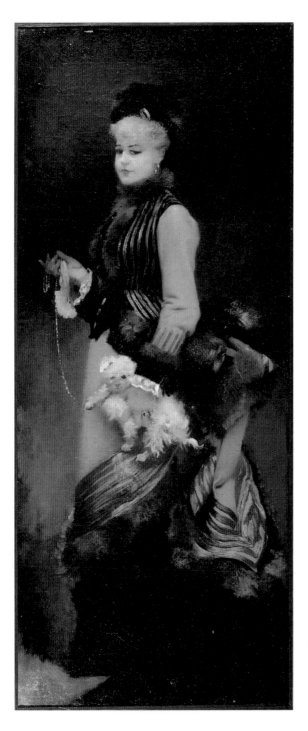

FIGURE 2.9 |
Ernest-Ange Duez,
Splendeur, after 1874,
oil on canvas, 136 ×
57.5 cm, Musée
Carnavalet, Paris.

wears what Hollis Clayson has labelled '*the* correct fashion of the day'.[83] Clayson argues that the paintings functioned to show the 'two coexisting and competing forms of prostitution in the capital in the 1870s'.[84] To expand on Clayson's interpretation, the diptych of *Splendeur* and *Misère* is perhaps more about truth and deception. Both figures are prostitutes, yet the figure's appearance in *Splendeur* is disguised by its clothing and makeup, which could conceal the wearer's true self. In a way, *Misère* is perhaps more representative of the figure's true identity. The depiction of heavy makeup in *morphinomane* visual culture associates the habitual morphine user with artists' images of prostitutes or *demi-mondaines,* aligning them with concepts surrounding these types (sexuality, independence, danger).[85] The deceptive nature of makeup parallels contemporaneous debates on a woman's alleged abilities to hide habitual morphine use and deceive those around her. How can habitual morphine users be identified in actuality if their outward appearance is concealed by a cosmetic illusion?

Assembling the *Morphinomane*

"'She reminds me", continued my companion, "of the *morphinomane* that the painter Hermenegilde Anglada depicted in a setting like this one tonight." / "It may be the same", I observed, watching the walker. / "Well", he said, "there is more than one *morphinomane* in Paris." / "And one swallow", I added, "does not make a spring."'[86] These are the concluding lines to Toulet's 'Nocturne Élyséen', which opened this chapter. In these final words, the first-person narrator states that the woman they see as they walk down the Champs-Élysées may actually be the same woman that Anglada-Camarasa depicts in *Le Paon blanc*. Through his characters' comparison between a painted figure and a real woman – in the context of a fictional story – Toulet attributes credibility to Anglada-Camarasa's representation of the *morphinomane*. The boundaries of art and (a false fictional) reality are merged. Using a painted figure as the reference point for determining the identity of a 'real' woman reinforces art's role in setting a precedent for the appearance of the *morphinomane*, whose visibility was in actuality concealed by social condemnation or by the exclusivity of medical institutions.

Some tropes used in *morphinomane* artworks have their roots in reality and in the medical understanding of habitual morphine use. Yet in artworks they are suggested rather than portrayed. Even though the habitual morphine user would inject morphine to any fatty part of the body, the bare, outstretched arm is constructed as the cornerstone of the *morphinomane*'s hypodermic administration. Several recurring tropes – figures at night,

boredom, exaggerated eyes – also have some grounding in reality but are deployed to attribute new meanings to the *morphinomane*. By using these tropes to construct an image of the deviant woman, artists take the morphine addict beyond the realms of truth. Needless to say, artists' references to Eve, the Sphinx, and the animalistic body would not be helpful to those who attempted to identify habitual morphine users in reality; the figure of the *morphinomane* was not, and could not be, real. Contemporary writers scarcely described the *morphinomane* as a *femme fatale* (they mostly used these terms to describe the drug itself), but artists influenced and took influence from *femme fatale* narratives in their portrayal of the *morphinomane*. Most concerning to contemporary viewers, perhaps, were artists' references to deception via fashion and makeup. Such references manifested anxieties about identifying the *morphinomane* in reality, whilst other identifying characteristics, paradoxically, would not be found.

In parallel with the implied corporeal transformations in *morphinomane* artworks – animalistic transformations, cosmetic transformations, transformations from good to bad women – artists transformed the real habitual morphine user into a set of recurring tropes. This practice concealed the 'true' identity of those who were addicted to morphine (namely male medical professionals), in the same way that makeup and *haute-couture* fashions implied the *morphinomane*'s desire and ability to hide her identity as a habitual user. The very nature of artists portraying a figure that in reality could not be defined or categorised by its outward appearance confirms the purpose of tropes in artists' visualisations: to aid viewers in identifying the *morphinomane*, if not in reality then at least in art.

Art played an active role in shaping perceptions about the *morphinomane*'s identity, driving the habitual morphine user beyond its nineteenth-century corporeal appearance and towards conflating the *morphinomane* with problematic women. Artists influenced and took influence from novels, newspaper articles, theatrical performances, and, most significantly, from other artistic representations of problematic femininity *and* from visible changes in users' bodies according to medical evidence. This amalgamation of symptoms identified by medical professionals and constructed by artists created a female figure that becomes symbolic of the *morphinomane*, yet cannot be said to represent the real habitual morphine user of fin-de-siècle France.

Plates

PLATE 2 | Hermenegildo Anglada-Camarasa, *Le Paon blanc* (known until 1905 as *Le Jardin-concert*), 1904, oil on panel, 78.5 × 99.5 cm, Carmen Thyssen-Bornemisza collection, Madrid, © DACS 2023.

PLATE 3 (*opposite*) | Eugène Grasset, *La Morphinomane*, 1897, colour lithograph, 41.3 × 31.2 cm, Cleveland Museum of Art, Cleveland.

PLATE 4 (*opposite*) | Vittorio Corcos, *La Morfinomane*, c.1899, oil on canvas, 166 × 128 cm, private collection.

PLATE 5 | Santiago Rusiñol, *La Morfina* (also known as *After the Morphine*), 1894, oil on canvas, 87.3 × 115 cm, Museo del Cau Ferrat, Sitges.

PLATE 6 |
Hermenegildo
Anglada-Camarasa,
La Morfinómana, 1902,
oil on panel, 33 × 40 cm,
private collection,
© DACS 2023.

PLATE 7 | Pablo Picasso, *Morphinomane* (also known as *Margot* and *L'Attente*), 1901, oil on cardboard, 68.5 × 56 cm, Museu Picasso, Barcelona, © Succession Picasso/DACS, London 2023.

PLATE 8 (*opposite*) | Manuel Orazi, front-cover illustration, Victorien du Saussay, *La Morphine* (Paris: A. Méricant, 1906).

LA
MORPHINE

Victorien DU SAUSSA

Vices et Passions des Morphinomanes

...rt MÉRICANT
ÉDITEUR

ROMAN PASSIONNEL ILLUSTR...
par MANUEL ORAZI

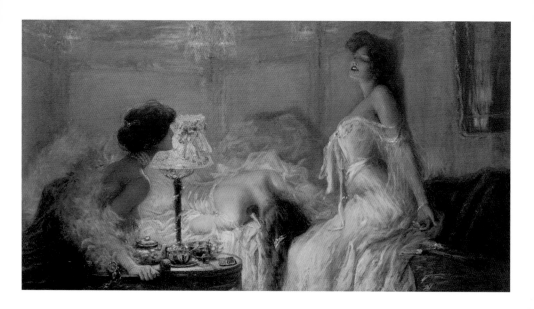

PLATE 9 | Albert Matignon, *Les Morphinomanes*, 1905, oil on canvas, 109 × 196 cm, Château-Musée de Nemours, Nemours.

PLATE 10 (*opposite*) | Théophile Steinlen, '*Les Possédés de la morphine*, par Maurice Talmeyr,' *Gil Blas illustré*, 21 February 1892.

LES POSSÉDÉS DE LA MORPHINE, par Maurice Talmeyr

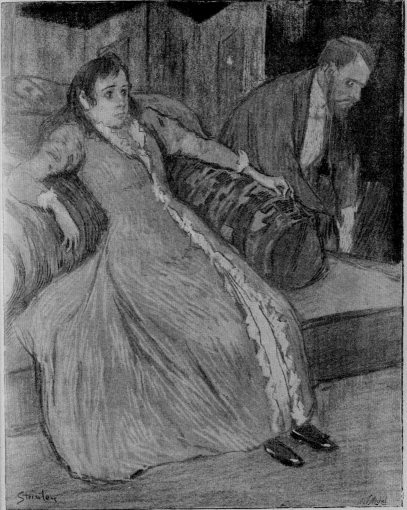

(Dessin de Steinlen.)

... ILS EN ARRIVENT TOUS A UNE INCONSCIENCE SORDIDE, A UNE INDIFFÉRENCE AFFALÉE ET DÉGOUTANTE, AUX CHEMISES SALES, AUX MAINS NOIRES, A L'AVILISSEMENT ET A LA CRASSE....

UN PEU DE REPOS

Ma foi, nous passerons notre journée au lit.
Le repos du combat d'amour vous amollit
Et sur la volonté comme sur les paupières
Pose ses doigts câlins plus pesants que des pierres.
A quoi bon nous lever? Il est plus de midi

Des langueurs vont flottant et font l'air attiédi
Dans la chambre bien close et pleine de silence.
La paresse sous nos courtines se balance
Ainsi qu'une de ces grands papillons aux vols lourds
Qui traînent dans la nuit leurs ailes de velours.
Rien ne respire autour de nous, rien ne s'agile,
Rien ne viendra troubler la paix de notre gîte.
Oh! n'ouvrons pas nos yeux, ne levons pas nos
 fronts!

Dormons profondément! Nous nous réveillerons
Plus tard, bien tard, pas même aujourd'hui, pas
 encore
Mais demain seulement, quand, pour fêter l'aurore
Dans le rayon filtrant par le trou du volet,
Les atomes dorés danseront leur ballet.

JEAN RICHEPIN.

PLATE 11 (*opposite*) | Pablo Picasso, *Les Morphinomanes*, 1900, oil and pastel on canvas, 55.2 × 46.4 cm, private collection, © Succession Picasso/DACS, London 2023.

PLATE 12 | Louis Legrand, *Au Café*, before 1910, pastel on paper, unknown dimensions, unknown location. Reprinted in Camille Mauclair, *Louis Legrand, peintre et graveur* (Paris: H. Floury et G. Pellet, 1910), 248.

3

Feminising the *Morphinomane*

'Are men more often addicted to morphine than women?' asked Paul Regnard in an 1885 article for *Revue scientifique*.[1] A survey of artworks depicting the *morphinomane* would lead us to believe that morphine addiction affected women almost exclusively; but, as Regnard continued, his consultation of 1884 statistics showed that amongst a hundred habitual morphine users it was rare to find more than twenty-five women.[2] In 1889 Georges Pichon conducted his own statistical study after visiting various asylums, hospitals, patients, and acquaintances and found that out of 120 habitual users 66 were men and 54 were women.[3] In addition, Paul Rodet's landmark statistical study of 1897 showed that out of 1,000 habitual morphine users 350 were women and 650 were men.[4] In the following decade, Paul Sollier concluded that 70 per cent of morphine users were male.[5] Although these statistics vary, they undoubtedly contradict the overwhelming visualisation of the *morphinomane* as female.

Medical professionals attempted to offer explanations for the high number of male habitual morphine users. Whilst one doctor acknowledged that women made up only a quarter of users, and that statistics supported this, he claimed in the same article that women users were more numerous.[6] Similarly, Regnard argued that the numbers were likely not accurate because women were better at concealing their addiction.[7] These examples are indicative of a wider tendency to diverge from the truth and to promote the feminised narrative of morphine use and addiction found in visual culture. By perpetuating ideas about femininity that were manifesting in the medical sector and in French society more broadly, artists drew on two key themes that contributed greatly towards the feminisation of *morphinomanie*: the existing feminisations of illness and of fashion, which form the two sections of this chapter.

Constructing Contagions

The synergistic relationship between text and art reveals that a significant contributor to the feminisation of *morphinomanie* was its characterisation as

a contagion that shifted between pathophysiological disease and neurosis. Two cholera pandemics (1881–96 and 1899–1923), the consistent threat of tuberculosis, which peaked in the 1880s and 1890s, and a prevalent syphilophobia provoked extensive concerns about contagious diseases in fin-de-siècle France. Women were typically perceived as the vectors of these illnesses and rarely their victims. As demonstrated by Jan Goldstein, the professionalisation of psychology and the shaping of neurology as a medical specialism meant that the latter half of the nineteenth century was replete with the classification of various neurotic illnesses and manias, many of which were feminised.[8] Women's supposed susceptibility to deviant behaviours and to these socially constructed psychological disorders was based on an assumption of inherent weakness and emotional instability. Now, in the twenty-first century, it is understood that there is a distinction between socially constructed diseases such as hysteria, the real psychological and physical addictiveness of opiates, and the pathophysiological conditions of tuberculosis or syphilis. At the end of the nineteenth century, particularly following France's defeat to Prussia and concomitant concerns about degeneration, however, each of these types of illness was perceived as similarly dangerous to the individual and to the national body.

In the 1860s Louis Pasteur analysed the presence of organisms in the air, driving discussions on public hygiene. By 1875 scientists had confirmed the existence of tertiary syphilis. Whilst syphilis had been referred to as a contagion since the sixteenth century, the second half of the nineteenth century saw new debates arise on the contagious nature of secondary symptoms of the disease alongside increased knowledge on bacterial germ theories. In 1877 French physician Auguste Benoist de la Grandière claimed that contagious diseases spread through the air, thereby reinforcing the feared relationship between germs and diseases. And in 1882 Robert Koch identified the tubercle bacillus, thus proving that tuberculosis was contagious. Discussions on diseases permeated fin-de-siècle society and an array of lifestyles, habits, and conditions – *morphinomanie* amongst them – were designated as contagions.

Physician Jules Rochard, writing in *Le Temps*, warned that *morphinomanie* was a 'real social danger', whilst journalist Albert Wolff stated: 'the victims of morphine are now becoming so numerous that it is time to worry about them in the same way as smallpox or cholera'.[9] Other medical writers perceived *morphinomanie* as something that could 'spread rapidly' and be 'contracted'.[10] Journalists were more hyperbolic in their vocabulary, with one describing morphine addiction as a contagion that 'threatens future generations'.[11] Writers' emphasis on the supposedly contagious nature of *morphi-*

nomanie paralelled the numerous reports of morphine-related deaths that appeared in newspapers between 1880 and 1910 in the form of accidents, suicides, and murders. By using the same vocabulary to describe *morphinomanie* as might be expected in reports on contagions, writers implicitly aligned the dangers of drug addiction with the impact of contemporaneous diseases – they were a threat to personal and national health.

In *The Making of a Social Disease*, David Barnes discusses attitudes towards the spread of tuberculosis in nineteenth-century France: 'women rarely figured in any account of the disease's causes except as careless wives, dangerous domestic servants, or prostitutes. On the rare occasion when women were portrayed as *victims* of disease, that status was usually secondary to their role as vehicles of transmission or contagion (endangering males).'[12] The perception of women as spreaders of disease extended beyond tuberculosis to other contagions such as syphilis. By further extension, women, particularly bourgeois women, were considered responsible for the health of the family and future generations. 'The health and happiness of women', wrote Maurice Barenne in an 1886 issue of *L'Hygiène*, 'is the health and happiness of all people.'[13] By the late nineteenth century, it was acknowledged that contagions in the form of germs and bacteria could be carried into the home on clothes or through the air, settling in the domestic space as dust and creating unclean surfaces. Women of all classes were held directly or indirectly responsible for the cleanliness of the home. Even though male domestic servants existed, Barnes notes, in nineteenth-century narratives on cleanliness the domestic servant was most often portrayed as female.[14] This implication reinforced women's culpability for any ill health in a home or family; if a household member contracted a disease, a woman could always be blamed.

Contagions in the home that could be spread by dust and microbes were tangible and could be removed (it was believed) by cleaning. Unlike the 'filthiness of housing in the poorer quarters', the bourgeois or *haut-bourgeois* apartment was a relatively clean space that could be protected from many diseases.[15] However, no place, not even the salubrious atmosphere of the bourgeois apartment, could be shielded from the alleged insidiousness of *morphinomanie*. Although medical professionals were gaining some understanding of addiction and withdrawal, little was known about morphine addiction in terms of its physical and psychological symptoms.[16] It was certain, however, that morphine use often originated in the home following visits from the family doctor. Fin-de-siècle journalists exacerbated these observations with phrases such as 'morphine has penetrated everywhere'; in a front-page article of 1886, under the subheading 'Parisians, be careful!',

a journalist warned, 'morphine invades your homes more than ever'.[17] The home's vulnerability in narratives on *morphinomanie* was underscored throughout the period. From reports of police searches in the properties of morphine vendors, to the discovery of bodies and hidden syringes following morphine-related overdoses and crimes, the majority of articles about morphine focused on the home.[18]

Personifying Disease

Throughout the nineteenth century artists made efforts to visualise contagions. Some created exaggerated representations of the microbe or virus, as seen on the front page of an 1884 issue of *Le Grelot*; the illustration shows a monstrous cholera microbe at '125 times larger than life'.[19] Other artists, particularly those working in more conventional art media such as British painter Richard Tennant Cooper, created personifications of contagious diseases. In a series of several paintings commissioned by Henry Wellcome around 1912 when Cooper was working in Paris, the artist included personifications of typhoid, cholera, and tuberculosis.[20] One of his portrayals of syphilis personifies the venereal disease as a naked, female perpetrator (Fig. 3.1). He also shows the physical symptoms of the disease through its portrayal as a vulnerable male victim who is covered in syphilitic rashes. Unlike these diseases, however, opiate addiction does not display physical symptoms, nor is it spread from a microbe, so it was more difficult for artists to visualise *morphinomanie* as a contagion. In a manner perhaps comparable to Cooper's personification and feminisation of syphilis, artists' depictions of female figures as the *morphinomane* offer a visualisation of *morphinomanie*: a contagious, insidious disease, personified and existing within the home. What is more, many artists perpetuated anxieties about the home by depicting the morphine addict in the domestic space, dramatising *morphinomanie* as a (contagious) intruder of the clean, bourgeois or *haut-bourgeois* home. Portrayals of the *morphinomane* in domestic spaces not only reinforce the violability of the home and the insidiousness of *morphinomanie*, but also feminise the drug and its users by association with a space constructed as feminine.

Depicting morphine-addicted female figures in a domestic space enabled artists to show them as reclining or collapsed, a common trope found throughout art history. In art, recumbent bodies at home can represent sickness or vulnerability, the diseased or dying body. Since morphine was renowned for its sleep-inducing properties, the drug lent itself easily to portrayals of the (female) *morphinomane* reclining or collapsed at home, as can

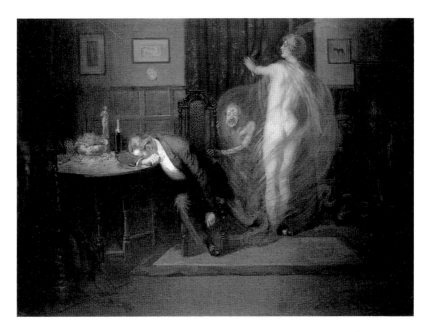

FIGURE 3.1 | Richard Tennant Cooper, *Syphilis*, 1912, gouache on board, 52 × 70.5 cm, Wellcome Collection, London, in copyright.

be seen across media, from oil on canvas to caricature. It is not uncommon to see recumbent and sick female figures in art throughout the nineteenth century, but depictions of men reclining or sleeping are rare. Femininity too lends itself to depictions of vulnerability with sexualised undertones, and such poses echoed women's traditionally assumed inherent weaknesses. In *morphinomane* visual culture the weakness of the addict's 'diseased' body, as portrayed through these reclined poses, reinforced women's supposed susceptibility to addiction and their need for morphine to mask physical or psychological pain.

The feminisation of the *morphinomane* body is best understood through a brief analysis of one of the very few images of a male morphine user. Léon Kern's caricature, which appeared in a 1911 edition of the humorous newspaper *Le Pêle-Mêle* (Fig. 3.2), epitomises the perceived feminisation of *morphinomanie* specifically and of addiction more broadly. With reference to weaning a patient off a morphine addiction, the accompanying caption notes, 'it would be dangerous to suddenly deprive the young *morphinomane* of his favourite drug'.[21] Kern represents the figure's body as a fluid form. As emphasised by the prematurely aged face of the 'young *morphinomane*', this male morphine user is so weak that its limbs cannot support its body. Kern's

FIGURE 3.2 | Léon Kern, 'Maladies à ménager', *Le Pêle-Mêle*, 3 December 1911.

inclusion of a chaise longue – an item of furniture most often associated with both femininity and lassitude – contributes further to the emasculation of the figure's body and reinforces *morphinomanie* as a feminised and feminising contagion. Masculine strength (moral, physical, and psychological) is not at all synonymous with morphine addiction.

Morphinomanie *by Persuasion*

Artworks depicting morphine users often show two or three female figures. This practice not only detracts from the often isolated reality of addiction, but it also creates a false narrative of sociability, echoing contemporary assumptions that women were the catalytic force behind this so-called contagion. These portrayals of female figures support claims in scientific journals, novels, and newspaper articles that *morphinomanie* was spread between (female) friends, leading to new users. Henri Guimbail dedicated a section of his medical study on morphine use to what he defined as '*morphinomanes* by persuasion'.[22] Similarly, Maurice Notta remarked that women 'distribute [morphine] to friends who are too curious', whilst D. Bougon stated that a female morphine user was injected with morphine 'on the advice of a *morphinomane* friend'.[23] Newspapers reiterated these ideas. In one of many examples, a front-page article for the national newspaper *Le Petit Parisien* condemned the 'poor weak women' who let themselves be 'led by the example of [their] friends or neighbours'.[24] By strengthening the association between weakness, femininity, and *morphinomanie*, the journalist offers an

explanation for women's susceptibility to morphine addiction and, therefore, for why *morphinomanie* could be spread between friends, as was so frequently depicted in visual culture.

'Morphinomanes ... look for each other, seek each other out and form a strange morbid Freemasonry', stated one doctor in an interview for *La Presse* in 1904.[25] It was believed that women would congregate together, administering morphine as a new form of social activity. Artists visualised similar anxieties about this new manifestation of women's sociability by showing morphine users engaging in socially acceptable activities, primarily tea drinking. In a caricature in *Revue illustrée*, Albert Lammour shows a male waiter carrying a tea tray to two female *morphinomanes* (Fig. 2.2). A similar narrative is put forward in other artworks, such as paintings by Albert Matignon (Plate 9) and Serafino Macchiati (Fig. 5.5). These visualisations align tea drinking with morphine use, inferring that addiction and drug use may have originated with socially acceptable (feminised) activities.[26] This speaks to broader contemporary anxieties about women's sociability, demonising their growing social freedoms at the end of the nineteenth century.[27] Moreover, the female figures in these artworks are almost always shown as soporific and hedonistic, despite the unpleasant and potentially dangerous effects of withdrawal from sustained morphine use. Representations of the *morphinomane* as hedonistic play into broader concerns about decadence and excess, whilst disregarding the debilitating nature of addiction and its most often medically induced point of origin. Notions of hedonism and sociability in these images present a problematic narrative of addiction being a choice for which one can be blamed; images of the *morphinomane* rarely leave the viewer feeling sympathy for the figure.

Artists, medical writers, and populist authors of the mid- to late nineteenth century often stressed that it was women who introduced *morphinomanie* into the home. A female morphine-addicted patient at Saint-Louis hospital in Paris reportedly 'led her husband down the same path', thus positing the woman as the perpetrator of *morphinomanie* or carrier of the supposed contagion.[28] In 1891 a writer under the pseudonym Docteur X claimed that 'very often and perhaps even most often, it is the woman who leads the man' to administer morphine in order to create a 'pleasure companion'.[29] By the turn of the twentieth century, however, there was a shift in this narrative which suggested an incipient acknowledgement of the true statistics. Newspapers printed reports on the deaths of both male and female morphine users, thereby including unavoidable accounts of morphine-related deaths of illustrious men such as those in the military. There were also reports of husbands encouraging wives to self-administer morphine. In coverage of the

Wladimiroff trial, for instance, Henry Fouquier stated that Madame Dida, who was murdered in 1890 by Pierre de Wladmiroff, had been introduced to morphine on her husband's advice.[30] Similarly, in 1897 Rodet stated in his medical book *Morphinomane et morphinisme* that it was more common for the 'contagion' to be passed from husband to wife.[31] Nevertheless, artists disregarded this shift in narrative and continued to depict female figures as the vectors of *morphinomanie*.

One of the few exceptions to the representation of the *morphinomane* in art as exclusively female was a lithograph by Théophile Steinlen (Plate 10), whose successful career was built mainly on creating illustrations for magazines and novels. This unusual image, which appeared in *Gil Blas illustré*, was created as an illustration to *Les Possédés de la morphine*, a semi-fictional text about morphine addiction by French author Maurice Talmeyr.[32] The use of plurals in the print's caption, a quotation taken from Talmeyr's text, states that both figures in the illustration are addicted to morphine: 'They awaken to a sordid unconsciousness, to a slumped and disgusting indifference, to dirty shirts, to black hands, to debasement and filth.'[33] The excerpt reiterates the false dichotomy of clean/healthy *versus* unclean/diseased. This has significance in terms of the broader characterisation of addiction as a contagious disease at the end of the nineteenth century, but it also has impact in more recent discussions of addiction; to come off drugs is to be 'clean', with the problematic implication that addiction is therefore dirty.

Talmeyr does not detail how these morphine addictions originated, but the relationship between the two figures in Steinlen's visualisation is noteworthy and likely corresponds to contemporary discourse on women being the vectors of *morphinomanie*. The female figure sits in the print's foreground, overshadowing the male figure. In a less exaggerated version of Kern's *Le Pêle-Mêle* caricature, Steinlen's male figure sits behind the female figure and has a slouched pose and small stature. These tropes are indicative of weakness and a lack of masculinity resulting perhaps from his addiction or from his wife's control over him – or both.

Excerpts from Talmeyr's book were printed in *Gil Blas* during the week leading up to the publication of Steinlen's print in *Gil Blas illustré* at the weekend. Although Talmeyr does not mention any furniture in his description of this scene, Steinlen includes a sofa and a folding screen. This choice of furniture reveals more about the couple's relationship. The arm of the sofa forms a barrier between the two figures, perhaps symbolic of a physical and psychological separation. In late nineteenth-century art, folding screens generally symbolised physical intimacy or voyeurism. But the sofa barrier between the couple in Steinlen's print disrupts the screen's sexual potential

and functions instead to emphasise the sexual disconnect between the figures. This disconnect alludes to the wider effects of morphine addiction – the male figure's loss of virility and its effect on reproduction.[34] Morphine's long-term effect on male and female reproductive organs was relatively well known and was discussed in medical journals and popular newspapers. It became a major concern at the end of the nineteenth century due to France's decreasing population and circulating ideas about degeneration. It was a woman's role to reproduce and raise a family, but visualisations of (female) *morphinomane* figures imply that they were sacrificing opportunities for reproduction and thus sabotaging the promise of future generations.

Syphilis and the Morphinomane

Like morphine addiction, syphilis was seen as a threat to France's population. The contagious nature of syphilis, its association with degeneration, and its impact on birth defects and infertility placed women at the centre of the nineteenth-century syphilis epidemic. In addition to 'Morphinomane by persuasion', Guimbail described another way of contracting a morphine addiction: '*Morphinomanie* of the innocents'.[35] In his medical book on morphine addiction, Guimbail established a direct link between *morphinomanie* and *syphilis insontinum* (syphilis of the innocents) by likening foetuses developing an opiate addiction from the mother's habitual use to the transmission of syphilis from mother to unborn child.[36] Emphasis on the effect of syphilis on newborns resulted in nineteenth-century medical professionals often blaming women for the spread of this contagious venereal disease. Mothers were blamed, despite often being what Susan Sontag has described as an 'unsuspecting receiver' from an 'ignorant sender', and prostitutes were blamed because they were deemed the point of origin of syphilis.[37] By the turn of the twentieth century, attitudes towards syphilitic mothers had shifted slightly since the publication of Alexandre Parent-Duchâtelet's monumental *De la Prostitution dans la ville de Paris* in 1857.[38] In his 1887 book on syphilis prophylaxis, the nineteenth-century syphilographer Alfred Fournier details his understanding of the transmission process and its prevention: 'The contamination of the virtuous spouse and the contamination of the child are often only the products of the syphilis of the prostitute. Consequently, to pursue the syphilis of the prostitute is to protect ipso facto the virtuous woman and the child.'[39]

Syphilis and prostitutes were inextricably connected and both deemed a substantial threat to France's future. Contemporary writers and medical professionals likened syphilis to *morphinomanie*, as did some artists. A useful

example of this can be seen in Pablo Picasso's *Les Morphinomanes* (Plate 11), an oil and pastel on canvas created during the artist's first stay in Paris in the autumn of 1900. In this work, two female figures walk on either side of a shadowed figure who is presumably male. The unkempt attire of the female figures implies their disreputable social standing. The night-time setting, the female figure's exposed chest, and the use of heavily applied makeup further indicate their status as prostitutes. Contemporary viewers, living through what nineteenth-century physician Paul Berthod called 'venereal peril', would have undoubtedly associated these (*morphinomane*) prostitutes with syphilis.[40] Picasso's choice to label them as *morphinomanes* places morphine addiction directly in the same pictorial, scientific, and populist discourse as the threatening venereal contagion. The male figure in this painting, dressed in dark clothing and surrounded by 'dangerous' prostitute types, is led to his early demise, abetted by syphilis and morphine.

Picasso uses unexpected tones on the female figures' skin. Unblended pinks, yellows, and greens create an imperfect representation of skin, alluding to dirtiness and, perhaps, syphilitic rashes. Comparable representations of dirtied skin appear in other depictions relating to syphilis. The Catalan artist Ramon Casas, for instance, dirties the skin of the female figure in his turn-of-the-century poster advertising a syphilis clinic in Barcelona (Fig. 3.3). The use of grey on the figure's skin goes beyond using shadow for the illusion of depth, and functions to reinforce the same dichotomy of clean/healthy *versus* unclean/diseased as seen in the Steinlen lithograph.[41] *Morphinomanie* and syphilis were perceived as contagious diseases rooted in femininity. Picasso's *Les Morphinomanes* perpetuates women's role in spreading venereal diseases and, ultimately, in spreading *morphinomanie*. The contemporary understanding of morphine addiction as part of this discourse on contagions and venereal diseases contributed significantly towards the feminisation of *morphinomanie*; women's suffering of life-threatening contagions and addiction was subordinate to their status as vectors of 'disease'.

Picasso was not an exception in his portrayal of the morphine-addicted sex worker. Several artists, including Hermenegildo Anglada-Camarasa and Louis Legrand (Plate 12), indicate the female *morphinomane*'s disreputable nature through prostitutes' outward appearance, night-time settings, and urban locations. The *café-concert* was the location of choice for artists depicting the *morphinomane* in public. These entertainment venues were unique locations because they were frequented by different classes of prostitutes at the end of the nineteenth century. As such, *cafés-concerts* were deemed a symptom of degeneration and became one of the 'principal targets' for the threat of syphilis.[42] These venues were not only problematic because they

FIGURE 3.3 |
Ramon Casas,
Sífilis, c.1900, colour
lithograph, 66.3 ×
28.2 cm, Wellcome
Collection, London.

were deemed the source of vices and venereal diseases, but the actual events were 'looked upon as a contagion', as Rae Beth Gordon has shown, particularly by those concerned with the increasing number of working-class *cafés-concerts*.[43] *Morphinomanie* was also believed to be rife at *cafés-concerts*, likely due to the presence of the same 'unscrupulous' women who were continually associated with habitual drug use. Artists' combination of the problematic *café-concert* location with prostitute-*morphinomane* figures reinforced the perceived danger of these venues and led to broader debates on hygiene and contagion. By implying a link between their association with supposedly degenerate locations and hedonistic drug use, artists reiterated the threat to society of these socially 'dangerous' women.

Manias and Neuroses

In a discussion of Yvette Guilbert's recent *café-concert* performances, which included 'La Morphinée', morphine was described as the 'orchestra conductor'.[44] Michel Zévaco, the reviewer, added that Guilbert's body was the 'quintessence of feminine neurosis'.[45] As with syphilis, it was believed that psychological and degenerative disorders could be spread at *cafés-concerts* amongst attendees or from the performers, whose songs about neuroses could manifest in spectators.[46] Psychological disorders were at that time often perceived as degenerative contagions and women were believed to be most susceptible. The 'contemporary woman' was characterised by 'unconscious neurosis', claimed Octave Uzanne in 1886.[47] Amongst the many neuroses that had been newly categorised with the professionalisation of psychiatry were neurasthenia (a nervous disorder thought to be due to overstimulation), hysteria, kleptomania, hypochondria, ennui (the state of boredom and dissatisfaction with life) and, I propose, *morphinomanie*. In fact, the first substantial mentions of *morphinomanie* in newspapers can be found in columns about Benjamin Ball's medical lecture on morphine at the Sainte-Anne psychiatric hospital in Paris from 1884.[48]

It was believed that hypochondria stemmed from women's innate weakness and susceptibility to pain, which were also deemed causes of morphine addiction. Hysteria, another feminised disorder, which had been associated with women for centuries, had reached its 'golden age' in the 1880s.[49] Like hypochondria, hysteria was often characterised by an overall feeling of 'habitual anxiety' and was associated with morphine addiction in various ways.[50] In his landmark study of 1891, Guimbail argued that addiction to morphine could bring out dormant hysteria symptoms: 'out of ten *morphinomanes*, one must expect to find eight hysterics'.[51] A few years later, in an

FIGURE 3.4 |
Paul Regnard, 'Attaque: Crucifiement,' interior collotype, Désiré-Magloire Bourneville and Paul Regnard, *Iconographie photographique de la Salpêtrière: Service de M. Charcot* 2 (Paris: Progrès médical, 1878), plate XXXVI.

article in *La Médecine nouvelle*, an S. Faber stated that morphine addiction could cause 'attacks comparable to crises of hysteria, epilepsy, or even ... a kind of acute mania'.[52] These assertions had real-world consequences. In the latter half of the nineteenth century, morphine was used at the Salpêtrière hospital and other Parisian asylums to subdue hysteria patients.[53] At the same time, habitual morphine users were admitted to these institutions because of their addiction, whilst other patients later required treatment for morphine addiction as a result of the drug's being prescribed for other disorders.[54] Jean-Martin Charcot's conceptualisation of hysteria derived from case studies of his patients and the photographic documentation of hysteria,

as seen in the three volumes of *Iconographie photographique de la Salpêtrière*. The unnatural postures of the hospital's hysteria patients (Fig. 3.4), particularly Blanche (Marie) Wittmann, became synonymous with hysteria. Santiago Rusiñol employs this iconography of hysteria in his 1894 oil on canvas *La Morfina* (Plate 5). Rusiñol's choice to depict a slightly arched back and rigid hands, as seen in several photos of *Iconographie photographique*, concretises the contemporary medical association between feminised neuroses and addiction.

Ennui, understood as the 'state of emptiness that the soul feels', was another neurosis connected with addiction.[55] French physician Émile Tardieu, in his substantial psychological study of 1913, *L'Ennui*, argued that ennui caused a 'drive towards voluptuousness' – a word often associated with women's morphine use.[56] Similarly, a writer for *Nice-médical* noted that ennui was 'one of the greatest factors of *morphinomanie*' and an article in *Le Gaulois* claimed that 'the bored' and 'the idle' were key users of morphine.[57] Added to this was the frequent characterisation of ennui as a microbe that could spread.[58] But, unlike syphilis or tuberculosis, ennui was constructed as an illness almost exclusively of the *bourgeoisie* – the same group that were deemed most prone to *morphinomanie*. Like morphine addiction, ennui was often feminised. Women were deemed more susceptible to ennui because 'the [bourgeois] woman lives in boredom', according to Tardieu, who described ennui specifically as 'the woman's demon'.[59] These notions of emptiness and nothingness echo artists' use of the iconography of boredom and the absent gaze, key tropes used by artists in their visualisation of the *morphinomane*.

Ennui was to be feared because it was linked to idleness, 'the mother of all vices'.[60] By analogy with *morphinomanie*, women's ennui and idleness were especially problematic since it was believed that women should dedicate their time to being good wives and mothers. If women were not occupied in these roles, ennui could cause them to indulge in dangerous forms of entertainment ranging from excessive piano playing and illicit affairs to unrestrained shopping (leading to kleptomania), drug use, and reading.[61] Paralleling the influx of fictional literature on morphine addiction, which coincided with the visual proliferation of *morphinomanie*, Rodet wrote of 'contagion by book' in his monograph *Morphinomanie et morphinisme*, noting that the type of people who read fiction were 'neurotic women' whose curiosity leads them to 'transform the description of morphine sensations into lived sensations'.[62]

Artistic references to ennui demonstrate how the connection between *morphinomanie* and feminised neuroses contributed to the feminisation of

morphine addiction. The frequent inclusion of books in *morphinomane* imagery creates and perpetuates the interrelationship between ennui as a feminised neurosis and habitual morphine use. The open pages of the book in Georges Moreau de Tours's *La Morphine* (Plate 1) indicate that it was being read before the morphine was administered, perhaps implying that the figure was inspired to take morphine as a result of reading. The book on the floor of Vittorio Corcos's painting (Plate 4) functions in a similar way. Corcos depicts the moment after the book has dropped to the floor, possibly as a result of boredom and a desire for a more extreme form of stimulation such as morphine. In both works, the figures' status as *morphinomanes* alludes to the symptoms of ennui and acts as a reminder of the possibilities of inappropriate relief from boredom – the desire to seek out ever more pleasurable experiences (reading or morphine use) to detract from the boredom of modernity.

Since the symptoms and causes of these neuroses were often interchangeable and socially constructed, nineteenth-century psychiatrists' efforts to categorise the disorders met with difficulty. French writer Henri Duvernois, in his critique of fin-de-siècle novels, for instance, clustered nymphomaniacs and *morphinomanes* with the other 'sad examples' of 'nervous breakdowns'.[63] Analogously, doctors Guimbail and Lubin-Émile Delorme made direct comparisons between *morphinomanie* and other degenerative conditions such as neurasthenia.[64] The former was believed to be both a cause and result of the latter. It was also proposed that a person experiencing ennui might become a kleptomaniac or neurasthenic, as both were considered conditions of modernity, whilst an article in *Le Petit Parisien* implied that kleptomania could be directly caused by *morphinomanie*.[65] Each of these psychological neuroses focused on women's behaviour and emotionality, highlighting their excess and social expectations about femininity. This is no more apparent than in consumerist neuroses such as kleptomania, since both kleptomania and *morphinomanie* were ostensibly rooted in women's uncontrollable desires and the indulgence of modern consumerism.[66]

Fashioning Femininity

In the early nineteenth century, with the expansion of consumer culture, consumerism became constructed as feminine. The mid-nineteenth century saw the rise of the department store in Paris and further afield. By the end of the nineteenth century, department stores targeted women almost exclusively. In late nineteenth-century France, as argued by Lisa Tiersten, the bourgeois woman's new role as consumer risked lowering the standards of

French taste and republican ideals.[67] Furthermore, according to a study by Leora Auslander, the role of bourgeois women as consumers, was to 'adorn themselves' and to 'represent the family's social identity through goods'.[68] The bourgeois home was to be different from other homes – but not too different. Analogously, it was expected that women strive for a similar state of equilibrium across all aspects of fashion and consumerism. Women should have a modest interest in fashion in order to demonstrate awareness of their public appearance, but there was a fine line between respectability and extravagance. Department stores functioned primarily to target women who desired commodities, yet if women desired too much it became a cause for concern. The *morphinomane*, as depicted by artists, represents such problematic lapses into excess – extravagance, which verges on decadence, and an insatiable craving for both fashion and morphine.

Abigail Susik examines Eugène Grasset's *La Morphinomane* (Plate 3) in relation to fin-de-siècle consumer culture by placing the morphine addict at an intersection of the capitalist potential of the print's '*japoniste*-avant-garde' style, social degeneration (via morphine and consumer culture), and the female figure as consumer.[69] Susik concludes that Grasset's *morphinomane* is simultaneously the consumer and the consumed. Thus, the *morphinomane*, whose inherent femininity, or weakness, creates an insatiable desire for morphine, finds a place within a discourse on women's consumerism. Beyond Grasset's *La Morphinomane*, I contend that depictions of the *morphinomane* more generally should be understood as part of a broader discussion on fashionable women and anxieties about independent women with money. By representing the *morphinomane* as female, wealthy, and fashionable, artists associated the habitual morphine user with the (feminised) consumer and contributed to existing narratives on women's fashions and the concealment of addiction.

Expressions of Wealth

Morphine was attainable only by the 'rich and wealthy classes', according to one doctor writing in 1891.[70] Newspapers and scientific texts continually reminded their readers that morphine addiction was 'the alcoholism of the rich', contrasting the recent surge in opiate use with widespread alcohol consumption in France.[71] Alcoholism was fuelled largely by the low cost of alcoholic beverages, which were accessible to almost all income levels by the end of the nineteenth century. In contrast, morphine addiction was associated with those wealthy enough to afford doctors' visits and prescriptions. Newspapers often included an estimated value of morphine stock-piles in

news reports in order to emphasise the drug's high cost.[72] Traffickers selling morphine illegally after the turn of the twentieth century made it easier to obtain the drug, although it remained relatively expensive.[73] Many reports, including scientific studies, asserted that any morphine use in the poorer classes was usually due to their working in wealthy households as domestic servants or seamstresses.[74]

According to newspaper reports at the time, large bottles of morphine were often found in the homes of socialites (*mondaines*) and *demi-mondaines*. Since both of these categories of femininity had expendable income, they were targeted as consumers. Paul Brouardel, a specialist in forensic medecine, reported visiting the home of a *mondaine* in 1889 and seeing a bottle holding 200 grams of morphine, likely similar in size to the bottle seen in *La Morphine* by Moreau de Tours.[75] Nineteenth-century writer Louis Régnier also noted that wealthier *morphinomanes* were known to buy more than 200 grams of morphine at a time directly from druggists.[76] These quantities far exceeded even a typical weekly supply of morphine (the average dose, according to Rodet, was between 50 centigrams and 1 gram per day).[77] The size of the bottle in these artworks shows not only the extent of the users' addictions, perpetuating an association between wealth and morphine use, but also the extent of their discretionary income. It reinforces ideas about excessive consumption, which are applicable both to consumer culture and to problematic ideas about addiction, as well as the broader themes of national degeneration and decadence.

Through visual culture, artists orchestrated the image of the affluent *morphinomane* using domestic interiors as symbols of wealth and femininity. The large stone balcony and references to *hôtels particuliers* in Moreau de Tours's canvas situates these *morphinomanes* in a wealthy home. Likewise, for the humorous and mildly erotic magazine *La Vie Parisienne*, Louis Vallet created an illustration to accompany a text by Marion titled 'De trois à sept' (Fig. 7.2).[78] The text gives descriptions of various female characters who live in different Parisian *quartiers*, referencing a popular genre of urban fiction dating back to the 1830s that classified urban types found in certain parts of Paris. Vallet's illustration of a *morphinomane* – whose state is reinforced via the inclusion of morphine paraphernalia in the illustration – accompanies a text describing the Quartier des Champs-Élysées, an area of Paris known for its affluent inhabitants and fashionable shops.

Another illustration by Vallet appears in 'Cabines de toilette et dessous' (Fig. 3.5), a similar fictional text from *La Vie Parisienne*, also written by Marion, which tells of a female character who regularly uses morphine; again, Vallet includes paraphernalia.[79] Vallet's illustration corresponds to

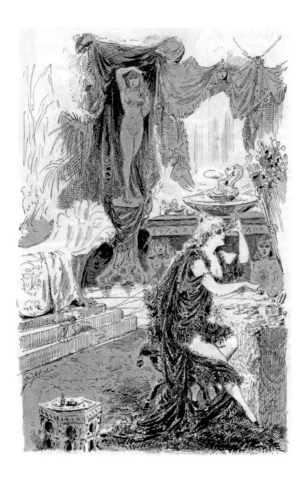

FIGURE 3.5 | Louis
Vallet, 'Rue de Prony,'
Marion, 'Cabines de
toilette et dessous,' *La Vie
Parisienne*, 21 February 1891.

many of the interior details described in the accompanying text, including
the 'fur carpet' that adorns the room, along with a white marble statue on
'a pedestal of malachite', a 'green marble dressing table', and an 'oriental
table', which holds a bottle of morphine and syringe.[80] The wealth of this
morphinomane is highlighted by the array of expensive materials and ob-
jects. The excess of fabric draped over the otherwise naked female figure
encapsulates the surplus of wealth that became associated with problematic
consumers and *morphinomanes*. The illustration is captioned 'Rue de Prony',
a wealthy area of Paris that was reportedly home to disreputable inhabitants.
Rumours about this particular street fuelled the cultural imagination. On
the rue de Prony, one could find 'a Lilliputian masterpiece, nicknamed the
eighth wonder of the *demi-monde*', narrated Arsène Houssaye in his fictional
anecdote of 1885 on the character Mademoiselle Fleurs-de-Lys.[81] In Vallet's
illustration of the morphine-addicted figure of the rue de Prony, affluence,

morphinomanie, and women of dubious morals are coalesced through the depiction of the figure's living quarters.

On 1 June 1890, the front-page image for *Le Bon Journal*, a relatively popular weekly publication that printed serialised novels and short stories, was an engraving by Émile Bayard (Fig. 6.2).[82] It was one of several accompanying front-page artworks created to illustrate Albert Delpit's novel *Comme dans la vie*, which was serialised in *Le Bon Journal* between May and July of 1890. Bayard's engraving shows the novel's two protagonists, Madame Readish, who injects a syringe of morphine into her shoulder, and Roland Montfranchet, who sits at a desk in the corner. The print could have been a cropped composition focusing on the morphine injection, but Bayard filled the illustration with the imagined home of Readish: an opulent interior with a large porcelain vase, high ceilings, an electric lamp, luxurious fabrics, and many items of furniture. Delpit's text only mentions a table, a chaise longue, and a silk pillow, but Bayard chose to reinforce the association between wealthy, independent women and *morphinomanie* through his depiction of the domestic interior. Not only is the morphine-addicted Readish wealthy; Bayard's illustration informs the viewer that she is fashionable too. The solid blackness of the large hatbox stands out against the monochromatic lines and blank areas that form the rest of the illustration. The hatbox is indicative of nineteenth-century women's fashion interests – a presumption reinforced visually by Bayard and yet another item that Delpit does not mention.

Women with disposable incomes, such as the fictional Readish, had become targets for the interlocking fields of consumerism and fashion. This trend was heightened by the recent rapid growth in the production of clothing, particularly *grand couture* (the creation of exclusive clothing for the very wealthy by designers such as Charles Frederick Worth) and *confection* (the mass production of ready-made clothing aimed at the bourgeoisie). The items of clothing depicted in most *morphinomane* imagery show the types of *haute-couture* clothing that both *demi-mondaines* and *mondaines* often wore, hence fuelling anxieties regarding the ability to distinguish honest women. Morphine was associated with the same affluent women who were constructed as consumers of fashion. Thus, fuelled by artists' images of fashionable women as the *morphinomane*, a synonymy was formed between habitual morphine use and women's fashion.

Desires for Morphine and Fashion

Valerie Steele remarks that 'the fashionable Parisienne was herself an icon of modernity'.[83] And, like fashion, morphine represented modernity. Morphine

was a current social issue, a relatively recent discovery in modern medicine, and was the focus of contemporary newspaper articles, artworks, and other cultural forms. The artists who chose to depict the *morphinomane* were often painters and printmakers of modern life or newspaper illustrators, whose drawings commented on issues of the day and society's anxieties. The *Le Figaro* journalist known as Labruyère claimed 'morphine has become a fashion', following the showing of Moreau de Tours's *La Morphine* at the 1886 Salon des Artistes Français.[84] The timing of this article underscores the influential role played by visual culture in depicting and dictating fashions in clothing and social trends. In art, portrayal of the *morphinomane* in fashionable clothing situates the habitual morphine user within its distinct fin-de-siècle period. This placement not only reinforces the drug's association with fashionability but also gives the social issue a sense of relevance and urgency.

As early as the 1870s national newspapers described morphine as 'the current vogue' and something that was becoming 'more and more fashionable'.[85] By the 1880s, morphine was frequently labelled a 'feminine luxury' and something that was a 'fashionable vice'.[86] The drug was described as a new object of consumption for women, like buying an extravagant hat or a new pair of gloves. In artworks where *morphinomane* figures are in urban environments and morphine paraphernalia is not depicted, as in paintings by Anglada-Camarasa, artists emphasised extravagant *haute-couture* fashions with ostentatious hats, puffed sleeves, and lavish dresses. Fashionable clothing displaces morphine and one feminised commodity replaces another.

In a front-page article of *Le Petit Parisien*, morphine was simultaneously described by the pseudonymous author Jean Frollo as a 'deadly poison' and as a 'kind of "elegance"'.[87] The latter characterisation reaffirms artists' association of fashionable and affluent women with habitual morphine use, whereas the former indicates the severe ramifications of becoming obsessed with the latest trends; a failure to resist both fashion and drugs. 'Frollo' implies that the desire to be fashionable outweighs the danger of morphine, whilst attesting to the addictiveness of fashion as a threat to society. Other writers made similar assumptions. Morphine was perceived as both 'fashionable remedy' and 'fashionable medicine' and *morphinomanie* was labelled a 'fashionable illness'.[88] The blurring of the boundaries between morphine as a medical treatment and morphine as an object of desire functions in two ways. First, it feminises the drug by associating it with sickness and weakness. Second, these descriptions align fashion with illness, echoing some of the neuroses that linked women with consumerism. A woman could be diagnosed with kleptomania or become a *magasinite* (someone who undergoes a

'specific intoxication from the department store', according to the 1902 publication *Les Voleuses de grands magasins*).[89]

The desires of the fashionable Parisienne merged with the insatiability of the *morphinomane*. A manifest alignment recurred between unscrupulous women – in this case, artists' depictions of the *morphinomane* – and fashionable clothing, the French fin-de-siècle epitome of consumerism. Women's consumerism was considered problematic because, as Rita Felski argues, it could be seen as 'the discourse of female desire'.[90] Just like the reported effects of morphine, the fashionable Parisienne 'seemed to many dangerous and unnatural', a woman who ignored family duties 'in pursuit of her own pleasures'.[91] In notes for his 1883 novel *Au Bonheur des dames* (The Ladies' Paradise), Émile Zola described the department store as a substitute for church-going: '[Women] go there to pass the hours as they used to go to church; an occupation, a place of enthusiasm where they struggle between their passion for clothes and the thrift of their husbands'.[92] The department store became a problematic place, supposedly festering with women's uncontrollable yearnings for fashion and consumer products. Women were supposedly driven by impulses, both as consumers and as sexual beings, in a way comparable to how artists constructed the *morphinomane*.

Artists and writers affiliated sexual and consumerist desires through descriptions and visualisations of women touching fabrics. The silk department in Zola's *Au Bonheur des dames*, for example, became known as a place where women were 'at their most voracious'.[93] Certain materials used frequently in women's clothing became imbued with sensuality and eroticism. In *The Psychology of Clothes*, John Flügel claimed that the 'pleasures of contact with silk, velvet, fur, etc.' gave certain 'pleasant cutaneous sensations' and incurred the 'displacement of skin-eroticism from natural stimuli [sun and air], to clothes'.[94] The abundance of these fabrics in various images of the *morphinomane*, depicted specifically as touching the female figure's bare skin, echoes Flügel's claims about the auto-erotic qualities of these materials, whilst paralleling contemporary discussions on the sensual nature of women touching fabrics. *Morphinomane* figures are frequently collapsed into masses of silken materials that enfold the body. In one of several examples, Vallet's illustration of the *morphinomane* at rue de Prony shows fabric snaking its way up the figure's bare leg from a heap of superfluous material. Bayard's illustration of Madame Readish likewise shows an abundance of fabrics falling over the figure's body. The profusion of drapery in the room's background should also be noted; according to Tamar Garb, this was an artistic trope used in nineteenth-century portraiture to indicate the 'perfect analogue of female decoration and surface seduction'.[95]

An article on kleptomania in a 1905 issue of *Journal de psychologie normale et pathologique* described the 'voluptuous sensations' that occurred when a woman touched silk.[96] Fur was also 'invested in libidinal desires', particularly when worn by women.[97] Like silk, fur conjured the erotic imagination and frequently appeared in *morphinomane* imagery as clothing, accessories, and rugs. Fur rugs, such as those portrayed by Corcos and Vallet, also indicate the wealth of the figures in these works and were often imbued with sensuality and eroticism.[98] Of particular significance is artists' inclusion of fur furnishings and clothing in illustrations of morphine addicts for fictional texts, particularly when authors do not describe these details.

Fur was often seen in images of the *femme fatale* also because of its association with 'violent excess, both sexual and material'.[99] Additionally, as it was in Leopold von Sacher-Masoch's novella of 1870, *Venus im Pelz* (Venus in Furs, translated to French in 1902), fur was eroticised, fetishised, and associated with sexual deviance and decadence.[100] Fur was also understood as an elite commodity, steadily increasing in fashionability towards the end of the nineteenth century. Under its entry in Gustave Flaubert's *Dictionnaire des idées reçues*, fur was simply defined as a 'sign of wealth'.[101] Fin-de-siècle women in furs were socially coded in two categories. Furs were worn either by rich, respectable women, as seen in portraiture since the seventeenth century, or by untamed and sexually aware women.[102] The latter was most often chosen by artists, who frequently clothed such female figures in fur.[103] This dichotomy echoes the constructed dual persona of the *morphinomane*, reiterating the period's anxieties about the 'true' identity of habitual morphine users, which could be disguised by makeup and clothing.

Fashionable and Feminine Paraphernalia

A journalist writing under the pseudonym Tout-Paris for the French national newspaper *Le Gaulois* likened the newly reported bejewelled morphine syringes to the progress of fashion, or the advance from 'the fig leaves and animal skins' of Eve to the innumerable frills of contemporary dresses.[104] As the nineteenth century progressed, syringes and their cases allegedly became adorned with decoration, contributing further to the drug's feminisation and associations with decadence and excess. The last two decades of the century saw recurring reports of bejewelled syringes that could be made to order, in a similar process to the making of an *haute-couture* dress, jewellery, or *objet d'art*.[105] And, not surprisingly, morphine paraphernalia was often described by words associated with femininity. Pichon mentions the 'cute syringes' and 'artistic bottles' that women with 'good taste' were able

to order, while Regnard described the syringes used to inject morphine as 'little' and 'adorable'.[106] A journalist writing for *Le Gaulois* similarly called syringes 'cute trinkets' and 'elegant', whilst 'Frollo' proposed that the syringe had 'become a jewel'.[107] Phrases such as these align descriptions of the hypodermic syringe with articles on the latest clothing trends, directly borrowing tropes from fashion reporting. Such descriptors position syringes as desirable objects intended to appeal almost exclusively to the wealthy female consumer, thus further feminising morphine use via the feminisation of its paraphernalia.

Although artists often portrayed morphine paraphernalia in their images, they disregarded contemporary claims about bejewelled syringes. The size of the syringes in images of morphine use would have limited the ability to add decorative, feminising details. The composition in Bayard's illustration of Madame Readish covers a large space. The print shows the whole room, emphasising both the lavish furnishings and the syringe's small size. The daintiness of the syringe is further indicated by Readish's elegantly raised little finger, which perhaps also infers elitism. The raised little finger also appears in Albert Robida's centrefold 'Les Victimes de la science' in *La Vie Parisienne* (Fig. 4.2), where the caricatured nature of the image exaggerates the raising of the little finger and the tiny syringe seems hardly to fit in the figure's hand.

It is the small size of these syringes alone that feminises the paraphernalia. This observation is enhanced by the existence of the few known examples that show a male figure holding a syringe of morphine: the doctor injecting a male *morphinomane* in the caricature from *Le Pêle-Mêle* (Fig. 3.2); a caricature by Tel [Raoul Cabrol] from a 1912 edition of *Le XIXe siècle* (Fig. 3.6), which concerns drug trafficking; and a caricature by Stop [Louis Morel-Retz] of Guy de Maupassant's play *Musotte* (Fig. 4.3). The latter shows the character Dr Pellerin preparing to inject the character Musotte with what is comically described as a 'small injection of morphine'.[108] In contrast to the miniscule syringes in images of female figures, which are certainly more to scale, male figures hold enormous syringes of morphine. These gigantic syringes allude both to the instrumental role of doctors in creating morphine addictions (an emphasis on the diagnostic rather than on leisure and portability) and to the power medical professionals had over their addicted patients.

Caricature allowed artists to exaggerate the syringe, under the guise of humour and its predetermined non-naturalist style. Tel and Stop are thus able to portray these male figures holding absurd syringes. The syringe held by Tel's drug trafficker is particularly phallic, reinforcing contemporary allusions to the syringe as penetrator of the (female) body. Susan Stewart

LE FAIT DU JOUR

« En ce moment, la police donne la chasse aux morphinomanes et aux trafiquants de cocaïne. » (Les Journaux.)

UNE ARRESTATION

— Le temps de m'insensibiliser et vous pourrez me passer à tabac toute la soirée!...

FIGURE 3.6 |
Tel [Raoul Cabrol],
'Le Fait du jour,'
Le XIXe siècle,
28 December 1912.

metaphorises the miniature as bourgeois interiority and the gigantic as the 'abstract authority of the state and the collective, public, life'.[109] Stewart's presentation of this dichotomy echoes the presumed condition of femininity and masculinity in late nineteenth-century France, particularly in terms of social codes and social spaces. Artists' visualisations of the hypodermic syringe as miniature for female figures and as gigantic in the hands of male figures conform to Stewart's claim that the narrative of interiority and of the miniature is 'not a narrative of the object; it is a narrative of the possessor'.[110] Hence, artists' depiction of the object (the syringe), in its archetypal visualisation as miniature, is not just an 'exaggeration of interiority', but should also be understood as an exaggeration – or extension – of femininity.[111] The construction of gigantic as masculine and miniature as feminine implies that it was not possible to portray a male figure holding something so delicate and coded with femininity. The giant syringes held by male figures in these caricatures contradict the actuality of the petite morphine syringe, which is feminised simply by its true size and thus by its visualisation with female figures.

Alongside the feminisation of morphine paraphernalia, undoubtedly enhanced by reports of bejewelling and customisation, there appeared to be a growing market for disguised syringe cases and morphine vials. Some objects were allegedly made specifically to hide paraphernalia under the false exterior of everyday objects. Frédéric Gilbert reported that 'many elegant women' would hide syringes in 'the secret drawer of a piece of furniture', emphasising the drug's use in the domestic sphere and the secretive habits of

the *morphinomane*.[112] Regnard draws attention to these narratives of secrecy in his discussion of the numerous available types of syringe case; many of these models, he states, were created to be discreet and some were even designed to resemble household objects such as match-holders (Fig. 4.4).[113] It was also reported that morphine paraphernalia could be disguised in anything from the handles of fans and umbrellas to cigar cases, bun combs, and embroidery kits. Surreptitious fan handles and embroidery cases are mentioned often, thereby perpetuating connotations of femininity and secrecy (Gaston Jollivet declared that manufacturers strove to hide the syringe 'luxuriously'), despite the likely exaggeration of such claims.[114] The mention of secrecy is yet another sign of concern regarding the identification of morphine users due to their allegedly deceptive makeup and clothing, as indicated in artworks.

Regardless of the overt feminisation of morphine paraphernalia in reports of disguised syringe cases, artists always depict a traditional case or bottle of morphine. This inclusion of paraphernalia functions partly to make the figures' conditions explicit, despite the fact that *morphinomane* figures were generally identifiable by other recurring tropes. With the knowledge that artists borrowed many of these tropes from the visualisations of transgressive femininity, it could be argued that the explicit display of morphine administration and paraphernalia (as opposed to disguised syringes and secrecy) reinforces pre-established notions about the *morphinomane* as brazen and flagrant. The undisguised syringe is for 'shameless morphine addicts', argued Jollivet in a front-page article of 1888 in *Le Figaro*.[115] Legrand's *Au Café* (Plate 12) exemplifies Jollivet's assertion. Legrand's depiction of injecting morphine in a public space portrays the figure's shamelessness and uncontrollable desire for morphine. The fashionable figures in *Au Café* are adorned in fur and wear ostentatious headpieces. The craving for morphine echoes reports of women's yearning for eroticised fabrics and fashionable clothing. Morphine and its paraphernalia are framed as feminised commodities epitomising the dangers associated with unleashed feminine desire.

For many nineteenth-century writers, Felski notes, 'the idea of the modern becomes aligned with a pessimistic vision of an unpredictable yet curiously passive femininity'.[116] To Felski, 'modern' represents the rise of consumer culture. Interpreting the condition of *morphinomanie* as modern and fashionable places the drug within this feminised narrative. The association of habitual morphine use with fashionable women also excludes the male *morphinomane* and simultaneously demonises the desire for fashion and consumerism.[117] Artists chose to disregard reports on bejewelled and surreptitious paraphernalia but instead used miniaturisation alone to suggest

the feminisation of syringes, and thus of *morphinomanie*, whereas the brazen display of morphine injection makes a commentary on wider issues about problematic femininity. Sensualised fabrics such as silk and fur in *morphinomane* imagery function to create affluent and fashionable personas, enhancing the construction of habitual morphine users as feminine and modern. A pivotal cause of the feminisation of the *morphinomane* was artists' alignment of habitual morphine users with three modern concepts: the female consumer, demonised consumer culture (the desire to consume), and the feminised fashionability of turn-of-the-twentieth-century France. Visual emphasis on the *morphinomane*'s wealth via material possessions not only creates an obvious association between fashionable women and morphine, but it also summons contemporaneous anxieties about women's desire, a recurring narrative in discourse on morphine, decadence, and consumerism. By inserting the *morphinomane* and morphine paraphernalia into the feminised discourse of fashion and consumerism, late nineteenth-century artists created and perpetuated the figure of the habitual morphine user as someone who could only be female.

Concealed and Categorised

Spaces, objects, pastimes, and bodies were – and still are – constructed as feminine or masculine. The morphine user's recumbent body is feminised because of its associations with illness and (sexual) vulnerability. Through depictions of the *morphinomane* at home, artists represent *morphinomanie* as a contagion or neurosis that resides insidiously – secretively even – in an exclusively (socially constructed) feminine space. By incorporating the *morphinomane* within the feminised discourse of consumerism and fashion, artists attribute problems allegedly relating to women's excess to the habitual morphine user as well. Artists represent female habitual morphine users as vectors of their habit, not as victims; that is, as results – or causes – of feminine weakness, and thus as posing the same threat to public health as other feminised and dangerous diseases and disorders.

Behavioural and spatial classifications based on gender functioned to provide limits of social acceptability for women in particular, and acted as a form of control. The *morphinomane*, represented as transgressing codes of 'acceptable' femininity, became representational of deviant women. The proliferation of manias and contagions at the end of the nineteenth century signalled social anxieties, just as the feminisation of diseases, disorders, and consumerism indicated an underlying threat of femininity. As Anthea Callen states, the classification of illnesses and the attempt to control them was

also an attempt to control the threat posed by unbridled female desire.[118] Analogously, the feminisation of the habitual morphine user was an attempt to control anxieties about women, and, in turn, to avoid disrupting three influential, patriarchal institutions: journalism, the art world, and the medical sector.

Women's secrecy caused recurring anxieties throughout the nineteenth century – even pockets in women's clothing could arouse suspicion in that they represented a wealth of possibilities in terms of monetary independence, bodily agency, or storage of private communications.[119] Inevitably, therefore, an underlying theme in this chapter has been the potential for women to conceal things. Commentators justified the high number of male morphine users in statistical studies by arguing that women were simply better at hiding their addiction. By extension, as the following chapter explores, the constructed feminisation of the *morphinomane* in visual culture functioned to conceal men's morphine use. Comparably, and inextricably connected with *morphinomanie* and its assumed role as a contagion, a syphilis infection could be unseen and knowingly or unknowingly spread. Newspaper reports on morphine-related crimes also generated a narrative of concealment, which often centred on hiding syringes in furniture pieces at home. The hypodermic syringe by its very nature is small and therefore easy to conceal or disguise. Its small size is also symbolic of both femininity and interiority. Interiority and interior spaces, coded as feminine, became inextricably connected with women's secrecy and morphine use.

Although medical professionals and journalists tried to downplay the reality of men's morphine use, their public acknowledgement of these statistics meant that no fin-de-siècle institution misrepresented the *morphinomane* more than the art world. Artists responded to existing categories and classifications of femininity in their portrayals of morphine users. This not only solidified the feminisation of the *morphinomane* but also removed its potential to be male. By depicting the *morphinomane* as part of the contemporary discourse on feminised neuroses and contagions, artists perpetuated the feminisation of morphine use(rs) and could legitimately exclude the male *morphinomane*. Visual references to contagions, neurotic disorders, and fashionable consumers allowed artists to concurrently feminise and de-masculinise the *morphinomane*, in essence foreclosing the possibility of acknowledging the male morphine user. In other words, artists' feminisation of the *morphinomane* was an effectual avoidance of the real statistics of morphine users in France at the end of the nineteenth century.

4

The Doctor's Absent Presence

The habitual morphine user in late nineteenth-century France was overtly feminised. But the active de-masculinisation of morphine and its users – an avoidance of the reality of morphine use and the high numbers of male users – likewise contributed to the feminisation of the *morphinomane*. It appears that fin-de-siècle doctors 'would have *liked* more women to use morphine, to support their ideas about *morphinomanie*', remarks Jean-Jacques Yvorel.[1] This penchant was perhaps due to the growing trend in statistical studies to provide a breakdown of the professions of morphine users and the finding that an overwhelming proportion of male *morphinomanes* were medical professionals.[2] In a sweeping statement covering several studies on habitual morphine users, Zaborowski, writer for the science column in *La Justice*, reported: 'One [study] counted 32 doctors out of 82 *morphinomanes*, the other 45 out of 85, the other still 97 out of 143, a fourth 3 out of 3, a fifth 56 out of 160.'[3] In a similar vein, Paul Rodet's 1897 study showed that, of 650 male morphine users, 340 were doctors or worked in the medical profession.[4] Paul Sollier in turn found that a quarter of the 202 male morphine users at the Boulogne-sur-Seine asylum between 1890 and 1910 were doctors.[5]

Whilst the feminisation of the *morphinomane* prevented its visualisation as masculine somewhat by default, the de-masculinisation of morphine use in image and text occured more intentionally across the medical world, the art world, and the popular press. Out of the known images of morphine use(rs), only a couple include male morphine users and/or the doctor. 'Silence', writes Hannah Thompson, 'is, perhaps paradoxically, another way of speaking the unspeakable, or at least of flagging its existence and encouraging the reader to look again at what the text is pointedly not saying'.[6] In Thompson's analysis of the hidden bodies in French realist literature, absence is significant and the absent presences of disabled, gender-confused, and abused bodies are analysed. Whilst the absences Thompson has studied

are not the focus of this chapter, her methodological approach to absences is of particular relevance to the de-masculinisation of *morphinomane* imagery. The physician's absence from these artworks is noteworthy because of the patent connection between morphine and its medical uses. As such, the absence of the physician from *morphinomane* artworks means that his hypothetical bodily presence is problematic.[7]

Thompson looks to Sigmund Freud's definition of taboo: '"taboo" has about it a sense of something unapproachable, and it is principally expressed in prohibitions and restrictions'.[8] The bodies that Thompson describes as taboo are, among others, the ill body, the abnormal body, and the sexual body. These bodies are taboo because they do not conform to societal norms. In contrast, the physician is presumed normal – prestigious even, implicitly trustworthy, and masculine – yet in the specific condition of the *morphinomane*'s visualisation the physician's bodily presence is rendered taboo: prohibited and restricted. But why? Medical professionals are depicted in the presence of the *morphinomane* only on very few occasions and almost exclusively in the form of caricature. A detailed look at these caricatures reveals criticisms of the medical sector and consequently offers explanations for the doctor's bodily absence and latent presence in all other art media.

The Fin-de-Siècle Physician

Medical professionals were generally trusted, respected, and celebrated throughout the nineteenth century, in part thanks to a number of momentous medical inventions and advances that had occurred over the previous century. For example, Edward Jenner's pioneering smallpox vaccination in 1796, the invention of anaesthesia (ether in 1846–47, chloroform later in the century, and cocaine in 1884), Louis Pasteur's contribution to germ theory in the mid-nineteenth century, and the production of an anti-diphtheria serum in 1894. These medical advances coincided with the invention and improvement of new medical instruments, including the hypodermic syringe (around 1853), blood pressure gauges in 1847, improved microscopes and thermometers (1860s), electro-cardiology (1881), and x-rays in 1895. According to Horace Bianchon's *Nos grands médecins d'aujourd'hui* (Our Great Doctors of Today) of 1891, the doctor was 'placed at the very top of our social ladder' because he was 'one of our great educators [and] leaders of our civilisation'.[9] As the century progressed, the sheer number of medical practitioners increased. The Association Générale des Médecins de France, founded in 1858, had acquired 1,551 members by 1859; by the 1870s there

were 6,000 members, and by the end of the century their numbers had grown to 9,000.[10] Throughout the Third Republic, as the number of medical practitioners grew, so did physicians' political eminence and presence in other societal roles, including urban planning, criminology, and education.[11] Along with this growing acceptance of science and medicine, the role of the church in French society was weakening. Each of these factors, in addition to the doctor's presumed trustworthiness, gave medical professionals a new social status in the latter half of the nineteenth century, with many medical men also taking on parliamentary roles.

Following France's defeat in the Franco-Prussian War, which brought concerns about social and cultural degeneration, physicians were considered responsible for individual and familial health and were perceived as instrumental to rehabilitating the national body.[12] As such, alongside the popularisation of medicine across the arts and other cultural forms, the medical professional made increasing appearances in art and literature at the end of the nineteenth century. Whilst the general representation of the physician in French visual and textual forms has already been explored by historians, physicians' absence from specific scenarios – in particular their absence from the visual culture of morphine use – is yet to be questioned. In French literature, as analysed by Martha Hildreth, the family physician was mostly 'protective and paternalistic' and was generally portrayed neutrally or positively.[13] What is more, as Mary Hunter demonstrates, in French art the medical professional was typically depicted as intelligent, trustworthy, virile, and representative of 'ideal manliness'.[14] Numerous contemporary artworks showed doctors injecting patients with vaccinations following the invention of the hypodermic syringe in the 1850s (Fig. 1.1). Thus, the absence of doctors injecting patients with morphine initially seems peculiar, since it was not the visualisation of administering drugs via syringe that was problematic.

Since the discovery of morphine at the beginning of the nineteenth century, the drug had been used for medical purposes. The need for morphine during and after the Franco-Prussian War exponentially increased the drug's usage in Paris hospitals.[15] Nineteenth-century doctors hailed morphine as a drug that could 'work miracles' thanks to its fast-acting pain relief, which solidified the doctor's role as someone trustworthy who could ease pain.[16] In scientific and popular texts from the end of the nineteenth century, however, there was a gradually increasing acknowledgement among those in the medical sector, particularly physicians, that morphine addiction was also a cause for concern. This concern was exacerbated by a growing awareness of the high levels of habitual morphine use among medical professionals themselves.

To show a doctor injecting a (female) patient could be interpreted as portraying a hypocritical act that would remind the viewer of the negative relationship between doctors as perpetrators of *morphinomanie* and as habitual users of morphine. By excluding the morphine-administering doctor from their artworks, artists could avoid any acknowledgement that the *morphinomane* could either be a doctor or be male. In a brief return to Thompson's approach to the taboo body, we note the observation that the creation of a taboo 'evoke[s] the importance of agency'; 'a taboo is intentionally created by a group of people who are in turn led by a particular figure of authority'.[17] Through its absence from images of the *morphinomane*, artists construct the hypothetical presence of a doctor in such images as taboo. Like the rest of society, artists were affected – consciously or subconsciously – by the societal and institutional power of the medical sector in early Third Republic France. From one masculinised institution (the art world) to another (the medical sector), artists' exclusion of the *morphinomane* medical practitioner secures the masculine and intellectual persona which doctors had come to symbolise.[18]

Newspapers attempted to downplay the morphine addiction problem within the medical sector. Despite nineteenth-century studies exposing the reality of who was using morphine, there were many attempts to neutralise these claims. An article in the widely circulated *Le Petit Parisien* noted that the majority of morphine addicts were doctors; at the same time, near the end of the article the author claimed that women were more likely than men to 'resort to this dangerous panacea'.[19] A similar mixed narrative occurs in an interview between newspaper writer Louis Paillard and a Dr Buvat in a 1904 issue of the inexpensive daily newspaper *La Presse*. After Paillard asks which group of people have the highest numbers of morphine addicts, Buvat responds with 'businessmen, doctors, lawyers', stating that 30 per cent of *morphinomanes* are doctors.[20] This concurs somewhat with contemporary statistics; yet Buvat follows that assertion with an irrational statement about women's usage: 'I was forgetting to tell you about *demi-mondaine*s who provide statistics with the highest proportion'.[21] This is incorrect, but, perhaps most significantly, it diverts attention away from doctors and places it on problematic and unscrupulous women.

Rodet claimed that women (*mondaines* and *demi-mondaines*) used morphine because it was a 'first-rate aphrodisiac'.[22] Although he noted that men who were addicted to morphine did exist, he justified doctors' use of morphine as 'very excusable' because their job was 'overwhelming' and they 'have morphine at their disposal'.[23] This statement exemplifies how newspapers and scientific texts justified the habitual morphine use of medical

professionals more broadly. An article in *Revue scientifique* stated that morphine use could help with intellectual work, thus suggesting why men with careers in mathematics and medicine would use the drug.[24] Unsurprisingly, such justifications failed to appear in explanations for women's habitual morphine use. In another example, an anonymous doctor argued in *Le Gaulois* that medical professionals turn to morphine 'out of weariness and disgust' for 'the most thankless careers' in which they are 'obliged to struggle for their bread [livelihood] often without success'.[25] Such narratives convey the generally respected place of physicians in society, regardless of the statistics, and help explain why these figures are excluded from *morphinomane* artworks. Throughout the nineteenth century and into the twentieth century, the doctor continued to be viewed by most people as an upstanding member of society who worked tirelessly to regenerate the national body.

It may be contended that the absence of doctors from *morphinomane* imagery is simply due to the portrayal of the *morphinomane* as a person who used morphine for pleasure-seeking reasons and therefore did not require a doctor. In addition, whether the *morphinomane* was a pleasure-seeker or not, the presence of a doctor in artworks set in domestic space would disrupt the feminisation of morphine. The presence of a doctor would imply that the female figures were patients who had been treated with morphine for pain and illness and thus become iatrogenically addicted to morphine, rather than conforming to their typical portrayal as pleasure-seekers, framed by *morphinomanie*'s association with femininity, neuroses, and fashion. But these figures, depicted medically unattended, would still need to acquire morphine to maintain their habit, and the fact remains that the overwhelming majority of morphine habits originated with doctors' prescriptions, as was increasingly acknowledged at the end of the century. Even in images of the *morphinomane* where a narrative of clandestine use is possibly inferred, the surreptitious acquisition of morphine would still likely have followed a medical route, involving corrupt doctors, pharmacists, or drug dealers.

Criticisms and Caricature

Although the dominant discourse of the late nineteenth-century physician as the prestigious, masculine saviour of the French population endured, criticisms did exist and manifested in various ways. By the start of the twentieth century, there was a mounting association between morphine and the medical community. Doctors' use of morphine originally legitimised the profession's attempts to relieve pain ('morphine's analgesic power' enhanced physicians' 'credibility in the eyes of their patients', notes Sara Black), but

morphinomanie implicated the doctor in the development of this new 'disease' and exposed the sector's powerlessness to cure it.[26] Added to this was the small yet growing fear in the late nineteenth century that doctors were abusing their power to experiment on patients.[27]

In an attempt to challenge the presumption that the doctor was always characterised as the nation's hero, Mary Donaldson-Evans has questioned the sincerity of the 'sycophantic courting of the medical practitioner' in French narrative prose of the latter half of the nineteenth century.[28] Manifestations of sincerity, with regard to the portrayal of the morphine-administering or *morphinomane*-doctor in visual culture, are useful to consider. Artists working in so-called serious media, such as oil on canvas, continued to exclude the physician from *morphinomane* artworks. Caricature – an insincere artistic style in terms of satire and humour – functions differently, often for a different audience, and allows for undisguised criticism of medical professionals. Narrative prose relied on subtle insincerities to criticise the medical sector, as Donaldson-Evans argues, but caricature was able to make overt comments on the same underlying social anxieties.[29] By its very nature, caricature is paradoxical: in its exaggerated and simplified visualisations it is far from realistic, and yet it can function to represent social truths. It is this paradox that allows for extending the boundaries of acceptability and thus offers a reason for naturalist art's typical avoidance of uncomfortable truths such as the *morphinomane*/doctor interrelationship. Social truths depicted accurately (naturalistically) would be far more confronting than those depicted under the guise of satire or humour.

Criticism of the upstanding doctor in caricature is more overt than in written text. From the early nineteenth century, caricaturists such as Honoré Daumier ridiculed doctors' exorbitant charges, as well as mocking physicians and quacks who would prescribe huge doses and excessive treatments. But censorship had a negative impact on the extent of criticism in caricature, particularly if it portrayed political figures. As of 29 July 1881, however, the Loi sur la Liberté de la Presse cut back on censorship and liberalised public discussion. As a consequence, the late nineteenth century saw a dramatic increase in caricatures across all subjects, including political and medical themes, particularly as medical professionals gained a growing presence in politics.[30] Accordingly, it is perhaps unsurprising that criticisms of the relationship between the medical profession and the *morphinomane* never manifest in serious art media but almost always come in the form of caricature.[31]

'Les Victimes de la science' by French illustrator and caricaturist Albert Robida offers some criticism of the medical sector (Fig. 4.1).[32] This centrefold spread, published in an 1890 issue of *La Vie Parisienne*, includes a central

FIGURE 4.1 | Albert Robida, 'Les Victimes de la science,' *La Vie Parisienne*, 12 April 1890.

PHARMACIE — VARIÉTÉS NÈGRES — FILLES — GARÇONS

COMPTOIR de la GÉNÉRATION ARTIFICIELLE

FINE CHAMPAGNE

CHATEAU BORGIA

ACIDE

Microbe de l'AMOUR

le Bacille de la BRAVOURE dit à Bayonnette

Morphine

LE MICROBE DE L'A-MOUR est découvert et tué par la vaccination préventive. C'est fini, poésie des âmes candides, envolez-vous!

Quant à l'austère devoir de la propagation de l'espèce, besogne jadis imposée par la nature, la science arrive à remplacer cette vieillerie par la reproduction artificielle. Nouvelle spécialité pharmaceutique. Se défier des contrefaçons et sophistications.

LE MICROBE DE LA BRAVOURE ayant sévi dans les siècles d'obscurité, quand la guerre était un terrible et magnifique déchaînement de l'énergie humaine et non une science abstraite.

Ce microbe est tout à fait tué par le microbe de la médisite s'inoculant à 18 kilomètres, on attendant mieux. On ne voit rien, on projette des microbes de fonte au hasard, d'autres microbes arrivent et vous êtes pulvérisés sans avoir eu aucun agrément.

...et surtout trop chimique. La ... l'homme civilisé. Tout est so ... mobilisière, fabriqué par les ... tous les éléments chimi-... prunée, le sucre est un miné-...duits en été. Les acides coulent ... petit Bourgogne de succession!

...diquons absolument nécessaires pour maintenir ...faisant l'être humain moderne.

SAINTE MORPHINE ET SES PURGATOIRES ARTIFICIELS. — Cela devait venir, pour endormir la cuisson de la vie comme on se fait chloroformer pour l'extraction d'une dent.

LE MICROBE DE LA SANTÉ! — Dernières nouvelles. — Un illustre savant vient de découvrir le microbe de la santé sur un sauvage polynésien anthropophage. Après différentes cultures, l'illustre savant a réussi à inoculer le microbe. Malheureusement il est à peine dans nos veines qu'il meurt empoisonné ou dévoré par les autres microbes!

FIGURE 4.2 |
Albert Robida, vignette
from 'Les Victimes de la
science,' *La Vie Parisienne*,
12 April 1890.

image of medical professionals gathered behind a table. Around this scene
are several vignette caricatures depicting various real and imagined ways
in which science was changing society. Among others, Robida features the
'microbe of love' (killed by a preventive vaccine), a baby being force-fed ar-
tificial milk, the 'Bank of Artificial Generation', and 'Saint Morphine and her
artificial purgatories'.[33] The latter caricature (Fig. 4.2) shows a fashionably

FIGURE 4.3 | Stop [Louis Morel-Retz], engraved by Michelet, vignette from *Musotte*, *Le Journal amusant*, 28 March 1891.

dressed female figure about to administer morphine with a syringe. The large bottle of morphine behind the figure infers the seemingly unlimited supply of the drug, perhaps authorised by the types of medical figures at the central table. Despite Robida's use of *morphinomane* tropes to portray this figure, particularly the large vacant eyes, the inclusion of this image under the heading 'victims of science' unusually attributes some sympathy to (female) habitual morphine users. Most significantly, it unexpectedly places responsibility on those in the medical sector and reinforces the slowly growing negative association between morphine and physicians.[34] Nonetheless, a look at the centre-page spread as a whole confirms that no medical figures are actually shown in the vicinity of the *morphinomane*.

A caricature from the following year portrays more overt criticism of the doctor's role in *morphinomanie*. The image, drawn by the caricaturist known as Stop, unusually shows a doctor holding a syringe of morphine (Fig. 4.3). An analysis of this caricature sheds light on some of the negativity associated with doctors administering morphine and offers reasons for the absence of medical professionals from almost all other examples of *morphinomane* artworks. Stop's drawing appeared in an 1891 issue of *Le Journal amusant*, a successful weekly publication that produced satirical content based on theatre and fashion. The caricature of the doctor is part of a full-page set of illustrations by Stop, engraved by Michelet, which tells the story of *Musotte*, a play by Guy de Maupassant and Jacques Normand.[35] *Musotte* was a comedy

in three acts performed at the Théâtre du Gymnase in the spring of 1891 and was mostly considered a great success.[36]

Musotte is set in contemporary Paris and spans just one evening. The play opens on the wedding night of Gilberte de Petitpré and Jean Martinel, a young artist who had previously enjoyed a three-year affair with his female model known as Musotte. The affair had ended eight months prior to his marriage. Near the end of the first act, Jean receives a letter from Dr Pellerin stating that Musotte is close to death, having given birth to Jean's baby two weeks earlier. Act II opens in Musotte's apartment and features several conversations between Pellerin, the midwife Madame Flache, and nurse Lise Babin, whilst Musotte lies on a chaise longue. The audience learns that Musotte is very ill. Morphine is delivered to the apartment and Pellerin tells Musotte to be calm, stating, 'the fever is coming back again ... I don't want you to be delirious when [Jean] comes.'[37] Pellerin injects Musotte with morphine and she sleeps until the end of Act II, when Jean arrives. Sensing her imminent death, Musotte asks Jean to take care of the baby. Act III sees Jean reveal all to his family and Gilberte. The play ends with Jean and his new wife agreeing to look after the newborn child.

It is initially implied that Musotte is ill with postpartum complications and that morphine is being used for palliative care. Yet when Pellerin administers the morphine, he states that it is to calm her down.[38] In one of the few reviews that did mention the doctor and the function of morphine in the play, the theatre critic François Oswald noted that the 'doctor finally manages to calm the patient'; and a review in *Les Annales du théâtre et de la musique* similarly reported that Pellerin 'calms her with an injection'.[39] Stage directions imply that Musotte has been injected with morphine regularly, as she 'uncovers her own arm' without instruction.[40] Once she has been injected, Lise remarks, 'How she sleeps!' and describes morphine as a 'blessing', presumably in reference to Musotte's earlier agitation.[41] Immediately after the injection, Pellerin starts conversing with the midwife about his love for opera and women. Stop draws particular attention to this quick change in the next illustration, which is captioned 'After [injecting Musotte], [Dr Pellerin] jokes around in a corner with the midwife'.[42] It is inferred that Pellerin administers morphine casually, moving on to lighter subjects with no concern for his patient.

Stop's caricature shows Pellerin inspecting Musotte's tongue before administering morphine. There are no stage directions for this action, and it appears to have little relevance to Pellerin's reasons for injecting her. Stop presents this as a pointless act, inferring that Pellerin would have injected Musotte with morphine regardless of her medical condition because its ulti-

mate function was sedative. The exaggerated size of the syringe in the carica-
ture not only represents the power that can be wielded by the administration
of morphine for control over patients but also points to the huge quantities
of the drug that could be accessed by any number of health professionals.
The enormous syringe takes on a sinister role, attributing to Pellerin power
and control over his patient via morphine. This suggestion of power evokes
the contemporaneous use of morphine in Parisian asylums in the 1870s and
1880s to sedate (mainly) female patients in order to 'cure' their mania, hys-
teria, and melancholia.[43] Since doctors and nurses on hospital wards were
concurrently using morphine for its sedative properties, it is perhaps unsur-
prising that Maupassant and Normand direct the doctor to inject an agitated
Musotte almost as soon as she wakes.

Stop depicts the doctor wielding the syringe as if it were literally a 'wea-
pon against pain', as it was often described in newspapers.[44] Ironically, a
key advantage of the hypodermic syringe was its ability to measure precise
doses of powerful medicines. A syringe of the size that Pellerin holds would
contain multiple lethal doses of morphine and disregards any suggestion of
precision. The image also reflects a steadily increasing anxiety about doc-
tors' blasé attitudes to morphine administration. Pellerin's position of power
is analogous to the powerful effects of morphine on the body and its ad-
dictiveness. Under the guise of caricature illustrating a comedic play, Stop's
representation of Maupassant's fin-de-siècle doctor emphasises some key
concerns regarding the doctor-patient power relationship, notwithstanding
the physician's prestige in society. Caricature is by definition a category of
visual representation in which the subject's distinctive or defining features
are purposefully magnified. The syringe in Stop's caricature of Pellerin is
highly exaggerated, as it is in one of the only other examples of a doctor
injecting a patient (Fig. 3.6), thereby emphasising the instrument's signifi-
cance both to the image and to the physicians' profession.

The Hypodermic Syringe

By the end of the nineteenth century, the hypodermic syringe had been
branded the 'mother of *morphinomanie*'.[45] Alongside various other mod-
ern diagnostic instruments that were invented or transformed during this
period, such as the stethoscope and the thermometer, the new syringe had
become a requisite medical instrument. And each medical advance and
invention functioned to increase the doctor's authority. The hypodermic
syringe allowed for easy and precise delivery of morphine in comparison
to previous options for the drug's administration. Morphine syrups lacked

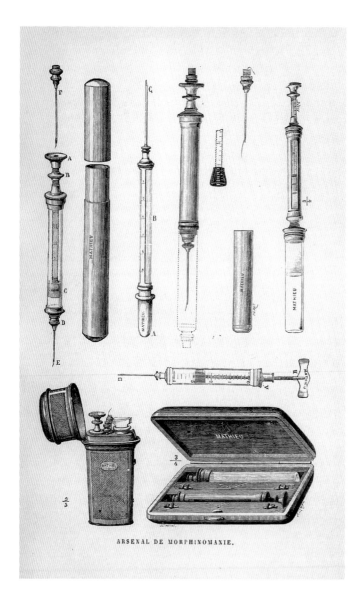

ARSENAL DE MORPHINOMANIE.

FIGURE 4.4 | 'Arsenal de morphinomanie,' interior illustration, Paul Regnard, *Les Maladies épidémiques de l'esprit: Sorcellerie, magnétisme, morphinisme, délire des grandeurs* (Paris: E. Plon, Nourrit et Cie, 1887), 315.

accuracy and the external application of morphine – which usually involved removing the skin's top layer and applying morphine salt crystals – was more painful and caused scarring.[46] In 1853 Alexander Wood of Edinburgh and Charles Pravaz of Lyon independently reported their respective inventions of the hypodermic syringe.[47] Whilst the function of Pravaz's syringe was for aneurysm treatment in animals (though he believed this could be extended

to use in humans), Wood was the first to use his hypodermic needle to inject a patient with morphine to treat a case of neuralgia, and he is more often credited with the popularisation of hypodermic injection as a medical technique. Although many contemporary French writers acknowledged Wood, the majority considered Pravaz the 'true inventor of the syringe'.[48] The hypodermic needle was thus accorded a national superiority that heightened France's awareness of its medical advances and was significant to the instrument's association with morphine use and its medicalisation.

'The Arsenal of Morphinomanie', an illustration in Regnard's medical book *Les Maladies épidémiques de l'esprit*, shows a variety of hypodermic syringes and cases created by the celebrated Mathieu surgical instrument manufacturer, based in Paris (Fig. 4.4). As the end of the nineteenth century neared, the syringe became synonymous with morphine. In France the hypodermic syringe was often referred to as 'the Pravaz syringe' or simply 'the Pravaz' in medical and popular texts, in recognition of the veterinary surgeon's contribution to the instrument's development.[49] Referring to the syringe by its (French) inventor's name not only boosted public perception of the country's contribution to international medicine but also firmly situated the hypodermic syringe in the medical world by associating it with a celebrated figure, albeit one from the world of veterinary science. *La Vie Parisienne*'s call to all 'lovers of the Pravaz' to read Maurice Talmeyr's *Les Possédés de la morphine* and Gaston Jollivet's front-page column, 'La Seringue de Pravaz', which focused entirely on morphine use, demonstrates how the hypodermic syringe was becoming metonymic of morphine.[50] Despite the usefulness of the hypodermic needle in administering other plant alkaloid solutions such as atropine, strychnine, and aconitine, this metonymy persisted.

In consequence, artists' inclusions of syringes in *morphinomane* imagery serve as a latent medical presence. The overt portrayal of drug paraphernalia can be seen in a wealth of images across artistic mediums, from caricature and lithographs to engravings and oil paintings. Whilst these portrayals do not necessarily imply a deliberately critical comment on the artist's part, the depiction of morphine paraphernalia creates – or reaffirms – the association between habitual morphine use and the medical sector, even in the absence of a doctor. Rather than depict the decorated or disguised syringes that were reported in the press, artists' generally showed ordinary morphine paraphernalia, thereby equating the syringes used by *morphinomane* figures with those found in the physician's medical bag. The medicalisation of the syringe, its close association with its scientific inventor, and its inseparable connection to morphine use in contemporary society together means that the frequent inclusion of hypodermic syringes in artworks depicting

morphine use must be taken as a metaphorical and critical comment on the role of doctors in *morphinomanie*.

As early as 1875 Édouard Levinstein had announced in his pioneering study that almost two-thirds of morphine users 'suffered from a painful chronic illness', whilst Léopold Calvet noted that a third of *morphinomanie* cases 'occurred in late-stage cancer patients'.[51] In 1884 Maurice Notta claimed that 'eight times out of ten' morphine habits originated in patients with neuralgia or peritonitis 'whose pain was only relieved by injections of morphine'.[52] In 1890, in an issue of *Le Temps*, one of the most widely circulated newspapers of the Third Republic, the physician Jules Rochard assigned blame to doctors and pharmacists: 'it is rare that this deplorable habit does not have its point of departure in medical advice'.[53] In an important report prepared for the Ministry of Justice in 1895, Paul Brouardel, the dean of medicine, had no choice but to address concerns about the doctor's role in perpetuating morphine addiction. Significantly, Brouardel acknowledged: 'most *morphinomanes* learned about morphine and acquired the habit as a result of a medical prescription. Perhaps some physicians give morphine too easily to their patients.'[54] By the end of the century, following the publication of these remarks, it was common knowledge that the majority of morphine addictions originated in legitimate pain relief and consultation with a doctor. This acknowledgement implicitly inserted the fin-de-siècle physician into any and all visual or textual representations of the *morphinomane*.

The rise in the number of morphine habits could easily have been blamed on pharmacists, who were often at the centre of debates on corruption and malpractice, or on the growing numbers of independent drug manufacturers.[55] Whilst medical professionals tended to be blamed for initiating a morphine habit, pharmacists and druggists were blamed for perpetuating the problem that doctors had created. Non-specialist texts such as newspaper articles, novels, and plays tended to emphasise the pharmacist's role over the physician's, perhaps because of the upstanding societal position of the trustworthy doctor in contrast to the pharmacist, a more familiarly unscrupulous character. Nevertheless, Brouardel's acknowledgement that doctors played an instrumental role in introducing patients to morphine stressed the seriousness of the situation. Paradoxically, then, the absence of the doctor from *morphinomane* imagery, particularly from artworks that include morphine paraphernalia, draws attention to the instrumental role of the physician in creating and sustaining morphine habits. Despite the generally high regard in which the physician was held in the early Third Republic, *morphinomane* artworks facilitated a discreet yet emerging criticism of the doctor's role in *morphinomanie*.

In Benjamin Ball's pioneering study of 1885, *La Morphinomanie*, he stated: 'Above all, we avoid leaving the patient to carry out injections himself and the means to do so. The doctor alone should carry out this procedure when it is necessary.'[56] Rochard, also speaking from a position of medical authority, echoed Ball's assertion in a lengthy article for *Le Temps*: 'In no case should the doctor entrust the patient with the instrument intended for the injection. It is, in fact, a small surgical operation and it is [the doctor] who must always stay in control of the situation.'[57] An 1886 column on a new remedy for phthisis also noted the ease with which morphine could be acquired to help with pulmonary tuberculosis, stating that 'many people abuse morphine injections' because 'doctors too often make the mistake of leaving [this little syringe] in patients' hands'.[58] The medicalisation of morphine and its paraphernalia, along with the overwhelming evidence that habitual morphine use almost always originated in doctors' prescriptions, placed the fin-de-siècle physician at the centre of *morphinomanie*. The latent medical presence created through the hypodermic syringe in this corpus of artworks emphasised doctors' careless attitudes to morphine administration. The figural absence of a doctor paradoxically draws attention to the doctor's failing role.

In artworks showing the *morphinomane*, the potential bodily presence of the doctor is constructed as taboo or something prohibited. The physician's absence is also a clear avoidance of morphine use statistics. Regardless, the overt medicalisation of morphine and the hypodermic syringe means that artists' depictions of paraphernalia should be interpreted as a latent medical (male) presence. This interpretation reinforces the connection between morphine and the medical sector without disrupting artists' carefully constructed feminisation of the *morphinomane*. If the doctor's 'ideal manliness', as described by Hunter, was directly associated with something as hyper-feminised as *morphinomanie*, the future of French masculinity could be deemed at risk.[59] The virile character of the doctor would be called into question; he was constructed as someone who worked to rehabilitate the French nation rather than contribute to its degeneration.

Maupassant and Normand are able to portray Dr Pellerin negatively because *Musotte*, as a play, is comedic by nature and can thus function in a similar way to caricature. Additionally, the impermanence of theatre in comparison to traditional art media perhaps allows for the uncensored portrayal of more controversial topics. After all, Pellerin's character is performed by an actor, not a real doctor. The illusionary nature of art implies that figures are depicted from life, particularly when they are painted in a naturalist style. On the other hand, the caricatural depiction of figures have an evident

unreality which allows for a more overt social criticism. Under the guise of humour, caricatured depictions of the morphine-administering doctor provide scrutiny of both the art world and the medical sector by the very nature of what they portray. Stop's *Musotte* caricature is anti-institutional: it is anti-institutional not only because it criticises the highly regarded and socially influential medical professional, but because it represents the antithesis of the institutionalised and serious art world, which created and perpetuated social mistruths about women as habitual morphine users.

The truth about *morphinomanie* and the morphine-administering doctor is confronted only a few times in the form of caricature. By exaggerating the syringe, a requisite tool used by the physician, caricaturists offer a rare critique of the fin-de-siècle doctor. The latent presence of the medical practitioner via the visualisation of the hypodermic syringe is a reminder of the power of the medical sector and its relationship to habitual morphine use: for the artist, whether deliberately or not, it is an unavoidable symbol of *morphinomanie*. The active de-masculinisation effected by the absence of the (male) doctor perpetuates the feminisation of the *morphinomane*. The additional feminisation of morphine via its association with contagions and neuroses positions the medical professional in opposition to the *morphinomane*, as someone who could fight and prevent *morphinomanie*, despite being most culpable for its proliferation and use.

5

Feminists, Lesbians, and the *Femme Nouvelle*

Perched on a stool behind a beach hut, a female figure injects a syringe of morphine into its thigh (Fig. 5.1). The image is part of a centrefold spread by French illustrator Louis Vallet, titled 'Médicamentées' (Medicated Women), from an 1898 issue of *La Vie Parisienne*. The accompanying caption tells the reader that the figure has come to this beach location on a bicycle. Women's cycling emerged in France in the mid-nineteenth century. The first women's bicycle race took place in 1868 with only four participants but, as a competitive sport and leisure activity, women's cycling increased in popularity over the following decades. Regardless, many considered it a problematic hobby for women. Cycling was a solo activity, unlike riding in a carriage, and was thus seen to promote women's independence. Moreover, it was believed that cycling had the potential to arouse autoerotic sensations. The unusual inclusion of the thigh as the injection site in Vallet's image reinforces the transgressive nature of women's cycling and is in keeping with the risqué nature of *La Vie Parisienne*. In order to work the pedals, women generally wore modern fashions that had less fabric and allowed for greater movement. Female cyclists were typically portrayed wearing loose trousers (culottes or bloomers), which were deemed a radical, unfeminine item of clothing often seen in depictions of the 'New Woman' – the *femme nouvelle*. But Vallet depicts his figure in a simple feminine skirt, probably in keeping with the journal's mildly erotic illustrations designed for a male audience.

An iconic image of the *femme nouvelle* had appeared as a caricature on the front page of *Le Grelot*, a satirical and political weekly newspaper, on 19 April 1896. The caricature demonstrates how the *femme nouvelle*, as a socially constructed concept, was used to demean the perception of independent women. The image shows a female figure wearing culottes, cigarette dangling from mouth, and standing next to a bicycle. In the background is a crying child and a male figure, presumably the female figure's husband, who appears exhausted from washing dishes. The female figure says she is going to the Feminist Congress and commands the man to have dinner ready for

FIGURE 5.1 |
Louis Vallet,
vignette from
'Médicamentées,'
La Vie Parisienne,
24 September 1898.

her return. The caricature is likely based on Maria Pognon, who, at the International Feminist Congress in Paris the previous week, had raised a toast to the bicycle and the emancipation it had given bourgeois women.[1] By the end of the nineteenth century, women and bicycles were inextricably associated with feminism and the *femme nouvelle* – a figure whose appearance and ideologies became representational of France's relatively small, but growing, feminist movement. Henceforth, Vallet's portrayal of the cyclist, who is unable to give up her morphine injections according to the accompanying caption, can only be understood alongside contemporaneous rhetoric on feminism and the *femme nouvelle*.[2]

Vallet's cyclist-*morphinomane* is different to other visualisations of the morphine addict. The figure is turned away from the viewer, concealing any distinguishing tropes associated with habitual morphine use, such as eyes, skin, or makeup. Additionally, the figure does not conform to the common types of femininity that artists often associated with the *morphinomanie*: Vallet's figure is neither *demi-mondaine*, prostitute, *femme fatale*, or housewife. Yet this image makes a significant comment on deviant femininities in relation to addiction. Vallet's *morphinomane*, as cyclist and therefore as *femme nouvelle*, epitomises the connections that were made between the unconventional lifestyle of the (female) *morphinomane* and the threats of

socially problematic women to the future of France. Whilst this specific representation of the *morphinomane* is unusual, the manifest connection that Vallet creates between deviant, independent women (the *femme nouvelle* and/or feminists) and the *morphinomane* can actually be seen in the majority of images showing morphine users.[3] Artists' consistent feminisation of habitual morphine users is part of a commentary on wider societal concerns about women and feminism. The types of women depicted in *morphinomane* artworks – and the very fact that these figures are almost always female and that male figures are almost always absent – must be analysed in conjunction with wider social concerns relating to women and feminism.

Ann-Louise Shapiro draws a connection between such large issues as feminism and the criminalisation of women, and describes narratives of female criminality that occurred during this time as 'stories more terrifying than the truth itself'.[4] Thus, we are led to ask: How much are these feminised criminal narratives truly about an increase in crime? Are they not more about criminalising the types of women who featured in these narratives? The fact that representations of deviant femininity functioned to criticise changes in women's social experience is not a new argument, but their application to images of the *morphinomane* has been unexplored as a way of interpreting women's perceived danger to the national body.[5] *Morphinomane* artworks cannot be understood solely as a commentary on morphine addiction or *morphinomanie*. Rather, *morphinomanie* is a device used to comment on the changing status of femininity via its references to female figures who defied social convention. The *morphinomane* represents something far larger than its immediate visualisation; it was used by artists as a vehicle to problematise modern femininity.

Depopulation and Domesticity

As discussed in the previous chapter, the feminisation of morphine use in art paradoxically draws attention to the absence of men. Artists' obvious de-masculinisation of the *morphinomane* – through this exclusion of male figures, specifically doctors – is in turn indicative of the high numbers of men who were habitually using morphine; it also alludes to the general high regard for the medical sector in France during the early Third Republic. Further, this respect for medical professionals can be linked to the aftermath of the Franco-Prussian War and the importance placed on the health of the national body. Doctors were deemed crucial to regenerating the postwar health of a declining nation, whilst women were seen as pivotal to the needed procreative resurgence. Artists' consistently feminised portrayal

of the *morphinomane* in these years should consequently be interpreted as a comment on the body politic. The association between war and the national body is often found in commentary on *morphinomanie*. Medical writers and journalists used military language to describe the *morphinomane*, for example labelling the proliferation of habitual morphine use as an 'invasion' of both the body and society.[6] Once the *morphinomane* body was infiltrated, it symbolically became an enemy of the nation. Jules Rochard, for example, described users as 'recruit[ing] for the army of morphine addicts', whilst Paul Regnard asserted that habitual users had become 'volunteers of the *morphinomane* army'.[7] In this context, *morphinomane* imagery operates on two levels: superficially, as a depiction of damage to the (female) *morphinomane* body and, symbolically, as an invasion on society and an assault on the body politic.

If the *morphinomane* body is symbolic of the infiltrated national body, the unscarred skin in *morphinomane* artworks can be viewed as the collective skin of society, which is depicted as idealised and impenetrable in accordance with artistic conventions. Although artists conform to representations of the skin as unpunctured, the *morphinomane*'s need to inject the skin is implied. In line with nineteenth-century ideas about addiction, addicts' repeated use of morphine was often deemed by medical professionals to be a choice only they themselves could control. Hence, images showing the act of injecting can be seen as an act of sabotage on the national body. Puncturing the skin damages the wholeness of the *morphinomane* body and the body politic, rendering it degenerative, penetrable, and open to a host of other contagious diseases and social ills. It is therefore particularly poignant that the *morphinomane* is almost always female. This feminisation not only exempts the respected fin-de-siècle physician, protecting his role as restorer of health and regenerator of the national body, but it also labels the (female) *morphinomane* as sabotaging any attempts to rejuvenate the French population.

The *morphinomane*'s threat to the national body was exacerbated by anxieties about depopulation. French birth rates had been declining since the 1850s.[8] By the 1890s, anxieties about France's population had culminated in what Michael Finn has called a 'reproductive panic'.[9] In 1900 France had 22.0 births per thousand in comparison to its 34.8 births per thousand in 1800.[10] Such concerns were no doubt heightened by reports that the populations of England and Germany were increasing. In 1896 the demographer Jacques Bertillon founded the Alliance Nationale pour l'Accroissement de la Population Française in response to figures released by the French government from the previous year that showed deaths outnumbering births by almost 20,000 (852,000 deaths and 834,000 births).[11] Most significantly,

this was not an anomaly; censuses of 1890, 1891, and 1892 had revealed the same unfavourable trend. In 1909 socialist physician Just Sicard de Plauzoles proclaimed that France's problems were 'depopulation, degeneracy, and decadence', and that the only way to stop the evil of depopulation was the 'organization of motherhood into a national service'.[12] The simplest way to explain the decreasing demographic was to attribute it to changes in society that had occurred during the same period: decadence, degeneration, and an increasing numbers of neuroses and contagious diseases, in addition to social movements such as feminism, which were believed to encourage divorce and women's independence. *Morphinomanie* encompassed these categories. Anxieties about habitual morphine use and depopulation were related to premature deaths amongst (female) *morphinomanes*, the physical effects of habitual morphine use on reproductive organs, and the association between the types of women who rejected motherhood and the types of women deemed prone to morphine use.

The impact of *morphinomanie* on depopulation and the health of the national body was exaggerated. Whilst deaths caused by morphine were often written about in obituary columns, these deaths were not numerous enough to skew population statistics. Regardless, in his medical thesis titled 'Morphine, morphinomanie, morphinomanes', Paul Macé established a relationship between the increasing number of suicides, understood by Macé as 'voluntary or imposed as a result of unfortunate circumstances', with habitual morphine use.[13] More significant, however, was the drug's supposed impact on birth rates. In an 1892 issue of a psychiatry journal, Charles Lefèvre compared *morphinomanie* with alcoholism. He drew particular attention to the latter's impact on procreation, stating, 'If the people, already afflicted with alcoholism, acquire a taste for morphine, we will see the number of births decrease even more rapidly.'[14] Medical texts elaborated on the impact of habitual morphine use on fertility. Henri Guimbail noted that 'the phenomenon of ovulation rapidly fails', concluding that fertilisation was possible but rare.[15] Despite the fact that Guimbail and other medical professionals also discussed men's impotence as a result of habitual morphine use, women (female figures) remain the focus of *morphinomane* artworks.

Guimbail stated that, along with problems of impotence and fertilisation, 'morphine abuse quickly brings on frigidity in women', and 'a morphine habit destroys sexual desire'.[16] Artists ignored this symptom and, on the contrary, hypersexualised the figure of the *morphinomane* via their depictions of underwear and erotic poses or by borrowing traits associated with deviant sexuality. For artists such as Vittorio Corcos, Louis Legrand, Hermenegildo Anglada-Camarasa, and Pablo Picasso, depicting the *morphinomane*

as prostitute or *demi-mondaine* was integral to their representations of morphine addiction. This characterisation associated the *morphinomane* with sexual availability and uncontrolled desire. Sexual availability caused wider concerns about the spread of disease, particularly syphilis, whilst deviant sexual behaviour implied straying from national procreation efforts. These artworks emphasised the various dangers posed to the nation's future through the association between *morphinomanie* and sexual availability.

In general, artists depicted the *morphinomane* as a sexualised pleasure-seeker whose desire for new (deviant) experiences could be assimilated with habitual morphine use. Although most images suggest gratification in one way or another, pleasure-seeking is especially obvious in some artistic examples. Crucially, in such images this form of gratification, with sexualised overtones, is not sought via heterosexual intercourse. Satisfaction comes instead from morphine, a feminised substance that offers 'pleasure' to women.[17] Women's self-administration of morphine forms part of a larger narrative of women's autonomous sexual desire. These associations were worrying because they disrupted the common perception that women's sex should be solely for procreation. In his front-page article on depopulation, Émile Zola proclaimed, 'All love that does not have procreation as its purpose is essentially debauchery', and many others concurred.[18] Although a discourse of sexual pleasure for women did emerge by the end of the nineteenth century, mutual pleasure was often still overridden by a need for procreative resurgence.[19] The emphasis on the functionality of sex patently reflected social anxieties regarding depopulation, positing women's self-sufficient (sexual) gratification as being detrimental to the national body. In turn, the visualisation of the female *morphinomane* as portrayed by artists found itself at the centre of these discussions on depopulation.

Journalists contributed to shaping the discourse on *morphinomanie* and established a connection between morphine use, women, and France's decreasing birth rate. In the radical newspaper *La Justice*, Zaborowski reported on two cases that usefully draw attention to the way the *morphinomane* was portrayed in art and text. In the first example, all four of a woman's children die allegedly as a direct result of neglect caused by their mother's addiction.[20] Zaborowski strengthens the connection between this woman and the country's declining birth rate further, noting that the woman had also had two children who had died during pregnancy.[21] Zaborowski's second example tells of a young woman who became a habitual morphine user just before her wedding, and infers that her addiction resulted in her children being 'disabled' and having 'almost no chance of survival'.[22] Zaborowski's emphasis on the absence or death of children and the importance of mar-

riage to procreation meant that women's habitual morphine use had the potential to disrupt the so-called 'natural path'.

Before introducing addicted mothers as a specific *morphinomane* type, Zaborowski argued that *morphinomanie* affected women above all. He noted the worrying state of mothers, whose addiction affected themselves and their children.[23] Zaborowski's use of 'mères de famille' (married women who have given birth or planned to do so) draws particular attention to the problematic nature of the wife/mother-turned-*morphinomane*. It suggests a transformation from respectable homemaker to deviant drug user, in comparison to the *demi-mondaine* type who was deemed undesirable for procreation. Bourgeois women were urged to be 'republican mothers' and be 'dedicated to the domestic hearth' following France's national anxieties about population and its 1871 defeat.[24] This emphasis on the mother's expected commitment to the bourgeois home is particularly significant to representations of the *morphinomane*.

Where artists' depictions of *morphinomanes* in public spaces at night-time indicate perpetually inappropriate potential mothers, artists' depictions of domestic space in *morphinomane* artworks specifically juxtapose the habitual morphine user with the presumed location of the ideal bourgeois mother.[25] This association is most obvious in Georges Moreau de Tours's *La Morphine* (Plate 1), Manuel Orazi's illustrations of *morphinomane* Blanche for Victorien du Saussay's *La Morphine* (Fig. 1.5), and Théophile Steinlen's *Les Possédés de la morphine* (Plate 10); but domestic space is implied in many other works too, such as those by Eugène Grasset and Corcos. Depictions of interior space have a threefold function. They emphasise narratives of secrecy, imply visits from doctors, and perpetuate the feminisation of morphine use. Significant here is the implication that these homes could hardly be considered appropriate locations for raising a family, as inferred by the harrowing consequences reported by Zaborowski. The absence of children from all images of the *morphinomane* is also significant, although it is particularly noticeable in images set in domestic space. Whilst the *morphinomane* is almost always depicted as female and of child-bearing age, no children are ever present. It is implied that the figures have chosen an unconventional lifestyle that does not involve having children or they have abandoned their family for the pursuit of morphine.

Some artists also comment directly on the role of marriage in *morphinomanie*. The inclusion of a ring on the wedding finger of the *morphinomane* must be thought of as a reflection on marital relationships and consequently on procreation. In artworks by Grasset and Moreau de Tours, for instance, the figures' poses are manipulated so that the ring faces the viewer. A wedding

FIGURE 5.2 |
'Le thorax de la
malade de l'obser-
vation IV,' interior
illustration originally
in watercolour,
Alphonse Roussille,
'Les Taches bleues
des morphinomanes:
Publication de
cinq cas nouveaux'
(Medical PhD thesis.
Lyon, 1907).

band even appears in a illustration of a patient from Alphonse Roussille's medical thesis (Fig. 5.2). All the woman's identifying features are obscured except for the wedding ring, which has no relevance to Roussille's investigation into the blue scars on the skin of morphine users. Including wedding rings insinuates a transformation narrative from respected wife and mother to a dangerous woman who submits to natural desires; the traditional and socially accepted lifestyle has been replaced by morphine.

The depiction of domestic space, as seen in the majority of these artworks, underscores anxieties about women metaphorically or literally abandoning married life and motherhood. Visual suggestions of abandonment echo news reports that spoke of the death and maltreatment of the *morphinomane*'s children. Most disturbing to contemporary viewers would have been artists' references to transformation: the implication being that before becoming the *morphinomane* these female figures had been ordinary, unproblematic women and that anyone could be subject to this dangerous change. (This transformation contrasts with the eternally problematic *demi-mondaine* type, who was already considered unsuitable for motherhood.)

The eroticisation of the *morphinomane* and artists' use of *demi-mondaine* tropes infers women's sexual availability and their desire for gratification. Like the narrative of the transformed mother, narratives of sexual availabil-

ity fit into wider debates on the disruption of the secure family unit. In the same way that the female *morphinomane* is the focus of artistic depictions, women were placed at the centre of France's concerns about its depopulation and weakening national body. Through signs of boredom, abandoned marriages, and deviant transformations, artists emphasise (women's) habitual morphine use as the antithesis of the ideal bourgeois life, ultimately conforming to wider discourses on depopulation and women's role in regenerating or sabotaging the home and national body.

Alter Egos of the *Femme Nouvelle*

In a lengthy article of October 1881, Jules Claretie stated that 'women, some of whom ... excitedly demand their *rights*, a number of years ago already won a unique, entirely new and very fatal right which I shall call the *Right to Morphine*'.[26] Despite the fact that many feminists were conservative Catholics – hardly a type to be associated with deviant femininity and hedonism – Claretie makes an undeniable connection between the *morphinomane* and feminism. France's growing feminist movement consisted mostly of middle- and upper-class women who campaigned for changes to their social and legal status. Feminism in the late nineteenth century was mainly about asserting women's power in the family, but the size and ideologies of the movement were much exaggerated.[27] The constructed figure of the *femme nouvelle* came to represent a hyperbolised version of the diverse feminisms that existed in the early Third Republic. Shapiro outlines the 'autonomous bourgeois woman' (the *femme nouvelle*) as both an 'egoist who refused to have children' and 'an adultress or a lesbian', demonstrating how each version contributed to national anxieties about depopulation.[28] Increasingly, it was believed that women would choose education, careers, and divorce over the traditional family unit, despite the fact that very few women succeeded in male-dominated professions.

Characterised by dress reform, rejection of motherhood, and social, financial, and sexual independence, the *femme nouvelle*'s existence, as argued by Rachel Mesch, was 'an accumulation of stereotypes circulated through the mass press'.[29] Many portrayals of habitual morphine users in art reference contemporary identities for the *femme nouvelle*. The cyclist, the lesbian, and the sexual deviant could each be associated with the rising feminist movement in one way or another. Thus the *femme nouvelle* must be viewed as a composite figure and as an alter ego of the *morphinomane*. Vallet's cyclist-*morphinomane* epitomises the amalgamation of *morphinomanie*, the *femme nouvelle*, and feminism. In 'Médicamentées' Vallet's cyclist-*morphinomane*

is hidden from the other figures and is turned away from the newspaper's viewer. This secretive, yet public, act of injecting is analogous to contemporaneous fears about the insidiousness of *morphinomanie* spreading among the population, which echoed anxieties about the growth of the feminist movement. Vallet's use of an outdoor public location, in conjunction with the accompanying caption ('although ... women need all their strength, their ardour, to engage with the bicycle, she has never been able to give up her precious injections'), suggests that satisfying a morphine addiction is uncontrollable, and therefore may have to be done in a public space.[30] This implies that the desire for morphine could be attributed to feminine weakness, regardless of the physical strength needed for cycling. Vallet's fusion of habitual morphine use with a figure characterised by independence and rejection of motherhood demonises the *femme nouvelle* and classifies her as dangerous to the body of the nation.

In 'Le Féminisme et le bon sens' of 1895, an article in *La Plume* reacting against the *femme nouvelle*, journalist Victor Jozé argued that women had 'no business competing in public life' with men.[31] Implications of the *femme nouvelle*'s threat to the future of France are found in a centrefold spread by Ferdinand-Sigismond Bach, known as Bac, in *La Vie Parisienne* of 15 March 1890. The page consists of fourteen figures, each dressed in a unique outfit for an imaginary ball. Most significant is a vignette showing a female figure wearing trousers, a waistcoat, jacket, and hat (Fig. 5.3). The figure injects its thigh with a syringe, although the potential eroticisation of the thigh is negated by the figure's masculine outfit and clothed skin. Female figures in masculine clothing (likely an exaggeration of women's culottes) signified feminists and the *femme nouvelle*. The title assigned to this figure, 'Costume of a "Century's Commencement"', plays on anxieties about the future of France as it entered the twentieth century with feminism and other social changes. The masculinised appearance of Bac's *morphinomane* suggests the figure's potential to be part of men's social experiences, with wider access to careers and financial independence.

Women's career prospects were enhanced by recently legislated admissions to *lycées* and opportunities in male-dominated professions. In conjunction with the figure's masculinised appearance, the caption to Bac's *morphinomane* describes the figure's transition from *la doctoresse* (a female doctor) to *monsieur le docteur* (Mr Doctor). This development parallels two concerns regarding feminism: first, the supposedly masculine appearance of feminists and, second, the increasing, albeit still small, presence of women in careers assumed to be uniquely for men. In turn, this shows how social anxieties centred on women taking over traditionally male roles in society

FIGURE 5.3 |
Bac [Ferdinand-Sigismond Bach], vignette from 'Revue en costumes,' *La Vie Parisienne*, 15 March 1890.

COSTUME D'UN « COMMENCEMENT DE SIÈCLE » (pour bals incohérents et hors barrières). — A fait sauter son dernier jupon par-dessus les Moulins-Rouges. La doctoresse, la femme palmée, est devenue monsieur le docteur, monsieur l'officier d'académie. Elle n'a pas renoncé pour cela à ses chers vices, surtout à son inséparable petite seringue de Pravaz qui, pour elle, remplace tout, tout, tout, vous m'entendez bien? Elle se fera deux ou trois petites piqûres pendant le bal, et elle sera la femme la plus heureuse du nouveau siècle.

and becoming their equals. Bac's decision to portray this androgynous figure as a *morphinomane* demonises both its feminist lifestyle and the ideologies associated with the figure's appearance. Similarly, Vallet's references to the Pravaz syringe in his image of the cyclist-*morphinomane* are a reminder of assumed feminine weakness.[32] The implication is that, despite its deceptive masculine appearance, this figure and, by extension, all women users still depend on morphine because they are weak, victims of supposedly innate female desires, and thus susceptible to addiction. A similar narrative occurs in Albert Delpit's *Comme dans la vie*, the serialised novel about morphine published in *Le Bon Journal*. Delpit characterises the protagonist Madame Readish as an intelligent, sexually emancipated, financially secure,

and independent woman, but her independence is limited by her morphine dependence, which eventually kills her.

Women's growing independence formed the crux of anxieties about feminism. Many believed that women's new career opportunities made men's roles in society redundant, particularly because men would no longer be needed to provide financial support through marriage. Such ideas about male social redundancy were likely a factor in triggering the association of the *femme nouvelle* with the lesbian; perceptions of both figures involved rejecting men and advocating clothing reform. Both the lesbian and the feminist were seen to represent deviant femininity and the potential loss of a long-established gender binary and traditional family structure. Both figures were also deemed threats to national regeneration. The association between the lesbian and the growing feminist movement – Shapiro labels the lesbian as the feminist's 'presumed alter ego' – created a lesbian fusion figure that symbolised a multitude of social anxieties.[33]

In the context of wider debates on degeneration and sexual deviance, lesbianism was a 'more acceptable vice' than male homosexuality, but only until it became a 'deliberate challenge to sexual hierarchy', writes Jennifer Birkett in *The Sins of the Fathers*.[34] In tandem with the growing feminist movement, the 1880s saw lesbians of the *haute bourgeoisie* become more visible in society.[35] As shown by Leslie Choquette, the increased visibility of elite lesbians coincided with growing concerns for (women's) habitual morphine use, feeding into broader anxieties about degeneration, since lesbianism was concurrently considered a hereditary pathology.[36] Artists' depictions of lesbians as the *morphinomane* are significant and the connection between these two social types is no coincidence. Critical responses to Moreau de Tours's *La Morphine* of 1886 created an early connection between morphine use and lesbianism. Several critics noted the artist's detailed inclusion of Charles Baudelaire's *Les Paradis artificiels* and remarked on the dangers of women reading this book about drug use and other writings by Baudelaire, such as the infamous *Les Fleurs du mal* (originally titled *Les Lesbiennes*). Most significant, however, was Henri Fouquier's fabricated assertion that one of the untitled books in *La Morphine* was the lesbian erotic novel *Un Été à la campagne*.[37] Fouquier epitomises the contemporaneous connection between lesbians, or sexual deviancy, and habitual morphine use. Drug use has been associated with sexual and moral deviance throughout history and, against the backdrop of degeneration and decadence in Third Republic France, morphine use proves no exception.

Morphine use is explicit in Legrand's *Au Café* (Plate 12), and the artwork's location implies lesbianism. In fin-de-siècle Paris certain sites, such as cafés,

FIGURE 5.4 |
Louis Legrand, *La Négresse*, 1909, pastel on paper, etching and drypoint, 20.7 × 14.3 cm., from *Les Bars* series of 8 drypoints. Reprinted in Camille Mauclair, *Louis Legrand, peintre et graveur* (Paris: H. Floury et G. Pellet, 1910), 211.

were coded as lesbian and/or gay spaces.[38] The Rat Mort, a café in Place Pigalle, played an important role in the visibility and legitimisation of lesbians during the last few decades of the nineteenth century, and it featured in several literary works. Paul Alexis's short story of 1880, *La Fin de Lucie Pellegrin*, which centres on Chochotte, a lesbian who spends most of her time at the Rat Mort, initiated this visibility. The Rat Mort lesbians gained further notoriety in the following decade after the success of Jules Davray's *L'Amour à Paris*. From this point on, lesbians were increasingly portrayed as invaders of public space, specifically cafés, as also seen in Legrand's other depiction of morphine use, his 1909 drypoint *La Négresse* (The Black Woman) (Fig. 5.4), where the figures appear to inject themselves publically. Its brazen display of morphine injecting parallels the apparent brazen visibility of lesbians in public spaces and aligns the *morphinomane* with the lesbian.

FIGURE 5.5 | Serafino Macchiati, *Morfinomani*, 1905, oil on canvas, 38 × 56 cm, private collection. Reprinted in Vittoria Pica, 'Serafino Macchiati,' in Vittoria Pica and G.U. Arata (Galleria Pesaro), *Mostra individuale* (Milan: Bestetti e Tumminelli, 1923), 13.

Androgyny characterised the lesbian, whose typecast appearance was indistinguishable from that of the *femme nouvelle*.[39] In *L'Amour à Paris* Davray described the stereotypical lesbian: 'massive, tall, masculine features, short hair, cigarette dangling from her lip, she comes and goes in her *brasserie*'.[40] Most relevant here is the fact that some artists also portray the *morphinomane* as an androgynous figure, creating an undeniable connection between lesbianism, feminism, and habitual morphine use, as seen in Bac's caricature for the double-page spread on fin-de-siècle costumes. The conflation of lesbianism and the *morphinomane* is also indicated in Serafino Macchiati's *Morfinomani* of 1905 (Fig. 5.5) – a painting created after the artist's move from Rome to Paris in 1898 – which shows two habitual morphine users in a domestic space. Macchiati borrows key elements from Moreau de Tours's *La Morphine* in his representation of two *morphinomane* bodies: a collapsed, prostrate figure and an alert, upright figure that faces the viewer. The collapsed female figure is presented in a decorative, traditionally feminine dress, whilst the seated figure, who also appears to be female, is depicted with very short hair in a white ruffled blouse, black jacket, and black trousers. The dichotomy of gender representations in Macchiati's painting mimics the stereotypical

appearance of a heterosexual relationship, reinforcing contemporary fears about the replacement of men. The figure's androgynous appearance mirrors the portrayal of lesbians during this time, whilst the artist's inclusion of a traditionally feminine figure acts as a foil to this masculine appearance.

Macchiati's dichotomy of masculine versus feminine is analogous to other narratives of lesbian couples at the turn of the century. Guy de Maupassant's short story of 1881, *La Femme de Paul*, tells of four notorious lesbians at La Grenouillère, two of whom dress as women and the other two as men. Although the story exaggerated the prevalence of such couples in reality, a notorious lesbian, the Marquise de Morny, was renowned at the time for her masculine clothing.[41] Also known as Mathilde de Morny or Missy, the marquise divorced her husband, Jacques Godart, in 1903 and lived with the author and actress known as Colette (Sidonie-Gabrielle Colette) from the summer of 1906. In December of the same year, the satirical magazine *Fantasio* printed a column titled 'La Marquise'. Writing under the pseudonym Le Vitrioleur, the author claimed that this unnamed marquise 'despise[d] the law of the sexes'.[42] By including photographs of the Marquise de Morny in masculine clothing and Colette in traditionally feminine clothing, the article seemed to give an identity to the otherwise anonymous marquise in question. Whilst the article was misleading – and the real marquise successfully sued the paper for libel – the photographs reinforced the text's message about the disruptive potential of women in traditionally masculine clothes.[43]

The notoriety of the Marquise de Morny captured the imagination of journalists and novelists alike. She was often used as a vehicle for wider messages of sexual and moral deviance and degeneracy. Notably, in *Les Possédés de la morphine*, Talmeyr describes a cross-dressing lesbian whose identity was revealed at a dinner party: 'He stood up, unfastened his trousers, pulled an enamelled syringe out of a pocket in his dinner jacket, stuck the needle in his thigh, and injected himself right in the middle of the dinner ... [A]t that point the Viscount, dressed in a tuxedo, with his hair done in curls, had to abandon his disguise. It was none other than the Madame de M., who used drugs and chased after women. And this extravagance was neither the first time nor the first dinner party where she had given in to this urge'.[44] Talmeyr's use of 'chased after' places 'Madame de M.' in a position of power over other women, as emphasised further by the revelation of the character's deceptive appearance. Nicole Albert has convincingly identified Talmeyr's 'Madame de M.' as the Marquise de Morny, but there is no credible evidence to suggest that the marquise used morphine.[45] The fact that Talmeyr nevertheless dedicates significant detail to a description of the marquise's

clothing emphasises the importance of gendered appearances in relation to morphine use and lesbianism.

Two important dichotomies make up Macchiati's painting: the contrasting bodily poses and the feminine and masculine clothing. What is crucial here is that the figure in masculine clothing, the lesbian figure, is alert, whilst the figure representing traditional femininity is collapsed on the sofa. These metaphorical implications can be found in contemporary texts that portrayed the 'frightening image of older lesbians initiating young acolytes', as hinted at by Talmeyr's mention of Madame de M. pursuing women.[46] Such narratives suggest that unsuspecting women were morally corrupted by lesbians. Of note here is the reverberation of such narratives in relation to *morphinomanie*, with the dangerous *morphinomane* reportedly persuading honest women to begin injecting themselves with morphine.[47] Macchiati's use of contrasting states of consciousness implies a similar narrative, and his use of a female figure in masculine clothing parallels Guimbail's medical comments on *morphinomanie par persuasion*.[48] Macchiati's depiction of the lesbian in a position of power echoes national anxieties about the increased visibility of lesbians around the turn of the twentieth century, which was reportedly changing the composition of society and contributing to its degeneracy.

Artists' representations of the *morphinomane* draw on different types of femininity, each of which addresses wider national concerns about the changing status of women and their potential threat to the national body. Alongside the lesbian, the *morphinomane* can be understood as another alter ego of the *femme nouvelle*, borrowing from existing types of deviant femininity and amplifying the supposed danger of these types by associating them with *morphinomanie*. Artists' continual feminisation of the habitual morphine user, their various references to sexual deviance, suggestions of lesbianism, and implications that the traditional family unit had been abandoned demonstrate how artists made use of these existing categories of femininity in their depictions of the *morphinomane*. In reaction to France's small but significant feminist movement, the *femme nouvelle* and the *morphinomane* were identifiable by their independence and unconventional lifestyles. Both were socially constructed and deemed a threat to the national body.

Disruptive Desires

The *femme nouvelle* and the lesbian, as constructed figures, spurned men. In addition, the unfeminine appearance of the *femme nouvelle* was charac-

terised as being unattractive to men and, in turn, to the male viewer.[49] The *femme nouvelle* was seen as a mostly unappealing figure who subverted what Debora Silverman describes as 'women's roles as decorative objects'.[50] Paradoxically, the *femme nouvelle* and the lesbian both epitomised sexual emancipation (often interpreted as promiscuity) and transgressive behaviours. But the undesirable appearance of the *femme nouvelle* was incompatible with its supposed licentiousness. This paradox provides an explanation for the absence of the *femme nouvelle* in traditional art media: how can the (male) artist provide an image of the *femme nouvelle* that is simultaneously repulsive (hence reflecting the ugliness of its social ideals) and sexually promiscuous, all whilst offering something desirable to the (male) art viewer? The *morphinomane* fills this role.

Subtle artistic references to issues associated with the *femme nouvelle* present the habitual morphine user as a danger to the future of France, but the representation of the user as a hedonistic pleasure-seeker allows for an eroticised depiction. The feminisation of *morphinomanie* and its undertones of secrecy and gratification aid in sexualising habitual morphine use, and sexualisation is further heightened by the rare representation of the figure injecting morphine into a bare thigh rather than an arm. The loss of self-consciousness that accompanies morphine use allows for a constructed-as-voyeuristic (male) gaze on the vulnerable and sexualised (female) body. Additionally, to reiterate, the pleasure-seeker's desire for morphine is undeniably associated with sexual desire and lesbianism. Lesbianism, when not associated with the masculinised *femme nouvelle*, was often eroticised as it has been throughout art history.

Even in Macchiati's painting, the masculinised female figure may be understood as a displacement of the male viewer (or male *morphinomane*). The viewer's desires – the voyeuristic gaze upon the unconscious female body – are the same as the implied desires of Macchiati's masculinised female figure: the figure's consciousness asserts power over the vulnerable, feminine figure. Artists' images of the *morphinomane* in domestic space function in two ways. First, picturing the *morphinomane* at home highlights the figures as the antithesis of the ideal bourgeois mother. Second, these scenes offer a voyeuristic view of a space deemed inaccessible to men. The viewer's voyeuristic satisfaction from these artworks is gained from a range of artistic features: the suggestions of lesbianism, the eroticisation of female figures, figures in clothing worn only in private, and – crucially – the supposed (sexual) gratification of administering morphine, a private activity conducted in secrecy and often at home. Thus, the *morphinomane*, whilst not always

explicitly the *femme nouvelle*, solves the problem of how to visualise something that is both desirable to art viewers and representative of women's social change.

Categorisations of femininity stem from early nineteenth-century trends towards classification systems of social types. The proliferation of categories relating to women – including, but not limited to, the *demi-mondaine*, the *femme nouvelle*, and numerous prostitute types – is indicative of anxiety about social change. These categorisations were perpetuated by the advent of sexology and criminology in the 1870s and 1880s, along with degeneration anxieties and Social Darwinism.[51] In *The Order of Things* Michel Foucault argues that the will to classify is essentially about social control. The ability to classify types of femininity implies a power over women. With the division of deviant femininity into specific types – such as the *femme nouvelle*, the *demi-mondaine*, the lesbian, and the *morphinomane* – women's deviant behaviour can be identified and presumed to be controlled. Using the term *morphinomane* in the categorisation of women can be seen as a strategy to exert control over women's bodies, a control analogous to the way morphine was often used by the medical sector to regulate and control hysteric women.

But the *morphinomane* problematises categories of femininity. Foucault, in his description of plant and animal classifications, emphasises the institutional importance of a 'description of the visible' with a focus on 'surfaces and lines', not 'functions or invisible tissues'.[52] By analogy, each type of femininity in late nineteenth-century France could be labelled via its appearance: clothing, accessories, living quarters. These attributes are then translated into artworks, thus constructing a recognisable figure for the art viewer. The *morphinomane* should be understood as one of these representational types of femininity. Simultaneously, however, the *morphinomane* problematises these categorisations because its appearance is not easily identifiable. Recognisable tropes in artistic depictions of the *morphinomane* are specific to their status as art: tropes of animalistic transformations, iconographic representations of boredom, the limp bare arm with idealised skin, and enlarged inhuman eyes make the *morphinomane* recognisable for the art viewer. Unlike the clothing and accessories mentioned in discussions of the *femme nouvelle*, the *demi-mondaine*, and other types, the *morphinomane*'s tropes cannot be found in reality. The *morphinomane*'s appearance borrows from all sorts of visualisations of femininity. It is sometimes the *demi-mondaine* (as seen in works by Anglada-Camarasa and Corcos), sometimes the *bourgeoise* (Moreau de Tours's painting), sometimes the lesbian (Macchiati's painting), or sometimes ambiguous (Grasset's print); but crucially, and despite the use

of recurring tropes (enlarged eyes, heavy makeup, limp arms, night-time settings), it is not consistent in its reference to typecast femininities. Hence it cannot be categorised. This elusiveness disrupts attempts to control the *morphinomane* as a social type, whilst paralleling contemporaneous anxieties about the insidious spread of *morphinomanie*.

The one consistent feature in representations of the *morphinomane*, however, is artists' reference to deviant femininity. In the same way that categorisations of femininity are attempts to contain and identify problematic behaviour, the *morphinomane* is used as a vehicle to indicate deviance, desire, and danger – or decadence and degeneracy. This appropriation of the *morphinomane* figure aligns the *morphinomane* with other deviant figures of femininity who are recognisable via repeated visual tropes. For example, the *morphinomane* as *demi-mondaine,* who has more freedom as a result of financial independence, signals the dangers of uncontrolled femininity, whilst the *morphinomane* as (previously) respectable bourgeois woman is emblematic of feminine weakness and thus the need to control women's behaviour to prevent excessive pleasure-seeking. In almost all images of the *morphinomane*, artists conflate morphine use with the assumed deviance of independent women who increasingly lived unconventional lifestyles, attributing the danger associated with the allegedly insidious spread of morphine addictions to these types of women.

Morphinomanie was unusually perceived as both a neurosis and a disease. The feminisation of fin-de-siècle neuroses in particular contributed to the feminisation of morphine addiction and created the perception that these illnesses could be contained within domestic space. Although artists endeavoured to contain *morphinomanie* within its constructed gendered confines, by the turn of the twentieth century newspapers began reporting on the actual statistics of habitual morphine users and declared that *morphinomanie* was not necessarily containable within single categories of gender or class. Moreover, whilst the bourgeois home was often (inaccurately) deemed a space safe from real contagious diseases such as syphilis and cholera, it was observed that *morphinomanie* originated and remained within the home: 'morphinomanes remain at home and die there quietly', Rochard remarked in an 1890 article for *Le Temps*.[53]

Silverman states that in the 1890s republican statesmen strategised how to 'contain and interiorize women' by reinstating the boundaries between public and private.[54] Calls for women to stay at home were intended to protect them from societal dangers and encourage them to focus on motherhood – the antithesis of the *femme nouvelle*, whose supposed independence allowed access to new careers, public spaces, and alternative lifestyles.

Paradoxically, despite the fantastical representations of figures brazenly injecting themselves in public spaces as seen in some artworks, morphine use occurred almost solely in the home. Portrayals of the *morphinomane* body as female, unscarred, and without the broken surface of the skin symbolise the construction of the bourgeois home as a shelter impenetrable by disease and a space characterised by femininity and a lack of masculinity. Despite visual representations of the *morphinomane* as conforming to artistic conventions of the female body, the inclusion of the *morphinomane* in domestic space in fact reveals the bourgeois home as unprotected: an unsafe and inappropriate environment to raise the next generation.

Morphine addiction was considered a threat to France in the early Third Republic, a factor contributing to the nation's degeneration. By inference, not only could the female figures in these artworks be seen as a threat to society, but the traits associated with the types of femininity they represented – sexual desire, independence, divorce, rejection of motherhood – could have disastrous consequences for France's future generations. The *morphinomane* is an appropriate solution for representing the simultaneously repulsive and sexualised *femme nouvelle*, but it is also a problem. The *morphinomane* disrupts affirmed categories of femininity and exploits the supposed dangers of women's desire. While the *morphinomane* in art is consistently represented so as to appeal to the male viewer, it is inherently undesirable to France's future.

Feminist Voices

Both *morphinomanie* and the construction of the *morphinomane* centred on femininity. Yet in discussions of women's actual experiences, such as those found in the French feminist newspaper *La Fronde*, *morphinomanie* was rarely mentioned. *La Fronde* was run exclusively by women and presented the diversity of French feminism. The paper's detailed news reports and discussions on feminist issues, as explored by Mary Roberts, confronted and deliberately avoided many of the journalistic techniques used by the mass press to garner attention and sales via sensationalism.[55] During *La Fronde's* eight years of publication (1897–1905), the newspaper made very few references to *morphinomanie*. At the same time, its journalists wrote about other concerning social issues – the rising number of suicides in Paris, for instance – so the absence of discussions on morphine use is noteworthy. The exclusion of *morphinomanie* from *La Fronde* draws attention to the truth of the so-called 'epidemic'. On the rare occasion that *La Fronde* journalists mentioned morphine use, it was in reference to legitimate medical purposes,

its secondary role in an ongoing court case, or changes to the law. The paper's readers were the same bourgeois and *haut-bourgeois* women who were perceived to be at the centre of *morphinomanie*. Hence, if *morphinomanie* was a credible and feminised 'epidemic', as it was represented in art and text, it would surely have been extensively reported on in *La Fronde* to act as a warning.[56]

The stories that fin-de-siècle male-dominated newspapers chose to sensationalise and exaggerate reveal not only the curiosity of their predominantly male readers but also the anxieties of contemporaneous society. In the same way that the majority of newspapers and artists fixated on the *morphinomane*, these papers also exploited changing aspects of femininity to attract attention, with the 1880s and 1890s seeing an influx of exaggerated and false commentary on feminism. Alain Corbin notes that the 'spread of adultery' and 'propaganda in favor of women's sexual emancipation' all belonged to 'the progress of feminism'.[57] Henceforth, representations of the *morphinomane* cannot be understood solely as a commentary on habitual morphine use; the figure of the *morphinomane* in fin-de-siècle art should be analysed through its links to wider societal debates. And, because of its consistent feminisation, it is crucial in particular that *morphinomanie*, as a concept and sociological phenomenon, be understood alongside contemporaneous attitudes towards women, regardless of their actual life situation.

The interconnection between wider societal issues such as adultery and the spread of syphilis was associated with women and their supposed changing status in society. A similar narrative occurs again and again with representations of the *morphinomane*. Significant national problems, including depopulation and contagious diseases, were linked not only to women but also to the increasing visibility of habitual morphine use(rs). Artists created visual associations between the *morphinomane* and women who defied social conventions, whose lifestyles evoked wider anxieties regarding population, divorce, women's professionalisation, and independence. Representations of the androgynous lesbian in *morphinomane* imagery in turn address concerns about potential replacement of the traditional male role. Additionally, and somewhat in contradiction to depictions of the *femme nouvelle*, artists chose to depict the *morphinomane* as a pleasure-seeker, loaded with insatiable female desire for new experiences that could be assimilated with habitual morphine use. Representation of this sort functions voyeuristically for the viewer and allows for a falsely eroticised visualisation of feminism.[58]

Arguably the most problematic aspect of the *morphinomane* was the impossibility of categorising the figure through a consistent appearance, aside from its gender; if it cannot be classified and thus identified, it cannot be

controlled. *Morphinomanie* was deemed a threat to the future of France, in the same way that women who lived unconventional lifestyles were deemed dangerous to the national body. The feminisation of *morphinomanie* is more about commenting on femininity than on drug use – which perhaps explains its exclusion from *La Fronde*. As defined by its representation in art, *morphinomanie* was a device that functioned to control women's changing societal status. The *morphinomane*, an exaggerated and misconstrued figure that was almost always portrayed as feminine and problematic, provided a fitting vehicle for the condemnation of women who led unconventional lifestyles. Thus, the *morphinomane*'s visualisation in art should be interpreted as a social construction, influenced by issues far wider than the so-called morphine epidemic, which afflicted male and female users alike.

6

Newspapers and Sensationalism

In the rapidly growing consumerist society of late nineteenth-century France, businesses sought new ways to increase sales within their competing sectors. From department stores and newspapers to artworks and advertisements, respective markets became saturated with new concepts and products which required innovative ways of attracting attention. Simultaneously, and perhaps not so coincidentally, fin-de-siècle Paris was characterised by spectacularisation.[1] As described by Maurice Samuels, spectacularisation – the process of presenting something as eye-catching, public, and entertaining – was in the nineteenth century essentially the phenomenon of creating and theorising spectacles.[2] Large-scale events such as the city's Expositions Universelles were prime examples, but less obvious phenomena – the morgue, boulevard posters, *morphinomanie* – were also turned into spectacles.[3] The combination of spectacularisation and capitalism created a form of sensationalism. This was particularly present in journalism, since, as Ben Singer remarks, news reports 'compensated for and mimicked the frenzied, disjointed texture of modern life'.[4] Singer aptly understands the craze for sensationalism to have occurred at the moment when a combination of 'economic opportunism' and 'morbid curiosity' took priority over accurate reportage.[5] Fin-de-siècle newspapers utilised sensationalist techniques to promote sales in an increasingly saturated sector. Ultimately, the sensationalism of *morphinomanie* fuelled a fascination to read and see more.

As mass production of magazines, newspapers, and journals crowded the market, editors and journalists explored new ways of attracting readers' attention, seeking profit through two interconnected methods: sensationalism and imagery. Sensationalism relied on the exaggeration of narratives, and the advent of chromolithography in the 1880s allowed for a visual dimension that could appear as a discrete feature or as an enhancement to text.[6] Throughout history, whether in illustrated religious books, in paintings depicting scenes from mythology and history, or in advertisements, imagery has functioned to embellish or replace text. The explosion of print culture

in the latter half of the nineteenth century, however, marked a new direction for text and image. The interconnections between art and text during those years became more complex than the simple provision of illustrations in newspapers. Newspaper editors and artists alike created and deployed images of the *morphinomane* in a variety of ways to evoke interest. The phenomenon of *morphinomanie*, along with the familiarity of the *morphinomane* image-type, encapsulates not only the interconnection of art and text in early Third Republic France but also the influence it had on its audience.

Blurring Boundaries

Georges Moreau de Tours's *La Morphine* (Plate 1) of 1886 was understood by contemporary critics as a 'medical painting'.[7] Many factors contributed to the canvas's being interpreted as a convincing representation of habitual morphine use; the fact that the artist's father was a physician, the diagrammatic nature of the composition, and the painting's accompanying caption all helped give it a quasi-medical status. This medicalisation authenticated the less-factual elements within the painting such as the references to lesbianism, the feminisation of morphine users, and the drug's association with fashionability. *La Morphine* is an example of how the blurring of fact and fiction could incite an overwhelming amount of attention. Factual or medicalised elements legitimised the painting's less credible aspects.

A similar legitimisation occurs in the bibliographies of many medical texts on *morphinomanie*. These bibliographies always refer to other medical sources, but they also cite fictional texts such as Charles Baudelaire's *Les Paradis artificiels* (1860) and *Les Fleurs du mal* (1857); Jules Claretie's novel about morphine use, *Noris* (1883); Maurice Talmeyr's semi-fictional *Les Possédés de la morphine* (1892); and Jean-Louis Dubut de Laforest's novel *Morphine* (1891), as well as autobiographical texts about drug use, such as Laurent Tailhade's *La 'Noire Idole'* (1907). Noticeably, in many of the bibliographies that mention Laforest's *Morphine*, the word *roman* (novel) follows the title and informs the reader of its fictional nature. However, this indication is absent from most of the other semi-fictional and fictional works listed.[8] The lack of any such acknowledgement conceals the fictional nature of these texts and, in turn, attributes a medical authority and truth-value to their representations of habitual morphine use.

Despite the inclusion of popular novels in the bibliographies of medical texts, it was likely that medical theses and lengthy scholarly articles on *morphinomanie* were intended for specialist readers; the medical terminology, complex theories about withdrawal symptoms, and pulse-rate charts in such

texts all require prior medical knowledge. But even the medical genre was a publishing industry that needed to make sales. As such, several lengthy books on *morphinomanie* that were published at the end of the twentieth century were not necessarily aimed at a specialist audience. Although books by medical professionals such as Henri Guimbail and Paul Rodet included more accurate information than sensationalised newspaper reports did, non-medical readers were also potential buyers. For example, Guimbail's 1891 book, *Les Morphinomanes*, published over a decade after Eduard Levinstein's *Die Morphiumsucht* was first translated to French, begins by outlining basic information about morphine use. The first subheadings, including 'History' and 'Arsenal of the *Morphinomane*', are directed at non-specialist readers, whilst other subheadings, such as 'Mysterious Effects', 'Artificial Paradises', and 'Is *Morphinomanie* a Psychosis?', seem designed to create a sense of intrigue that is not found in strictly medical texts.[9] Rodet uses similar techniques in his *Morphinomanie et morphinisme* of 1897, using rhetorical questions, sensational language, and exclamation marks to heighten reader engagement, as well as quoting from pseudo-reportage texts such as Talmeyr's *Les Possédés de la morphine*.[10] Moreover, the use of illustrations in Paul Regnard's *Les Maladies épidémiques de l'esprit*, many of which were reprints of seventeenth- and eighteenth-century artworks of little relevance to the text, further suggests that some medical books on *morphinomanie* were marketed to non-specialists.

The merging of the boundaries of fact and fiction also occurs in literary texts relating to morphine use. In one of several examples, Albert Delpit's novel *Comme dans la vie*, the narrator offers interjections of putative statistics of morphine use. In a brief description of the immediate effects of morphine on the appearance of Madame Readish, readers are told that '*morphinomanes* are almost incurable; barely 30 out of 100 patients remove the root of this deadly habit'.[11] Reviewers of these fictional texts about morphine perpetuated the medicalised narrative. In reviewing *Les Détraquées de Paris*, for instance, Jean Valgore stated that René de Schwaeblé 'pushes his scalpel into the wounds of modern vice and makes accurate reports on the results of his research'.[12] Similarly, Rodet described the writing style of Talmeyr's semi-fictional *Les Possédés de la morphine* as one that could be 'dictated by a doctor'.[13] Whilst Rodet admits that Talmeyr's book has no 'scientific character', he says it is built on truth and composed of 'true medical observations presented in a literary form'.[14] Other reviews stated that Talmeyr 'very legitimately rejects ... the idea of fiction' and described the text as 'documentary' by nature.[15] Narrative interjections of alleged facts and the medicalised commentary of fictional *morphinomane* texts function in the same way as

the medical authentication of Moreau de Tours's *La Morphine*; claims about habitual morphine use are legitimised at the expense of accuracy.

Both *Les Possédés de la morphine* and *Les Détraquées de Paris* were published in instalments in the style of the *roman-feuilleton*, or serial novel, often reserved for openly fictional texts. The *roman-feuilleton* (first introduced by Émile de Girardin, founder of *La Presse*, in 1836) was an effective device used by newspapers to increase sales, and reports of real events often inspired their plots and characters.[16] *Romans-feuilletons* were often separated from the rest of the newspaper page by a thick horizontal line three-quarters of the way down the page, thus signalling their fictional nature.[17] However, texts by Schwaeblé and Talmeyr were not printed in demarcated sections but were included alongside main news story columns. This placement assigned a truth-value to these fictional texts, further confusing the boundaries of fact and fiction.

Sensationalism, understood as the presentation of 'facts' or narratives at the expense of accuracy, is often augmented by such blurring of the boundaries between fact and fiction. In response to the abundance of newspapers established during the second half of the nineteenth century, sensationalist tactics were essential for garnering and sustaining audience interest and increasing sales, particularly as many newspapers moved away from political coverage. Papers such as *Le Petit Journal* relied on a steady supply of spectacularised crime stories to fill their non-political pages. A significant reason for this was to avoid the heavy security deposit and the *droit de timbre* of six centimes that opinion newspapers were forced to pay the government during the Second Empire.[18] *Faits divers* columns, first seen in *Le Petit Journal* in 1863, were very short news reports that 'turn the anecdotal into a news item'.[19] These stories often featured scandals, murders, and other crimes, and their publication became a journalistic technique used primarily by the non-political press in the late nineteenth century. Authors of the *roman-feuilleton* took inspiration from events described in the *faits divers*, but the latter in fact often had their own fictitious origins. As Thomas Cragin remarks, newspapers often 'pursued fictitious leads and sometimes even reported fiction as fact' because *faits divers* columns were essential for profits.[20]

Around the time of the turn of the twentieth century, some newspapers published columns styled as *faits divers* that reported solely on morphine-related incidents. These columns would carry such titles as 'Faits divers', 'Bloc-notes Parisiennes', 'Nouvelles discourses', or 'Échos', and each would be broken into subheadings. To draw the reader's eye to morphine-related stories, careful consideration went into the page layouts of headlines and advertisements. In 1901, for example, *Le XIXe siècle* newspaper ran several

columns titled 'The Dangerous *Morphinomane*(s)' in their *faits divers* section following the story of a pharmacist who had been assaulted by a customer demanding morphine.[21] Analogous to the other headings in *faits divers* columns of *Le XIXe siècle* – including 'The Temperature', 'Suicide or Accident', and 'The Fire' – 'The Morphine Addict' thus became a separate category of news. *Le Petit Journal* deployed a similar technique in its regular 'À travers Paris' column, where instalments from 1891 were repeatedly titled 'Une Morphinomane'.[22] Papers even indicated that these stories continued from one issue to the next, with '(*Suite*)' (Continued) indicating a new development in the news story. These sensationalised news sections, all written in the style of the *faits divers*, likely achieved their success precisely thanks to their repetitive format; always given the same heading and often found on the same page in each issue, they could easily be found, and avid readers could turn to them immediately. News reports on *morphinomanie* also appeared as distinct front-page articles under short titles that would include the word *morphine* or *morphinomanie*.

Newspapers certainly sensationalised the *morphinomane*, using it as a tool to promote sales via exaggerated narratives, eye-catching front-page articles, and emphatic typefaces. In an issue of *Excelsior*, for instance, *morphinomanie* seems integral to the paper's sensationalist agenda. In an edition of 15 March 1912, the title for the 'Faits divers' column is in the same font size as the titles for the main text items, whilst the first subheading in that column, 'La mort du morphinomane', is far larger than the other subtitles.[23] Significant also to the success of reports on morphine addiction was the fact that anyone could be affected. This apparent ordinariness meant that 'readers could identify with the narrative', whilst exaggerated and morbid details about such morphine-related events indicated, as Vanessa Schwartz remarks, that 'all life, no matter how banal, could be rendered spectacular through sensational narrative'.[24] Specific fin-de-siècle topics such as *morphinomanie* were themes that newspapers could keep reusing in *faits divers* columns, where they functioned to attract attention and to re-affirm the relevance of *morphinomanie* in concurrent fictional narratives that occurred on the same page.

Morphinomane Art in Newspapers

The first *morphinomane* imagery to appear in newspapers came in the extraordinary amount of art commentary on Moreau de Tours's *La Morphine* in 1886. Via the various techniques employed by the artist, the painting created the attention that Moreau de Tours had no doubt hoped for. In fact, it could be argued that the style in which much of this art criticism on

La Morphine was expressed – short, impactful sentences describing a sensational narrative that could occur in contemporary society – is comparable to that of *faits divers* stories on morphine-related events that flooded newspapers in the 1890s. Essentially, Moreau de Tours's painting set a precedent not only for *morphinomane* artworks but also for the way newspapers could use morphine-related imagery to attract attention.

Following the display of *La Morphine*, newspaper editors used images of the *morphinomane* to heighten reader interest and engagement. The inclusion of images, particularly those that illustrated seemingly factual news reports, was a profit-driven move that undoubtedly contributed to journalism's sensationalism. In tandem with the growing popularity of reports of *faits divers* and morphine-related events, illustrated journals became cheaper and more accessible. Not only did publication of images to accompany factual and fictional texts add (false) credibility to news reports and *romans-feuilletons* but these images also gave additional reasons to buy newspapers. In his article on the reproduction of fine art in nineteenth-century illustrated journals, Tom Gretton notes that the 'relationship between the news-value and the spectacle-value of the illustrated journal' was transformed and 'the object-value of the printed image dwindled to almost nothing ... as the photograph, and its irresistible truth-value, made its triumphant entry into news media'.[25] Whilst this is perhaps the case for reproductions of fine art, the focus of Gretton's article, the question of imagery becomes more complicated when discussing illustrations for reportage or *romans-feuilletons*. Although photographs have an 'irresistible truth-value', many artistic prints that were used for illustrative purposes in newspapers were also accorded a truth-value simply by their placement as accompaniments to reportage.

Moreau de Tours's *La Morphine* is an interesting case in point. Five years after the painting was first exhibited, it appeared in print form in an 1891 issue of *Le Petit Journal*'s illustrated supplement (Fig. 6.1) to accompany a news report.[26] *Le Petit Journal supplément illustré*, which had launched just two years earlier, published a full-page colour reproduction by Henri Meyer of *La Morphine* alongside a short article on the origins of morphine addiction and a few comments on the painting. The authenticity of Meyer's print is enhanced in two ways. First, the painting was renowned for its supposed accuracy and credibility when it was shown at the Salon des Artistes Français five years earlier. Second, brief references to the ongoing news story of the Wladimiroff trial in the accompanying article hinted at a connection to a legitimate event. The inferred connection between the inauthentic and sensationalist narrative of Moreau de Tours's painting and a real news story

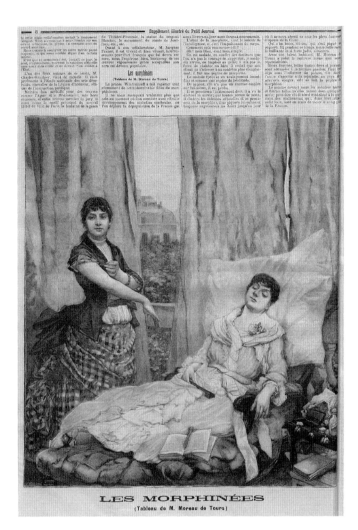

FIGURE 6.1 | Henri Meyer, colour print after Georges Moreau de Tours, 'Les Morphinées,' *Le Petit Journal supplément illustré*, 21 February 1891.

LES MORPHINÉES
(Tableau de M. Moreau de Tours)

resembles the influence of *faits divers* reports in *romans-feuilletons* and the blurred boundaries of reality and representation.

The Wladimiroff trial involved the prosecution of Pierre de Wladimiroff for the murder of Madame Dida. Despite the tragic end to her life and the unfortunate events leading up to the crime, many newspapers sensationalised the story and blamed Dida's morphine addiction for clouding her judgement and causing her untimely death.[27] Echoing these reports on the Wladimiroff trial, the article accompanying the *La Morphine* reprint blamed women for the increase in morphine addiction. In addition, the author

changed the painting's title from *La Morphine* to *Les Morphinées* (The Morphine Addicts). This change shifted the focus of the painting from the drug itself (as an example of how morphine is administered and its effects) to the drug's users, who (as in most visual examples) are female. Through the use of Moreau de Tours's painting for illustrative purposes and references to an ongoing and well-reported news event, the artwork was presented as a supposedly accurate representation of the type of people who used morphine – and this was despite the fact that Georges Pichon's recent and widely referenced analysis of 1889 had shown that more men than women were addicted to the drug.[28]

The anonymous author of the *Le Petit Journal supplément illustré* article offered some criticism of Moreau de Tours's painting, stating that the artist should have shown the figures as 'haggard and withered' as would be expected in the appearance of morphine addicts, likely in keeping with the newspaper's conservative political alignment.[29] Despite that criticism – possibly included to enhance their argument regarding the negative impact of morphine use – it is likely that *Le Petit Journal* chose to reproduce Moreau de Tours's *La Morphine* rather than create a new image to show events from the Wladimiroff trial, in order to benefit from the notoriety it had acquired at its original showing and to take advantage of the artist's celebrated career. In fact, it could be argued that the newspaper's brief mention of the Wladimiroff trial had a somewhat tenuous function and served simply to justify the reproduction of Moreau de Tours's painting alongside a vaguely relevant news report.

As was typical for *Le Petit Journal*, the paper advertised the reproduction in several preceding issues. Large front-page advertisements on 17 and 18 February 1891 and inside-page advertisements on 19, 20, and 21 February 1891 used the artist's name and the title of the painting to arouse interest. Cragin argues that *Le Petit Journal* borrowed not only the format and content of *canards* (newspaper sheets with large images and false stories, popular in the eighteenth and nineteenth centuries) but also their sales techniques. These included 'huge headlines', 'illustrations just like those of the *canards*', and 'distribution through *colportage*'.[30] By the end of the 1860s almost 1,200 peddlers cried *Le Petit Journal* headlines into the streets. This method of publicity undoubtedly involved shouting the names of artists such as Moreau de Tours, when their works were reproduced in the illustrated supplement, particularly since the journal often contained prints by unknown artists. The combination of a celebrated artist, a well-known painting, and a sensational topic was sure to attract the attention of passers-by. Buying a newspaper

meant that readers could cut out and keep reproductions of Salon artworks for a small price.[31]

Front-page newspaper images – usually illustrations of significant news stories or *roman-feuilleton* plots – also attracted pedestrians strolling along the boulevards. Serial novels relied on creating stories from believable events, using suspense and unexpected plot twists to entice readers to buy the next instalment. Interest was enhanced by sensationalised plots, as well as by characters such as the *morphinomane* and the addition of artworks that could be noticed by passers-by. A useful example of this can be seen in *Le Bon Journal*'s publication of *Comme dans la vie* between 15 May and 17 July 1890. *Le Bon Journal*, issued every three or four days, printed instalments of the novel in every edition of the paper.[32] Delpit, who was born in New Orleans in 1849 and naturalised French in 1892, was a famous author who had won several literary prizes in the preceding decades. The novel's illustrator, Émile Bayard, had also enjoyed a successful career leading up to the publication of *Comme dans la vie*. His numerous works for literary giants of the late nineteenth century included illustrations for well-known novels by Jules Verne, Alphonse Daudet, and Victor Hugo. The celebrated status of the novel's author and illustrator, along with the sheer length of *Comme dans la vie*, meant that the newspaper chose to publish a comparatively high number of front-page illustrations for a *roman-feuilleton*. Bayard was commissioned to create seven original front-page illustrations for *Comme dans la vie*, which drew attention not only to Delpit's text but to this relatively small-scale newspaper as well.

The plot of *Comme dans la vie* sees the protagonist, Roland, working for Madame Readish, who is addicted to morphine. *Le Bon Journal*'s sixth instalment featured a front-page illustration of Readish injecting morphine (Fig. 6.2). Until this point in the story, however, morphine had not yet been mentioned. The preceding instalment of *Comme dans la vie* had ended by showing Readish seated with Roland, who had come for an interview. Readish says, 'Forgive me if I don't get up to receive you ... I'm sick! So sick!', but there was no mention of morphine use.[33] The next issue of *Le Bon Journal*, three days later, includes Bayard's illustration of Readish injecting her shoulder and is captioned with a variation of the previous statement: 'It is a morphine injection ... I am so sick!'[34] This front-page image gives potential readers a 'sneak peek' of the upcoming inclusion of morphine in the plot. The instalment, which starts on the third page (and therefore cannot be read easily without purchasing the newspaper) goes straight into details about Readish's morphine use. Without opening the paper, the reader is already

Le Bon Journal

COMME DANS LA VIE, par ALBERT DELPIT

— C'EST UNE PIQURE DE MORPHINE., JE SUIS SI MALADE!... (Voir page 601.)

FIGURE 6.2 |
Émile Bayard, 'C'est une piqûre de morphine ... Je suis si malade! ...,' *Comme dans la vie*, par Albert Delpit,' *Le Bon Journal*, 1 June 1890.

aware of the story's progression from its previous cliff-hanger; the sensationalist potential of morphine-related imagery has worked. The fact that, in its book form, this section of narrative is not broken up through chapter structure or paragraphing indicates that this cliff-hanger technique was a deliberate choice by *Le Bon Journal*'s editors.

Talmeyr's *Les Possédés de la morphine*, extracts of which appeared in the newspaper *Gil Blas*, displayed an image of morphine users to attract attention in a different way. Talmeyr's extracts began on 15 February 1892 and were printed regularly until 20 March.[35] One of the instalments was illustrated by Théophile Steinlen and appeared in *Gil Blas*'s weekly supplement on 21 February 1892 (Plate 10). Steinlen's image refers to an excerpt that was printed on the front page of the daily *Gil Blas* on 16 February 1892.[36] As with

previous and subsequent excerpts of *Les Possédés de la morphine* in *Gil Blas*, the novel's title is printed in three font sizes. The largest font is used for the 'La Morphine' section of Talmeyr's title. Additionally, three days later, the reader is notified that the upcoming illustrated supplement will publish 'a superb tinted Steinlen study of the ravages of morphine' as is 'described with so much power' by Talmeyr.[37] Steinlen's print is mentioned twice on the front page of this instalment, prior to its appearance in the illustrated supplement two days later: first, in the list of items to appear in the next *Gil Blas illustré* and, second, in its own demarcated section.

The accessibility of the daily *Gil Blas* was limited by both price and subject matter. It cost fifteen centimes (twenty centimes for those outside Paris) in comparison to *Le Petit Journal*'s five centimes. The price was likely justified by the desirability of the content created specifically for the newspaper by such illustrious artistic and literary figures as Guy de Maupassant, Émile Zola, and Steinlen. Unlike *Le Petit Journal supplément illustré*, which reproduced Moreau de Tours's recognisable Salon painting, *Gil Blas illustré* consistently published original content. Steinlen was the chief artist for *Gil Blas illustré* during the 1880s and 1890s. The fact that Steinlen's illustration did not appear with the publication of *Les Possédés de la morphine* as a book indicates that the print was created solely for *Gil Blas illustré*. Evidently, the newspaper saw an opportunity to increase its readership whilst promoting instalments of Talmeyr's text. A review of a new book titled *Steinlen and His Art* in a 1912 issue of *The Burlington Magazine for Connoisseurs* stated that many people would buy *Gil Blas illustré* each week specifically to 'cut out the front page for the sake of the "Steinlen"'.[38] Although Steinlen's illustration was not a front-page image, the statement suggests that commissioning Steinlen to create the illustrations had a specific economic purpose for *Gil Blas*'s sales.[39] Moreover, *Gil Blas illustré* cost only five centimes, the same price as *Le Petit Journal*'s illustrated supplement.[40] This leads one to hypothesise that some readers may have purchased only the illustrated supplement – the likelihood of which would be increased when a sensationalist theme such as *morphinomanie* was depicted by a celebrated artist.

As shown through *Le Petit Journal*'s manipulation of Moreau de Tours's *La Morphine* and *Le Bon Journal*'s use of a celebrated illustrator such as Bayard, the act of commissioning Steinlen for *Gil Blas*'s instalments of *Les Possédés de la morphine* also demonstrates the significance of artists' reputation in contributing to newspapers' use of *morphinomane* imagery. Newspapers manipulated *morphinomane* artworks in several ways: to embellish and authenticate a news story with an old artwork (Moreau de Tours's *La Morphine*); to add anticipation and intrigue to a subsequent *roman-feuilleton* instalment

(Bayard's *Comme dans la vie* illustration); and to use the treatment of a sensational subject by a prominent artist to increase sales (Steinlen's *Les Possédés de la morphine*). Each of these techniques employs the visualisation of the sensationalised *morphinomane* to heighten interest, thereby augmenting readership and sales.

Art as *Fait divers*

Morphinomanie featured in all forms of newspaper content: artworks, advertisements to help habitual users, long front-page columns, serialised novels, centrefold illustration compilations, and *faits divers* stories. As Schwartz notes, it was the 'category of reality as an object of consumption' that truly enticed late nineteenth-century audiences and proved the success of the *fait divers*.[41] But there is no reason that the significance of 'reality as an object of consumption' should be applied only to newspaper techniques. In the same way that the saturated newspaper market made it necessary to compete for buyers' attention, the expanding art market meant that artists also needed to turn to new techniques. The commodification of real-life events such as morphine addictions and other related incidents by reporting them in the *faits-divers* style was a formulaic tool used by both journalists and artists to increase publicity. Newspapers had profit-seeking motives for using images and *faits-divers* reportage on *morphinomanie*, but artists also used the *morphinomane* to generate attention and boost interest in their careers. Comparisons can be drawn between the *fait divers* and art.

Bridget Alsdorf, in analysing Félix Vallotton's mock-autobiographical posthumous novel *La Vie meurtrière* (The Murderous Life) written in 1907, contends that the Swiss-French artist/writer draws on the influence of the prints he created in Paris during the 1890s, the period when the novel is set.[42] Alsdorf states that the key theme of Vallotton's art and text – the relation between witnessing crime and social responsibility – finds its parallel in the fin-de-siècle *fait divers*. In her subsequent book on *badauds* ('gawkers'), Alsdorf also applies this argument to works by artists such as Jean Léon-Gérôme and Charles Angrand, which similarly centre on the social context of the *fait-divers* narratives within their artworks and their emphasis on the witness.[43] Alsdorf's argument turns to Maurice Merleau-Ponty's analysis of the *fait divers* (the popularity of this phenomenon, says the French philosopher, comes from the 'desire to see'), since, in artworks by Vallotton, the viewer is also 'given the chance to gawk at the horrible spectacle'.[44] Alsdorf argues that the narrative quality of these images, in conjunction with their 'provocative yet prosaic subject matter', contributes to the artwork's

fait-divers form.[45] But could it be that what artists are really drawing upon is the sensationalism within these implied narratives, rather than the subject matter or specific event itself?

Artists portraying *morphinomanie* relied on the same sensationalist techniques as journalists to create publicity and increase sales; similarities can be drawn between artistic works depicting the *morphinomane* and the phenomenon of the *fait divers*. Artworks depicting morphine use are similar in content to the *faits divers*–type columns headed 'Un(e) Morphinomane/ Morphinomanie', and their success similarly relies on the repetition of specific tropes to contribute to the *morphinomanie* narrative as feminised, eroticised, and dangerous. In his essay on the structure of the *fait divers*, Roland Barthes describes the form as *une information totale*; it contains everything necessary for understanding it and refers to nothing beyond itself.[46] Whether in text or art, aside from titles, which explicitly state the subject of the article or artwork, no prior information is needed for the reader to understand the work's content. This is notably different to political reportage and history paintings, both of which require additional knowledge in order for the reader or viewer to understand the representation of events.

In the context of *morphinomanie*, the sensational aspects are the act of injecting and the person who is doing the injecting. In both art and text, titles are crucial to attracting attention. Whilst newspapers relied on large sensationalist headings and different typefaces, artists' depictions of the *morphinomane* were almost always explicitly titled and were similarly effective for garnering attention. These headings or titles relied on pre-existing sensationalism surrounding habitual morphine use and acted as a beacon for viewers or readers navigating the textual pathways within the newspaper, exhibition catalogue, or art criticism. This use of attention-attracting techniques suggests that artists were not necessarily inspired by specific *morphinomane* stories in newspapers as may be initially presumed, but that journalists and artists alike seized on the *morphinomane* for its effect as a sensationalist framework.

The familiarity of the fin-de-siècle French morphine user resulted primarily from its presence in sensationalised mass culture and artworks. Cragin argues that the popular (non-political) press often resorted to and emphasised the sensational not because censorship purged the political but simply because it sold best.[47] Sensationalising the *morphinomane* functioned to separate representations of addiction from the reality of the drug and its dependence, and served to drive profits rather than to tell the truth about addiction. If capitalism is the driving force behind sensationalism, the *morphinomane* can be understood as a commodity. Newspapers' use of the

morphinomane demonstrates the importance of images to the commodification of sensationalised topics and the potential for these artworks to shape the opinions of viewers and readers. The stories that newspapers chose to sensationalise reveal not only the objects of their readers' curiosity but also the anxieties of contemporary society.[48]

Newspapers relied on the sensationalism of reports and artworks to attract and sustain readership in a competitive market. The *morphinomane* was manipulated to its profit-earning, attention-grabbing potential. The blurring of boundaries between fact and fiction, in textual and artistic form, was crucial to the sensationalism of *morphinomanie*, which existed as a minefield of exaggerated information. Information on the *morphinomane* almost always came at the expense of accuracy. Like the numerous artworks depicting the *morphinomane*, 'the newspaper *claimed* to tell the truth, to present a nonfictive drama of contemporary life'.[49] This fusion – rather, amalgamation – of reality and representation that occurred in both newspapers and artworks cemented an inaccurate perception of habitual morphine use. The naturalism and medicalisation of Moreau de Tours's *La Morphine* helped establish the feminisation of the *morphinomane*, whilst images accompanying *morphinomane* newspaper stories and interconnections between medical theses, fiction, and *faits divers* columns perpetuated the trope of the feminised and sensationalised morphine addict. *Morphinomanie* provided the fusion of the ordinary, the unusual, the erotic, and the morbid – an ideal combination to promote interest and sustain audience in art as it did in text.

7

Art, Innovation, and Strategy

The latter half of the nineteenth century is renowned for having brought significant changes to the Paris art world: its markets, its artistic styles, its demographic, its exhibitions. In 1863 the Salon des Refusés drew unexpected attention to the artworks it displayed and its jury-free structure. In 1874, following rejections by the official state-sponsored salon, the Impressionists exhibited their work for the first time in the studio of photographer Nadar. These events introduced new ways of exhibiting art and allowed the public to view art independently from the criteria imposed by the Salon jury. Artists such as Paul Gauguin and Georges Seurat realised they could carve out their own artistic careers away from the official Salon or the École des Beaux-Arts. By rethinking what and how artworks could be exhibited, these events and artists of the mid- to late nineteenth century were in a sense retaliating against the formal Salon. As accounted for by Patricia Mainardi in her pioneering book *The End of the Salon*, the Salon was a state-sponsored institution that existed for two centuries until, against the backdrop of cultural and economic developments of the Third Republic, the French government withdrew from organising the annual exhibition in the early 1880s.[1]

Concurrent with the above events, several new art societies and salons were initiated, a growing number of (commercial) exhibition spaces were opened, and new art media such as colour lithography created impact and change.[2] Art criticism, auction houses, and the art dealer system also found newly significant roles in the Parisian art market. Mainardi's analysis of the Salon's demise marked a turning point in art-historical scholarship on the changing art world in Paris at the end of the nineteenth century. Since *The End of the Salon*, art historians have further expanded our knowledge of the interconnecting fields of capitalism and art. Investigations into artists' marketing techniques and the importance of art spaces have allowed for a fresh understanding of the changing art landscape, and the locations of art dealers in Paris have been mapped using new digital technologies in order

to demonstrate an empirical change that occurred at the end of the nineteenth century.[3]

By the turn of the twentieth century, Paris had firmly established its reputation as an international artistic capital that attracted artists from around the globe to its prominent independent exhibition culture and diversified art markets. With the rise of consumerism, art objects in all cultural forms became commodities with a saleable function. The aforementioned events concerning the official Salon forced a revivification of art display and compelled artists to find new ways to exhibit and market their work. In order to stand out, artists relied to an unprecedented extent on marketing their art as commodities and themselves as innovators. It was necessary for artists to be aware of the current art market – strategy and innovation were required in equal measure.

The Formulaic *Morphinomane*

Sensationalism was formulaic. If a newspaper article involved ordinary people in an uncomplicated narrative composed of curious, morbid, or unusual events, it was presented as a *fait divers*; it was its sensationalist potential that created and sustained interest, not its specific narrative. Correspondingly, artists used the *morphinomane* more to exploit its sensationalist narrative than to present information about actual morphine use. Both to arouse attention and to promote themselves as artistic innovators in the saturated Paris market, artists chose to manipulate sensationalist subjects such as *morphinomanie*. Hence, artists' depictions of the *morphinomane* are mainly about recognising a market and reproducing a sensationalised phenomenon in a formulaic way.

The representation of *morphinomanes* in *La Morphine* by Georges Moreau de Tours (Plate 1) was counted a success not for the direct sale of the large canvas (it was not sold until the twenty-first century) but for the attention it stimulated – key to marketing one's work and oneself as an artist. The idea that depicting the *morphinomane* became a formulaic way to boost attention is supported by the fact that almost every artist who represented the *morphinomane* did so only once or twice. In a way, each new image of the *morphinomane* was a parody of the original. *La Morphine* was deemed a credible representation in 1886 primarily thanks to its naturalism and the medical authority attributed to it. Since it was the first impactful visual depiction of habitual morphine use, these factors were essential to justifying the subject as something believable. However, the widespread recognisability of habitual morphine use in artworks and newspapers towards the turn

of the century meant that artistic representations no longer required naturalism to assert their credibility because, as a topic, *morphinomanie* was by then pre-established.

Belgian art critic Émile Verhaeren reviewed the 1891 Salon des Indépendants in the radical republican newspaper *La Nation*: 'There is no longer any single school, there are scarcely any groups, and those few are constantly splitting. All these tendencies make me think of moving and kaleidoscopic geometric patterns which clash at one moment only to reunite at another, which now fuse, and then separate and fly apart a little later, but which all revolve nonetheless within that same circle, that of the new art'.[4] This description alludes to the rapid changes in the new art market, which are crucial to understanding the function of the *morphinomane* in artists' works during this period. Verhaeren's analogy of the kaleidoscope can be applied to help understand the successive representations of the *morphinomane*. In the centre, the place where these artists 'clash at one moment', is the (female) figure of the *morphinomane*. But it was necessary to continue to stylistically reinvent the *morphinomane* in order to vivify its sensationalist potential. Following the renown of Moreau de Tours's *La Morphine*, the *morphinomane* remained a sensationalised topic until the 1910s and became a staple ingredient of a formula for garnering attention and thus recognition. The *morphinomane* allowed artists not only to represent female desire and decadence, but also to depict a contemporaneous and specific fin-de-siècle concept; that may partly explain its waning use in the lead-up to the First World War. The repetition of the same subject matter with only stylistic differences shows that the *morphinomane* was likely more about marketing oneself as doing something shocking, than about making a commentary on contemporary events.

Initiating one's career with the recognisable subject matter of the *morphinomane* was a calculated move; it showed an understanding not only of the current art market but also of other cultural forms such as newspapers that turned to the same sensationalised topics. Utilising the *morphinomane* was a tactical career move, but it was still necessary to represent something original. The recognisability of Moreau de Tours's *La Morphine* meant that artists who intended to create attention via innovation had to present the *morphinomane* in a new way. Yet the possibilities for figural representation of the *morphinomane* were somewhat limited because the *morphinomane* is constrained by its feminisation and recognisable tropes. Artists were obliged to include certain characteristics in the figures' appearance to make them identifiable to contemporary viewers as habitual users. At the same time, they had to preserve the drug's feminisation and thus discount male

users and medical professionals. Accordingly, the simplest way to innovate was via colour and artistic style – an effective means for artists to create difference between their depiction of the *morphinomane* and those that had come before.

Reinvention through Colour

Moreau de Tours's *La Morphine* initiated visualisations of the *morphinomane* through a painterly language of credibility. The blended brushstrokes and muted colours do not detract from what was, in 1886, an innovative and original depiction of modern Parisians. Moreau de Tours conformed to the painterly style typical of Salon naturalism in the 1880s; reviewers therefore focused solely on the subject matter rather than on other potentially innovative aspects of the painting such as composition or colour.[5] Artists who followed soon dismantled the painterly credibility of Moreau de Tours's supposed documentary depiction of the *morphinomane* in favour of the exaggerations that typified the shift from naturalism to fin-de-siècle decadence. This exaggeration comes in all forms; the *morphinomane* becomes more degenerate, light and shadow become accentuated as the settings move from day to night, facial features and bodies become almost caricatured, and, of most significance to this discussion on reinventing the *morphinomane*, colours are exaggerated and heightened, showing a marked difference from the muted colours found at the Salon.

In response to the developments of Impressionism and post-Impressionist styles such as Neo-Impressionism and Synthetism, the latter part of the nineteenth century saw a shift to formalist art criticism. In 1890, writing under the pseudonym P. Louis, Maurice Denis wrote his manifesto on aesthetics, 'Définition du Néo-traditionnisme', in which he famously stated: 'Remember that a picture – before it is a picture of a battle horse, a nude woman, or some story – is essentially a flat surface covered in colours arranged in a certain order'.[6] Denis emphasised the significance of colour over subject matter. Artists undoubtedly chose the figure of the *morphinomane* in order to exploit the sensational potential of its content, but colour was now the focus of many artwork reviews. This change usefully coincides with artists' formulaic utilisation of the *morphinomane*; the *morphinomane* topic attracts the initial attention that allows critics to then focus on artists' innovative use of colour. This emphasis on stylistic innovations on the part of artists and reviewers alike corroborates the familiarity of the *morphinomane* as a subject. It does not need explaining via its painterly credibility as it did with Moreau de Tours's *La Morphine*.

The Paris art scene consisted of artists from all over Europe who had flocked to the French capital. Amongst them were Spanish artists Pablo Picasso and Hermenegildo Anglada-Camarasa, both of whom created *morphinomane* artworks. During their time living and exhibiting in Paris, their use of colour was praised by numerous critics. Louis Vauxcelles, for instance, described how Anglada-Camarasa was able to 'transcribe the sublime colours of the hours of the night'.[7] Other reviewers described his paintings as 'curious mosaics' painted with 'gems or melted glass'.[8] Similarly, a review of Picasso's first significant exhibition in Paris noted a 'wonderful science of colour', where 'colours sing and tremble in sweet harmonies'.[9] Picasso was a 'new harmonist of light colours', according to art critic and writer Gustave Coquiot in his review of the same exhibition.[10] Coquiot closed the review by re-emphasising the artist's use of colour – 'like a crazy but subtle goldsmith, he enshrines the most sumptuous yellows, the most magnificent greens, the most reddish rubies' – signifying its importance to the characterisation of Picasso as an artist.[11] Although Coquiot did not refer to any painting in particular, this colour palette was found only in a few paintings at this exhibition: *Danseuse naine* (Dwarf Dancer), *Danseuse espagnole* (Spanish Dancer), and *Morphinomane* (Plate 7). In *Morphinomane*, the figure's torso is formed of vibrant ruby red, as described by Coquiot, whilst the background is made up of unblended strokes of red, yellow, green, and blue. The title of *Morphinomane* in the exhibition catalogue engaged viewers' attention in text form, but the colours provided optical engagement for exhibition visitors.

Eugène Grasset also used bold colours. In his seven-colour lithograph, *La Morphinomane* (Plate 3), colours are significant not only to the artist's pursuit of individualism but also to the print's function as a commodified art object. Grasset's *La Morphinomane* was published as one of thirty-two prints in Ambroise Vollard's second album, *L'Album d'estampes originales de la Galerie Vollard*, in the spring of 1897. The purpose of the album was to demonstrate the possibilities of the relatively new medium of colour lithography, which had simultaneously revolutionised the French newspaper industries thanks to its quick and cheap method of image reproduction. In order to best showcase the possibilities of the medium, Vollard recruited skilled lithographer Auguste Clot to print many of the artworks. It is noticeable, first, that Grasset chose to depict the *morphinomane* and, second, that he used an unusual colour palette for the Vollard album, which was devised expressly to reach an audience interested in this new medium. Not only did *La Morphinomane* stand out from the other prints in the album due to its unusual colours but it contrasted with Grasset's typical muted colour palette. Grasset attributed great importance to artistic innovation and individualism. In an

article in *Art et décoration*, he is quoted as saying, 'Anything is better than the immobility of artistic progress; it is better to disappear than not to invent'.[12] The article's author, Henri Vever, went on to note that Grasset's followers had been keen to see 'something unforeseen arise'.[13] That issue of *Art et décoration* was published in 1898, the year after Grasset created *La Morphinomane*. Whilst the habitual morphine user was no longer an original subject, response to the concept still mimicked the initial attention that Moreau de Tours's *La Morphine* had attracted over a decade earlier.

Grasset typically portrayed idealised female figures, but his occasional depiction of female figures as menacing and dangerous, as in *La Morphinomane*, further implies that the *morphinomane* was still able to draw attention and create shock (in terms of subject matter and artistic innovation). Other factors may also have governed the inclusion of the *morphinomane* in Vollard's album. As well as choosing the artists to be included, it is possible that Vollard encouraged the presentation of certain topics in the prints. *La Vitrioleuse* (The Acid Thrower) (Fig. 7.1), Grasset's earlier lithograph of 1894, reveals much about the reasons behind such choices. Concurrent to the appearance of *La Vitrioleuse*, rumours were spreading about women throwing acid to disfigure their rivals – rumours that were part of a larger rhetoric on the feminisation of crimes of passion. The *vitrioleuse* was exaggerated and sensationalised by the press, just as habitual morphine users were, and as *les pétroleuses* (women who committed arson in support of the 1871 Paris Commune) had been earlier.[14] The *morphinomane*, the pétroleuse, and the *vitrioleuse* should each be viewed as part of the long history of vilifying women during the nineteenth century.

Newspapers and artists played a crucial role in imagining the appearance and attributes of these politicised confections of actual women. Like the *morphinomane*, the figure of the *vitrioleuse* also featured in *faits divers* columns at the turn of the twentieth century. On 1 December 1901, for example, *Le Petit Parisien*'s illustrated supplement printed a short *faits divers* story on the ambush of a male shop worker, who was reportedly attacked with acid by a woman. Notwithstanding the relative insignificance of this article in the newspaper itself, the entire back page of the illustrated edition consists of a print reimagining the perpetrator of the attack.[15] This was despite the fact that the victim stated that he 'did not have time to recognise' the woman's features.[16]

In the article accompanying *Le Petit Parisien*'s illustrated supplement, it was claimed that the woman who carried out this acid-throwing attack was deliberately sabotaging the man's upcoming marriage.[17] The *vitrioleuse*, described by Ann-Louise Shapiro as 'the most recent incarnation of the home-

FIGURE 7.1 |
Eugène Grasset, *La Vitrioleuse*, 1894, colour lithograph, 39.3 × 27.4 cm, The Metropolitan Museum of Art, New York.

making woman gone awry', signalled similar contemporary concerns as the *morphinomane* did, and both were said to be symptomatic of 'a particularly modern malaise' and of degeneration.[18] The *vitrioleuse* was seen as a deviant female figure, akin to the *morphinomane*, who was associated with unconventional lifestyles stemming from shifting gender roles, and was a latent signifier of the *femme nouvelle*. They both possessed a sensationalistic function that could be utilised strategically.

The choice to portray the *morphinomane* for *L'Album des estampes originales,* whether the decision of Grasset or Vollard, was likely made in the aftermath of the publication of *La Vitrioleuse*. The acid-thrower lithograph appeared in André Marty's 1894 *L'Estampe originale* (Album VI). The album was published in editions of a hundred, with ninety-four prints over nine albums issued quarterly from March 1893 to early 1895. Roger Marx, art critic and champion of the print as art, stated that *L'Estampe originale* was

'the first to combine monochrome prints with those of the widest range of colour' – an aim notably similar to that of Vollard's album three years later.[19] Marty's albums were commercially and critically successful and included works by some of the most influential printmakers of the decade. Twelve of the artists for Marty's albums reappeared in Vollard's first album, *L'Album des peintres-graveurs* (1896), which contained prints by twenty-two artists. Whilst Grasset's wide-ranging skills in different media and in commercial poster art certainly contributed to his success, the publication of *La Vitrioleuse* in Marty's second album coincided with the artist's newly widespread recognition. Following the release of the sixth volume of his *L'Estampe originale* in 1894, *La Plume* published a special issue that focused solely on Grasset's work, the first major study on the artist.[20] By 1897, when Vollard released *L'Album d'estampes originales de la Galerie Vollard*, Marty's album had ceased to exist. Perhaps Vollard and/or Grasset aimed to replicate the success Grasset had achieved from Marty's earlier album of artistic prints with a similarly shocking and sensationalised subject. This time, for *La Morphinomane*, Grasset chose a much more lurid palette than for the previously successful *La Vitrioleuse* to show difference and reinvention.

The *morphinomane* and the *vitrioleuse* are very different to the idealistic and desirable female types more often found in Grasset's work. Differences exist between images of habitual morphine use by Grasset and other artists, but there is also reinvention within his own oeuvre, from *La Vitrioleuse* to *La Morphinomane*. The sensationalist potential of the *morphinomane* is evident; the *morphinomane* was a confected figure employed, like the *vitrioleuse*, as a tool by artists just as it was by newspapers. As an established fin-de-siècle construction with specific iconographic traits, the figural representation of the *morphinomane* could not easily be altered. Thus, accorded greater importance by the advent of colour lithography and the shift to formalist art criticism, colour became significant to any reinvention of the *morphinomane*. Artists' use of the *morphinomane* after Moreau de Tours's *La Morphine* highlights three key factors: an awareness of the current art market, the usefulness of a sensationalist topic to attract attention, and the importance of doing something new through artistic innovation, which, in this instance, occurs mostly through the use of colour.

Catalans in Paris

The most useful way to understand the formulaic potential of the *morphinomane* is to analyse artworks by artists for whom it was more difficult to break into the Parisian market: foreigners. Amongst them were several Italian and

Spanish artists who created images of the *morphinomane* whilst living in the French capital at the fin de siècle.[21] The artists Vittorio Corcos, Serafino Macchiati, and Manuel Orazi were amongst the Italians who created *morphinomane* artworks, and each was involved in the French art world in a different way. Corcos met the Italian expatriate community in Paris in the 1880s. He saw success at the Paris Salon and at the end of the decade returned to Italy with an established career and a signed contract with French art dealer Adolphe Goupil. To appeal to the dealership's clientele of wealthy Parisians and American collectors, Goupil commissioned and influenced numerous works by Corcos. Macchiati and Orazi, by contrast, stayed on in the French capital rather than return to Italy. Macchiati lived in Paris, working as a painter and illustrator from the mid-1890s until his death in 1916. The artist's obituaries in French newspapers expressed Macchiati's love for France, and when his work was exhibited posthumously at the Venice Biennale in 1922, he was described as the artist who 'painted Paris'.[22] Orazi, for his part, moved to Paris in 1892 and, like Macchiati, spent his entire career there. Orazi exhibited at the Salon de la Société Nationale des Beaux-Arts, of which he became a member in 1897. Typically, in images created for novels, newspapers, and posters, Orazi depicted decadent Parisian life and the Occult. In a 1902 issue of *Le Figaro*, he was described as a 'marvellous illustrator' whose images had a 'disconcerting power'.[23]

At least six paintings of the *morphinomane* were created by Spanish artists, specifically Santiago Rusiñol, Picasso, Evelio Torent, and Anglada-Camarasa. Late nineteenth-century Spanish artists often pursued career paths that emulated those of the successful Spanish artists of the previous generation. The first generation of Catalan artists to arrive in Paris at the end of the 1880s were what Francesc Fontbona has labelled the *modernistes* and includes the leading figures of Catalan *Modernisme*, Ramon Casas and Rusiñol.[24] The late 1890s and early 1900s marked an influx of the *postmodernistes*, the next generation of Catalan artists in Paris – Anglada-Camarasa, Picasso, Isidre Nonell, Ricard Canals, and others.[25] While Spain's internal conflicts were a potential impetus for these artists moving to Paris, Laura Karp Lugo suggests that the primary draw was the art market. These Catalan artists were in search of a 'market that they couldn't find in Spain', she argues.[26] And their reasons for depicting the *morphinomane* are made clear by an analysis of marketing techniques that they used.

Several years before Anglada-Camarasa and Picasso created their depictions of the figure of the *morphinomane*, Rusiñol painted *La Morfina* (The Morphine Addict) (Plate 5) during his third and final stay in Paris.[27] *La Morfina* was exhibited in October 1894 at the well-known Sala Parés gallery in

Barcelona, where Rusiñol showed works depicting Montmartre life along-side traditional Spanish scenes. This combination of Parisian modernity and Spanish culture reappeared in the oeuvres of many Catalan artists at the turn of the twentieth century. Rusiñol's art and literature were fundamental to the formation of Catalan *Modernisme* and the enthusiastic reception of the movement in Paris in the 1890s. Consequently, upcoming Catalan artists such as Picasso and Anglada-Camarasa were keen to imitate his themes and career. In addition to being acquainted with Rusiñol's renowned artistic career, the majority of Catalan artists knew each other and once in Paris congregated in Montmartre where rent was inexpensive. Rusiñol was influential in Picasso's approach to modernity and his shift away from the traditional art of the Spanish schools.[28] Similarly, Anglada-Camarasa drew influence from Rusiñol and in turn inspired Picasso.[29]

Following in Rusiñol's footsteps, Picasso first visited Paris in late October 1900 with Carles Casagemas. They attended the Exposition Universelle to view Picasso's submission, *Derniers Moments*.[30] The pair took over Nonell's studio on rue Gabrielle in Montmartre, where they lived for three months, and they immediately began creating artworks. Pere Mañach, another Catalan living in Paris, soon became Picasso's agent. In a move that would become crucial to Picasso's career, Mañach introduced the artist to the dealer Berthe Weill and promised to organise an exhibition for him.[31] This exhibition would be Picasso's first commercial exhibition and first major showing of his work.[32] To prepare, Picasso returned to Paris from Spain in the spring of 1901 and stayed with Mañach in a studio on boulevard de Clichy, Montmartre. The exhibition, shared with Basque painter Francisco Iturrino, was held at Galerie Vollard from 25 June to 14 July 1901. Picasso showed sixty-four paintings and an unspecified number of drawings, most of which were created specifically for the exhibition and only a few weeks before its opening.[33]

It was at Galerie Vollard in Room 7 that Picasso exhibited one of his two known *morphinomane* works: *Morphinomane* (Plate 7). Picasso's movements in the months preceding the exhibition are still under debate, but the choice to show a depiction of the *morphinomane* at his first commercial exhibition, and in Paris, is significant.[34] Although the figure conforms with other depictions of the *morphinomane,* habitual morphine use in this painting is by no means explicit. In the exhibition catalogue *Morphinomane* is immediately followed by works titled *L'Absinthe* (The Absinthe Drinker), *Moulin-Rouge*, and *La Buveuse* (The Drinker). Akin to Anglada-Camarasa's turn-of-the-century paintings, each of these Picasso paintings was just another depiction of Parisian types, conforming to a (foreigner's) notion of French decadence,

produced and reproduced by an artist attempting to attract attention in a saturated market. It was not necessarily about the subject of the painting, but more about how the title in the exhibition catalogue could attract attention or, at least, demonstrate an acknowledgement of French art and culture. The exhibition catalogue shows *Morphinomane* listed as number nine, which is early in the total of sixty-four listings. *Morphinomane*, along with the other Parisian types, appears on the first page of works listed under Picasso. The title alone would have caught the attention of the catalogue's readers.

The painting's title functions in the same way as 'Morphinoman(i)e' columns in newspapers and relies on the pre-existing sensationalism surrounding the supposed morphine epidemic. This is particularly significant if one considers an exhibition catalogue as a 'tool to inflate the market value of a school or individual artist'.[35] In the preface of the catalogue Coquiot praised Picasso and Iturrino; part of the catalogue text was then used in Coquiot's regular column in *Le Journal*, 'La Vie artistique'. The art critic's involvement in the exhibition catalogue meant the newspaper review was overwhelmingly positive and was part of a larger marketing strategy to elevate the perception of Picasso in the Parisian art world.[36]

Coquiot's control over Picasso's public persona went beyond positive reviews. He is often credited with assigning the titles to many of the paintings in the exhibition, including *Morphinomane*. Pierre Daix claims that Coquiot gave titles to the works without asking Picasso, who barely understood the titles because they 'only had a distant relationship to the real subject'; Picasso, he says, was still 'irritated' by this sixty years later.[37] Moreover, contemporary critic Pere Coll reviewed the exhibition and ambiguously suggested that Picasso had 'been led to paint' unusual subjects.[38] It is quite plausible that Coquiot chose the title for *Morphinomane*, particularly considering that some of the tropes in the painting could be found (possibly coincidentally) in other more obvious depictions of habitual morphine users. Although Picasso was surely aware of *morphinomanie* as a supposedly Parisian phenomenon, and had indeed created his *Les Morphinomanes* painting during that same period (Plate 11), Coquiot is more likely to have understood the sensationalist potential of the decadent *morphinomane* as a representational type to aid Picasso's integration into the Parisian art world. The painting's title, an explicit reference to morphine use, suggests further that portraying and displaying the *morphinomane* was a deliberate tactic adopted by (agents on behalf of) artists.

The choice of artworks to sell or exhibit was crucial for aspiring artists and their agents. By the turn of the twentieth century, Anglada-Camarasa was a successful commercial artist who exhibited internationally. In addition to his

depictions of the *morphinomane* and his oil on canvas *La Droga* (The Drug) (c.1901–03), of whose potential sensationalist repercussions he was surely aware, he used other marketing techniques to increase publicity and therefore sales. Maria Villalonga suggests that Anglada-Camarasa used a similar sales technique to avant-gardist Gustave Courbet earlier in the nineteenth century.[39] Courbet chose to exhibit his 'provocative and demanding works' and to sell his 'pot boilers' because they were created with the intention of making money: 'the second type gave him the freedom and independence he needed for the first type'.[40] Essentially, the popular and saleable works were irrelevant to Courbet's characterisation as an innovative and controversial artist, particularly because his 'pot boilers' were rarely displayed in public.

Anglada-Camarasa approached the sales of his work in a comparable way to Courbet; he deliberately gave his exhibited paintings – the more controversial, sensationalist works – inordinately high prices so that they would not sell. In 1903 he stated: 'during the year when I became *associé* [1902], numerous were the artists who were really keen on purchasing my exhibited works but could not afford them because I had prized [*sic*] them so high. Instead they came to my studio and bought some sketches and small drawings valued at 500 francs each ... I knew this was going to be a decoy that would enable me to sell all the rest at much higher prizes [*sic*], which is exactly what happened.'[41] Whilst it cannot be certain that Anglada-Camarasa used this technique specifically for each of his *morphinomane* paintings, it is known that he refrained from selling one *morphinomane* painting, *Le Paon blanc* (Plate 2), until around 1908.[42] This was after it had been exhibited at some major European shows in 1904, including the Paris Salon de la Société Nationale des Beaux-Arts, before its title was changed for the Venice Biennale in 1905. The change in the painting's title from *Le Jardin-concert* to *Le Paon blanc* suggests that Anglada-Camarasa was prepared to recycle previously successful artworks from other European exhibitions and reuse them with new titles. In a similar way to Coquiot on behalf of Picasso, Anglada-Camarasa was very much aware of the sensationalist potential of subject matter such as the *morphinomane* and how it could benefit his artistic status both in reputation and in earnings.

'Paris is the centre of the cult'

Artists used their *morphinomane* paintings to garner attention, but for foreign artists their artworks also provided a means to show an understanding of or integration into Parisian culture. Discourse on the *morphinomane* perpetuated the international reputation of Paris as a place of decadence:

pleasure, artifice, and excess were said to typify the French capital. By the mid-1880s, coinciding with the showing of Moreau de Tours's *La Morphine* and the abundance of sensationalist newspaper reports, Paris had become widely associated with morphine use. The perception of the 'City of Light' in Britain and Ireland is a case in point. A *Weekly Irish Times* article of September 1886 titled 'The Morphine Habit in Paris' opened with a description of *La Morphine* and went on to inform readers, 'there are at least 50,000 persons confirmed in the habit [in Paris]'.[43] As early as 1882 the *Western Gazette* of Somerset, England, reported that 'vast numbers of ladies in Paris use morphine daily'.[44] From then onwards, there was continuous reporting on the situation across the Channel. This included reports on the 'morphine dens of Paris', an article republished in various papers including the *Edinburgh Evening News* and the *Sheffield Evening Telegraph*, and columns headlined 'Parisians and Morphine', as seen in the *Cheltenham Chronicle*, among others.[45] Robert Hichens's novel *Felix* of 1902 uses an informative narrative voice to describe the 'morphia craze' in London, but reassures its British readers that 'in Paris it's ten times worse … Paris is the centre of the cult'.[46]

The phenomenon of the *morphinomane* as a Parisian type was exacerbated by the inclusion of Moreau de Tours's *La Morphine* at the Columbian World's Fair of 1893 in Chicago. When speaking about French submissions to the fair, the exhibition reference book states that the jury was 'extremely careful in collecting works of art to be sent' and that 'scarcely one-third of the works presented [were] accepted'.[47] In an article on French art at the exposition, a journalist for the *Chicago Daily Tribune* noted that the chosen paintings were 'representative specimens of French modern art'.[48] Although *La Morphine* did not receive the amount of attention it had at the 1886 Salon des Artistes Français – in part due to the enormous scale of the World's Fair and its wide-ranging exhibits – it was reproduced in *Art and Artists of All Nations*, a book of 140 photographs of the 'greatest paintings' exhibited at the World Fair's Fine Art exhibition.[49] Singling it out from the 4,647 paintings on display, a lengthy paragraph in the *Chicago Daily Tribune* was dedicated to Moreau de Tours's painting.[50] The author describes *La Morphine*, retitled *Morphiamania* for the exhibition, as 'worthy [of] the attention of medical men' and, significantly, as 'eminently French'.[51] The fact that *La Morphine* was perceived as representative of modern French culture demonstrates how the *morphinomane* was seen as a quintessentially Parisian type in Europe and beyond.

Art critic Georges Rivière, in a 1912 article from *Journal des arts*, asserted that the 'gradual invasion of foreigners' was problematic for 'truly Independent [Parisian] artists'.[52] It was important for foreign artists such as the

Catalans to become integrated and show an understanding of Parisian (artistic) culture in order to be accepted by contemporary critics. With over three hundred Spanish artists working in Paris at the time, French critics often discussed Spanish artists *en masse* in exhibition reviews.[53] The creation of stylistic reinventions of subjects that were evidently French, such as Montmartre life or the *morphinomane*, was an important tactic to enable foreign artists to be named individually in French exhibition reviews. Many of the subjects of Picasso's paintings at the Vollard exhibition were of Parisian women, the city, and night-time entertainment. Similarly, until around 1904, Anglada-Camarasa created numerous artworks showing Parisian nightlife. Traditional Spanish subjects by Catalan artists did have commercial value in the French art market, but it was their depictions of stereotypical French types and locations that were discussed by critics as innovative and interesting. While French newspapers used the figure of the *morphinomane* to create attention and thus economic achievement, aspiring foreign artists used this quintessential Parisian type to provoke international recognition as artistic innovators with a knowledge of contemporary Paris as a place of opulence and decadence.

Exoticism

Picasso, Anglada-Camarasa, and Rusiñol each created a wealth of Spanish-themed paintings, as did the majority of Catalan artists in Paris, even though such artworks were rarely mentioned in reviews. In fact, Picasso exhibited a large number of paintings with traditional Spanish themes at his Vollard exhibition, most of which appeared in the latter half of the exhibition catalogue. Catalan artists often depicted Spanish motifs, such as bullfights, Andalucian landscapes, and flamenco dancers, because of the relative success of these topics in terms of commercial sales in the French art market. In 1901, the same year as the exhibition at Galerie Vollard, Picasso sold three bullfighting pastels – his first sales – to Weill through Mañach despite the somewhat unfavourable stance to bullfighting promoted in the short-lived art magazine *Arte Joven*, co-directed by Picasso during the same year.[54] This suggests that the young artist evidently understood the French art market because he created Spanish-themed works for their economic worth, rather than as specific personal expressions of culture or identity.

The profitability of Catalan artists portraying Spanish culture for the Paris art market relied on exotic rather than sensationalist or contemporary subjects. Artists' representations of Spain typically centred on romanticised images of traditional and rural life rather than modern cities or contemporary

hardships.[55] As Alisa Luxenberg has argued, these idyllic Spanish images relied simultaneously on escapism and on an exoticised otherness; the latter was a key marketing tool in the turn-of-the-twentieth-century French art market for Catalan artists.[56] Images of Spain required a real or imagined move away from Paris, yet the concept of othering to encourage public interest can also be applied to images of Montmartre – the inferred location in Catalan artists' depictions of the *morphinomane*. The physical outsiderness of Montmartre – situated on a hill on the outskirts of Paris – encouraged notions of moral and cultural outsiderness, in addition to associations with independence that were rooted in the revolutionary uprisings on the hilltop at the beginning of the Paris Commune.[57] Despite the rapid commercialisation of Montmartre that had taken place by 1900, and the shift towards central Paris as the site for popular entertainment, the *arrondissement* remained a place to visit because of its subcultures, decadence, and otherness.[58]

The otherness of Montmartre was enhanced by its popularity among immigrants and foreigners as a place to settle in Paris, thanks to its cheap rent and existing communities. Sold to tourists and other Parisians as a decadent bohemian underworld, Montmartre was characterised by sexual freedom and the spectacle; an entertainment industry where one could see a conglomeration of Parisian types in audiences and on stage. Anglada-Camarasa in particular emphasises this otherness via his otherworldly depictions of the *morphinomane*s and other *demi-mondaine* figures whose animalistic traits contribute to their otherness. Where previous generations of Spanish artists in Paris had 'tended to observe from a distance', Anglada-Camarasa and Picasso immersed themselves in Parisian subcultures.[59] They drew on the exoticism and otherness of Montmartre to heighten interest not only in their art, but also in their own lifestyles.

Montmartre had a history of opium dens and, by 1900 the *arrondissement* had become the location for illicit morphine sales and the broader unlicensed drugs market, which had recently expanded to include cocaine. Commenting on the growing trade in the area, a front-page article in *La République* newspaper claimed in 1901, '*morphinomanie* has nowhere more fervent followers than Montmartre'.[60] This marked a shift away from narratives of the previous decade that were more likely to describe bourgeois women purchasing morphine from corrupt pharmacists. As the drugs market became democratised and illicit, journalists focused *faits divers* columns on raids of vendors' houses and the many arrests of those selling morphine in Montmartre. Anglada-Camarasa and Picasso's paintings of the *morphinomane* acknowledge a transition from the supposedly exclusive *haut-bourgeois* use seen in Moreau de Tours's *La Morphine* in 1886 to the alleged democratisation of

morphine used by Montmartre's inhabitants and night-time visitors. This new focus lends credibility to their paintings, as well as demonstrating a real and representative progression from *La Morphine*.

By producing artworks that clearly referenced Montmartre's alleged decadence and its inhabitants such as the *morphinomane*, Picasso and Anglada-Camarasa created identities for themselves, which art reviewers in turn exaggerated. Their individualism – or perhaps, more accurately, a performative outsiderness – was a contributing factor to the artistic recognition of these Catalans living in Paris.[61] Critics used the fact that the majority of Catalan artists chose to live in Montmartre during their stay in Paris, and made the *arrondissement* the focus of their artworks, to create sensationalised Parisian narratives around the lives of Anglada-Camarasa and Picasso. And descriptions of their artistic practice around Montmartre simultaneously contributed to the otherness of the subjects of their artworks and characterised the artists as explorers of the 'exotic'.

Art criticism was fundamental to the creation of artists' identities.[62] Whilst living in Paris, Anglada-Camarasa was internationally characterised as someone who lived this unconventional lifestyle. A Catalan journalist reported on a visit to see Anglada-Camarasa in 1906, following his creation of artworks depicting Montmartre types. The article, titled 'Anglada Eats and Lives but Only at Night', describes the artist walking around Montmartre after dusk and seeing 'cabaret-elegant people' and those 'on the look for a contrast, a new sensation'.[63] Similarly, in the liberal London newspaper *The Westminster Gazette*, Claire de Pratz stated in 1904 that Anglada-Camarasa 'sleeps all day and works all night'.[64] Pratz identified the artist with the 'extraordinary females [that] he portrays', the likes of which cannot be met 'in broad daylight'.[65] Analogously, Coquiot created a persona for Picasso in his review of the Vollard exhibition, the first lengthy text on the artist in a Paris newspaper: 'It is easy to imagine him – wide awake, with a searching eye, keen to record everything happening in the street … We can see at once that P.R. Picasso wants to see everything and say everything … an artist who paints all round the clock, who never believes the day is over, in a city that offers a different spectacle every minute.'[66] These characterisations align the two Catalans with other night-time figures associated with Montmartre and fin-de-siècle decadence, emphasising the otherness of both the *arrondissement* and the artists. This tactic sustained public interest in the two artists' lives and the alleged snapshots of their subjects' lives in paint.

Undoubtedly influenced by characterisations of the artists in newspapers, several reviews mentioned the credibility of Picasso and Anglada-Camarasa's depictions of Montmartre nightlife and its supposed inhabitants.

Art critic Henry Marcel described how Anglada-Camarasa pursued a 'vein of nocturnal observations', labelling his paintings 'Parisian investigations'.[67] Jeanne Fernande Perrot, writing under the pseudonym Harlor in *La Fronde*, described the Vollard exhibition paintings as Picasso's memories of Parisian excursions, whilst François Charles noted that 'one could say where each of his paintings [came] from'.[68] The personas that had been created enhanced the believability of the artworks in general, as well as, more specifically, the artists' representations of Montmartre and the *morphinomane*. The creation of an identity in the Parisian popular press and further afield not only enhanced the credibility of Picasso and Anglada-Camarasa's images but it also solidified contemporary beliefs that the *morphinomane*, among other types, could actually be seen around Montmartre. This subtle marketing method situates both the artist and the artistic subject as an exoticised other that could be found in the liminal space of Montmartre.

Eroticism

Throughout art history, female figures have been depicted in an idealised and sexualised way, characterised by their sexual availability either via an exoticised and eroticised otherness or by an overtly sexualised representation. The *morphinomane* is no exception; it is imbued with an eroticisation that stems from its otherness or divergence from normality. This characterisation was achieved partly via associations with Montmartre, a place of sexual freedom and excess, in paintings by Rusiñol, Picasso, and Anglada-Camarasa. Similarly, depictions of the *morphinomane* as *demi-mondaine* are indicative of promiscuity and sexual perversion, a portrayal that aligns with wider societal concerns about degeneration and relates to the complex relationships between sex and drugs, as explored by Sara Black.[69] In art, the *morphinomane*'s sexual availability is also implied via the gaze, indicative of moral or sexual deviance and an absence of shame and self-consciousness in comparison to expected social behaviours. Artists' references to pleasure-seeking, undress, and unconsciousness in *morphinomane* artworks lend eroticism to the depicted figures.

In the late 1870s and early 1880s, several medical professionals attempted to assign habitual morphine users to two categories: those with *morphinisme* (an addiction to morphine as a result of its role as pain alleviator) and those with *morphinomanie*. *Morphinomanie* (morphine-mania) was believed to be a result of moral weakness or the pursuit of pleasure. In an 1887 medical article, Benjamin Ball and Oscar Jennings proclaimed that 'one enters *morphinomanie* through the door of voluptuousness'.[70] Newspapers preferred to use

morphinomanie in their reports on habitual morphine use, and most medical professionals eventually did as well. By the 1890s *morphinomane* was generally used as a blanket term to describe anyone who habitually used the drug, and this was the term used by artists in their artwork titles. The use of *morphinomane* fails to acknowledge the medical sector's role in introducing and perpetuating habitual morphine use in patients, as well as the legitimate use of morphine for chronic illness or pain. Most important, however, is that the term confines habitual morphine users to notions of unauthorised pleasure-seeking, which are associated with the overt and erroneous feminisation of the drug and its users.

The feminisation of morphine users, and the portrayal of their bodies in art as unscarred and idealised, enhances the sexualised undertones of *morphinomanie*. The sexualisation of the *morphinomane* is most evident in the corporeal presentation of the figures' bodies in which they connote what Laura Mulvey has called a 'to-be-looked-at-ness'; of course, this sexualisation conforms to the wider representation of women throughout art history as sexualised by the (male) artist for the (implied male) viewer.[71] Depictions of the *morphinomane* as signifier of sexual availability and pleasure-seeking stemmed in part from the merging of addiction as an 'irresistible impulse' with sexual desire.[72] Even in respected medical theses on *morphinomanie*, women are described as having a 'latent eroticism' and 'lustful visions', as being plunged into a 'state of delightful reverie' or experiencing an 'indefinable mixture of pleasure and acute pain'.[73] The ambiguity in the latter quotation is paralleled in Rusiñol's *La Morfina* (Plate 5). With bare shoulders and chest, slightly parted lips, and unkempt hair, the female figure grasps the bed sheets in what was described by theatre critic Salvador Canals in 1895 as a 'painful and joyous spasm'.[74] In his description of Rusiñol's painting, Canals aligns the use of morphine with a form of sexual gratification, as echoed in the figure's representation. The sexualisation of the figure's addiction in the form of a 'joyous spasm' not only equates habitual morphine use with sexual satisfaction, but it also functions to suggest the eroticised female body's availability to the presumed male viewer.

Yet this combination of pain and pleasure can be understood in a more nuanced way. Grasset's *La Morphinomane* (Plate 3) is a depiction of pain, not pleasure, but its representation nevertheless functions to provide pleasure for the (male) viewer. The figure's state of undress, furrowed brow, and dishevelled hair imply some physiological effects of addiction. But Grasset removed many of the model's facial wrinkles from his preliminary sketch, thereby adding to the *morphinomane's* youthfulness and hence its sexualisation.[75] At the same time, the figure's clothing eroticises the *morphinomane*

and conforms to the ambiguously sexualised understanding of addiction as an irresistible impulse. Grasset's depiction of clothing – or lack thereof – functions only for the desires of the print's viewer. The state of semi-undress implies that the figure has recently been dressed for public appearance. Tights or stockings functioned to transform 'carnal flesh into the sublimated' and thus, as Abigail Solomon-Godeau describes in her analysis of the mid-nineteenth-century erotic photographs of Countess de Castiglione, the 'naked leg appears only in the context of the nude or in the specifically erotic gesture of removing or putting on stockings'.[76] The stocking functions similarly in many artworks from the same period and became a trope representative of women's undressing. It is the presence of the stocking in Grasset's *La Morphinomane* that 'codes the woman's body erotically', not necessarily the bare thigh.[77] Grasset deliberately includes the stocking and garter, cutting the composition off slightly below that point and using the surrounding white fabric to emphasise the blackness of the figure's hosiery. This contrast draws the viewer's eye to the figure's thigh, which functions erotically to signify the state of undress.

Many visual representations of the *morphinomane* reflect the sleep-inducing nature of the drug, consequently utilising a genre that has consistently sexualised female figures throughout history. As a narcotic, morphine lends itself to the lassitudinous representation of the *morphinomane* and thereby enhances the sexualisation of habitual morphine users. This is most conspicuous in the depiction of morphine addicts in *La Vie Parisienne*, a newspaper whose reputation for frivolity and risqué illustrations made it a perhaps unsurprising location for such images. An example by Louis Vallet (Fig. 7.2) shows a topless female figure, partially covered by sheer material. The openness of the figure's body indicates sexual availability in a more explicit way than Catalan artists' visual associations between the *morphinomane*, *demi-mondaines*, and Montmartre. Another image by Vallet is from a centre-page spread on the activities of fictional, single, and seemingly wealthy women (Fig. 7.3). As with other images on this centrefold, the figure is semi-naked, and reclining. Vallet exaggerates the serpentine curve of the hips – a key trope found in representations of the eroticised female body throughout art history – and reveals the figure's bare hip and breast.

The serpentine curve and revealing clothing can also be seen in Albert Matignon's 1905 painting *Les Morphinomanes* (Plate 9), which was exhibited at the Paris Salon des Artistes Français. The painting received very little attention in comparison to Moreau de Tours's *La Morphine* of almost two decades earlier. Reviews of Matignon's canvas did not focus on the painting's implied narrative or painterly style, but spoke instead about the representation of

FIGURE 7.2 | Louis Vallet and Marion, 'De trois à sept,' *La Vie Parisienne*, 21 November 1891.

FIGURE 7.3 | Louis Vallet, vignette from 'Petits Levers,' *La Vie Parisienne*, 17 September 1892.

female figures, which are overtly eroticised. One writer described the figures' faces as full of 'voluptuousness' and 'lust', whilst another labelled the painting a fantasy.[78] Playwright and theatre critic Charles Méré stated that *Les Morphinomanes* shows the 'ecstatic *jouissance*' of the figures whose 'souls are drifting towards paradisiacal nirvanas'.[79] Matignon's painting and Méré's use of *jouissance* equates sexual pleasure and eroticism with the *morphinomane*. Since the sexualisation of the female body was a fail-safe formula used by artists working in a variety of artistic styles, the eroticisation of the *morphinomane* was inevitable; after all, the sexualised female body was an emergent force of capitalism.[80]

Matignon's *Les Morphinomanes* enjoyed reasonable commercial success. Following its showing at the Salon, the French state bought the painting in 1907 for 1500 francs.[81] In terms of creating attention and boosting artistic status, however, *Les Morphinomanes* was not successful. The fact that work is an oil on canvas painted in a naturalist style with muted colours and sexualised female figures proves that using the *morphinomane* was not in itself enough to create attention. By the turn of the twentieth century, innovation, in terms of colour and artistic style, was also key to artistic recognition. Although Matignon makes use of the *morphinomane*, he does not depict anything new in terms of subject matter or style. By these standards, the painting was not a success. Reviewers were left focusing solely on the sexualised female figures, which was certainly not a new concept in 1905.

The failure of Matignon's *Les Morphinomanes* in terms of its sensationalist potential reveals a trajectory of artistic content and style in the fin-de-siècle art world.[82] Matignon's *Les Morphinomanes* of 1905 and Moreau de Tours's *La Morphine* of 1886 were both displayed at the Salon des Artistes Français, which had been managed by the Société des Artistes Français since 1881 after the state's withdrawal of sponsorship from the official Paris Salon. It is significant that the innovative aspect of Moreau de Tours's *La Morphine* – its original subject matter, the *morphinomane* – transcends the traditional Paris Salon and its naturalism. Henceforth, the *morphinomane* is found in new artistic spaces, exemplifying the commercialisation of art, the necessity for artistic recognition, and new techniques of display and sales. Yet, as demonstrated by the reception of Matignon's naturalist canvas of three morphine users, the innovations found in subsequent reinventions of the *morphinomane* – namely colour and style – did not flow back to the Salon des Artistes Français. Admittedly, this is a simplistic conclusion of the relationship between what might be called Salon insiders and Salon outsiders, but it is important to note that the time that passed between the creations of *La Morphine* and *Les Morphinomanes* corresponded to the simultaneous

waning of debates on decadence and the decline in relevance of the Salon des Artistes Français. By 1905 this once prestigious institution had lost almost all signs of innovation.

As Fae Brauer states, the renown of the Neo-Impressionists in the final decade of the nineteenth century 'proved that they did not need to rely upon the [Salon des Artistes Français] in order to achieve visibility in the French art world'.[83] Artists who wished to innovate, particularly in terms of colour and style, could exhibit at any number of new salons and artistic spaces. This freedom benefited the types of art display practices that were employed for the *morphinomane* works of Picasso, Anglada-Camarasa, and Grasset, among others. In the context of the expanding commercial art world of turn-of-the-century Paris, artists' use of the *morphinomane* – with its potential to be recycled, manipulated, and innovated as something sensational, decadent, French, exotic, and erotic – established success through a combination of formulaic sensationalism *and* innovation.

The Multifunctional *Morphinomane*

The *morphinomane* was sensationalised and manipulated both by journalists and by artists; in literary as well as artistic contexts it functioned to elicit attention and sustain interest. Even today, using the same tools employed by turn-of-the-twentieth-century artists and journalists, scholars, writers, curators, and producers continue to draw on the sensationalism of the fin-de-siècle *morphinomane*, exploiting the impact of those images. Out of 101 objects in the Hammer Museum's exhibition *Tea and Morphine: Women in Paris, 1880–1914* in 2014, Grasset's print was one of just two images showing morphine users; nevertheless, the exhibition centred on those works. Little of the exhibition could be seen from its entrance, but *morphinomane* prints by Grasset and Albert Besnard (Fig. 2.3) were featured on the first viewable wall. Additionally, the exhibition pamphlet opened with a description of Grasset's lithograph and included a full-page reproduction on the opposite page. John Seed's preface to an interview with the exhibition's curator Victoria Dailey began by stating: 'If you were to ask writer, independent curator and antiquarian bookseller Victoria Dailey "What is the most shocking image of the late 19th century?" her answer would likely surprise you: Eugène Grasset's *La Morphinomane* (The Morphine Addict), which Dailey feels is "at least as shocking" as Edvard Munch's *Scream* series of the same era.'[84] Press coverage of *Tea and Morphine* told a similar story. Reviewers used images of Grasset's *Morphinomane* and Besnard's *Les Morphinomanes, ou Le Plumet* to open their articles.

The sensationalist potential of Grasset's *Morphinomane* in present-day art and text parallels the use of Moreau de Tours's 1886 Salon painting, *La Morphine*, in late nineteenth-century France.[85] *La Morphine* was the reference point for the visualisation of *morphinomanie* and was consequently parodied and reinterpreted in the following three decades. *La Morphine* was referenced and reused because of its naturalism and apparent medicalised credibility. The familiarity of the *morphinomane* figure, largely as a consequence of *La Morphine*, meant that subsequent artists did not need to present credible versions of habitual morphine use(rs) as Moreau de Tours had. Instead, artists were able to profit from the sensational and careerist potential of the *morphinomane*, whilst pursuing innovative formal changes relating to the use of colour and artistic style. Like journalists, artists exploited and sensationalised *morphinomanie* to capture attention, increase sales, and – in the case of foreign artists in particular – to enhance their recognition as modern, French creators, with little concern for the truth of the apparent epidemic. Controlled by its representation in art, the multifunctional *morphinomane* can and should be seen as a device that exists through its sensationalist potential as a profit-driven, attention-grabbing tool that occurs within a much longer art-historical narrative of eroticised representations of the female body.

Connections and Conclusions

Morphinomane artworks mark the first historical moment in Western art to visualise cohesively any form of habitual substance use. In other words, this fin-de-siècle visual culture set a historical precedent for the visualisation of addiction. This is in comparison to depictions of substances with a much longer history, such as alcohol and opium, where artists relied on including paraphernalia specific to that substance to tell a narrative of dependency. This initial visualisation of morphine addiction is indicative of when habitual narcotic use became 'an object of popular concern', setting the long-lasting paradigm that, as Timothy Hickman argues, developed into heroin chic.[1] Although Hickman's article was written in 2002, just after the end of what may be deemed the heroin chic period, this was by no means an end point for the visualisation of addiction. Moving into the twenty-first century, there exists a continuing presupposition, analogous to visual constructions of the *morphinomane* over a century earlier, that a distinct set of recurring tropes can be used to identify the present-day 'addict'.[2]

The *morphinomane* and, by extension, *morphinomanie* must be perceived as a social construction. Whether affected consciously or subconsciously by the society in which they live, artists make deliberate choices of what to include and exclude. By first questioning the validity of the presentation of the habitual morphine user as female, bourgeois or *haut-bourgeois*, of child-bearing age, and fashionable, it is possible to analyse both how and why artists used these characteristics to represent the *morphinomane*. This book shows that these characteristics were created as a direct consequence of contemporary anxieties and societal changes, despite the fact that actual habitual morphine users living in fin-de-siècle France rarely corresponded to the tropes seen in these works.

The Intrinsic and Extrinsic *Morphinomane*

The visual culture of the *morphinomane* can be broken down into eight facets, which have recurred throughout this book: tropes, identification, absences

and presences, the art market, Paris, femininity, blurred boundaries, and society. These themes, outlined in the following paragraphs, are crucial to understanding the creation and perception of the *morphinomane* from 1870 to 1914, and the significance of these images to the visualisation of the 'addict'.

Tropes

Artists used repeated tropes in images of the *morphinomane*: large eyes, heavy makeup, a vacant gaze, fashionable clothing, and animalistic features, among others. Individually, these tropes derived both from the medical understanding of *morphinomanie* and from the much longer history of visualising problematic female figures in art. But, combined, these characteristics constructed a specific visualisation of the drug user, which was initiated with Georges Moreau de Tours's *La Morphine* in 1886, seen by hundreds of thousands of people when it was displayed at the Salon and recirculated in the following decades. The recognisability of these tropes cannot be underestimated. The figure in Hermenegildo Anglada-Camarasa's *Le Paon blanc* was interpreted as a *morphinomane* because of the tropes used, not because of references to morphine use in the composition or title. Morphine's feminisation (constructed by these recurring tropes) was, in part, an attempt to categorise the *morphinomane*'s appearance. Paradoxically, the existence of many of these recurring tropes in art indicates the invisibility of real habitual morphine use. Hugely exaggerated eyes, animalistic transformations, and Sphinx-like characteristics, for example, cannot be found in actuality. These unhuman features not only exacerbate the difficulty of representing an addiction that has no direct physiological effects, but they also emphasise the extent to which these figures have been orchestrated in both text and image.

Identification

Ideas about who was or was not using morphine were a distinct concern, particularly because *morphinomanie* was framed as an insidious contagion that could penetrate the domestic space. Artists' references to fashion and makeup perpetuated anxieties about (women's) deceptive identities and contributed to broader debates on women's concealments, prostitution, and class. Although some of the tropes employed by artists were based on medical observations, such as enlarged pupils and insomnia, these traits were removed from their medical origins and re-deployed into a visual culture of untrustworthy and problematic women. Viewers interpreting these recurring tropes could be seen as analogous to medical professionals: art viewers

could 'diagnose' figures as habitual morphine users by interpreting recognisable visual clues.

Absences and Presences

The presence of recurring tropes and female figures constructed a false perception of the habitual morphine user. Simultaneously there is an absence of medical figures within these images. Artists actively de-masculinise their compositions by depicting the feminised domestic space and excluding male morphine users and doctors. The absence of Moreau de Tours's *La Morphine* in a medical journal's Salon review was an early indication of attempts from the medical sector to absolve responsibility from *morphinomanie*. Regardless, artists' inclusion of the Pravaz hypodermic syringe attributed a significance and responsibility to the medical sector. The syringe implies the physician's role in *morphinomanie* and acts as an absent medical presence within these otherwise feminised artworks. Absences and presences are linked with truth and deception. Although the morphine addict was portrayed in a wide variety of mediums, its representation as caricature reveals some social truths about *morphinomanie* and offers somewhat of a counterpoint to other art media.

Art Market

Morphinomanie coincided with the decline in the authority of the official Paris Salon and the commercialisation of the art market. It was this specific set of conditions that allowed for the breadth of the *morphinomane* image-type (caricature, Salon paintings, modernist lithographs), as well as its connections with commercialisation and sensationalism. The commercialisation of *morphinomanie* in art paralleled the sensationalist techniques used by journalists. In the same way that Moreau de Tours employed a variety of tactics to make *La Morphine* stand out among the thousands of other Salon entries, aspiring young foreign artists like Pablo Picasso used colour to innovate the *morphinomane* beyond its initial naturalistic portrayal, using the figure to boost their emerging careers. Innovation was possible for them because the believability of the figure had already been established.

Paris

Foreign artists in Paris depicted the *morphinomane* for its so-called Frenchness, in addition to its sensationalist potential and the capital's associations

with decadence and excess. Whilst other nations such as America, Germany, and Britain also saw increases in morphine use during this period, *morphinomanie* was often constructed internationally as something eminently French. Additionally, the specific artistic conditions in turn-of-the-century Paris allowed for the unusually widespread representation of the *morphinomane* across media. This geographical specificity is significant to *morphinomanie*. Disregarding the unprecedented output of artistic visual culture from the French capital during this time, as has been done in prior scholarship, would simultaneously disregard the role of artistic images in the history of visualising narcotic addiction and, as a consequence, the significance of Paris and *morphinomanie*. This research has shown that France, and Paris in particular, is important because it is where a significant number of images relating to the international increase in morphine use were created, exhibited, and discussed. But future research should go beyond France, investigating how the politics and gendering of addiction in nineteenth-century visual culture transgressed cultural and geographical boundaries.

Femininity

Despite statistical studies showing the high number of male morphine users, particularly from the medical sector, artists consistently depicted the *morphinomane* as female. Artists' construction of *morphinomanie* as fashionable and as contagious were two key aspects that contributed to the drug's feminisation. By approaching the *morphinomane* as both a social construction and as a comment on femininity – created by male artists for a presumed male viewer – it was necessary to analyse why artists depicted the *morphinomane* as female and how these images existed as recurring image-types. Inextricable connections can be drawn between the hyper-visibility of the *morphinomane* and the contemporaneous changes in women's social experience. Artists established the *morphinomane* as an alter ego of the *femme nouvelle* by associating socially problematic women with habitual morphine use. *Morphinomanie* and women who lived unconventional lives, each constructed as insidious contagions, were perceived to be dangerous threats to the national body, against a backdrop of concerns relating to depopulation, degeneration, and defeat against Prussia.

Blurred Boundaries

The blurred boundaries of fact and fiction perpetuated the misconception that social constructions such as the *femme nouvelle* and the *morphinomane*

could be found in actuality. The concept of blurred boundaries is crucial to understanding the phenomenon of *morphinomanie*. Although artists did not depict skin scarred by hypodermic injections, other side effects that were discussed in medical texts, such as insomnia and the condition of the eyes, are implied. This corpus of artworks epitomises the large amount of often conflicting information on *morphinomanie* that could be found in the range of sources drawn upon throughout the book: medical texts, newspaper articles, novels, and artworks. Artists and journalists blurred the boundaries of fact and fiction and ultimately created a sensationalism around *morphinomanie*. By exaggerating and enhancing factual information on habitual morphine use, interest in *morphinomanie* was heightened for the potential reader, buyer, or viewer.

Society

Images of the *morphinomane* had a wide-reaching national and international impact on society and the art world. The origins of the facts and fictions of *morphinomanie* 'can scarcely ever be located', to return to Roland Barthes' concept of intertextuality.[3] *Morphinomanie* manifested in a wide range of sources and cultural forms. As such, this book has taken an all-encompassing approach to nineteenth-century French society. Visualisations of the *morphinomane* were available in various forms, accessible to all types of people. One could visit the Paris Salon for free to view Moreau de Tours's *La Morphine*, see the illustration of a morphine addict's arm in a pseudo-medical book, view Picasso's *Morphinomane* at his first Parisian exhibition, pass Bayard's morphine user on the front cover of *Le Bon Journal* in a newspaper kiosk, buy a copy of *L'Album des estampes originales* to own Eugène Grasset's *Morphinomane* lithograph, or see Louis Vallet's cyclist-*morphinomane* illustration in the risqué *La Vie Parisienne*. These embodiments of the *morphinomane* were inextricably connected to the society in which they existed.

With consideration for trends in visual representation, the implications of these trends can be addressed and *morphinomane* artworks can be approached in a new way: a methodological approach that can be applied beyond *morphinomanie* to future research on substance use across history and geographical locations, as proposed in the Epilogue. I hope this book stimulates more sustained, interdisciplinary conversations and investiga-

tions into the interlocking fields of art, medicine (drugs), and femininity. Where drugs history has tended to disregard art-historical methodologies, art history has similarly been disengaged with histories of substance use and addiction. Art spans global history and culture, but so do drug use and addiction – neither are autonomous, both impact and influence society.

The *morphinomane* image-type must be understood through an acknowledgement of society's interconnectivity, in which visual culture cannot be discounted. Just as textual sources could influence artists' representations of the *morphinomane*, these artworks had an impact on other artists and writers, creating false assumptions, on an international scale, of what the habitual morphine user might look like. As this book has sought to show, art played a pivotal role in the construction of *morphinomanie*, setting a long-lasting precedent for the visualisation of the homogenised 'addict', as the Epilogue presents. Detached from the reality of the drug and its dependents, the visibility of real people addicted to morphine was concealed by the exclusivity of medical institutions or by societal presumptions and stereotypes created and perpetuated through visual culture.

Analysing visualisations of the *morphinomane* not only tells us about the historical gendering of addiction but it speaks to broader issues like motherhood, sexual deviance, sex work, and the powerful influence of the pharmaceutical and medical sector; each remain important and urgent themes relating to substance use in the twenty-first century. Today, addiction is foremost a global public health issue. Yet equal access to addiction treatment is prevented by barriers relating to gender, race, and class that hinge on identity stereotypes and presumptions about what 'the addict' might look like.

Epilogue: Narcotics and Photography, 1930s

In the early 1930s, the Italian-born photographer Heinz von Perckhammer photographed a woman appearing to inject morphine into her thigh (Fig. E.1). It is a pastiched portrayal of the way in which the morphine addict had been perceived and portrayed in French art from the Franco-Prussian War of 1870–71 to the First World War. What follows in this epilogue is a brief discussion of how the drug addict was portrayed in the 1930s. It shows how the changing representations of substance use(rs) in the 1930s remained rooted in earlier visualisations of *morphinomanie*. By returning to some of the key themes in this book, I draw attention to important areas for future research into substance use and visual culture, which coalesced with visualisations of the *morphinomane*, manifested in homogenised depictions of substance use in the 1930s, and persist today.

The fetishisation of the stocking and bare thigh in Perckhammer's photograph is reminiscent of Eugène Grasset's lurid, seven-colour lithograph of 1897. But Perckhammer's eroticisation of the act of injecting drugs, of penetrating the skin's surface, surpasses those more subtly sexualised visualisations by earlier artists like Grasset, Santiago Rusiñol, and Albert Matignon. The photographer's use of high contrasting lighting smothers the woman's torso in shadow, highlighting only the bare skin of the thigh and the whiteness of the syringe. The woman has no individuality. She exists only through her sexualised legs and high heels; her only identity is her addiction and body. The eroticisation of morphine addiction as seen in preceding decades is now exaggerated to its full potential. Partly because of the photographic form of Perckhammer's image, the tropes of the morphine addict constructed by artists in the nineteenth century are removed. There are no enlarged eyes, bestial bodies, or heavy makeup. But the roots of those tropes, which centred on problematic, hedonist women, remain. The morphine addict, still female as it almost always was in visual culture, is entirely deindividualised. The dehumanisation and sexualisation of the woman in Perckhammer's photograph are perhaps indicative of the relationship between sex work and

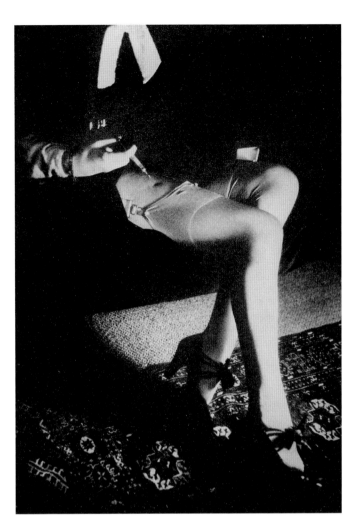

FIGURE E.1 |
Heinz von Perckham-
mer, *Woman Injecting
Morphine*, c.1931,
photograph, un-
known dimensions,
unknown location,
© Perckhammer
Estate.

addiction that still exists today. Further research is needed into the histor-
ical visualisations of sex work and substance dependency, although Pablo
Picasso's *Les Morphinomanes* is an early indication of this complex narrative.

Perckhammer's photograph was likely staged and taken in his studio.
The rug in the *morphinomane* photograph also appeared in an erotic pho-
tograph from one of his earlier series, *The Bridal Night* (no. 6, specifically),
printed in 1931. From the 1930s, having spent the previous decade visiting
Beijing and Macau to photograph brothel inhabitants, Perckhammer con-
centrated on fashion and nudes. His photography continued to epitomise
pleasure-seeking and rule-breaking as it had done previously in artworks

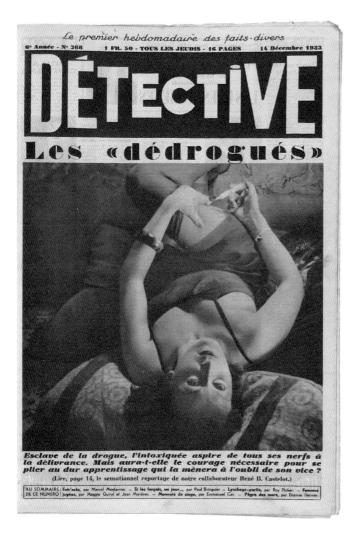

FIGURE E.2 | Front cover of *Détective*, 14 December 1933.

created in Paris. From his sexualised photographs of lesbianism to his photographs of sadomasochistic night club scenes, staged and recreated in his studio, the *morphinomane* photograph was not unexpected in the oeuvre of a photographer whose work centred concurrently on erotica and the underbelly of Western Europe.[1]

Around the same time that Perckhammer took the photograph of a supposed morphine user, an equally orchestrated photograph was taken in France. The French photograph shows a female figure in black lingerie, lying down, looking up at the camera, and injecting her bare thigh above the

stocking with a syringe. In this case, however, the sexualised addict does not appear under the guise of art in the private studio work of a photographer known for capturing the eroticised female body. Instead, the photograph appeared on the front page of the very popular and public French crime magazine *Détective*, on 14 December 1933 (Fig. E.2).[2]

The 1930s were the golden age of detective fiction in France. Emerging at the same time, and similarly influenced by international interest in American gangsters, were crime and detective magazines. The popularity of this detective discourse was likely due to its escapist appeal in conjunction with its appearance as an 'apt metaphor for its bleakness' following the First World War, writes Kim Sichel.[3] *Détective* magazine was launched in France in 1928 and would continue until the outbreak of the Second World War. *Détective* blurred the boundaries of fact and fiction, as many artists portraying the *morphinomane* had done before. *Détective* reported on crime in France and overseas, sometimes with contributions from politicians and lawyers, but it also included stories of fictional detectives, such as Georges Simenon's Inspecteur Maigret, who first appeared in 1930. The magazine's subtitle, 'the first weekly *faits divers*', conveyed not only its sensationalist approach to reportage but also its grounding in artistic and journalistic techniques of the previous century.[4] Although in part thanks to its *faits divers* style and focus on crime, the crux of *Détective*'s success lay with its photojournalism, an emerging field taken full advantage of by sensationalist crime magazines.[5] Many photographers contributed to *Détective*, creating images that accompanied the magazine's anticipated reports into the criminal underworld. The subject matter of these photos, which were often explicit in their portrayals of the body and of violence, gave *Détective* a notorious reputation. In 1932 Paris police banned posters advertising the magazine within the city walls.[6]

Coinciding with the growth of the global narcotics trade in the interwar period, reportage on drug use and drug trafficking played on popular themes that were easy to sensationalise, as they had been in the early Third Republic, and as they continue to be in the twenty-first century. 'A slave to drugs' (*Esclave de la drogue*), exclaimed the accompanying caption to *Détective*'s front-page photograph of drug use. In a manner reminiscent of the ways in which newspaper editors and artists used images of the *morphinomane* to sensationalise stories and boost sales at the fin-de-siècle, *Détective* editors used a sexualised woman appearing to inject drugs as its leading image, even though the article on drugs was not the issue's leading story. The short report on drugs, written by René B. Castelot, falls in fact on the penultimate page. One of the interior photographs shows an unconscious woman holding a hypodermic syringe, which, on close inspection, appears to be

superimposed. Photo manipulation was a technique repeatedly used by editors, particularly of crime magazines, who experimented with collage and overlaying techniques to heighten sensationalism and to enhance reader experience.[7] Today, visualisations of addiction in all cultural forms – films, documentaries, drama series, newspaper frontpages – still operate through the lens of sensationalism to increase sales.

Castelot's article is accompanied by additional photographs. One photograph depicts a rather contrived scenario showing a woman who has 'managed to escape her husband' to find a bartender in Montmartre who can sell her drugs; the other photographs show the so-called 'detoxification services' on offer for addicts at the Henri Rousselle hospital, Paris.[8] The article is continued in the next issue (21 December 1933), which is illustrated with more photographs of women addicted to drugs who were supposedly patients at the hospital. The articles perpetuate the still-existing association between inherent (feminised) weakness and addiction which was established in the nineteenth century through the feminisation of *morphinomanie*.

The Henri Rousselle hospital, opened in 1922, was part of Sainte-Anne psychiatric hospital, where Benjamin Ball delivered his foundational lecture on *morphinomanie* in 1884, initiating the first substantial newspaper reports on morphine addiction in France. As the twentieth century progressed, Sainte-Anne hospital would continue to specialise in neurology and psychiatry, but it would also become a specialist in addiction research and treatment, the seeds of which can be seen in *Détéctive*'s coverage. Today, the hospital remains a specialist facility in recovery from all forms of addiction, including alcohol and drug use, gambling, and sex addiction. The hospital's dedicated centre for the study of addiction is now known as the Centre Moreau de Tours, in acknowledgement of Jacques-Joseph Moreau (de Tours), the renowned psychiatrist who first studied the effects of drug use on the brain and, by extension, his sons – Paul Moreau (de Tours), a psychiatrist specialising in suicide, and the artist Georges Moreau de Tours, who has featured prominently throughout this book.

Despite the fact that all photographs in both of *Detéctive*'s articles on drugs feature only women, the report opens with a description of a male drug addict. Referred to as Paul M., the man is addicted to heroin and cocaine, two drugs that had become more popular from the turn of the twentieth century and were therefore of particular interest to readers of *Détective*. According to the report, Paul was introduced to drugs by his lover, Betty, whom Castelot describes as a young actress. In the article, Castelot interviews Roger Dupouy, the medical director of the detox department at Henri Rousselle. Dupouy notes that some addictions are caused by curiosity and the search

for new sensations, whilst others are 'therapeutic addiction', mostly caused by morphine and heroin being 'recklessly facilitated'.[9] Most significantly, however, when talking about drug addiction more generally, Dupouy notes, 'women are the most prone to such contagion'.[10] Although the report does not focus solely on morphine, *Détective's* narrative – a case study of a male drug addict, illustrated with images of women – indicates that little had changed since the precedent set by visual culture of the *morphinomane* in the previous century.

The 1930s saw the creation of several other crime news magazines such as *Police Magazine* and *Scandales*, which attempted to mimic the success of *Détective* through a focus on photojournalism and *faits divers*. On 2 October 1938, *Police Magazine* led with the front-page headline 'The War on Narcotics'.[11] The article focuses on drug use and drug trafficking in France and around the world, with an emphasis on Japanese and Chinese trade (Créteuil notes that twenty-one clandestine narcotics factories had been found in Shanghai, seventeen of which were run by the Japanese). The front-cover photograph is a collage of four vignettes (Fig. E.3): a woman's legs, a woman offering white powder, a woman holding an opium pipe, and a girl of East Asian ethnicity. Like the *morphinomane* visual culture of the previous decades, and the more recent *Détective* issue on addiction, all images of drugs users in *Police Magazine* feature women. The four vignettes epitomise concurrent attitudes towards drugs, addiction, and hypodermic injection, perpetuating the narratives created in the early Third Republic and satisfying the ongoing appetite for sensationalist reports on drug use and trafficking through the 1930s and into the present day.

The photograph of the woman offering up white powder likely refers to cocaine use. Coca wine, Vin Mariani, had been popular in France since the 1860s. Simultaneously, cocaine solutions were used medicinally; in 1884 cocaine was used as an anaesthetic for the first time. But by the end of the nineteenth century, coinciding with a growing global drugs trade, the use of cocaine in its powder form became more widespread.[12] The woman offering the powder wears heavy makeup, aligning her with comparable unscrupulous figures seen in artworks of morphine users from the fin-de-siècle. The blurriness of the photograph not only exaggerates the makeup but also obscures the woman's identity, perhaps echoing already established anxieties about identifying addicts and their ability to remain undetected. As similar visualisations materialised later in the twentieth century, references to fashion and makeup functioned to glamorise drug use and addiction, as seen most prominently in the emergence of 'heroin chic' fashion photography of the 1990s.

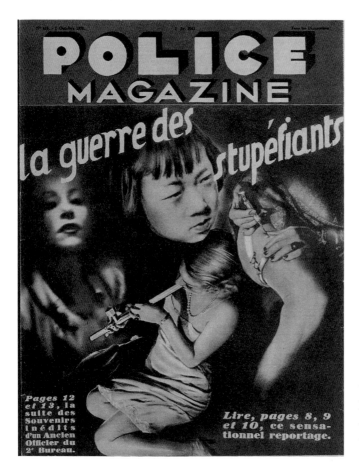

FIGURE E.3 |
Front cover of
Police Magazine,
2 October 1938.

The woman's legs in the vignette on *Police Magazine*'s front cover are almost identical to the disembodied stockinged legs seen in the 1933 issue of *Détective* and in Perckhammer's earlier photograph. As in *Détective*, the syringe in this vignette also appears fake; a paper cut-out held by the model or a superimposition onto the photograph. *Police Magazine*'s focus on a range of drugs takes the disembodied eroticised thighs beyond morphine visual culture and into the realm of injectable drugs more broadly. This suggests that the hypodermic syringe is no longer metonymic with morphine use only. By the 1930s the syringe had become a recognisable motif for drug addiction generally, including morphine and heroine, as it remains in the twenty-first century.

The front-cover vignette of a woman holding an opium pipe reminds the reader of the longer history of opium use in France, which became wide-

spread in the 1860s with the emergence of opium dens in Paris, in addition to the creation of the drug's various derivatives. In comparison to the *morphinomane*, the opium user is not depicted with a comparable set of repeated tropes and is typically identified by accompanying paraphernalia. Opium use can be seen in French visual culture throughout the nineteenth and into the twentieth century. The gendering of opium use in comparison with morphine use was beyond the scope of this book, but it is an important line of enquiry for future research. For example, although Henry Vollet, who visited Indochina as France's official colonial artist, sexualised female opium users in his paintings, he also included French men smoking opium, in contrast to images of morphine use (see, for example, *Le Poison de Bouddah: Fumerie d'opium à Hanoï* [Buddha's Poison: Opium Den in Hanoi], exhibited at the 1904 Salon des Artistes Français). *Police Magazine* also sexualises the female opium user in the issue's interior pages, where photographs show opium paraphernalia held by naked women.

The final vignette from *Police Magazine*'s 'War on Narcotics' front-page photograph is a girl who is intended to represent the people of East Asia. This image epitomises a noteworthy undercurrent of addiction and opiate history that warrants further exploration. This is a prime example of how crime and picture magazines of the 1930s often orchestrated what Will Straw labels 'Orientalizing articles'.[13] *Police Magazine*'s choice to include this photograph in their coverage of the so-called war on drugs not only perpetuates a narrative on the geographical source of much of the world's opium and thus of its derivatives but it also attributes an overarching sense of blame to a homogenised other, as different and distanced from France.

This orientalised or racialised connection to drugs started much earlier than the 1930s. In 1887 Paul Regnard stated in his book *Les Maladies épidémiques de l'esprit*, 'our fathers in Asia' have 'already bequeathed many evils' to France, proclaiming that morphine 'derives from the theriacs of the East and the opium smokers of China'.[14] These narratives became prominent, first, with the Second Opium War (1856–60), which initiated the global proliferation of opium; second, with France's monopolisation of all opium trade in Indochina in the 1890s as a result of its colonisation; and third, with the emergence of a global heroin network in the 1930s. This network, often referred to as the French Connection, linked heroin smuggling channels between Indochina and France to America and Canada.[15] Whereas this book has focused primarily on the gendering of addiction and morphine use, the racialised undercurrents of opiate use in visual culture more broadly remain an important area for exploration.[16] Although this commentary is not always overt in French nineteenth-century discussions on morphine addiction

specifically, the undercurrents are consistent and stem from broader, more conspicuous discussions in which opium use and East Asia are amalgamated. These narratives, whilst always existing, appear more overtly in the 1930s and are enhanced by the influence of photojournalism and the fascination with criminal activity.

Regardless of the cohesive representation of the *morphinomane* by artists working in Paris in the 1880s, 1890s, and 1900s, the *morphinomane* is rarely visualised in the same way again after the First World War due to fresh curiosity about drugs like cocaine and heroin. Despite this, photographs epitomising drug addiction and the 'war against drugs' in France's 1930s crime magazines are grounded in the artistic visual culture of the *morphinomane* that emerged in the early Third Republic. These photographs in *Détective* and *Police Magazine* represent a culmination of the sensationalism and sexualisation of the (female) drug user. Like Perckhammer's photograph of the legs of the *morphinomane*, the photographs used in these interwar crime magazines are exaggerated and pastiched versions of what came before. By the 1930s, visual tropes and concepts associated initially with *morphinomanie* are no longer specific to morphine use. The feminisation and eroticisation of the morphine addict becomes part of a homogenised and sensationalist narrative of narcotic use, in which the figure of the gendered and/or dehumanised drug addict is used for socio-political commentary.

Figures and Plates

Figures

2.6 Franz von Stuck, *Sphinx*, 1904, oil on canvas, 83 × 157 cm, Hessisches Landesmuseum Darmstadt, Darmstadt. Photograph: © Foto: Wolfgang Fuhrmannek, Hessisches Landesmuseum Darmstadt | 61

2.7 Demetrios Galanis, 'Dessins de Galanis,' *L'Assiette au beurre (La Police II)*, 30 May 1903, © ADAGP, Paris and DACS, London 2023. Photograph: BnF | 64

2.8 Giovanni Boldini, *Portrait of Gertrude Elizabeth (née Blood), Lady Colin Campbell*, 1894, oil on canvas, 184.3 × 120.2 cm, National Portrait Gallery, London. Photograph: © National Portrait Gallery, London | 65

2.9 Ernest-Ange Duez, *Splendeur*, after 1874, oil on canvas, 136 × 57.5 cm, Musée Carnavalet, Paris. Photograph: Paris Musées / Musée Carnavalet – Histoire de Paris | 68

3.1 Richard Tennant Cooper, *Syphilis*, 1912, gouache on board, 52 × 70.5 cm, Wellcome Collection, London, in copyright. Photograph: Wellcome Collections, London | 75

3.2 Léon Kern, 'Maladies à ménager,' *Le Pêle-Mêle*, 3 December 1911. Photograph: BnF | 76

3.3 Ramon Casas, *Sífilis*, c.1900, colour lithograph, 66.3 × 28.2 cm, Wellcome Collection, London. Photo: Wellcome Collections, London | 81

3.4 Paul Regnard, 'Attaque: Crucifiement,' interior collotype, Désiré-Magloire Bourneville and Paul Regnard, *Iconographie photographique de la Salpêtrière: Service de M. Charcot* 2 (Paris: Progrès médical, 1878), plate XXXVI. Photograph: Wellcome Collections, London | 83

3.5 Louis Vallet, 'Rue de Prony,' Marion, 'Cabines de toilette et dessous,' *La Vie Parisienne*, 21 February 1891. Photograph: BnF | 88

3.6 Tel [Raoul Cabrol], 'Le Fait du jour,' *Le XIXe siècle*, 28 December 1912. Photograph: BnF | 94

4.1 Albert Robida, 'Les Victimes de la science,' *La Vie Parisienne*, 12 April 1890. Photograph: BnF | 104–5

4.2 Albert Robida, vignette from 'Les Victimes de la science,' *La Vie Parisienne*, 12 April 1890. Photograph: BnF | 106

4.3 Stop [Louis Morel-Retz], engraved by Michelet, vignette from '*Musotte*,' *Le Journal amusant*, 28 March 1891. Photograph: BnF | 107

4.4 'Arsenal de morphinomanie,' interior illustration, Paul Regnard, *Les Maladies épidémiques de l'esprit: Sorcellerie, magnétisme, morphinisme, délire des grandeurs* (Paris: E. Plon, Nourrit et Cie, 1887), 315. Photograph: BnF | 110

5.1 Louis Vallet, vignette from 'Médicamentées,' *La Vie Parisienne*, 24 September 1898. Photograph: BnF | 116

5.2 'Le thorax de la malade de l'observation IV,' interior illustration originally in watercolour, Alphonse Rousille, 'Les Taches bleues des morphinomanes: Publication de cinq cas nouveaux' (Medical PhD thesis, Lyon, 1907). Photograph: author | 122

5.3 Bac [Ferdinand-Sigismond Bach], vignette from 'Revue en costumes,' *La Vie Parisienne*, 15 March 1890. Photograph: BnF | 125

Plates

6 Hermenegildo Anglada-Camarasa, *La Morfinómana*, 1902, oil on panel, 33 × 40 cm, private collection, © DACS 2023. Photograph: Per Myrehed

7 Pablo Picasso, *Morphinomane* (also known as *Margot* and *L'Attente*), 1901, oil on cardboard, 68.5 × 56 cm, Museu Picasso, Barcelona, © Succession Picasso/ DACS, London 2023. Photograph: Album / Alamy Stock Photo

8 Manuel Orazi, front-cover illustration, Victorien du Saussay, *La Morphine* (Paris: A. Méricant, 1906). Photograph: BnF

9 Albert Matignon, *Les Morphinomanes*, 1905, oil on canvas, 109 × 196 cm, Château-Musée de Nemours, Nemours. Photograph: © RMN-Grand Palais / Philippe Fuzeau

10 Théophile Steinlen, '*Les Possédés de la morphine*, par Maurice Talmeyr,' *Gil Blas illustré*, 21 February 1892. Photograph: BnF

11 Pablo Picasso, *Les Morphinomanes*, 1900, oil and pastel on canvas, 55.2 × 46.4 cm, private collection, © Succession Picasso/DACS, London 2023. Photograph courtesy of Sotheby's, Inc. © 2017

12 Louis Legrand, *Au Café*, before 1910, pastel on paper, unknown dimensions, unknown location. Reprinted in Camille Mauclair, *Louis Legrand, peintre et graveur* (Paris: H. Floury et G. Pellet, 1910), 248. Photograph: BnF

Notes

Introduction

1 ('La voici qui s'avance, la morphinée, en son allure morbide de perversion sensuelle, avec ses traits ravagés, creusés peut-être par l'invisible et lente usure des baisers d'une Goule, et ses lèvres étrangement rouges … des gestes symptomatiques de folie … les lyliales pâleurs de la face … un surprenant éclair de tendresse jailli de ses prunelles de sphinx … elle a voulu être la Maladie vivante, celle qui lentement s'enfonce dans la nuit dernière … plus que la Maladie: le Mal') Michel Zévaco, 'La Morphinée', *Le Courrier Français*, 18 February 1894. Unless otherwise noted, all translations are my own.

2 Yvette Guilbert captured the imagination of many artists living in Paris at the fin-de-siècle; she was a particular favourite of Henri de Toulouse-Lautrec.

3 Yvette Guilbert, 'Mes Lettres d'amour', *Candide*, 6 August 1931.

4 Paul Rodet's statistical study of 1897 showed that out of 1,000 morphine users 650 were men and 340 of those were in the medical profession. Rodet, *Morphinomanie et morphinisme*, 37.

5 ('dans un atelier en compagnie d'artistes') Francisque Sarcey, 'Chronique théâtrale', *Le Temps*, 5 February 1894.

6 My emphasis. Charles Blanc's *Grammaire des arts du dessin* was an important source of artistic theory in late nineteenth-century France. ('l'art est l'interprétation de la nature') Shaw, 'The Figure of Venus', 550.

7 I borrow this term from Hickman, 'Heroin Chic', 120.

8 Skelly, *Addiction and British Visual Culture*.

9 Black, *Drugging France*, 184–229.

10 Wilson, 'A Medicine for the Soul', 51–70.

11 Jean-Jacques Yvorel's article on *morphinomanie* was an early exploration into the gendering of morphine use in nineteenth-century France. Jesper Vaczy Kragh's chapter on morphine use in Europe more broadly is also worth mentioning. Yvorel, 'La Morphinée', 105–13; Kragh, 'Women, Men, and the Morphine Problem', 177–99.

12 Clark, *Image of the People*, 13.

13 Ibid., 15.

14 Barrell, *The Dark Side of the Landscape*, 89–130.

15 Foucault, *The Order of Things*.

16 Hickman, 'Heroin Chic', 122.

17 Italics as in original. Ibid., 119–20.

18 Ibid., 136.
19 Campbell and Ettorre, *Gendering Addiction*, 1.
20 Ibid., 1.
21 Ibid., 2.
22 There is some discrepancy over the date that Sertürner first isolated morphine, but it is often placed between 1803 and 1805.
23 Turkey was a key supplier of opium to Europe and America until the mid-nineteenth century. France's colonisation of Indochina, which began in the mid-1880s, also contributed to the global opiate trade. The French government monopolised rice alcohol, salt, and opium during the colonisation. On the use of laudanum and opium in particular, see Berridge and Edwards, *Opium and the People*; Kandall, *Substance and Shadow*.
24 ('l'opium d'Occident') Henri Fouquier, 'La Vie de Paris', *Le XIXe siècle*, 24 January 1891.
25 Guba, *Taming Cannabis*.
26 Black, 'Doctors on Drugs', 119.
27 ('la morphinomanie – cet alcoolisme des riches') Untitled, *Le XIXe siècle*, 9 December 1884.
28 Albéric Darthèze, 'Morphinomanie et morphinisme', *L'Aurore*, 28 October 1901.
29 Ibid.
30 For more on this, see Black, 'Morphine on Trial', 623–5; Padwa, *Social Poison*, 87–91, 109–38.
31 ('le premier coupable') Pichon, *Le Morphinisme*, 2.
32 Herzlich, 'The Evolution of Relations between French Physicians and the State', 245.
33 Thomson, *The Troubled Republic*, 7.
34 Thomson, 'Toulouse-Lautrec and Montmartre', 13.
35 ('des narcotiques et des stimulants') Nordau, *Dégénérescence* 1, 74.
36 Pick, *Faces of Degeneration*, 8. For more on sexuality and degeneration, see Gilman, *Difference and Pathology*, 191–216.
37 In relation to fin-de-siècle anxieties, gender politics, and social changes, Jennifer Birkett explores decadence in French literature in *The Sins of the Fathers*.
38 Nye, *Crime, Madness and Politics*.
39 Rodet, *Morphinomanie et morphinisme*, 10–12. See also Ball and Jennings, 'Considérations sur le traitement de la morphinomane', 373–7; Hodée, 'Contribution à l'étude des causes de la prophylaxie et du traitement de la morphinomanie', 11–28.
40 Rodet, *Morphinomanie et morphinisme*, 11; Chambard, *Les Morphinomanes*, 2.
41 ('une class intermédiaire'; 'accidentelle, par exemple sous l'influence d'un ennui'), Rodet, *Morphinomanie et morphinisme*, 9–11.
42 Ibid., 12.
43 The early 1880s saw newspapers discuss the spelling of the new term 'morphinomanie': Francisque Sarcey, 'Morphio ou Morphino', *Le XIXe siècle*, 16 April 1883.
44 Nye, *Crime, Madness and Politics*, 143.
45 Zieger, *Inventing the Addict*, 23.
46 For example, Paul Sollier concluded that men made up 70 per cent of morphine users. Sollier, 'Méthode physiologique de démorphinisaton', 875–7. Chapters 3 and 4 explore these discrepancies in greater detail.

47 Civil divorce by mutual consent was first introduced in French law in 1792, during the French Revolution. This law was abolished in 1816, following a restriction by Napoleon Bonaparte in 1803. For more, see Offen, 'How (and Why) the Analogy of Marriage with Slavery Provided the Springboard for Women's Rights Demands in France'.

48 Silverman, *Art Nouveau in Fin-de-Siècle France*, 66.

49 Offen, 'Depopulation, Nationalism, and Feminism', 654.

50 Granotier, 'L'Autorité du mari sur la personne de la femme et la doctrine féministe', 42, 45. Trans. Shapiro, 'Stories more terrifying than the truth itself', 212.

51 Menon, 'Images of Pleasure and Vice'.

52 Gullickson, *Unruly Women of Paris*, 159.

53 Shaw, 'The Figure of Venus', 542.

54 Ibid., 542.

55 Ibid.

56 Ibid.

57 Joyeux-Prunel and Marcel, 'Exhibition Catalogues in the Globalization of Art', 94.

58 As argued by Birkett in her important book *The Sins of the Fathers*, France was the centre of late nineteenth-century European decadence.

59 Przyblyski and Schwartz, 'Visual Culture's History', 6–7.

60 Note that all *morphinomane* artworks are referred to by the title used in their original display or publication. If this is unknown, the artwork title is given in the artist's native language. There are many more artworks than the number of images used in this book. As such, this collection of images should not necessarily be understood as a representative sample of this visual culture.

61 Barthes, 'Theory of the Text', 39.

62 For more on comparisons between the artistic and medical visual culture of the *morphinomane*, see Halliwell, 'In Art and Wax'.

Chapter One

1 Mainardi, *The End of the Salon*, 136. The Salon des Artistes Français is shortened to the Paris Salon throughout this chapter.

2 Over seven weeks, 518,892 visitors attended the 1876 state-sponsored Paris Salon. The number of visitors was not recorded for subsequent Salons, although it was noted that the number of visitors at the 1887 Paris Salon was just as considerable as previous years. 'Partie non officielle', *Journal officiel*, 13 August 1876; 'Partie non officielle', *Journal officiel*, 2 July 1887.

3 The admission cost was between one and two francs depending on time and day of entry. The opening day fee was five francs. In 1876 only 185,000 out of 518,892 visitors paid an entrance fee. 'Partie non officielle', *Journal officiel*, 13 August 1876.

4 The presence of Turkish delight in Paris dates back to at least the 1870s. In Pierre Larousse's 1872 *Grand Dictionnaire universel du XIXe siècle*, *rahat-loukoum* is included under the entry 'glyco', a generic term used to describe Greek confectioneries. He notes that it could be bought at cabarets, but that the best *rahat-loukoum* in Paris was available from the pastry chef Dimitri on rue d'Hermès. Larousse, *Grand Dictionnaire universel*, 1320.

5 'The anti-Semitic movement made itself apparent' with the appearance of Drumont's *La France juive*, wrote François Bournand in *Les Juifs et nos contemporains* in 1898. Bournand, *Les Juifs et nos contemporains*, 27. Trans. Wilson, *Ideology and Experience*, 170.

6 This supports the line of enquiry in chapter 5, which argues that *morphinomanie* was used more broadly as a marginalising device. The association between morphine use and anti-Semitism warrants further exploration, but for an overview of *La France juive* and its anti-Semitic narrative see Wilson, *Ideology and Experience*, 169–78. For more on how Jewish people were portrayed and perceived during the Third Republic, see Cohen, 'Recurrent Images in French Antisemitism'.

7 Mainardi, *The End of the Salon*, 47.

8 Charpin, *Les Arts incohérents*, 23.

9 For context, 65,000 Salon *livrets* were dispersed at the 1876 state-sponsored Paris Salon. 'Partie non officielle', *Journal officiel*, 13 August 1876.

10 ('Ce tableau a dû exciter la curiosité, tenter les sens') Francis Enne, 'À propos de morphine', *Le Radical*, 20 June 1886.

11 For more on naturalism as the dominant aesthetic, see Thomson, *Art of the Actual*.

12 Enne, 'À propos de morphine'; Wolff, *Figaro-Salon*, 19.

13 ('peintures de fait divers') Guy de Maupassant, 'Au Salon – II', *Le XIXe siècle*, 2 May 1886.

14 Cragin, *Murder in Parisian Streets*, 38.

15 'The Salon – Paris', *The Athenaeum*, 19 June 1886.

16 As Barthes states, 'the practice of painting pictures' is an example of one of the 'signifying practices [that] can engender text'. Barthes, 'Theory of the Text', 39, 41.

17 ('peinture médicale') Alexandre Georget, 'Salon de 1886', *L'Écho de Paris*, 1 May 1886; ('un tableau médical') Albert Wolff, 'Le Salon', *Le Figaro*, 30 April 1886.

18 ('une explication scientifique') Enne, 'À propos de morphine'.

19 ('destinée au savant ouvrage des docteurs') Guy de Maupassant, 'Au Salon – IV', *Le XIXe siècle*, 10 May 1886.

20 ('il en a étudié les causes et les effets') Armand d'Epirey, 'Salon de 1886 – II', *Officiel-artiste*, 20 May 1886.

21 For more on Jacques-Joseph Moreau, see Guba, *Taming Cannabis*, 130–40.

22 Mary Hunter discusses the influx of these types of paintings at the 1887 Salon in Hunter, *The Face of Medicine*.

23 See Halliwell, 'In Art and Wax'.

24 Hickman, 'Heroin Chic', 119.

25 Ibid., 128.

26 It is likely that Moreau de Tours used the first edition of the book to find this quotation (1883). The second edition (1885) was published after his father's death. Both editions include the same quotation. Bourneville and Bricon, *Manuel des injections sous-cutanées*, 1st ed., 102; 2nd ed., 137.

27 For example, Lecerf, 'Essai sur la symptomatologie de la morphinomanie', 76.

28 ('À petites doses et même à doses assez élevées, la période de prostration est précédée d'une période d'excitation, très courte; si les doses sont élevées: insomnie, agitation, hallucinations') Dupont, *Explication des ouvrages*, 141.

29 Enne, 'À propos de morphine'.

30 Bricon and Bourneville, *Manuel des injections sous-cutanées*, 1st ed., 137.

31 ('il n'est pas de morphinomane qui n'ait sous la peau au moins une demi-douzaine d'aiguilles cassées') Tout-Paris, 'Un Inventeur trop célèbre', *Le Gaulois*, 13 June 1892.

32 Regnard, *Les Maladies épidémiques de l'esprit*, 323.

33 On very close inspection of the painting – conditions unavailable to Salon viewers – a small pink mark on the figure's arm can be seen, implying injection has already happened. Halliwell, 'In Art and Wax', 62–3.

34 ('nous n'avons que d'éloges à donner à cette peinture') Claude Suty, 'Promenades au Salon – II', *L'Union médicale*, 13 May 1875.

35 ('placé un peu haut'; 'sans numéro et sans nom visible d'auteur') Claude Suty, 'Promenades au Salon – II', *L'Union médicale*, 23 May 1886.

36 Black, 'Doctors on Drugs', 114–36.

37 ('endoctrinés par le médecin') Zambaco-Pacha, *De la Morphéomanie*, 19.

38 ('seuls les pharmaciens se félicitent de l'introduction de la morphinomanie') Tout-Paris, 'Guerre à la morphine!', *Le Gaulois*, 7 April 1891.

39 Darzens, 'Chronique artistique', 87; ('romans honnêtes') Sahib [Louis Ernest Lesage], 'Mon salon, ton salon, son salon', *La Vie Parisienne*, 22 May 1886.

40 Spagnoli, 'Morphine and the Unmaking of Marriage', 105.

41 Brown, *Women Readers in French Painting*, 18.

42 Tout-Paris, 'Morphinomanes', *Le Gaulois*, 12 March 1890.

43 For example, Jean Frollo [pseud.], 'La "Fée" Morphine', *Le Petit Parisien*, 22 November 1891.

44 Darzens, 'Chronique artistique', 87.

45 ('un vrai dégénéré') Nordau, *Dégénérescence* 2, 62.

46 Hermenegildo Anglada-Camarasa, *Fleurs de Paris*, 1903, oil on panel, 59 × 72.5 cm, private collection.

47 ('*Fleurs de Paris* (lisez les *Fleurs du mal*)') Armand Dayot, 'Salle XVI', *Supplément du Gil Blas* [1903 Salon], 15 April 1903.

48 René de Schwaeblé, 'Les Détraquées de Paris', *Le Fin de siècle*, 24 December 1903.

49 Spagnoli, 'Morphine and the Unmaking of Marriage', 109, 111.

50 ('*Été à la Campagne* ou quelque chose d'analogue') Henry Fouquier, 'Le Salon', *Gil Blas*, 28 May 1886.

51 ('n'étaient pas … destinées à la publicité'; 'un auteur à la mode') Man of the World, *Un Été à la campagne*, preface.

52 Man of the World, *Un Été à la campagne*, English ed., preface.

53 Steele, *Paris Fashion*, 190.

54 Gagneur, *Bréviaire de la femme élégante*, 138–40; Garches, *Les Secrets de beauté d'une Parisienne*, 135–7; 'Les Robes d'intérieur', *Le Voleur illustré*, 17 January 1895.

55 Helen Burnham has suggested that the relationship between the dress couturier Charles Frederick Worth and the Lyon silk industry was a potential reason for this sudden reintroduction of the bustle. Burnham, 'Changing Silhouettes', 258–60.

56 ('la morphine est devenue une mode') Labruyère [Albert Millaud], 'Les Morphinomanes', *Le Figaro*, 1 June 1886.

57 ('J'ai souvent vu des gens du monde en possession d'un arsenal de petits instruments à injections') Zambaco-Pacha, *De la Morphéomanie*, 19; Delorme, 'Contribution à l'étude clinique de la morphinomanie', 16.

58 See, for example, Zaborowski, 'Revue des sciences', *La Justice*, 14 May 1885; Pierre Aubry, 'Morphinomanie', *La Petite République Française*, 13 May 1885; Marc, 'Les Nouveaux Poisons', *La Lanterne*, 6 March 1887.

59 Académie Française, *Dictionnaire de l'académie française*, 135.

60 Zanten, 'Looking Through, Across, and Up', 155.

61 For more on American tourists in France, see Levenstein, *Seductive Journey*, 85–92, 139–55.

62 Balducci, *Gender, Space and the Gaze in Post-Haussmann Visual Culture*, 113.

63 Stallybrass and White, *The Politics and Poetics of Transgression*, 136.

64 The painting's estimated value was €15,000–20,000, but it sold for €529,000. 'Lot 191: Georges Moreau dit Moreau de Tours (1848–1901), *La Morphine* ou *Les Morphinées*', Artcurial (website), March 2018, https://www.artcurial.com/fr/lot-georges-moreau-dit-moreau-de-tours-ivry-sur-seine-1848-bois-le-roi-1901-la-morphine-ou-les-3254.

65 Correspondence in June 2022 with the Frick Art Reference Library's director, Stephen Bury; and Stephen Bury, 'Inside the Parisian Studio', New York Art Resources Consortium (website), 19 December 2011, https://nyarc.org/blog/inside-the-parisian-studio.

Chapter Two

1 ('la robe claire et flottante'; 'au blanc visage tout mangé par ses yeux clairs au cerné meurtri') Paul Toulet, 'Nocturne Élyséen', *Revue illustrée*, 15 August 1905.

2 ('Elle me rappelle … cette morphinomane que le peintre Hermenegilde Anglada a représentée') Ibid.

3 ('Elle est toute seule, blafarde, dans un grand fauteuil – et si lasse, ah! si lasse de sourire. Près d'elle il y a des roses rouges, qui sont comme fardées par la lumière électrique, et, dans le fond … des tables, des bars, tout éclatants d'une lumière harmonieuse et bariolée') Ibid.

4 Skelly, 'Skin and Scars', 203.

5 Today it is known that narcotic addiction offers 'no infallibly visible markers'. Hickman, 'Heroin Chic', 119.

6 For discussion on these wax models, see Halliwell, 'In Art and Wax', 39–50.

7 ('l'aspect véritablement navrant du bras') Regnard, *Les Maladies épidémiques de l'esprit*, 323.

8 ('Les morphinomanes choisissent généralement pour siège de leurs piqûres les parties les plus accessibles de leur corps; aussi voit-on leurs bras, leurs cuisses, leurs jambes, leur poitrine et leur ventre couverts de lésions tout à fait caractéristiques') Chambard, *Les Morphinomanes*, 49.

9 ('la peau de l'abdomen, en remontant quelquefois jusqu'aux seins, le haut des cuisses … les jambes, les bras') Delorme, 'Contribution à l'étude clinique de la morphinomanie', 41.

10 ('elle ne songe qu'à ceci: se piquer quelque part, au bras ou à la jambe') Caliban [Émile Bergerat], 'Morphinomanie', *Le Figaro*, 1 March 1885.

11 ('Des hommes et des femmes, par milliers, se piquent le bras chaque jour') Guy de Maupassant, 'Causerie triste', *Le Gaulois*, 25 February 1884.

12 Garb, *The Painted Face*, 86.

13 Georges Lafosse, 'La Vaccinomanie', *Le Journal amusant*, 2 April 1870.

14 ('elle a injecté sous sa peau, – aux jambes ou aux bras') Jean Frollo [pseud.], 'La Morphine', *Le Petit Parisien*, 27 May 1882.

15 A second edition of *Les Détraquées de Paris* was released in 1910 without the illustrations, presumably making it more appropriate for sale. All existing illustrated copies are currently in private collections.

16 ('par un sentiment de coquetterie justifié, les femmes se piquent souvent en des régions dissimulées aux regards: les cuisses, le pubis, les régions fessières latérales sont ordinairement leur lieu d'élection. Les hommes choisissent plus volontiers les bras') Guimbail, *Les Morphinomanes*, 121.

17 Magoulas, *La Cure de la morphinomanie*, 10.

18 ('le moyen le plus commode et le plus prompt pour faire cesser des douleurs intolérables ou une insomnie opiniâtre') 'Les Morphinomanes', *Le XIXe siècle*, 20 February 1878.

19 'Académie de médecine (18 octobre)', *Le Temps*, 20 October 1887; ('les noctambules') Guimbail, *Les Morphinomanes*, 74.

20 ('Guérison radicale de l'insomnie / 8 heures de sommeil normal assuré chaque nuit / Unique moyen de guérir les Morphinomanes') Back-page advert, *Le Gaulois*, 23 November 1906.

21 ('une vie trop sédentaire occasionnait des insomnies') Bougon, 'Une Morphinomane', 668.

22 The striking similarities between the two works suggest, perhaps, that one was a sketch (Plate 4) for the other (Fig. 2.1), since Corcos's paintings usually lack the obvious and unfinished brushstrokes seen in the less detailed version. One of these paintings was sent for display in Philadelphia in 1899, although it ended up not being exhibited due to what was referred to as a misunderstanding about the purpose of the National Export Exposition. None of the seventy Italian works sent to Philadelphia were actually exhibited; they were instead placed at the gallery of James S. Earle & Sons, a celebrated frame-making company. 'Notizie di lettere e d'arte', *Rivista d'Italia*, 15 November 1899.

23 ('Quatre heures de l'après-midi … Il lui est aussi pénible de s'arracher de son lit à quatre heures du soir qu'à quatre heures du matin. Pour se remonter, – elle fait un abus excessif d'éther et de morphine') Louis Vallet, 'Petits Levers', *La Vie Parisienne*, 17 September 1892.

24 ('ses yeux, agrandis, brillent d'une lueur étrange') Octave Mirbeau, 'À Propos de la morphine', *Le Gaulois*, 29 October 1880.

25 ('La pupille, en se réduisant, brille d'un éclat perçant, rendant l'oeil singulièrement lubrique') Schwaeblé, *Les Détraquées de Paris*, 44.

26 Notta, *La Morphine et la morphinomanie*, 18.

27 Garelick, *Rising Star*, 45.
28 Albert Robida, 'Les Victimes de la science', *La Vie Parisienne*, 12 April 1890.
29 Albert Lammour and Jacques Rhéas, 'À quoi bon?', *Revue illustrée*, 10 April 1911.
30 ('des femmes aux yeux rendus immenses par la morphine') Ibid.
31 ('les prunelles agrandies d'hébétude') Louis Vauxcelles, 'Exposition Evelio Torent', *Gil Blas*, 3 February 1907.
32 Chantal, *La Civilité des jeunes personnes*, 48, 50. Trans. Iskin, 'Selling, Seduction, and Soliciting the Eye', 37.
33 Alq, *La Science du monde*, 209. Trans. Iskin, 'Selling, Seduction, and Soliciting the Eye', 37.
34 Iskin, 'Selling, Seduction, and Soliciting the Eye', 37.
35 Callen, *The Spectacular Body*, 186.
36 ('Pour combattre cet ennui, divers remèdes: Pharmacie. – Sirop d'éther. Morphine'; 'Et, cette vie si remplie, elle la trouve vide, creuse! Elle s'énnuie [*sic*]!') 'Les Fin-de-siècle', *Le Gaulois*, 21 February 1890.
37 ('la morphine est un remède contre la douleur et l'ennui') 'Le Centenaire de la morphine', *L'Aurore*, 28 July 1904.
38 ('a tout tenté pour se désennuyer'; 'quand il n'y a ni Opéra, ni dîner en ville, ni bal') Tout-Paris, 'Morphinomanes', *Le Gaulois*, 12 March 1890.
39 'Margot' is perhaps a reference to the daughter of Frédé, the owner of the café Le Lapin Agile, which Picasso often visited. Margot appears as a model in several of Picasso's canvases from 1904. Barnett, 'The Thannhauser Collection', 104.
40 ('Quelle est cette bête qui vient là, dans une robe de femme élégante? C'est là bête qui ne dort pas') Caliban, 'Morphinomanie', 1.
41 ('elle ressemblait à une tigresse qui défend sa proie') Saussay, *La Morphine*, 51.
42 ('les piqûres sont tellement rapprochées les unes des autres qu'elles se confondent … la peau ressemble plus à celle d'un reptile qu'à la peau d'un être humain') Regnard, *Les Maladies épidémiques de l'esprit*, 323.
43 ('changent à la longue le satin rose de la peau en une dégoûtante cuirasse écailleuse') Schwaeblé, *Les Détraquées de Paris*, 44.
44 ('ne sortent qu'avec la nuit comme les phalènes') Solrac, 'Le Salon de la société nationale de beaux-arts', *L'Occident*, May 1904.
45 ('los noctámbulos viciosos de Paris') Francisco Casanovas, 'Bellas Artes', *La Publicidad*, 3 May 1900.
46 ('le souple serpentement des bras'; 'pareille animalisation dans le *Paon blanc*'; 'le métier a ses exigences, il faut se mouvoir, se mettre en chasse') Marcel, 'Hermen Anglada', 108, 110.
47 Gyp [Sibylle Gabrielle Marie-Antoinette de Riquetti de Mirabeau, comtesse de Martel de Janville] and P. Draner, 'Au Salon', *L'Univers illustré*, 7 May 1887. For more on Gyp, an anti-Semitic female journalist, see Roberts, *Disruptive Acts*, 131–64.
48 ('cette année, Moreau de Tours expose encore une morphinomane') Gyp and Draner, 'Au Salon'.
49 ('je dirai bestiale') Ibid.
50 ('des flacons artistiques destinés à contenir la solution enchanteresse') Joleaud-Barral, 'La Morphinomanie', *La Justice*, 12 February 1892.

51 ('C'est qu'elle est l'enchanteresse, la séductrice puissante, la Morphine') Santillane, 'Les Morphinomanes', *Gil Blas*, 31 October 1896.

52 ('des perfidies de la séduisante sirène') Jean Frollo [pseud.], 'La "Fée" morphine', *Le Petit Parisien*, 22 November 1891. This is one of a number of references to the 'morphine fairy' at the fin-de-siècle. It likely borrows from the contemporaneous description of absinthe as the 'Green Fairy'.

53 ('la séduisante Sirène') E.M., 'Sus à la morphine', *Gil Blas*, 23 August 1889; ('l'attrait du fruit défendu') Tout-Paris, 'L'Asile des morphiomanes [*sic*]', *Le Gaulois*, 10 November 1886.

54 Stott, *The Fabrication of the Late-Victorian Femme Fatale*, viii. See also Birkett, *The Sins of the Fathers*, 24–7.

55 ('la destinée de son compagnon et de l'univers') Nozière [Fernand Aaron Weyl], 'La Femme fatale', *Le Temps*, 3 July 1909.

56 As an interesting counterpoint to this, Per Faxneld shows how some nineteenth-century feminist writers, such as Eliza Farnham and Henriette Greenebaum Frank, used the figure of Eve as 'an agent of progress'. Faxneld also discusses the appearance of Eve and the serpent in Decadent art and literature. Faxneld, *Satanic Feminism*, 132, 109–42, 251–326.

57 'Les Statues qu'elles aiment', *La Vie Parisienne*, 7 January 1899.

58 ('elle attend l'hallucination d'être elle-même entortillée par les reptiles') Ibid.

59 ('Elle verdit lorsqu'elle en parle') Ibid.

60 Alex Murray explores the recurrence of the Sphinx and the influence of Thomas de Quincey in Decadent literature. Murray, 'Enigmatic Intertexts', 89–102.

61 Oscar Wilde's *The Sphinx Without a Secret* was first published as a serial novel titled *Lady Alroy* in *The World* newspaper in May 1887. The change in title likely reflects both the fin-de-siècle fascination with the Sphinx as *femme fatale* (thus conflating the protagonist with the Sphinx) and the excavation of the Sphinx's paws at the beginning of 1887.

62 Wilde, 'The Sphinx Without a Secret', 205.

63 Murray, 'Enigmatic Intertexts', 96.

64 Nozière, 'La Femme fatale'.

65 Chapter 5 explores this connection in detail.

66 Shapiro, 'Stories more terrifying than the truth itself', 215.

67 ('morphinomane passionnée'; 'la femme Flambart a commis toute une série d'escroqueries') 'Pour se procurer de la morphine', *Le XIXe siecle*, 18 October 1892.

68 Shapiro, 'Stories more terrifying than the truth itself', 213.

69 ('Vous ne pouvez pas distinguer les femmes honnêtes! ... ') Demetrios Galanis, 'Dessins de Galanis', *L'Assiette au beurre (La Police II)*, 30 May 1903.

70 ('– ... Je suis dactylographe ... / – Menteuse! ... Faites voir vos piqûres d'aiguille') Ibid.

71 ('Ce sont des comédiennes éprises de l'effet à produire, soucieuse d'attirer l'attention et de dominer leurs rivales') Uzanne, *Sottisier des Moeurs*, 16. Trans. Steele, '*Femme Fatale*', 322.

72 Clayson, *Painted Love*, 62.

73 ('Plus d'hommes que de femmes s'adonnent à la morphine'; 'on ne compterait que vingt-cinq femmes pour cent hommes. La vérité, ajoute le docteur, est que ces dames

savent mieux cacher leur péché mignon') Pierre Aubry, 'Morphinomanie', *La Petite République Française*, 13 May 1885.

74 ('Les femmes réussissent mieux à cacher leur vice') Zaborowski, 'Revue des sciences', *La Justice*, 14 May 1885.

75 ('la crainte de perdre à la fois leurs dents et leurs cheveux est de nature à arrêter des femmes …') Masque de fer, 'À travers Paris', *Le Figaro*, 9 May 1885.

76 ('Le Dr Jackson a démontré que l'usage de la morphine est une cause active de couperose. Avis aux morphinomanes!') Monin, *L'Hygiène de la beauté*, 86.

77 ('pour acquérir une beauté plus grande, beauté perverse, yeux fous, charme factice qui ne laisse au bout de très peu de temps que des rides et des ruines') Mme Bouët-Henry, 'Un Fléau moderne: La Morphine', *La Petite République*, 15 July 1913.

78 As quoted by Théophile Gautier in Garb, *Bodies of Modernity*, 126.

79 Roberts, *Disruptive Acts*, 226.

80 ('elles connaissent tous les artifices du maquillage et en usent jusqu'à l'extrême limite') Solrac, 'Le Salon de la société nationale de beaux-arts'.

81 White skin was a signifier of status and wealth, marking a separation from the working classes who spent more time outdoors.

82 Clayson, *Painted Love*, 65–7.

83 Emphasis in original. Ibid., 65.

84 Ibid.

85 Zieger notes the association between morphine use and makeup in Victorian novels. Zieger, 'How Far Am I Responsible?', 72–3.

86 ('Elle me rappelle, continua mon compagnon, cette morphinomane que le peintre Hermenegilde Anglada a représentée dans un décor comme celui de ce soir. … / C'est peut-etre le meme, observai-je, en regardant la promeneuse. / Bon, dit-il, il y a plus d'une morphinomane à Paris. / Et une hirondelle, ajoutai-je, ne fait pas le printemps') Toulet, 'Nocturne Élyséen'.

Chapter Three

1 ('les hommes sont-ils plus souvent morphinomanes que les femmes?') Regnard, 'Deux poisons à la mode', 550.

2 Paul Regnard likely takes these statistics from Louis Rambaud's 1884 study. Ibid., 550.

3 Pichon, *Le Morphinisme*, 16.

4 Rodet, *Morphinomanie et morphinisme*, 37.

5 Sollier, 'Méthode physiologique de démorphinisaton', 875–7.

6 Louis Rambaud, 'Morphine et morphinomanie', *Journal de santé publique* 46, 1884. Trans. Yvorel, *Les Poisons de l'esprit*, 137.

7 Regnard, 'Deux poisons à la mode', 550.

8 Although Robert Nye disregards drug use in *Crime, Madness and Politics*, his argument that the medical model of deviance emerged from a divided and defeated nation in the aftermath of the Franco-Prussian War is relevant to this chapter's focus on neuroses and contagions and, as such, to the nineteenth-century approach to addiction. Goldstein, *Console and Classify*; Nye, *Crime, Madness and Politics*, xii.

9 ('d'un véritable péril social') Jules Rochard, 'La Morphinomanie', *Le Temps*, 19 September 1890; ('c'est pour cela que les victimes de la morphine deviennent maintenant si nombreuses qu'il est temps de s'en inquiéter comme de la variole ou du choléra') Albert Wolff, 'Courrier de Paris', *Le Figaro*, 29 March 1889.

10 ('rapidement propagée') Ball, 'La Morphinomanie', 450; ('une fois l'habitude de la morphine contractée') Guimbail, *Les Morphinomanes*, 182.

11 ('qui menace les nouvelles générations') Maurice Cabs, 'Morphinomanie', *La République*, 26 July 1901.

12 Italics as in original. Barnes, *The Making of a Social Disease*, 128.

13 Maurice Barenne, *L'Hygiène: Journal des familles* 1, 10 March 1886, 2. Trans. Kessler, *Sheer Presence*, 18.

14 Barnes, *The Making of a Social Disease*, 133.

15 ('la malpropreté des logements des quartiers pauvres') Collet and Savary, 'La Lutte contre la tuberculose en France', 490.

16 For example, Sollier, 'Méthode physiologique de démorphinisaton rapide', 875–7.

17 ('aujourd'hui la morphine a pénétré partout') Tout-Paris, 'Encore une!', *Le Gaulois*, 23 October 1885; ('la morphine envahit plus que jamais vos demeures') Domino, 'Échos de Paris – Parisiens, veillez!', *Le Gaulois*, 2 December 1886.

18 For example, vials of morphine were found hidden in various pieces of furniture, as stated in an article on a recent case of theft and fraud to fund a morphine addiction. 'Paris – Une Morphinomane', *Le XIXe siècle*, 19 November 1892.

19 ('125 mille fois plus gros que nature') Anon., 'Débarquement du traité de paix à Toulon', *Le Grelot*, 6 July 1884.

20 'Representing Syphilis. Watercolour by R. Cooper (Wellcome Library no. 24008i)', Wellcome Collection (website), accessed 20 July 2022, https://wellcomecollection. org/works/hy6v54k2.

21 ('il serait dangereux de priver d'un seul coup le jeune morphinomane de sa drogue favorite') Léon Kern, 'Maladies à ménager', *Le Pêle-Mêle*, 3 December 1911.

22 ('morphinomanes par persuasion') Guimbail, *Les Morphinomanes*, 40–3.

23 ('en distribuent à des amies trop curieuses') Notta, *La Morphine et la morphinomanie*, 17; ('sur le conseil d'une amie morphinomane') Bougon, 'Une Morphinomane', 668.

24 ('pauvres faibles femmes qui vous laissez entraîner par l'exemple de vos amies ou de vos voisines') Jean Frollo [pseud.], 'La Morphine', *Le Petit Parisien*, 27 May 1882.

25 ('les morphinomanes, poursuit le docteur Buvat se recherchent entre eux, se trouvent, et forment une étrange franc-maçonnerie morbide') Louis Paillard, 'Les Morphinomanes: L'Adoration du poison', *La Presse*, 6 September 1904.

26 Sara Black also notes how morphine use takes the place of more acceptable social activities. Black, *Drugging France*, 213–14.

27 This socio-historical context is the focus of chapter 5.

28 ('elle avait entraîné son mari dans la même voie qu'elle') Gastou, 'Cocaïnomanie et morphinomanie', 155.

29 ('très souvent et peut-être même le plus souvent, c'est la femme qui entraîne l'homme'; 'compagnon de plaisir') Docteur X., 'Morphinomanie', *Le Petit Journal*, 22 November 1891.

30 Henry Fouquier, 'La Vie de Paris', *Le XIXe siècle*, 24 January 1891.

31 Rodet, *Morphinomanie et morphinisme*, 20.

32 *Les Possédés de la morphine* was published initially as a serialised text in *Gil Blas*. The first instalment appeared on 15 February 1892.

33 ('Ils en arrivent tous à une inconscience sordide, à une indifférence affalée et dégoûtante, aux chemises sales, aux mains noires, à l'avilissement et à la crasse') Théophile Steinlen, '*Les Possédés de la morphine*, par Maurice Talmeyr', *Gil Blas illustré*, 21 February 1892.

34 Black explores drugs and the nineteenth-century reproductive family in Black, *Drugging France*, 218–29.

35 ('la morphinomanie des innocents') Guimbail, *Les Morphinomanes*, 41.

36 For more on *syphilis insontinum*, see Sherwood, *Infection of the Innocents*.

37 Sontag, *Illness as Metaphor*, 60.

38 A discussion between Henri Turot and the prefect of police, reported in a 1904 issue of *Bulletin municipal officiel*, suggests that attitudes were slowly changing: 'if there are many women with syphilis, there are also many men with syphilis who have it and spread it', noting that a man contributes 'to spreading this evil … only to satisfy his passions'. ('s'il y a beaucoup de femmes atteintes de la syphilis, il a également beaucoup d'hommes qui en sont atteints et qui la propagent … l'homme contaminé n'ignore jamais son mal, et s'il contribue à répandre ce mal, c'est uniquement pour satisfaire ses passions') Henri Turot, Adrien Mithouard, Maurice Quentin, et al., 'Conseil municipal de Paris', *Bulletin municipal officiel de la ville de Paris*, 15 March 1904.

39 Fournier, *Prophylaxie publique de la syphilis*, 60. Trans., Harsin, *Policing Prostitution*, 251.

40 ('le péril vénérien') Berthod, 'Législation sanitaire', 86.

41 Skelly discusses some of the associations between dirty skin and the 'dirty' addict in Skelly, 'Skin and Scars', 195–9.

42 Gordon, *Dances with Darwin*, 39.

43 Ibid., 32.

44 ('chef d'orchestre') Michel Zévaco, 'Yvette Guilbert et Judic', *Le Courrier Français*, 4 March 1894. The introduction explores 'La Morphinée' in greater detail.

45 ('Yvette quintessencie [*sic*] tout simplement la névrose féminine') Ibid.

46 Gordon, *Dances with Darwin*, 29–30.

47 ('névrose inconsciente qui caractérise[nt] la femme contemporaine') Octave Uzanne, *La Femme et la mode*, 227.

48 For example, 'La Morphinomanie: Une Visite aux pensionnaires de Sainte-Anne', *Le Matin*, 23 May 1884.

49 Goldstein, 'The Hysteria Diagnosis', 209. See also Showalter, *The Female Malady*.

50 ('anxiété habituelle') Guimbail, *Les Morphinomanes*, 60.

51 ('sur dix morphinomanes, il faut s'attendre à trouver huit hystériques') Ibid., 61.

52 ('des attaques comparables à des crises d'hystérie, d'épilepsie ou provoquer encore une sorte de manie aiguë') O. Dubui, 'Morphinomanie', *La Médecine nouvelle*, 7 September 1895.

53 Bourneville and Regnard, *Iconographie photographique de la Salpêtrière* 2, 124, 141, 160; Notta, *La Morphine et la morphinomanie*, 11.

54 Camus and Pagniez, *Isolement et psychothérapie*, 127; Pichon, *Folies passionnelles*, 221, 327, 347.

55 Kuhn, *The Demon of Noontide*, 13.

56 ('l'entraînement vers la volupté') Tardieu, *L'Ennui*, 249.

57 ('l'un des grands facteurs de la morphinomanie') Chambard, 'Traitement de la morphinomanie', 86; ('les ennuyées'; 'les oisives') Tout-Paris, 'Encore une!'

58 See, for example, J. Roques, 'Chronique de la semaine théâtrale', *Le Courrier Français*, 28 February 1886.

59 ('la femme vit dans l'ennui'); ('le demon de la femme') Tardieu, *L'Ennui*, 215, 218.

60 ('la mère de tous les vices') Gérard, *La Grande Névrose*, 204.

61 Kennaway, 'The Piano Plague'.

62 ('la contagion par le livre'; 'tous ces ouvrages sont entre les mains de gens inactifs, oisifs, de femme névrosées … La curiosité s'éveille bien vite chez tous ces êtres mal équilibrés, et ils ne tardent pas à transformer la description des sensations morphiniques en sensations vécues') Rodet, *Morphinomanie et morphinisme*, 19–20.

63 ('nymphomanes, morphinomanes et autres tristes échantillons de nos détraquements nerveux') Henri Duvernois, 'Critique littéraire', *La Presse*, 18 March 1895.

64 Guimbail, *Les Morphinomanes*, 59; Delorme, 'Contribution à l'étude clinique de la morphinomanie', 11.

65 'Morphinomane et kleptomane', *Le Petit Parisien*, 17 July 1901.

66 For more on women's insatiable desires and kleptomania, see O'Brien, 'The Kleptomania Diagnosis', 65–77; Abelson, *When Ladies Go A-thieving*.

67 Tiersten, *Marianne in the Market*, 15–54, 55–86.

68 Auslander, 'The Gendering of Consumer Practices in Nineteenth-Century France', 83.

69 Susik, 'Consuming and Consumed', 103–21.

70 ('aux classes aisées ou riches') Zaborowski, 'Les Morphinomanes et la morphinomanie', *La Justice*, 9 October 1891.

71 ('cet alcoolisme des riches') Untitled, *Le XIXe siècle*, 9 December 1884.

72 For example, an order of morphine worth 1900 francs is described in Maître X., 'Chronique des tribunaux', *Le Gaulois*, 3 May 1883.

73 Albéric Darthèze, 'Morphinomanie et morphinisme', *L'Aurore*, 28 October 1901.

74 Ibid.

75 Tout-Paris, 'Guerre à la morphine', *Le Gaulois*, 6 November 1889. An even larger bottle appears in Émilie Charmy's *La Morphinomane*, c.1908 (oil on canvas, 130 × 89.5 cm, private collection). Charmy's painting is a rare example of this topic being depicted by a woman artist.

76 Régnier, *L'Intoxication chronique par la morphine*, 56.

77 Rodet, *Morphinomanie et morphinisme*, 45.

78 Marion and Louis Vallet, 'De trois à sept', *La Vie Parisienne*, 21 November 1891.

79 Marion and Louis Vallet, 'Cabines de toilette et dessous', *La Vie Parisienne*, 21 February 1891.

80 The inclusion of the 'oriental table' is a rare nod towards imperial narratives relating to opium trade routes within morphine visual culture. ('tapis de fourrure'; 'un piédestal de malachite'; 'une immense table de toilette en marbre vert'; 'une table orientale') Ibid.

81 ('un chef d'oeuvre lilliputien, surnommé la huitième merveille du demi-monde') Houssaye, 'Mademoiselle Fleurs-de-Lys', 37.

82 Albert Delpit, '*Comme dans la vie*, par Albert Delpit', *Le Bon Journal*, 1 June 1890.

83 Steele, '*Femme Fatale*', 316.

84 ('la morphine est devenue une mode') Labruyère [Albert Millaud], 'Les Morphinomanes', *Le Figaro*, 1 June 1886.

85 ('la vogue actuelle des injections de morphine') 'Causerie médicale', *La Presse*, 15 June 1876; ('plus en plus à la mode') Masque de fer, 'À travers Paris', *Le Figaro*, 26 November 1877.

86 ('le luxe féminin') Tout-Paris, 'L'Asile des morphiomanes', *Le Gaulois*, 10 November 1886; ('le vice à la mode') Caliban [Émile Bergerat], 'Morphinomanie', *Le Figaro*, 1 March 1885.

87 ('l'emploi du funeste poison passe pour une sorte d'"élégance"') Jean Frollo [pseud.], 'La "Fée" Morphine', *Le Petit Parisien*, 22 November 1891.

88 ('c'est un remède à la mode') M. Champimont, 'Par-ci par-là', *Le Voleur illustré*, 4 April 1889; ('le médicament à la mode') 'Tribunaux', *Le Temps*, 4 May 1883; ('une maladie à la mode') X., 'Chronique des tribunaux'.

89 ('la griserie spéciale du grand magasin') Dubuisson, *Les Voleuses de grands magasins*, 206.

90 Felski, *The Gender of Modernity*, 65.

91 Steele, '*Femme Fatale*', 316, 322.

92 Miller, *The Bon Marché*, 177.

93 Zola, *Au Bonheur des dames*, 117.

94 Flügel, *The Psychology of Clothes*, 87–8.

95 Garb, *The Painted Face*, 2.

96 ('sensations voluptueuses') Dupouy, 'De la Kleptomanie', 413.

97 Emberley, *The Cultural Politics of Fur*, 4.

98 A tiger skin rug was worth up to 1,500 francs. A polar bear skin rug was worth up to 1,000 francs. Kretzschmar, *Les Animaux à fourrures*, 94, 107.

99 Emberley, *The Cultural Politics of Fur*, 11.

100 For a discussion of *Venus in Furs* see Emberley, *The Cultural Politics of Fur*, 73–102. Jennifer Birkett argues that the success of Sacher-Masoch's works in France was correlated to 'post-1870 efforts by the Right to urge ideologies of submission, rather than revolt'. Birkett, *The Sins of the Fathers*, 32.

101 ('Fourrure: Signe de richesse') Flaubert, *Dictionnaire des idées reçues*, 67.

102 Razek, *Dress Codes*, 10.

103 See Gauld, 'Victorian Bodies'.

104 ('des feuilles de figuier et des peaux de bête') Tout-Paris, 'Une Inventeur trop célèbre', *Le Gaulois*, 13 June 1892.

105 Joleaud-Barral, 'La Morphinomanie', *La Justice*, 12 February 1892; Gaston Jollivet, 'La Seringue de Pravaz', *Le Figaro*, 8 September 1888; Guimbail, *Les Morphinomanes, 16.

106 ('dames même, appartenant à la classe des plus élégantes, poussent leur bon goût jusqu'à se faire faire des bijoux recélant une seringue mignonne, et des flacons artistiques destinés à contenir la solution enchanteresse') Pichon, *Le Morphinisme*, 2–3; ('une adorable petite seringue') Regnard, *Les Maladies épidémiques de l'esprit*, 317.

107 ('élégante seringue de Pravaz'; 'ces mignons bibelots') Tout-Paris, 'L'Asile des mor-
phiomanes'; ('la terrible seringue de Pravaz est devenue un bijou') Frollo, 'La "Fée"
Morphine'.

108 Stop [Louis Morel-Retz] and Michelet, '*Musotte*', *Le Journal amusant*, 28 March 1891.

109 Stewart, *On Longing*, xii.

110 Ibid., 136.

111 Ibid., 44.

112 ('un joujou, que tant d'élégantes cachent dans le tiroir secret d'un meuble') Frédéric
Gilbert, 'Les Morphinées', *Le Gaulois*, 28 June 1884.

113 Regnard, *Les Maladies épidémiques de l'esprit*, 313–18.

114 ('dissimuler luxueusement') Jollivet, 'La Seringue de Pravaz'.

115 ('morphinomanes sans vergogne') Ibid.

116 Felski, *The Gender of Modernity*, 62.

117 For more on the demonisation of fashion and consumerism, see Tiersten, *Marianne
in the Market*, 15–54.

118 Callen, *The Spectacular Body*, 164.

119 See Burman, 'Pocketing the Difference', 459–63. See also Christine Bard's import-
ant work on the gendered and political history of trousers, *Une Histoire politique
du pantalon*.

Chapter Four

1 Italics as in original. ('les médecins *aimeraient* que les femmes utilisatrices de mor-
phine soient plus nombreuses, pour conforter l'idée qu'ils se font de la morphino-
manie') Yvorel, *Les Poisons de l'esprit*, 137.

2 Sara Black has accounted for this in detail in her article, 'Doctors on Drugs'.

3 ('l'un a compté 32 médecins sur 82 morphinomanes, l'autre 45 sur 85, l'autre encore
97 sur 143, un quatrième 3 sur 3, un cinquième 56 sur 160') Zaborowski, 'Les morphi-
nomanes et la morphinomanie', *La Justice*, 9 October 1891.

4 Rodet, *Morphinomanie et morphinisme*, 37.

5 Yvorel, *Les Poisons de l'esprit*, 126.

6 Thompson, *Taboo*, 7.

7 I use masculine pronouns for the fin-de-siècle physician throughout this chapter
since there were so few women physicians working at the end of the nineteenth
century. By 1900 there were 95 women physicians compared to almost 20,000 men.
Furst, 'Realism and Hypertrophy', 29, 46n1. For more on gender barriers in the med-
ical profession, see Walsh, '*Doctors wanted, no women need apply*'.

8 Freud, *Totem and Taboo*, 21. Freud also defined taboo as something that has two
meanings: 'on the one hand, "sacred", "consecrated", and on the other "uncanny",
"dangerous", "forbidden", "unclean".' Hannah Thompson makes use of these almost
contradictory definitions because her analysis focuses on the diseased or abnormal
body – a societal taboo – whereas my analysis focuses on a socially acceptable, and
highly regarded, body (the fin-de-siècle physician).

9 Bianchon, *Nos grands médecins d'aujourd'hui*, ii. Trans. Hunter, *The Face of Medi-
cine*, 10.

10 Furst, 'Realism and Hypertrophy', 29.

11 Donaldson-Evans, *Medical Examinations*, 8–11. See also Ellis, *The Physician-Legislators of France*.

12 For more context on medicine in nineteenth-century France, see Weisz, *The Medical Mandarins*; Hannaway and La Berge, *Constructing Paris Medicine*; Feingold and La Berge, *French Medical Culture*.

13 Hildreth, 'Doctors and Families in France', 201. See also Rothfield, *Vital Signs* for more on medical realism in nineteenth-century fiction.

14 Hunter, *The Face of Medicine*, 37.

15 Black, 'Doctors on Drugs', 119.

16 ('on fait des miracles') Pichon, *Le Morphinisme*, 457.

17 Thompson, *Taboo*, 3.

18 See Caputo and Yount, *Foucault and the Critique of Institutions*.

19 ('à recourir à cette dangereuse panacée') Jean Frollo [pseud.], 'La Morphinomanie', *Le Petit Parisien*, 25 April 1884.

20 ('les hommes d'affaires, les médecins, les avocats') Louis Paillard, 'Les Morphino-manes', *La Presse*, 6 September 1904.

21 ('j'oubliais de vous parler des demi-mondaines qui fournissent aux statistiques la plus forte proportion') Ibid.

22 ('un aphrodisiaque de premier ordre') Albéric Darthèze, 'Morphinomanie et mor-phinisme', *L'Aurore*, 28 October 1901.

23 ('très excusables; un labeur écrasant; ils ont la morphine à leur disposition') Ibid.

24 Ball, 'La Morphinomanie', 7 June 1884, 706.

25 ('par lassitude et dégoût de la plus ingrate des carrières. Obligés de lutter souvent sans succès pour le pain') Tout-Paris [pseud.], 'Qui se morphine le plus?', *Le Gaulois*, 30 October 1896.

26 Black, 'Doctors on Drugs', 114.

27 Hildreth, 'Doctors and Families in France', 192–4.

28 Donaldson-Evans, *Medical Examinations*, 11.

29 See Terdiman, *Discourse/Counter-Discourse*, 149–97.

30 See Goldstein, *Censorship of Political Caricature*.

31 One exception is an illustration by Lubin de Beauvais of a 'doctor' injecting a female figure whose bare thigh is raised to the doctor's syringe, as mentioned briefly in chap-ter 2. The doctor's face is turned away from the viewer and the female figure is the focus of the image. The image appears in René de Schwaeblé's *Les Détraquées de Paris*, which also includes chapters on sex dolls, voyeurs, Satanists, and vampires, among others. Many of the scenarios described in the book are absurd and can therefore be viewed under the same guise of insincerity and irreality as found in caricature. Schwaeblé, *Les Détraquées de Paris*, 37–45.

32 Albert Robida, 'Les Victimes de la science', *La Vie Parisienne*, 12 April 1890.

33 ('microbe de l'amour'; 'comptoir de la génération artificielle'; 'Sainte Morphine et ses purgatoires artificiels') Ibid. With reference to the first two examples, see Finn, 'Female Sterilization and Artificial Insemination'.

34 Black argues that some doctors were profiting from their attempts to 'cure' morphine addictions. Black, 'Doctors on Drugs', 130–1.

35　Caricature images illustrating contemporaneous plays were a common feature during the fin-de-siècle. Michelet and Stop often collaborated. For more information on Stop, see Bayard, *La Caricature et les caricaturistes*, 215–18.

36　See, for example, Le Masque de fer [pseud.], 'Instantanés', *Le Figaro*, 5 March 1891. François Oswald provides a detailed description of the plot, including excerpts of reviews from other newspapers. François Oswald, '*Muzotte* [*sic*]', *Le Matin*, 5 March 1891.

37　('la fièvre qui recommence ... Je ne veux pas que vous déraisonniez quand il [Jean] entrera') Maupassant, '*Musotte*', 109.

38　Ibid., 108.

39　('le docteur parvient enfin à rendre un peu de calme à la patiente') Oswald, '*Muzotte*'; ('le docteur la calme au moyen d'une piqûre') Noel and Stoullig, *Les Annales du théâtre et de la musique*, 173.

40　('Musotte découvre elle-même son bras') Maupassant, '*Musotte*', 109.

41　('comme elle s'endort!'; 'bénédiction') Ibid., 109.

42　('Après quoi il va rigoler dans un coin avec la sage-femme') Stop [Louis Morel-Retz] and Michelet, '*Musotte*', *Le Journal amusant*, 28 March 1891.

43　An article by Auguste Voisin, who worked at Salpêtrière, tells of the drug's use at the institution. Voisin, 'Du Traitement curatif de la folie', 115–22, 154–64, 202–14.

44　('arme contre la douleur') Philippe Maréchal, 'La Longévité', *Le Voleur illustré*, 18 April 1889; ('les médecins n'ont jamais trouvé de meilleure arme contre la douleur physique que la morphine') Paillard, 'Les Morphinomanes'.

45　('la mère de la morphiomanie') Notta, *La Morphine et la morphinomanie*, 15.

46　In 1821 French physiologist François Magendie published recipes for morphine syrups. Magendie, *Formulaire pour la préparation et l'emploi de plusieurs nouveaux médicamens*, 13–20.

47　Dr Francis Rynd (Ireland) is generally credited with the invention of the hollow needle and the first successful injection in 1844. Black, 'Doctors on Drugs', 116–17.

48　('le véritable inventeur de la seringue') Tout-Paris [pseud.], 'Un Inventeur trop célèbre', *Le Gaulois*, 13 June 1892. Journalists often referred to Alexander Wood if they were discussing the negative impact of the invention. For example, Émile Gautier argues that if morphine had continued to be absorbed via the mouth, rather than injected, it would have remained harmless. Émile Gautier, 'La Morphine', *Le Petit Journal*, 23 November 1897.

49　Charles Pravaz did not patent the hypodermic syringe, despite the many references to his name in descriptions of the syringe sold by other companies. In France, syringes were often manufactured by the surgical instruments company Charrière & Collin, founded by Joseph-Frédéric-Benoît Charrière in 1820.

50　('amoureuses de la Pravaz') X. [pseud.], 'Les Livres de la semaine', *La Vie Parisienne*, 11 June 1892; Gaston Jollivet, 'La Seringue de Pravaz', *Le Figaro*, 8 September 1888.

51　Calvet, 'Essai sur le morphinisme aigu et chronique'; Levinstein, *La Morphiomanie*, 8; Szabo, *Incurable and Intolerable*, 147.

52　('huit fois sur dix, sa réponse est la même: ils avaient une névralgie rebelle, une maladie quelconque ... dont les douleurs n'étaient calmées que par une injection de morphine') Notta, *La Morphine et la morphinomanie*, 15.

53 ('il est rare que cette déplorable habitude n'ait pas son point de départ dans un conseil médical') Jules Rochard, 'La Morphinomanie', *Le Temps*, 19 September 1890.

54 ('la plupart des morphinomanes ont appris à connaître la morphine et en ont contracté l'habitude à la suite d'une prescription médicale. Peut-être certains médecins donnent-ils trop facilement la morphine à leurs clients') Brouardel, *Cours de médecine légale de la Faculté de médecine de Paris*, 141–2. Georges Pichon, in his influential text on habitual morphine use, similarly argued that the physician is most culpable in creating morphine habits. Pichon, *Le Morphinisme*, 451. The doctor's role in creating morphine habits is also discussed in Courtwright, *Dark Paradise*, 42–54; Davenport-Hines, *Pursuit of Oblivion*, 67–93.

55 It should be noted that in 1889, attempts were made to legislate who could sell morphine (druggists could only sell to pharmacists) and to enforce the legitimacy of prescriptions (pharmacists could only accept a prescription once). However, these suggestions were not acted on until 1916. Black, 'Morphine on Trial', 649; Poincaré, 'No. 10090: Loi', 1154–6.

56 ('Nous éviterons surtout de laisser au malade le soin de se pratiquer lui-même des piqûres et les moyens de le faire. C'est au médecin seul qu'il appartient de faire cette opération quand elle est nécessaire') Ball, *La Morphinomanie*, 69.

57 ('Dans aucun cas, le médecin ne doit confier au malade l'instrument destiné à faire l'injection. C'est, en somme, une petite opération chirurgicale et c'est lui qui doit la faire pour rester toujours maître de la situation') Rochard, 'La Morphinomanie'.

58 ('puisque de nombreuses personnes en abusent pour s'injecter de la morphine avec cette petite seringue que les médecins ont trop souvent le tort de laisser aux mains des malades') 'Contre la phtisie', *Le Voleur illustré*, 20 May 1886.

59 Hunter, *The Face of Medicine*, 37.

Chapter Five

1 Iskin, 'Popularising New Women', 104.

2 Louis Vallet, 'Médicamentées', *La Vie Parisienne*, 24 September 1898.

3 For more on the *femme nouvelle*, see Roberts, *Disruptive Acts*, 19–47; Silverman, *Art Nouveau in Fin-de-Siècle France*, 63–74.

4 Shapiro, 'Stories more terrifying than the truth itself', 217.

5 This argument exists in scholarship on the prostitute, for example. See Clayson, *Painted Love*.

6 Guimbail, *Les Morphinomanes*, 8; S. Faber, 'Morphinomanie', *La Médicine nouvelle*, 7 September 1895.

7 ('recrutent pour l'armée des morphinomanes') Jules Rochard, 'La morphinomanie', *Le Temps*, 19 September 1890; ('les volontaires de l'armée morphinomane') Regnard, *Les Maladies épidémiques de l'esprit*, 313.

8 Offen, 'Depopulation, Nationalism, and Feminism', 649–52. For an analysis of French policymaking regarding depopulation in the long nineteenth century, see Cole, *The Power of Large Numbers*.

9 Finn, 'Female Sterilization and Artificial Insemination', 26.

10 McLaren, 'Sex and Socialism', 475.

11 Offen, 'Depopulation, Nationalism, and Feminism', 658.

12 Just Sicard de Plauzoles, *La Maternité et la défense nationale contre la dépopulation*, 93–4. Trans. Fuchs, *Poor and Pregnant in Paris*, 64–5.

13 ('volontaires ou imposés à la suite de circonstances malheureuses') Macé, 'Morphine, morphinomanie, morphinomanes', 35.

14 ('Si le peuple, déjà affligé de l'alcoolisme, prend goût à la morphine, l'on verra encore plus rapidement décroître le nombre des naissances') Lefèvre, 'Prophylaxie de la morphinomanie et de la morphino-cocaïnomanie', 232.

15 ('le phénomène de l'ovulation fait rapidement défaut') Guimbail, *Les Morphinomanes*, 143–4.

16 ('l'abus de la morphine amène rapidement la frigidité chez la femme'; 'habitude de la morphine anéantit le désir sexuel') Ibid., 141, 142.

17 Laura Spagnoli notes the lesbian undertones of morphine. Spagnoli, 'Morphine and the Unmaking of Marriage', 109–11.

18 Émile Zola, 'Dépopulation', *Le Figaro*, 23 May 1896. Trans. Finn, 'Female Sterilization and Artificial Insemination,' 34.

19 Mesch, 'Housewife or Harlot?', 70.

20 Zaborowski, 'Les morphinomanes et la morphinomanie', *La Justice*, 9 October 1891.

21 Ibid.

22 ('Tous ces enfants sont infirmes et, sauf l'aîné, ils n'ont presque aucune chance de survivre') Ibid.

23 Ibid.

24 Shapiro, *Breaking the Codes*, 179. Lamia Ben Youssef Zayzafoon demonstrates how this agenda was implicated across France's colonies, noting that 'French women, whether at home or in the imperial field, were taught courses in child-rearing, housework, and the new science of puériculture (infant hygiene)'. Zayzafoon, *The Production of the Muslim Woman*, 36.

25 Despite the visual and textual accounts of morphine users injecting in public, it was unlikely this was a frequent occurrence in reality. Most morphine use would have occurred in the home, particularly before the illicit market for morphine grew after the turn of the twentieth century. These narratives centring on morphine use in public function to conflate the *morphinomane* with deviant behaviours associated with the *demi-mondaine* or prostitute.

26 Italics as in original. ('Les femmes, dont quelques-unes, par exemple, réclament avec exaltation tous leurs *droits*, ont conquis, depuis un certain nombre d'années, un droit singulier, tout nouveau, et très fatal que j'appellerai le *Droit à la morphine*') Jules Claretie, 'La Vie à Paris', *Le Temps*, 4 October 1881.

27 For more on the formation of French feminism and feminism in Europe more broadly at the end of the nineteenth century, see Offen, *European Feminisms*, 50–76, 144–81.

28 Shapiro, *Breaking the Codes*, 181.

29 Mesch, *Having It All*, 18.

30 ('quoique … les femmes ont besoin de toutes leurs forces, de leur ardeur pour se livrer à la bicyclette, elle n'a jamais pu renoncer à ses chères piqûres') Vallet, 'Médicamentées'.

31 Victor Jozé [Joze Dobrski de Jastzebiec], 'Le Féminisme et le bon sens', *La Plume*, 15 September 1895. Trans. Silverman, *Art Nouveau in Fin-de-Siècle France*, 72.

32 The accompanying caption states, 'she has not given up her dear vices, especially her inseparable little Pravaz syringe which, for her, replaces everything, everything, everything.' ('Elle n'a pas renoncé pour cela à ses chers vices, surtout a son inséparable petite seringue de Pravaz qui, pour elle, remplace tout, tout, tout') Bac [Ferdinand-Sigismond Bach], 'Revue en costumes', *La Vie Parisienne*, 15 March 1890.

33 Shapiro, *Breaking the Codes*, 181. See also Dean, *The Frail Social Body*, 173–80.

34 Birkett, *The Sins of the Fathers*, 39. For more on sexual deviance, see Gilman's chapter on sexuality and degeneration in *Difference and Pathology*, 191–216.

35 Choquette, 'Homosexuals in the City', 149. On the 'making of lesbian sexuality', see Dean, *The Frail Social Body*, 173–215.

36 Choquette, 'Degenerate or Degendered?', 218–20.

37 Henry Fouquier, 'Le Salon', *Gil Blas*, 28 May 1886.

38 Choquette, 'Homosexuals in the City', 159.

39 Jozé called 'androgynes' a threat to the nation in an article from 1895. Jozé, 'Le Féminisme et le bon sens'.

40 Davray, *L'Amour à Paris*, 110. Trans. Choquette, 'Homosexuals in the City', 158.

41 The marquise dressed and lived as a man. Her life and identity were likely more complex than would be characteristic of the androgynous lesbian she was labelled.

42 Le Vitrioleur, 'La Marquise', *Fantasio*, 15 December 1906. Trans. Albert, 'Books on Trial', 136n15.

43 Albert, 'Books on Trial', 136n15.

44 Talmeyr, *Les Possédés de la morphine*, 97–8. Trans. Albert, *Lesbian Decadence*, 197.

45 Ibid., 197.

46 Choquette, 'Homosexuals in the City', 150.

47 Guimbail, *Les Morphinomanes*, 40.

48 Ibid., 40.

49 Mary Roberts explores the uneasy relationship between beauty and feminism in relation to the actress Marguerite Durand, founder of *La Fronde*. Roberts, *Disruptive Acts*, 243–7.

50 Silverman, 'The "New Woman," Feminism, and the Decorative Arts', 146.

51 Choquette, 'Degenerate or Degendered?' 218.

52 Foucault, *The Order of Things*, 137.

53 ('les morphinomanes restent chez eux et y meurent tranquillement') Rochard, 'La morphinomanie'.

54 Silverman, *Art Nouveau in Fin-de-Siècle France*, 72.

55 For more on *La Fronde* see Roberts, *Disruptive Acts*, 49–71.

56 Unsurprisingly, misinformed representations of femininity such as the *femme nouvelle*, which appear in other newspapers, are also absent from *La Fronde*.

57 Corbin, *Women for Hire*, 212.

58 As Laura Mulvey argues, the constructed viewing conditions of film make voyeurs of a film's viewers. Analogously, compositional techniques used in artists' *morphinomane* images construct the (male) gaze upon the image to be voyeuristic. Mulvey, 'Visual Pleasure and Narrative Cinema'.

Chapter Six

1 Vanessa Schwartz makes significant connections between mass culture and the spectacularisation of modern, urban city life in Schwartz, *Spectacular Realities*.

2 Samuels, *The Spectacular Past*, 13.

3 For a discussion on the morgue as spectacle, see Schwartz, *Spectacular Realities*, 45–88. For the importance of advertising in debates about spectacularising the city, see Hahn, *Scenes of Parisian Modernity*.

4 Singer, 'Modernity, Hyperstimulus, and the Rise of Popular Sensationalism', 93.

5 Ibid., 83.

6 The very end of the nineteenth century saw the introduction of half-tone reproductions of photographs in newspapers. Gretton, 'Difference and Competition', 145.

7 ('un tableau médical') Albert Wolff, 'Le Salon', *Le Figaro*, 30 April 1886.

8 Paul Rodet's *La Morphinomanie et morphinisme* is one of the few medical texts that offer a separate list for literature under the heading 'Ouvrages littéraires' (Literary Works). Rodet, *Morphinomanie et morphinisme*, 314.

9 ('Historique'; 'Arsenal du morphinomane'; 'Mystérieux effets'; 'Les paradis artificiels'; 'La morphinomanie est-elle une psychose?') Guimbail, *Les Morphinomanes*, 13, 15, 18, 46, 181.

10 Rodet, *Morphinomanie et morphinisme*, 12–13.

11 ('les morphinomanes sont presque inguérissables; à peine 30 malades sur 100 peuvent déraciner cette funeste habitude') Albert Delpit, '*Comme dans la vie*, par Albert Delpit', *Le Bon Journal*, 1 June 1890.

12 ('qui enfonce son scalpel dans les plaies du vice moderne et fait des rapports exacts sur le résultat de ses recherches') Jean Valgore, 'Les Détraquées de Paris', *Le Fin de siècle*, 9 June 1904.

13 ('dicté par un médecin') Rodet, 'Bibliographie', n.p.

14 ('il n'ait aucun caractère scientifique'; 'véritables observations médicales présentées sous une forme très littéraire') Ibid. *Le Matin* reported similar: '*Les Possédés de la morphine* par Maurice Talmeyr', *Le Matin*, 25 May 1892.

15 ('Il rejette très légitimement … le convenu de la fiction') Gustave Geffroy, '*Les Possédés de la morphine*', *La Justice*, 21 June 1892; ('très documentaire') Santillane, 'Les Morphinomanes', *Gil Blas*, 31 October 1896.

16 Schwartz, *Spectacular Realities*, 33–4.

17 Ibid., 32.

18 Ibid., 29.

19 Jullien, 'Anecdotes, *Faits Divers*, and the Literary', 68.

20 Thomas Cragin also notes that the Paris Prefect of Police complained of this practice in the 1880s. Cragin, *Murder in Parisian Streets*, 37–8. Maria Adamowicz-Hariasz shows that '*Le Petit Journal*'s dramatic retelling of one criminal's murderous activities increased the number of copies by close to 50,000, and these numbers grew proportionally as new corpses were discovered'. Adamowicz-Hariasz, 'From Opinion to Information', 179.

21 For example, 'Un Morphinomane dangereux', *Le XIXe siècle*, 20 October 1901.

22 For example, Jean de la Tour, 'À travers Paris – Une morphinomane', *Le Petit Journal*, 26 January 1891.

23 'Faits divers – La Mort du morphinomane', *Excelsior*, 15 March 1912.

24 Schwartz, *Spectacular Realities*, 39.

25 Gretton, 'Difference and Competition', 145.

26 'Les Morphinées', *Le Petit Journal supplément illustré*, 21 February 1891.

27 See Bataille, *Causes criminelles et mondaines de 1891*, 63–112.

28 Pichon, *Le Morphinisme*, 16.

29 ('hâves et flétries') 'Les Morphinées'.

30 Cragin, *Murder in Parisian Streets*, 37.

31 Gretton, 'Difference and Competition', 148.

32 *Comme dans la vie* was published as a book in 1890 in French (Paris: P. Ollendorff) and English (Waverly: New York, translated from the French by Remington Bramwell); and in German in 1891 (Stuttgart: Engelhorn, translated from the French by Dora Paul).

33 ('Excusez-moi si je ne me dérange pas pour vous recevoir ... Je suis malade, si malade!') Albert Delpit, '*Comme dans la vie*, par Albert Delpit', *Le Bon Journal*, 29 May 1890.

34 ('C'est une piqûre de morphine ... Je suis si malade! ... ') Caption for Émile Bayard's illustrations for Albert Delpit, '*Comme dans la vie*, par Albert Delpit', *Le Bon Journal*, 1 June 1890.

35 Maurice Talmeyr, *Les Possédés de la morphine*, Gil Blas, 15 February 1892.

36 ('ils en arrivent tous à une inconscience sordide, à une indifférence affalée et dégoûtante, aux chemises sales, aux mains noires, à l'avilissement et à la crasse') Maurice Talmeyr, *Les Possédés de la morphine*, Gil Blas, 16 February 1892.

37 ('une superbe étude teintée de Steinlen sur les ravages de la morphine, que décrit en ce moment avec tant de puissance notre collaborateur') Advertisement for Steinlen's illustration, *Gil Blas*, 19 February 1892.

38 C., 'Reviews and Notices', 302.

39 Perhaps it seems odd that this Steinlen image would not be used as the front page of the illustrated supplement, but this page was reserved for illustrations for the stories published solely in the supplement. In fact, the addition of an illustration that corresponded to text in the daily edition was out of the ordinary.

40 The illustrated supplement could be acquired at no cost if you paid for the regular *Gil Blas*. The price rose to 10 centimes after 1896, timing that coincides with the introduction of four-colour zincography in September 1895.

41 Schwartz, *Spectacular Realities*, 11.

42 *La Vie meurtrière* was written in 1907, but was not published until 1927. Alsdorf, 'Félix Vallotton's *Murderous Life*', 210–28. More recently: Alsdorf, *Gawkers*, 25–66.

43 Alsdorf, *Gawkers*, 28–37, 51–65.

44 Ibid., 33, 36.

45 Ibid., 34.

46 Barthes, *Critical Essays*, 186–7.

47 Cragin, *Murder in Parisian Streets*, 139.

48 Singer argues that sensationalism was not just about 'morbid curiosity and economic opportunism'; it also conveys a 'historically specific hyperconsciousness of physical

vulnerability in the modern environment'. Singer, 'Modernity, Hyperstimulus, and the Rise of Popular Sensationalism', 83.
49 My emphasis. Schwartz, *Spectacular Realities*, 33.

Chapter Seven

1 Mainardi, *The End of the Salon*, 9–35.
2 Simply because of the nature of the artworks discussed in this section, the role of new salons, of which there were many, is given little attention, despite their impact on the art world. For more, see Brauer, *Rivals and Conspirators*.
3 For marketing techniques, see Galenson and Jensen, 'Careers and Canvases' and Ward, *Pissarro, Neo-Impressionism, and the Spaces of the Avant-Garde*; for digital mapping, see Cavero, Saint-Raymond, and Maupeou, 'Les rues des tableaux'.
4 Pollock, *Avant-Garde Gambits*, 14.
5 For more on Salon naturalism, see Thomson, *Art of the Actual*.
6 ('Se rappeler qu'un tableau – avant d'être un cheval de bataille, une femme nue, ou une quelconque anecdote – est essentiellement une surface plane recouverte de couleurs en un certain ordre assemblées') P. Louis [Maurice Denis], 'Définition du Néo-traditionnisme', *Art et critique* 65, 23 August 1890; 30 August 1890.
7 ('transcrire le sublime coloris des heures de la nuit') Louis Vauxcelles [Louis Mayer], 'La Vie Artistique', *Gil Blas*, 12 January 1907.
8 ('curieuses mosaïques'; 'des gemmes ou des verroteries fondues') Monod, 'Le 17e Salon des Orientalistes Françaises', 3.
9 ('une science merveilleuse de la couleur'; 'des couleurs chantent et frissonnent en de suvantes [sic] harmonies') 'Un Artiste', *La Justice*, 30 June 1901.
10 ('un nouvel harmoniste des colorations claires') Gustave Coquiot, 'Pablo Ruiz Picasso', *Le Journal*, 17 June 1901.
11 ('comme un orfèvre fou et subtil, à sertir les plus somptueux jaunes, les plus magnifiques verts, les plus rougeoyants rubis') Ibid.
12 ('il vaut mieux n'importe quoi plutôt que l'immobilité du progrès artistique; mieux vaut disparaître que ne pas inventer') Vever, 'Boucles de ceinture', 158.
13 ('de voir surgir quelque chose d'imprévu') Ibid., 158.
14 On the myth of the *pétroleuses*, see Célérier, 'Les Pétroleuses de la Commune de Paris ou le mythe terroriste'; Gullickson, *Unruly Women of Paris*, 159–90.
15 Andrieux, 'Vengeance au vitriol', *Le Petit Parisien supplément littéraire illustré*, 1 December 1901.
16 ('dont il n'eut pas le temps de reconnaître les traits') 'Nos Gravures', *Le Petit Parisien supplément littéraire illustré*, 1 December 1901.
17 Ibid.
18 Shapiro, *Breaking the Codes*, 79; Shapiro, 'Stories more terrifying than the truth itself', 205.
19 Iskin, *The Poster*, 135.
20 Pol Neveux, 'L'Oeuvre de Eugène Grasset', *La Plume*, 15 May 1894.
21 For more on foreign artists in Paris, see Carter and Waller, *Foreign Artists and Communities in Modern Paris*.

22 H.B., 'Mort du peintre Macchiati', *L'Oeuvre*, 12 December 1916; 'Nécrologie', *Le Temps*, 13 December 1916; ('qui a peint Paris') André Geiger, 'La Plus Grande Exposition d'art du monde [1922 Venice Biennale]', *Le Monde illustré*, 19 August 1922.

23 ('un merveilleux illustrateur ... une puissance déconcertante') Georges Bourdon, 'Faut-il reconstruire la Campanile de Venise?', *Le Figaro*, 31 July 1902. In this column on the recently collapsed St Mark's Campanile, Venice, the journalist interviews a few artists to ask their opinions on whether it should be rebuilt. Alongside the celebrated French artists Jean-Léon Gérôme and Léon Bonnat, the much lesser known Orazi was asked for his view, perhaps due to his Italian heritage (he was born in Rome).

24 Fontbona includes Anglada-Camarasa as a *moderniste*, although his artistic style is more in keeping with the *postmodernistes*. Fontbona's list of *modernistes* and *postmodernistes* is a useful starting point for understanding when and why Catalan artists moved to Paris, although the split between the two groups is more nuanced than the lists imply. Fontbona, *La crisi del modernisme artístic*, 36.

25 Although Picasso is not strictly a Catalan artist (he was born in Málaga), he lived in Barcelona intermittently from 1895 until 1904, attended the Barcelona School of Fine Arts, and was acquainted with Catalan artists in both Barcelona and Paris.

26 Lugo, 'Catalan Artists in Paris', 111.

27 It is often believed that Rusiñol created two images of the *morphinomane*: the painting in question, *La Morfina*, and a painting that has become known as *Before the Alkaloid [Morphine]*, also known as *On despertarse* and/or *La Medalla* (Waking Up and/or The Locket). This painting was originally titled *Le Réveil* (The Dream) when it was shown at the Salon de Champs-de-Mars in 1894 and *Rêverie* the following year at Rusiñol's 1895 Sala Parés exhibition; note that this was the year after *La Morfina* was exhibited at Sala Parés. *Before the Alkaloid* is an incorrect title. As Josep de C. Laplana remarks, Rusiñol simply described *Le Réveil/Rêverie* as 'a woman sitting on a bed' in *Diario Mercantil* and made no attempt to connect the painting with sensationalist themes. The painting has no suggestion of morphine use. It is likely the name was attributed to the painting simply because of the similarities between this painting and *La Morfina*. Rusiñol used the same model (Stéphanie Nantes) and the same bedroom location. It is therefore difficult to suggest that *La Morfina* and *Le Réveil* were intended to represent a before and after. It is more likely that this was simply a case of Rusiñol being cost-effective by exhibiting similar paintings at two different exhibitions in Europe in 1894: *La Morfina* in Barcelona and *Le Réveil* in Paris (and Barcelona the following year). Laplana, *Santiago Rusiñol*, 515.

28 Panyella, 'From Els Quatre Gats to Cau Ferrat', 238–47.

29 Fontbona, 'Picasso and Els Quatre Gats', 11–17.

30 *Derniers Moments* was painted over for Picasso's *La Vie* in 1903, now at the Cleveland Museum of Art.

31 For more about their meeting and early relationship, see McCully, *Picasso in Paris 1900–1907*, 21–35.

32 Between 17 and 30 June 1901 Picasso had a small showing of three paintings at Galerie Bodinière. Tinterow, 'Vollard and Picasso', 100–17.

33 Most of these paintings are oil on board. This not only suggests Picasso's lack of monetary funds, because board is cheaper than canvas, but also, since oil paints dry faster on board, the speed at which they were produced.

34 Barnaby Wright believes Picasso was in Madrid from January to the end of April or beginning of May, then spent ten days in Barcelona and moved into his Paris studio in early May. Discrepancies over exact dates have led to scholars questioning where *Dwarf Dancer, Morphinomane*, and *Old Woman* were painted since the works are very similar in style. Marilyn McCully argues that all three were painted in Paris. Georges Boudaille and Pierre Daix suggest the works were created in Barcelona, except for *Morphinomane*, for which they propose Paris. Fabre believes *Old Woman* was created in Paris, but *Dwarf Dancer* and *Morphinomane* could have been Paris or Barcelona. Wright, *Becoming Picasso*, 19; McCully, *Picasso in Paris 1900–1907*, 47–9; Boudaille and Daix, *Picasso*, 141–2, 164; Fabre, *Picasso: Life and Work of the Early Years*, 226, 234–7.

35 Joyeux-Prunel and Marcel, 'Exhibition Catalogues in the Globalization of Art', 87.

36 It is unknown how much Coquiot was paid for his involvement in the exhibition. However, Coquiot did acquire a portrait of himself from Picasso in 1901, which was possibly in exchange for his contributions to the exhibition. Catalogue entry by Asher Ethan Miller in Rabinow, *Cézanne to Picasso*, 384.

37 ('un rapport lointain') Daix, *Dictionnaire Picasso*, 556.

38 Fabre, *Picasso*, 514.

39 Villalonga, 'Surviving the Modernist Paradigm', 195–8.

40 Bätschmann, *The Artist in the Modern World*, 130.

41 Hermenegildo Anglada-Camarasa, 'Letter from Paris', private correspondence to Pere Llort, 25 July 1903. Archives Beatriz Anglada Huelin, Pollença. Trans. Villalonga, 'Surviving the Modernist Paradigm', 196.

42 In chapter 2, I showed how this painting was understood by contemporary viewers to be a depiction of the *morphinomane*.

43 'The Morphine Habit in Paris', *Weekly Irish Times*, 25 September 1886.

44 'Foreign News', *Western Gazette*, 14 April 1882.

45 'The Morphine Dens of Paris', *Edinburgh Evening News*, 18 September 1894; 'Morphine Maniacs in Paris', *Sheffield Evening Telegraph*, 17 September 1894; 'Parisians and Morphine', *Cheltenham Chronicle*, 20 April 1901. American newspapers echoed these reports. For example, the *New York Times* reported that morphine is 'playing havoc in Paris society'. 'Morphine in Paris Society', *New York Times*, 28 November 1889.

46 Hichens, *Felix*, 289, 291.

47 Handy, *The Official Directory of the World's Columbian Exposition*, 117.

48 'French Fine Arts', *Chicago Daily Tribune*, 5 May 1893.

49 Ridpath, *Art and Artists of All Nations*. Subtitle: 'Over four hundred photographic reproductions of great paintings'.

50 500 out of the 4,647 oil paintings were from France. Bancroft, *The Book of the Fair*, 699, 764; E.J.M., 'Art at the World's Fair', *Chicago Daily Tribune*, 17 September 1893.

51 E.J.M., 'Art at the World's Fair'.

52 ('l'envahissement progressif des étrangers'; 'nombreux artistes sincères et véritablement Indépendants') Georges Rivière, 'Exposition de la Société des artistes indépendants', *Journal des arts*, 6 April 1912.

53 Hauptman, *El Modernismo*, 23.

54 In particular, see 'Notas', *Art Joven* [preliminary issue], 10 March 1901; Francisco de Asís Soler, '¡¡TOROS!!...', *Art Joven*, 15 April 1901.

55 Alisa Luxenberg suggests this is because it 'contradicted the prevailing stereotype of the poor, lazy, rural Spaniard'. Luxenberg, 'Over the Pyrenees', 28.

56 Ibid., 10–31.

57 Raymond Jonas argues that the exoticism of Montmartre's architecture, particularly the Sacré-Coeur, contributes to its othering. Analogously, Richard Sonn labels Montmartre a 'liminal realm, a borderland', which functioned as an intermediary between the classes. Jonas, 'Sacred Tourism and Secular Pilgrimage', 111–17; Sonn, 'Marginality and Transgression', 123.

58 Thomson, 'Toulouse-Lautrec and Montmartre', 21.

59 Ibid., 4.

60 ('morphinomanie ne compte nulle part plus de fervents adeptes qu'à Montmartre') Maurice Cabs, 'Morphinomanie', La République, 26 July 1901.

61 Griselda Pollock argues that manufacturing an identity secures additional value and creates an 'excessive mystique for, and overvaluation of, artistic personality'. Pollock, Avant-Garde Gambits, 16.

62 James Kearns discusses the changing nature of art criticism, including its professionalisation and its parallels to trends of avant-garde painting, in his useful chapter, 'The Writing on the Wall', 239–52.

63 Povo, 'Anglada come y vive de noche', La voz de Buñol, 16 June 1906. Trans. Villalonga, 'Surviving the Modernist Paradigm', 79.

64 Claire de Pratz, 'Views from France', Westminster Gazette, 18 May 1904.

65 Ibid.

66 Gustave Coquiot, 'Pablo Ruiz Picasso', Le Journal, 17 June 1901. Trans. McCully, A Picasso Anthology, 32–4.

67 ('son filon d'observations nocturnes'; 'investigations parisiennes') Marcel, 'Hermen Anglada', 110.

68 Harlor [Jeanne Fernande Perrot], 'Tableaux de P.R. Picasso et de F. Iturino [sic]', La Fronde, 1 July 1901; ('on pourrait dire d'où sort chacun de ses tableaux') Charles, 'MM. F. Iturrino et P.R. Picasso', 240.

69 Black, Drugging France, 184–229.

70 ('on entre dans la morphinomanie par la porte de la volupté') Ball and Jennings, 'Considérations sur le traitement de la morphinomane', 373.

71 Mulvey, 'Visual Pleasure and Narrative Cinema', 6–18.

72 ('d'une impulsion irrésistible') Rodet quoting Dr Magnan, Morphinomanie et morphinisme, 11. See also Black's discussion on sexual gratification in the novel La Comtesse Morphine in Black, Drugging France, 219–21.

73 ('d'érotisme latent'; 'des visions lubriques'; 'un état de rêverie délicieuse'; 'mélange indéfinissable de jouissance et de douleur aiguë') Guimbail, Les Morphinomanes, 141–2.

74 ('contrayéndose en doloroso y feliz espasmo') Salvador Canals, 'Los que son algo – Santiago Rusiñol', El Diario del Teatro, 19 January 1895.

75 Eugène Grasset, La Morphinomane sketch, pencil on paper, 41.2 × 31.2 cm, National Gallery of Australia, Canberra.

76 Solomon-Godeau, 'The Legs of the Countess', 74–5.

77 Ibid., 75.

78 ('de volupté, de luxure') Holl, 'Les Salons du printemps', 39; 'Société des beaux-arts français', *La Justice*, 30 April 1905.

79 ('extatique jouissance de jeunes femmes dont l'âme dérive vers de paradisiaques nirvanas') Charles Méré, 'Les Salons de 1905', *Le XIXe siècle*, 30 April 1905.

80 See Solomon-Godeau, 'The Other Side of Venus'; Duncan, 'The MoMA's Hot Mamas'.

81 Documentation from the Château de Nemours, where Matignon's *Les Morphinomanes* has been displayed since its 1907 purchase.

82 See Richard Thomson's chapter 'Repudiating Naturalism: The Avant-Garde Seeking Style' for a useful discussion on the relationship between avant-gardism, modernism, and naturalism in Thomson, *Art of the Actual*, 239–73.

83 Brauer, *Rivals and Conspirators*, 86.

84 John Seed, 'Victoria Dailey on 'Tea and Morphine' at the Hammer Museum', *The Huffington Post* (website), 7 May 2014, https://www.huffpost.com/entry/victoria-dailey-on-tea-an_b_5272463.

85 This is perhaps due to scholarship's tendency to favour modernist art, the lack of known images showing morphine use, and the print's use of bright colours (as well as the relatively unknown status of Moreau de Tours's *La Morphine*, which has remained in private collections since the artist's death).

Connections and Conclusions

1 Hickman, 'Heroin Chic', 122.

2 Campbell and Ettorre, *Gendering Addiction*, 1–2.

3 Barthes, 'Theory of the Text', 39.

Epilogue

1 Roepfer, 'One Hundred Years of Nakedness in German Performance', 162.

2 René B. Castelot, 'Les "Dédrogués"', *Détective*, 14 December 1933.

3 Sichel, *Making Strange*, 66.

4 ('le premier hebdomadaire des fait-divers'). For more on *Détective*, see Walker, 'Cultivating the *fait divers*: *Détective*'.

5 Readership of *Détective* rose to 800,000 in the first decade of publication. Ibid., 72.

6 Sichel, *Making Strange*, 68.

7 Will Straw analyses the authenticity of the photojournalism that appeared in *Police Magazine*, as well as outlining some of the formatting choices and visual techniques used by these magazines. Straw, 'After the Event', 140–3.

8 ('elle réussissait à échapper à son mari'; 'des services de désintoxication') Castelot, 'Les "Dédrogués"'.

9 ('l'accoutumance thérapeutique'; 'imprudemment facilitée') Ibid.

10 ('les femmes sont le plus sujettes à semblable contagion') Ibid.

11 Jean Créteuil, 'La Guerre des stupéfiants', *Police Magazine*, 2 October 1938.

12 French newspapers began discussing cocaine use more frequently from the turn of the century onwards. In 1912, the pseudonymous writer Tout-Paris claimed that morphine, heroin, and cocaine were common in Paris. Tout-Paris, 'Le Goût des poisons', *Le Gaulois*, 27 December 1912.

13 Straw, 'After the Event', 140.

14 ('nos pères d'Asie ... qui nous ont déjà légué bien des maux'; 'les morphiniques dérivent des thériakis de l'Orient et des fumeurs d'opium de la Chine') Regnard, *Les Maladies épidémiques de l'esprit*, 290.

15 For more on the French Connection, see Gingeras, *Heroin, Organized Crime, and the Making of Modern Turkey*, 105–12.

16 David Guba's research on colonial France and cannabis opens up important lines of enquiry for future research into these orientalising narratives. Guba, *Taming Cannabis*.

Bibliography

List of Periodicals

Art et critique
Arte Joven
L'Assiette au beurre
The Athenaeum
L'Aurore
Le Bon Journal
Bulletin municipal officiel de la ville
 de Paris
Candide
Cheltenham Chronicle
Chicago Daily Tribune
Le Courrier Français
Détective
L'Écho de Paris
Edinburgh Evening News
Excelsior
Fantasio
Le Figaro
Le Fin de siècle
La Fronde
Le Gaulois
Gil Blas
Gil Blas illustré
Le Grelot
Le Journal
Le Journal amusant
Journal des arts
Journal officiel de la République française
La Justice
La Lanterne

Le Matin
La Médecine nouvelle
New York Times
L'Occident
Officiel-artiste
Le Pêle-Mêle
Le Petit Journal
Le Petit Journal supplément illustré
Le Petit Parisien
Le Petit Parisien supplément
 littéraire illustré
La Petite République
La Plume
Police Magazine
La Presse
Le Radical
La République
Revue illustrée
Rivista d'Italia
Sheffield Evening Telegraph
Supplément du Gil Blas
Le Temps
L'Union médicale
La Vie Parisienne
Le Voleur illustré
Weekly Irish Times
Western Gazette
Westminster Gazette
Le XIXe siècle

Bibliographical Sources

Abelson, Elaine. *When Ladies Go A-thieving: Middle-Class Shoplifters in the Victorian Department Store*. New York: Oxford University Press, 1989.

Académie Française. *Dictionnaire de l'académie française* 1. 6th edition. Paris: Firmin-Didot frères, 1835.

Adamowicz-Hariasz, Maria. 'From Opinion to Information: The *Roman-Feuilleton* and the Transformation of the Nineteenth-Century French Press'. In *Making the News: Modernity and the Mass Press in Nineteenth-Century France*, edited by Dean de la Motte and Jeannene Przyblyski, 160–84. Amherst: University of Massachusetts Press, 1999.

Albert, Nicole. 'Books on Trial: Prosecutions for Representing Sapphism in *Fin-de-Siècle* France'. In *Disorder in the Court: Trials and Sexual Conflict at the Turn of the Century*, edited by Nancy Erber and George Robb, 119–39. Basingstoke: Macmillan, 1999.

– *Lesbian Decadence: Representations in Art and Literature of Fin-de-Siècle France*. Translated by Nancy Erber and William Peniston. New York: Harrington Park Press, 2016.

Alq, Louise d' [Marie Louise Alquié de Rieupeyroux]. *La Science du monde*. 2nd edition. Paris: Bureaux des causeries familières, 1884.

Alsdorf, Bridget. 'Félix Vallotton's *Murderous Life*'. *The Art Bulletin* 97, no. 2 (2015): 210–28. Taylor & Francis Online.

– *Gawkers: Art and Audience in Late Nineteenth-Century France*. Princeton: Princeton University Press, 2022.

Auslander, Leora. 'The Gendering of Consumer Practices in Nineteenth-Century France'. In *The Sex of Things: Gender and Consumption in Historical Perspective*, edited by Ellen Furlough and Victoria de Grazia, 79–112. Berkeley: University of California Press, 1996.

Balducci, Temma. *Gender, Space, and the Gaze in Post-Haussmann Visual Culture: Beyond the Flâneur*. London: Routledge, 2017.

Ball, Benjamin, and Oscar Jennings. 'Considérations sur le traitement de la morphinomane'. *Bulletin de l'académie de médecine* 2nd series: 17 (29 March 1887): 373–7.

Ball, Benjamin. 'La Morphinomanie'. *Revue scientifique* 3rd series: 4, no. 15 (12 April 1884): 449–54.

– 'La Morphinomanie'. *Revue scientifique* 3rd series: 4, no. 23 (7 June 1884): 705–8.

– *La Morphinomanie*. Paris: Asselin et Houzeau, 1885.

Bancroft, Hubert Howe. *The Book of the Fair* 4. Chicago: The Bancroft Company, 1893.

Bard, Christine. *Une Histoire politique du pantalon*. Paris: Seuil, 2010.

Barnes, David. *The Making of a Social Disease: Tuberculosis in Nineteenth-Century France*. Berkeley: University of California Press, 1995.

Barnett, Vivian Endicott. 'The Thannhauser Collection'. In *From van Gogh to Picasso, from Kandinsky to Pollock*, edited by Thomas Krens, 51–120. Milan: Bompiani, 1990. Exhibition catalogue.

Barrell, John. *The Dark Side of the Landscape: The Rural Poor in English Painting, 1730–1840*. Cambridge: Cambridge University Press, 1983.

Barthes, Roland. *Critical Essays* [1964]. Translated by Richard Howard. Evanston: Northwestern University Press, 1972.

– 'Theory of the Text' [1973]. In *Untying the Text: A Post-Structuralist Reader*, edited by Robert Young, 31–47. Boston: Routledge & Kegan Paul, 1981.

Bataille, Albert. *Causes criminelles et mondaines de 1891*. Paris: E. Dentu, 1891.

Bätschmann, Oskar. *The Artist in the Modern World: The Conflict between Market and Self-Expression*. New Haven: Yale University Press, 1997.

Bayard, Émile. *La Caricature et les caricaturistes*. Paris: C. Delagrave, 1900.

Bernier, Ernest, ed. *Le Musée de l'Hôpital St-Louis: Iconographie des maladies cutanées et syphilitiques*. Paris: Rueff, 1895.

Berridge, Virginia, and Griffith Edwards. *Opium and the People: Opiate Use in Nineteenth-Century England*. New Haven: Yale University Press, 1987.

Berthod, Paul. 'Législation sanitaire – Le Péril vénérien – La Réglementation actuelle de la prostitution'. *Médecine légale et jurisprudence médicale* 6, 1899: 86–95.

Bianchon, Horace [Maurice de Fleury]. *Nos grands médecins d'aujourd'hui*. Paris: Société d'éditions scientifiques, 1891.

Birkett, Jennifer. *The Sins of the Fathers: Decadence in France 1870–1914*. London: Quartet Books, 1986.

Black, Sara. 'Doctors on Drugs: Medical Professionals and the Proliferation of Morphine Addiction in Nineteenth-Century France'. *Social History of Medicine* 30, no. 1 (February 2017): 114–36. Oxford Academic.

– 'Morphine on Trial: Legal Medicine and Criminal Responsibility in the Fin de Siècle'. *French Historical Studies* 42, no. 4 (October 2019): 623–53. Duke University Press.

Boudaille, Georges, and Pierre Daix. *Picasso: The Blue and Rose Periods; A Catalogue Raisonné of the Paintings, 1900–1906*. Translated by Phoebe Pool. Greenwich: New York Graphic Society, 1967.

Bougon, D. 'Une Morphinomane'. *Revue scientifique* 3rd series: 9, no. 21 (23 May 1885): 668–9.

Bourneville, Désiré-Magloire, and Paul Bricon. *Manuel des injections sous-cutanées*. 1st edition. Paris: Libraire du Progrès médical, 1883.

– *Manuel des injections sous-cutanées*. 2nd edition. Paris: Librairie du Progrès médical, 1885.

Bourneville, Désiré-Magloire, and Paul Regnard. *Iconographie photographique de la Salpêtrière: Service de M. Charcot* 3. Paris: Progrès médical, 1879–80.

– *Iconographie photographique de la Salpêtrière: Service de M. Charcot* 2. Paris: Progrès médical, 1878.

– *Iconographie photographique de la Salpêtrière: Service de M. Charcot* 1. Paris: Progrès médical, 1877.

Brauer, Fae. *Rivals and Conspirators: The Paris Salons and the Modern Art Centre*. Newcastle-upon-Tyne: Cambridge Scholars Publishing, 2013.

Brouardel, Paul. *Cours de médecine légale de la Faculté de médecine de Paris: Opium, morphine et cocaïne*. Paris: J.B. Baillière et fils, 1906.

Brown, Kathryn. *Women Readers in French Painting, 1870–1890: A Space for the Imagination*. Farnham: Ashgate, 2012.

Burman, Barbara. 'Pocketing the Difference: Gender and Pockets in Nineteenth-Century Britain'. *Gender & History* 14, no. 3 (November 2002): 447–69. Wiley Online Library.

Burnham, Helen. 'Changing Silhouettes'. In Groom, *Impressionism, Fashion, and Modernity*, 253–69.

C., G. 'Reviews and Notices'. *The Burlington Magazine for Connoisseurs* 21, no. 113 (1912): 302.

Callen, Anthea. *The Spectacular Body: Science, Method, and Meaning in the Work of Degas*. New Haven: Yale University Press, 1995.

Calvet, Léopold. 'Essai sur le morphinisme aigu et chronique: Étude expérimentale et clinique sur l'action physiologique de la morphine'. Medical PhD thesis. Paris, 1876.

Campbell, Nancy D., and Elizabeth Ettorre. *Gendering Addiction: The Politics of Drug Treatment in a Neurochemical World*. Basingstoke: Palgrave Macmillan, 2011.

Camus, Jean, and Philippe Pagniez. *Isolement et psychothérapie: Traitement de l'hystérie et de la neurasthénie*. Paris: F. Alcan, 1904.

Caputo, John, and Mark Yount. *Foucault and the Critique of Institutions*. Pennsylvania: Pennsylvania State University Press, 1993.

Carter, Karen, and Susan Waller, eds. *Foreign Artists and Communities in Modern Paris, 1870–1914: Strangers in Paradise*. Farnham: Ashgate, 2015.

Cavero, Julien, Léa Saint-Raymond, and Félicie de Maupeou. 'Les Rues des tableaux: The Geography of the Parisian Art Market 1815–1955'. *Artl@s* 5, no. 1 (2016): 119–59. Purdue e-Pubs.

Célérier, Patricia-Pia. 'Les Pétroleuses de la Commune de Paris ou le mythe terroriste'. *Romance Quarterly* 44, no. 2 (1997): 93–8. Taylor & Francis Online.

Chambard, Ernest. *Les Morphinomanes: Étude clinique, médico-légale et thérapeutique*. Paris: Rueff, 1890.

– 'Traitement de la morphinomanie'. *Nice-médical* 17, no. 6 (March 1893): 84–92.

Charles, François. 'MM. F. Iturrino et P. R. Picasso'. *L'Ermitage* 23, no. 2 (July 1901): 239–40.

Charpin, Catherine. *Les Arts incohérents: 1882–1893*. Paris: Syros Alternatives, 1990.

Choquette, Leslie. 'Degenerate or Degendered? Images of Prostitution and Homosexuality in the French Third Republic'. *Historical Reflections* 23, no. 2 (1997): 205–28. JSTOR.

– 'Homosexuals in the City: Representations of Lesbian and Gay Space in Nineteenth-Century Paris'. *Journal of Homosexuality* 41, no. 3–4 (2002): 149–67. Taylor & Francis Online.

Claretie, Jules. *Noris: Moeurs du jour*. Paris: E. Dentu, 1883.

Clark, T.J. *Image of the People: Gustave Courbet and the 1848 Revolution*. 3rd edition. Berkeley: University of California Press, 1999.

Clayson, Hollis. *Painted Love: Prostitution in French Art of the Impressionist Era*. Los Angeles: Getty Research Institute, 2003.

Cohen, Richard. 'Recurrent Images in French Antisemitism in the Third Republic'. In *Demonizing the Other: Antisemitism, Racism and Xenophobia*, edited by Robert Wistrich, 183–95. New York: Routledge, 1999.

Cole, Joshua. *The Power of Large Numbers: Population, Politics, and Gender in Nineteenth-Century France*. Ithaca: Cornell University Press, 2000.

Collet, Dr, and Robert Savary. 'La Lutte contre la tuberculose en France – III'. *Annales des sciences politiques* 19 (1904): 487–506.

Corbin, Alain. *Women for Hire: Prostitution and Sexuality in France after 1850*. Translated by Alan Sheridan. Cambridge: Harvard University Press, 1990.

Courtwright, David. *Dark Paradise: A History of Opiate Addiction in America*. Cambridge: Harvard University Press, 2001.

Cragin, Thomas. *Murder in Parisian Streets: Manufacturing Crime and Justice in the Popular Press, 1830–1900*. Lewisburg: Bucknell University Press, 2006.

Daix, Pierre. *Dictionnaire Picasso*. Paris: Robert Laffont, 1995.

Darzens, Rodolphe. 'Chronique artistique'. *La Pléïade* 1, no. 3 (May 1886): 85–91. Reproduced facsimile. Genève: Slatkine reprints, 1971.

Davenport-Hines, Richard. *The Pursuit of Oblivion: A Global History of Narcotics, 1500–2000*. London: Weidenfeld & Nicolson, 2001.

Davray, Jules. *L'Amour à Paris*. Paris: J.B. Ferréol, 1890.

Dean, Carolyn. *The Frail Social Body: Pornography, Homosexuality, and Other Fantasies in Interwar France*. Berkeley: University of California Press, 2000.

Delorme, Lubin-Émile. 'Contribution à l'étude clinique de la morphinomanie'. Medical PhD thesis. Paris, 1898.

Delpit, Albert. *(Un monde qui s'en va) Comme dans la vie*. 15th edition. Paris: P. Ollendorff, 1890.

Donaldson-Evans, Mary. *Medical Examinations: Dissecting the Doctor in French Narrative Prose, 1857–1894*. Lincoln: University of Nebraska Press, 2000.

Dubuisson, Paul. *Les Voleuses de grands magasins*. Lyon: A. Storck, 1902.

Duncan, Carol. 'The MoMA's Hot Mamas'. *Art Journal* 48, no. 2 (Summer 1989): 171–8. JSTOR.

Dupont, Paul, ed. *Explication des ouvrages de peinture, sculpture, architecture, gravure et lithographie des artistes vivants*. 2nd edition. Paris: P. Dupont, 1886.

Dupouy, Roger. 'De la Kleptomanie'. *Journal de psychologie normale et pathologique* 2 (1905): 404–26.

Ellis, Jack D. *The Physician-Legislators of France: Medicine and Politics in the Early Third Republic, 1870–1914*. Cambridge: Cambridge University Press, 1990.

Emberley, Julia. *The Cultural Politics of Fur*. Ithaca: Cornell University Press, 1997.

Fabre, Josep Palau i. *Picasso: Life and Work of the Early Years: 1881–1907*. Translated by Kenneth Lyons. Oxford: Phaidon, 1981.

Faxneld, Per. *Satanic Feminism: Lucifer as the Liberator of Woman in Nineteenth-Century Culture*. New York: Oxford University Press, 2017.

Felski, Rita. *The Gender of Modernity*. Cambridge: Harvard University Press, 1995.

Finn, Michael. 'Female Sterilization and Artificial Insemination at the French Fin de Siècle: Facts and Fictions'. *Journal of the History of Sexuality* 18, no. 1 (January 2009): 26–43. JSTOR.

Flaubert, Gustave. *Dictionnaire des idées reçues*. Paris: L. Conard, 1913.

Flügel, John C. *The Psychology of Clothes*. 2nd edition. London: Hogarth Press, 1940.

Fontbona, Francesc. *La crisi del modernisme artístic*. Barcelona: Curial, 1975.

– 'Picasso and Els Quatre Gats'. In Ocaña, *Picasso and Els Quatre Gats*, 11–20.

Foucault, Michel. *The Order of Things: An Archaeology of the Human Sciences* [1966]. English edition. New York: Vintage Books, 1994.

Fournier, Alfred. *Prophylaxie publique de la syphilis*. Paris: G. Masson, 1887.

Freud, Sigmund. *Totem and Taboo: Some Points of Agreement between the Mental Lives of Savages and Neurotics* [1913]. Translated by James Strachey. London: Routledge, 1950.

Fuchs, Rachel. *Poor and Pregnant in Paris: Strategies for Survival in the Nineteenth Century.* New Brunswick: Rutgers University Press, 1992.

Furst, Lilian. 'Realism and Hypertrophy: A Study of Three Medico-Historical "Cases"'. *Nineteenth-Century French Studies* 22, no. 1–2 (Fall–Winter 1993–4): 29–47. JSTOR.

Gagneur, Marie-Louise. *Bréviaire de la femme élégante: L'Éternelle séduction.* Paris: E. Dentu, 1893.

Galenson, David and Robert Jensen. 'Careers and Canvases: The Rise of the Market for Modern Art in Nineteenth-Century Paris'. In *Current Issues in 19th-Century Art, Van Gogh Studies 1*, edited by Chris Stolwijk, 137–66. Amsterdam: Van Gogh Museum, 2007.

Garb, Tamar. *Bodies of Modernity: Figure and Flesh in Fin-de-Siècle France.* London: Thames & Hudson, 1998.

– *The Painted Face: Portraits of Women in France, 1814–1914.* New Haven: Yale University Press, 2007.

Garches, Jacques de [Mme Bindels-Vilette]. *Les Secrets de beauté d'une Parisienne.* Paris: H. Simonis Empis, 1894.

Garelick, Rhonda. *Rising Star: Dandyism, Gender, and Performance in the Fin de Siècle.* Princeton: Princeton University Press, 1998.

Gastou, Paul-Louis. 'Cocaïnomanie et morphinomanie'. In Bernier, *Le Musée de l'Hôpital St-Louis*, 155–8.

Gauld, Nicola. 'Victorian Bodies: The Wild Animal as Adornment'. *British Art Journal* 6, no. 1 (2005): 37–42. JSTOR.

Gérard, Joseph. *La Grande Névrose.* Paris: C. Marpon et E. Flammarion, 1889.

Gilman, Sander L. *Difference and Pathology: Stereotypes of Sexuality, Race, and Madness.* Ithaca: Cornell University Press, 1985.

Gingeras, Ryan. *Heroin, Organized Crime, and the Making of Modern Turkey.* Oxford: Oxford University Press, 2014.

Goldstein, Jan. *Console and Classify: The French Psychiatric Profession in the Nineteenth Century.* Cambridge: Cambridge University Press, 1987.

– 'The Hysteria Diagnosis and the Politics of Anticlericalism in Late Nineteenth-Century France'. *The Journal of Modern History* 52, no. 2 (June 1982): 209–39. JSTOR.

Goldstein, Robert Justin. *Censorship of Political Caricature in Nineteenth-Century France.* Kent: Kent State University Press, 1989.

Gonnon, A. *Album Gonnon: Iconographie médicale, 1895–1908.* Lyon: Mâcon, Imprimerie de Protat frères, c.1909.

Gordon, Rae Beth. *Dances with Darwin, 1875–1910: Vernacular Modernity in France.* Farnham: Ashgate, 2009.

Granotier, Paul. 'L'Autorité du mari sur la personne de la femme et la doctrine féministe'. Law PhD thesis, Paris, 1909

Gretton, Tom. 'Difference and Competition: The Imitation and Reproduction of Fine Art in a Nineteenth-Century Illustrated Weekly News Magazine'. *Oxford Art Journal* 23, no. 2 (2000): 143–62. JSTOR.

Groom, Gloria, ed. *Impressionism, Fashion, and Modernity*. Chicago: The Art Institute of Chicago, 2012. Exhibition catalogue.

Guba, David. *Taming Cannabis: Drugs and Empire in Nineteenth-Century France*. Montreal: McGill-Queen's University Press, 2020.

Guimbail, Henri. *Les Morphinomanes*. Paris: J.B. Baillière et fils, 1891.

Gullickson, Gay. *Unruly Women of Paris: Images of the Commune*. Ithaca: Cornell University Press, 1996.

Hahn, H. Hazel. *Scenes of Parisian Modernity: Culture and Consumption in the Nineteenth Century*. New York: Palgrave Macmillan, 2009.

Halliwell, Hannah. 'In Art and Wax: The Morphine Addict in France at the Turn of the Twentieth Century'. *The Social History of Alcohol and Drugs* 37, no. 1 (Spring 2023): 35–71. University of Chicago Press Journals.

Handy, Moses P., ed. *The Official Directory of the World's Columbian Exposition: A Reference Book*. Chicago: W.B. Conkey, 1893.

Hannaway, Caroline, and Ann La Berge, eds. *Constructing Paris Medicine*. Amsterdam: Rodopi, 1998.

Harsin, Jill. *Policing Prostitution in Nineteenth-Century Paris*. Princeton: Princeton University Press, 1985.

Hauptman, William. *El Modernismo: de Sorolla à Picasso, 1880–1918*. Milan: Fondation de l'Hermitage, 2011. Exhibition catalogue.

Herzlich, Claudine. 'The Evolution of Relations between French Physicians and the State from 1880 to 1980'. *Sociology of Health & Illness* 4, no. 3 (November 1982): 241–53. Wiley Online Library.

Hichens, Robert. *Felix*. London: Methuen and Co., 1902.

Hickman, Timothy. 'Heroin Chic: The Visual Culture of Narcotic Addiction'. *Third Text* 16, no. 2 (2002): 119–36. Taylor & Francis Online.

Hildreth, Martha. 'Doctors and Families in France, 1880–1930: The Cultural Reconstruction of Medicine'. In La Berge and Feingold, *French Medical Culture*, 189–209.

Hodée, Georges. 'Contribution à l'étude des causes de la prophylaxie et du traitement de la morphinomanie'. Medical PhD thesis. Paris, 1895.

Holl, J.-C. 'Les Salons du printemps'. *Les Cahiers d'art et de littérature* 3 (May 1905): 5–51.

Houssaye, Arsène. 'Mademoiselle Fleurs-de-Lys'. In *Le Nouveau Décaméron. La Rue et la route* 5, 36–64. Paris: E. Dentu, 1885.

Hunter, Mary. *The Face of Medicine: Visualising Medical Masculinities in Late Nineteenth-Century Paris*. Manchester: Manchester University Press, 2017.

Iskin, Ruth. 'Popularising New Women in Belle Epoque Advertising Posters'. In *A 'Belle Epoque'? Women in French Society and Culture 1890–1914*, edited by Diana Holmes and Carrie Tarr, 95–112. New York: Berghahn Books, 2006.

– *The Poster: Art, Advertising, Design, and Collecting, 1860s–1900s*. Hanover: Dartmouth College Press, 2014.

– 'Selling, Seduction, and Soliciting the Eye: Manet's *Bar at the Folies-Bergère*'. *The Art Bulletin* 77, no. 1 (March 1995): 25–44. JSTOR.

Jonas, Raymond. 'Sacred Tourism and Secular Pilgrimage: Montmartre and the Basilica of Sacré-Coeur'. In Weisberg, *Montmartre and the Making of Mass Culture*, 94–119.

Joyeux-Prunel, Béatrice, and Olivier Marcel. 'Exhibition Catalogues in the Globalization of Art. A Source for Social and Spatial Art History'. *Artl@s* 4, no. 2 (2015): 80–104. Perdue e-Pubs.

Jullien, Dominique. 'Anecdotes, *Faits Divers*, and the Literary'. *SubStance* 38, no. 1 (2009): 66–76. JSTOR.

Kandall, Stephen. *Substance and Shadow: Women and Addiction in the United States.* Cambridge: Harvard University Press, 1996.

Kearns, James. 'The Writing on the Wall: Descriptions of Painting in the Art Criticism of the French Symbolists'. In *Artistic Relations: Literature and the Visual Arts in Nineteenth-Century France,* edited by Peter Collier and Robert Lethbridge, 239–52. New Haven: Yale University Press, 1994.

Kennaway, James. 'The Piano Plague: The Nineteenth-Century Medical Critique of Female Musical Education'. *Gesnerus* 68, no. 1 (2011): 26–40. PubMed.

Kessler, Marni. *Sheer Presence: The Veil in Manet's Paris.* Minneapolis: University of Minnesota Press, 2006.

Kragh, Jesper Vaczy. 'Women, Men, and the Morphine Problem, 1870–1955'. In *Gendered Drugs and Medicine: Historical and Socio-Cultural Perspectives,* edited by Teresa Ortiz and María Jesús Santesmases, 177–99. London: Routledge, 2016.

Kretzschmar, Charles. *Les Animaux à fourrures.* 2nd edition. Chalon-sur-Saône: Kretzschmar et Rosselet, 1923.

Kuhn, Reinhard. *The Demon of Noontide: Ennui in Western Literature.* Princeton: Princeton University Press, 1976.

La Berge, Ann, and Mordechai Feingold, eds. *French Medical Culture in the Nineteenth Century.* Amsterdam: Rodopi, 1994.

Laforest, Jean-Louis Dubut de. *Morphine.* Paris: E. Dentu, 1891.

Laplana, Josep de C. *Santiago Rusiñol: el pintor, l'home.* Barcelona: Publicacions de l'Abadia de Montserrat, 1995.

Larousse, Pierre. *Grand Dictionnaire universel du XIXe siècle* 8 [F–G]. Paris: Administration du grand dictionnaire universel, 1872.

Lecerf, Joseph-Eugène-Ernest. 'Essai sur la symptomatologie de la morphinomanie'. Medical PhD thesis. Paris, 1895.

Lefèvre, Charles. 'Prophylaxie de la morphinomanie et de la morphino-cocaïnomanie'. *Annales de psychiatrie et d'hypnologie* 2, no. 8 (August 1892): 225–38.

Levenstein, Harvey. *Seductive Journey: American Tourists in France from Jefferson to the Jazz Age.* Chicago: University of Chicago Press, 1998.

Levinstein, Édouard. *La Morphiomanie: Monographie basée sur des observations personnelles.* 2nd edition. Paris: G. Masson, 1880.

Lugo, Laura Karp. 'Catalan Artists in Paris at the Turn of the Century'. In Carter and Waller, *Foreign Artists and Communities in Modern Paris,* 111–24.

Luxenberg, Alisa. 'Over the Pyrenees and Through the Looking-Glass: French Culture Reflected in Its Imagery of Spain'. In *Spain, Espagne, Spanien: Foreign Artists Discover Spain, 1800–1900,* edited by Suzanne L. Stratton, 9–31. New York: The Equitable Gallery, 1993. Exhibition catalogue.

Macé, Paul. 'Morphine, morphinomanie, morphinomanes'. Medical PhD thesis. Paris: 1904.

Magendie, François. *Formulaire pour la préparation et l'emploi de plusieurs nouveaux médicamens*. Paris: Méquignon-Marvis, 1822.

Magoulas, Georges. *La Cure de la morphinomanie: Traitement de Lafoux*. Montpellier: Imprimiere de Hamelin frères, 1899.

Mainardi, Patricia. *The End of the Salon: Art and the State in the Early Third Republic*. Cambridge: Cambridge University Press, 1993.

Man of the World [attributed to Auguste Poulet-Malassis]. *Un Été à la campagne: Correspondance de deux jeunes parisiennes*. Paris: printed privately, 1868.

Man of the World [attributed to Auguste Poulet-Malassis]. *Un Été à la Campagne: Correspondance between Two Young Parisian Ladies*. Translator unknown. Paris: printed privately, 1901.

Marcel, Henry. 'Hermen Anglada' *Gazette des beaux-arts* 51, no. 1 (January 1909): 106–17.

Mauclair, Camille. *Louis Legrand, peintre et graveur*. Paris: H. Floury et G. Pellet, 1910.

Maupassant, Guy de. 'Musotte'. In *Oeuvres complètes de Guy de Maupassant: Théâtre*, 45–160. Paris: L. Conard, 1910.

McCully, Marilyn. *A Picasso Anthology: Documents, Criticism, Reminiscences*. Princeton: Princeton University Press, 1982.

– *Picasso in Paris 1900–1907*. London: Thames & Hudson, 2011.

McLaren, Angus. 'Sex and Socialism: The Opposition of the French Left to Birth Control in the Nineteenth Century'. *Journal of the History of Ideas* 37, no. 3 (July–September 1976): 475–92. JSTOR.

Menon, Elizabeth. 'Images of Pleasure and Vice: Women of the Fringe'. In Weisberg, *Montmartre and the Making of Mass Culture*, 37–71.

Mesch, Rachel. *Having It All in the Belle Epoque: How French Women's Magazines Invented the Modern Woman*. Stanford: Stanford University Press, 2013.

– 'Housewife or Harlot? Sex and the Married Woman in Nineteenth-Century France'. *Journal of the History of Sexuality* 18, no. 1 (January 2009): 68–83. JSTOR.

Miller, Michael. *The Bon Marché: Bourgeois Culture and the Department Store, 1869–1920*. Princeton: Princeton University Press, 1981.

Monin, Ernest. *L'Hygiène de la beauté: Formulaire cosmetique*. Paris: O. Doin, 1886.

Monod, François. 'Le 17ᵉ Salon des Orientalistes Françaises'. *Art et décoration – supplément chronique* (March 1908): 1–3.

Mulvey, Laura. 'Visual Pleasure and Narrative Cinema'. *Screen* 16, no. 3 (1975): 6–18. Springer Link.

Murray, Alex. 'Enigmatic Intertexts: Decadence, De Quincey, and the Sphinx'. In *Decadent Romanticism: 1780–1914*, edited by Kostas Boyiopoulos and Mark Sandy, 89–102. Farnham: Ashgate, 2015.

Noel, Édouard, and Edmond Stoullig, eds. *Les Annales du théâtre et de la musique* [1891]. Paris: Bibliothèque charpentier, 1892.

Nordau, Max. *Dégénérescence* 1 and 2. Translated from the German [*Entartung*, 1892] by Auguste Dietrich. Paris: F. Alcan, 1894.

Notta, Maurice. *La Morphine et la morphinomanie*. Paris: Asselin et Houzeau, 1884.

Nye, Robert. *Crime, Madness and Politics in Modern France: The Medical Concept of National Decline*. Princeton: Princeton University Press, 2014.

O'Brien, Patricia. 'The Kleptomania Diagnosis: Bourgeois Women and Theft in Late Nineteenth-Century France'. *Journal of Social History* 17, no. 1 (1983), 65–77. Oxford Academic.

Ocaña, María Teresa, ed. *Picasso and Els Quatre Gats: The Early Years in Turn-of-the-Century Barcelona*. Barcelona: Museu Picasso, 1996. Exhibition catalogue.

Offen, Karen. 'Depopulation, Nationalism, and Feminism in Fin-de-Siècle France'. *The American Historical Review* 89, no. 3 (June 1984): 648–76. JSTOR.

– *European Feminisms, 1700–1950: A Political History*. Stanford: Stanford University Press, 2000.

– 'How (and Why) the Analogy of Marriage with Slavery Provided the Springboard for Women's Rights Demands in France, 1640–1848'. In *Women's Rights and Transatlantic Antislavery in the Era of Emancipation*, edited by Kathryn Sklar and James Stewart, 57–81. New Haven: Yale University Press, 2008.

Padwa, Howard. *Social Poison: The Culture and Politics of Opiate Control in Britain and France, 1821–1926*. Baltimore: Johns Hopkins University Press, 2012.

Panyella, Vinyet. 'From Els Quatre Gats to Cau Ferrat – The Artistic Links between Santiago Rusiñol and Picasso (1896–1903)'. In Ocaña, *Picasso and Els Quatre Gats*, 237–70.

Pica, Vittoria, and G.U. Arata (Galleria Pesaro). *Mostra individuale*. Milan: Bestetti e Tumminelli, 1923.

Pichon, Georges. *Considérations sur la morphinomanie et sur son traitement*. Paris: J.B. Baillière et fils, 1886.

– *Folies passionnelles: Études philosophiques et sociales*. Paris: E. Dentu, 1891.

– *Le Morphinisme: Impulsions délictueuses, troubles physiques et mentaux des morphiomanes [sic]*. Paris: O. Doin, 1889.

Pick, Daniel. *Faces of Degeneration: A European Disorder, c.1848–c.1918*. Cambridge: Cambridge University Press, 1989.

Plauzoles, Just Sicard de. *La Maternité et la défense nationale contre la dépopulation*. Paris: V. Giard et E. Brière, 1909.

Poincaré, R., Aristide Briand, Gaston Doumergue, Clémentel, L. Lalvy, and René Viviani. 'No. 10090: Loi concernant l'importation, le commerce, la détention et l'usage des substances vénéneuses, notamment l'opium, la morphine, et la cocaïne (12 juillet 1916)'. *Bulletin des lois de la République française* 8, no. 169–92 (1916): 1154–6.

Pollock, Griselda. *Avant-Garde Gambits, 1888–1893: Gender and the Colour of Art History*. London: Thames & Hudson, 1992.

Przyblyski, Jeannene, and Vanessa Schwartz. 'Visual Culture's History'. In *The Nineteenth-Century Visual Culture Reader*, edited by Jeannene Przyblyski and Vanessa Schwartz, 3–14. New York: Routledge, 2004.

Rabinow, Rebecca, ed. *Cézanne to Picasso: Ambroise Vollard, Patron of the Avant-Garde*. New York: The Metropolitan Museum of Art, 2006. Exhibition catalogue.

Razek, Rula. *Dress Codes: Reading Nineteenth Century Fashion*. Stanford: Stanford University Press, 1999.

Regnard, Paul. 'Deux poisons à la mode: La Morphine et l'éther'. *Revue scientifique* 3rd series: 9, no. 18 (2 May 1885): 545–56.

– *Les Maladies épidémiques de l'esprit: Sorcellerie, magnétisme, morphinisme, délire des grandeurs*. Paris: E. Plon, Nourrit et Cie, 1887.

Régnier, Louis Raoul. *L'Intoxication chronique par la morphine et ses diverses formes.* Paris: Progrès médical, 1890.

Ridpath, John Clark, ed. *Art and Artists of All Nations.* New York: Arkell Weekly Company, 1894.

Rodet, Paul. 'Bibliographie'. *Archives générales d'hydrologie, de climatologie et de balnéothérapie* 7 (December 1896): unpaginated.

– *Morphinomanie et morphinisme: Moeurs, symptomes, traitement, médecine légale.* Paris: F. Alcan, 1897.

Rothfield, Lawrence. *Vital Signs: Medical Realism in Nineteenth-Century Fiction.* Princeton: Princeton University Press, 1992.

Roussille, Alphonse. 'Les Taches bleues des morphinomanes: Publication de cinq cas nouveaux'. Medical PhD thesis. Lyon, 1907.

Samuels, Maurice. *The Spectacular Past: Popular History and the Novel in Nineteenth-Century France.* Ithaca: Cornell University Press, 2004.

Saussay, Victorien du. *La Morphine.* Paris: A. Méricant, 1906.

Schwaeblé, René de. *Les Détraquées de Paris.* Paris: Bibliothèque du Fin de siècle, 1905.

Schwartz, Vanessa. *Spectacular Realities: Early Mass Culture in Fin-de-Siècle Paris.* Berkeley: University of California Press, 1998.

Shapiro, Ann-Louise. *Breaking the Codes: Female Criminality in Fin-de-Siècle Paris.* Stanford: Stanford University Press, 1996.

– '"Stories more terrifying than the truth itself": Narratives of Female Criminality in Fin de Siècle Paris'. In *Gender and Crime in Modern Europe*, edited by Margaret Arnot and Cornelie Usborne, 204–21. London: UCL Press, 1999.

Shaw, Jennifer. 'The Figure of Venus: Rhetoric of the Ideal and the Salon of 1863'. *Art History* 14, no. 4 (December 1991): 540–70. Wiley Online Library.

Sherwood, Joan. *Infection of the Innocents: Wet Nurses, Infants, and Syphilis in France, 1780–1900.* Montreal: McGill-Queen's University Press, 2010.

Showalter, Elaine. *The Female Malady: Women, Madness, and English Culture, 1830–1980.* London: Virago, 1987.

Sichel, Kim. *Making Strange: The Modernist Photobook in France.* New Haven: Yale University Press, 2020.

Silverman, Debora. *Art Nouveau in Fin-de-Siècle France: Politics, Psychology, and Style.* Berkeley: University of California Press, 1989.

– 'The "New Woman", Feminism, and the Decorative Arts in Fin-de-Siecle France'. In *Eroticism and the Body Politic*, edited by Lynn Hunt, 144–63. Baltimore: Johns Hopkins University Press, 1991.

Singer, Ben. 'Modernity, Hyperstimulus, and the Rise of Popular Sensationalism'. In *Cinema and the Invention of Modern Life*, edited by Leo Charney and Vanessa Schwartz, 72–99. Berkeley: University of California Press, 1995.

Skelly, Julia. *Addiction and British Visual Culture, 1751–1919: Wasted Looks.* Farnham: Ashgate, 2014.

– 'Skin and Scars: Probing the Visual Culture of Addiction'. *Body & Society* 24, no. 1–2 (June 2018): 193–209. SAGE Journals.

Sollier, Paul. 'Méthode physiologique de démorphinisation rapide basée sur 357 cas de guérison (1890–1910)'. *Journal de médecine de Paris* 22 (December 1910): 875–7.

Solomon-Godeau, Abigail. 'The Legs of the Countess'. *October* 39 (Winter 1986): 65–108. JSTOR.

Sonn, Richard. 'Marginality and Transgression: Anarchy's Subversive Allure'. In Weisberg, *Montmartre and the Making of Mass Culture*, 120–41.

Sontag, Susan. *Illness as Metaphor*. New York: Farrar, Straus and Giroux, 1978.

Spagnoli, Laura. 'Morphine and the Unmaking of Marriage in Fin-de-Siècle French Fiction'. *Dix Neuf* 11, no. 1 (2008): 105–18. Taylor & Francis Online.

Stallybrass, Peter, and Allon White. *The Politics and Poetics of Transgression*. Ithaca: Cornell University Press, 1986.

Steele, Valerie. '*Femme Fatale*: Fashion and Visual Culture in Fin-de-Siècle Paris'. *Fashion Theory* 8, no. 3 (2004): 315–28. Taylor & Francis Online.

– *Paris Fashion: A Cultural History*. 2nd edition. Oxford: Berg, 1998.

Stewart, Susan. *On Longing: Narratives of the Miniature, the Gigantic, the Souvenir, the Collection*. Durham: Duke University Press, 1993.

Stott, Rebecca. *The Fabrication of the Late-Victorian Femme Fatale: The Kiss of Death*. Basingstoke: Macmillan, 1992.

Straw, Will. 'After the Event: The Challenges of Crime Photography'. In *Getting the Picture: The Visual Culture of the News*, edited by Jason Hill and Vanessa Schwartz, 139–44. London: Bloomsbury, 2015.

Susik, Abigail. 'Consuming and Consumed: Woman as *Habituée* in Eugène Grasset's *Morphinomaniac*'. In *Decadence, Degeneration, and the End: Studies in the European Fin de Siècle*, edited by Marja Härmänmaa and Christopher Nissen, 103–23. New York: Palgrave Macmillan, 2014.

Szabo, Jason. *Incurable and Intolerable: Chronic Disease and Slow Death in Nineteenth-Century France*. New Brunswick: Rutgers University Press, 2009.

Tailhade, Laurent. *La 'Noire Idole': Étude sur la morphinomanie*. Paris: Librairie Léon Vanier, 1907.

Talmeyr, Maurice. *Les Possédés de la morphine*. Paris: E. Plon, Nourrit et Cie, 1892.

Tardieu, Émile. *L'Ennui: Étude psychologique*. 2nd edition. Paris: F. Alcan, 1913.

Terdiman, Richard. *Discourse/Counter-Discourse: The Theory and Practice of Symbolic Resistance in Nineteenth-Century France*. Ithaca: Cornell University Press, 1985.

Thompson, Hannah. *Taboo: Corporeal Secrets in Nineteenth-Century France*. London: Legenda, 2013.

Thomson, Richard. *Art of the Actual: Naturalism and Style in Early Third Republic France, 1880–1900*. New Haven: Yale University Press, 2012.

– 'Toulouse-Lautrec and Montmartre: Depicting Decadence in Fin-de-Siècle Paris'. In *Toulouse-Lautrec and Montmartre*, edited by Richard Thomson, 2–23. Princeton: Princeton University Press, 2005. Exhibition catalogue.

– *The Troubled Republic: Visual Culture and Social Debate in France, 1889–1900*. New Haven: Yale University Press, 2004.

Tiersten, Lisa. *Marianne in the Market: Envisioning Consumer Society in Fin de Siècle France*. Berkeley: University of California Press, 2001.

Tinterow, Gary, with research by Asher Ethan Miller. 'Vollard and Picasso'. In Rabinow, *Cézanne to Picasso*, 110–17.

Uzanne, Octave. *La Femme et la mode: métamorphoses de la Parisienne*. Paris: A. Quantin, 1886.

– *Sottisier des Mœurs*. Paris: E. Paul, 1911.

Vever, Henri. 'Boucles de ceinture'. *Art et décoration* 2, no. 1 (January 1898): 156–60.

Villalonga Cabeza de Vaca, Maria. 'Surviving the Modernist Paradigm: A Fresh Approach to the Singular Art of Anglada-Camarasa, from Symbolism to Abstraction'. Art history PhD thesis. Oxford, 2009.

Voisin, Auguste. 'Du Traitement curatif de la folie par le chlorhydrate de morphine'. *Bulletin général de thérapeutique médicale et chirurgicale* 86 (1874): 49–54, 115–22, 154–64, 202–14, 296–309.

Walker, David H. 'Cultivating the *fait divers*: *Détective*'. *Nottingham French Studies* 31, no. 2 (September 1992): 71–83. Edinburgh University Press Journals.

Walsh, Mary Roth. *'Doctors wanted, no women need apply': Sexual Barriers in the Medical Profession, 1835–1975*. New Haven: Yale University Press, 1979.

Ward, Martha. *Pissarro, Neo-Impressionism, and the Spaces of the Avant-Garde*. Chicago: University of Chicago Press, 1996.

Weisberg, Gabriel, ed. *Montmartre and the Making of Mass Culture*. New Brunswick: Rutgers University Press, 2001.

Weisz, George. *The Medical Mandarins: The French Academy of Medicine in the Nineteenth and Early Twentieth Centuries*. New York: Oxford University Press, 1995.

Wilde, Oscar. 'The Sphinx Without a Secret'. In *Complete Works of Oscar Wilde*, edited by Merlin Holland, 205–8. London: HarperCollins, 2010.

Wilson, Stephen. *Ideology and Experience: Anti-Semitism in France at the Time of the Dreyfus Affair*. London: Littman Library of Jewish Civilization, 1982.

Wilson, Susannah. 'A Medicine for the Soul: Morphine and Prohibition in the French Cultural Imagination, 1870–1914'. In *Prohibitions and Psychoactive Substances in History, Culture and Theory*, edited by Susannah Wilson, 51–70. New York: Routledge, 2019.

Wolff, Albert. *Figaro-Salon*. Paris: Boussod, Valadon et Cie, 1886.

Wright, Barnaby, ed. *Becoming Picasso: Paris 1901*. London: Courtauld Gallery, 2013. Exhibition catalogue.

Yvorel, Jean-Jacques. 'La Morphinée'. *Communications* 56 (1993): 105–13. Persée.

– *Les Poisons de l'esprit: Drogues et drogués au XIXe siècle*. Paris: Quai Voltaire, 1992.

Zambaco-Pacha, Démétrius Alexandre. *De la Morphéomanie*. Paris: G. Masson, 1883.

Zanten, David Van. 'Looking Through, Across, and Up: The Architectural Aesthetics of the Paris Street'. In Groom, *Impressionism, Fashion, and Modernity*, 153–64.

Zayzafoon, Lamia Ben Youssef. *The Production of the Muslim Woman: Negotiating Text, History, and Ideology*. Lanham: Lexington Books, 2005.

Zieger, Susan. '"How Far Am I Responsible?": Women and Morphinomania in Late-Nineteenth-Century Britain'. *Victorian Studies* 48, no. 1 (Autumn 2005): 59–81. JSTOR.

– *Inventing the Addict: Drugs, Race, and Sexuality in Nineteenth-Century British and American Literature*. Amherst: University of Massachusetts Press, 2008.

Zola, Émile. *Au Bonheur des dames* (The Ladies' Paradise) [1883]. Translated by Brian Nelson. Oxford: Oxford University Press, 1998.

Index

heroin chic, 8, 185; *morphinomane* as fashionable, 19, 40–1, 46, 70–1, 85–93, 95–7, 102, 174–5, 177; women's pockets, 97

femme fatale, 46–7, 59–64, 70, 92, 116. *See also* Sphinx

femme nouvelle, 14, 20, 59, 62–3, 115–17, 123–35, 157, 177

First World War, 16, 23, 153, 180, 183, 188

Foucault, Michel, 7, 132

Franco-Prussian War, 10–11, 72, 100, 117, 177, 180

Fronde, La, 134–6, 167

fur, 57, 61–2, 88, 91–2, 95–6

gaze: in art, 54, 56, 58, 84, 167, 175; male, 131, 135, 212n58; women, 42, 53

Germany, 11, 61, 118; morphine, 9, 16, 177. *See also* Nordau, Max

Goupil, Adolphe, 65, 159

Grasset, Eugène: *La Morphinomane*, 86, 121, 132, 155–6, 168–9, 172–3, 178, 180; *La Vitrioleuse*, 156–8

Guilbert, Yvette, 3–4, 19, 82

Guimbail, Henri, 48–9, 76, 79, 82, 85, 119, 130, 139

heroin, 9, 16, 184–8, 219n12; heroin chic, 8, 174, 185

hypodermic syringe: adorned, 41, 92–5, 97; in art, 7, 30, 93–4, 109, 111, 113–14, 176, 183, 186; invention, 9, 11, 29, 99–100, 110–11; medical use, 34, 109–14. *See also* Pravaz, Charles; Wood, Alexander

hysteria, 11, 72, 82–4, 109

Impressionism, 26, 151, 154. *See also* Neo-Impressionism

Indochina, 187, 194n23

injection site: arm, 21, 30–1, 33, 46–9, 69, 108, 131; thigh, 47–8, 115, 124, 129, 131, 169, 180, 182, 208n31

insomnia, 32, 46, 49–51, 57, 175, 178

Italy: artists, 37, 50, 158–9, 180, 199n22, 216n23. *See also* Corcos, Vittorio; Macchiati, Serafino; Orazi, Manuel; Perckhammer, Heinz von

Kern, Léon, 75, 78, 93

kleptomania, 12, 82, 84–5, 90, 92

Lammour, Albert, 52, 77

Legrand, Louis, 80, 95, 119, 126–7

Levinstein, Éduard, 112, 139, 149

Macchiati, Serafino, 77, 128–32, 159

makeup, 66–7, 69, 185; and the *morphinomane*, 56, 58, 67, 70, 80, 92, 95, 116, 133, 175, 180

Manet, Édouard, 47, 53

marriage, 108, 120, 123, 126, 156; divorce, 13, 64, 119, 123, 129, 134–5, 195n47; wedding ring, 121–2

Matignon, Albert, 67, 77, 169, 171, 180

Maupassant, Guy de, 26–8, 47, 129, 147. *See also* *Musotte*

Montmartre, 17, 160, 164–7, 169, 184

Moreau de Tours, Georges, 24; Jacques-Joseph Moreau (de Tours), 28, 32, 34, 38, 184; *Les Fascinés de la Charité*, 30–1; Paul Moreau (de Tours), 28–9, 184; *Portrait de Mme et Mlle *******, 58; portrait of his father, 29, 34. *See also* *Morphine, La*

morphine: criminalisation of, 11, 16; discovery of, 9, 100; dosage, 32, 34–5, 87, 107, 109; impact on fertility, 79, 119; prescriptions, 10–11, 86, 102, 112–13; sedative use, 9, 32, 49, 50–1, 74, 108–9, 169; statistics, 13, 66, 71, 77, 97–8, 101–2, 112–13, 133, 139, 144, 177; syrup and salts, 110; terminology, 12, 167–8

Morphine, La (1886): books, 36–40, 85; Chicago, 163; fashion, 40–1, 65; lesbianism, 40, 126; medical influences,

28–35, 138, 140, 150; reproductions, 22, 44, 142–4, 147, 153–4, 173; sale, 43, 152; Salon display, 21–27, 44, 171, 176, 178. *See also* naturalism

motherhood,14, 51, 55–6, 84, 133; and addiction, 79, 120–1, 131, 179; rejection of, 58, 60, 119, 122–4, 134

murder, 73, 78, 140, 143, 148. *See also* Wladimiroff, trial of

Musotte, 93, 107–9, 113–14

naturalism, 26, 28, 34, 153–4, 171, 173

Neo-Impressionism, 154, 172. *See also* Impressionism

neurasthenia, 12, 82, 85

New Woman. See *femme nouvelle*

Nordau, Max, 11, 39

novels, 17–18, 35–7, 70, 76, 85, 103, 138, 145, 178; Saussay, 37, 57, 62, 121; Schwaeblé, 39–40, 48, 51, 57, 139–40, 208n31. *See also* Baudelaire, Charles; reading; *roman-feuilleton*; Talmeyr, Maurice

opera, 41, 55, 108

opium, 9, 31, 38–9, 188; art, 5, 7, 9–10, 174, 187; dens, 165, 187; paraphernalia, 185–7; Second Opium War, 9, 187; trade, 22, 187, 194n23

Orazi, Manuel, 37, 57, 59, 61–2, 121, 159, 216n23

Original Sin, 59, 61. *See also* snakes

Pasteur, Louis. *See* vaccination

Perckhammer, Heinz von, 180–2, 186, 188

pétroleuse, 14–15, 156

pharmacists, 6, 9–10, 32, 54, 141, 179, 210n55; corruption of, 35, 112, 102, 165. *See also* morphine

Picasso, Pablo: bullfighting, 164; influences, 52, 159–61, 165, 176; living in Paris, 17, 160–1, 164–5; *Morphinomane*, 56, 67, 119, 160–1, 164, 167, 172,

178; *Les Morphinomanes*, 80, 119, 172, 181; reviews, 155, 161, 166–7. *See also* Coquiot, Gustave

Pichon, Georges, 11–12, 71, 92, 144

Pravaz, Charles, 110–11, 209n49; Pravaz syringe 125, 176, 212n32

Rat Mort, 127

reading, dangers of, 36–7, 39–40, 84–5, 126

Regnard, Paul, 66, 71, 93, 95; *Les Maladies épidémiques*, 33, 57, 111, 118, 139, 187

Robida, Albert, 51, 93, 103, 106–7

Rodet, Paul, 12, 71, 78, 84, 87, 98, 101, 139

roman-feuilleton, 27, 89, 125, 140, 142–3, 145–8, 150–1

Rusiñol, Santiago, 159–60, 164, 167; *La Morfína*, 51, 84, 159, 168, 180, 216n27

Saint-Anne hospital, 82, 184

Salpêtrière, 28, 31, 83–4. *See also* hysteria

serial novel. See *roman-feuilleton*

servants, domestic, 10, 73, 87

sexual pleasure, 119–20, 122, 131, 167–8, 171

silk, 89, 91–2, 96, 197n55. *See also* department store

skin: animalistic, 57–60, 70; dirty, 78, 80; needle-scarred, 19, 33–4, 46; unscarred, 49, 51, 57, 63, 65, 118, 134, 168, 178. *See also* fur; injection site; silk; snakes

snakes, 57, 59–60, 62. See also *femme fatale*

Spain, 159, 160, 164, 165; Barcelona, 45, 58, 80, 160, 216n25, 217n34; Catalans in Paris, 52, 45, 158–66. *See also* Anglada-Camarasa, Hermenegildo; Casas, Ramon; Picasso, Pablo; Rusiñol, Santiago

Sphinx, 3, 27, 61–3, 70, 175, 201n61. See also *femme fatale*; Wilde, Oscar